THE CAMBRII
TO WILL

In his short life, William Morris (1834–96) combined the roles of poet, author, painter, designer, translator, lecturer, political activist, journalist, weaver, bookmaker, and businessman. This volume draws together influential voices from different disciplines who have participated in the recent critical, political, and curatorial revival of his work, with essays exploring the contemporary resonance of his remarkable legacy. As a critic of capitalism, his thinking has thrived in these years of financial crisis; as a theorist of work and craftsmanship, his legacy interacts with a more recent ethics of making that questions the values of 'off-shored' production; and as a protector of landscape and buildings, Morris's concern with what is precious strikes a chord in our age of environmental crisis. At the same time, a careful and scholarly approach observes the particularity of Morris's context, in a way that confounds the 'false friends' of hasty historical reception and reveals unexpected connections.

MARCUS WAITHE is Professor of Literature and the Applied Arts at the University of Cambridge, and a fellow of Magdalene College. He is the author of *The Work of Words* (2023), *Words Made Stone* (co-written with Lida Cardozo Kindersley) (2022), *Thinking through Style* (co-edited with Michael Hurley) (2018), *The Labour of Literature in Britain and France, 1830–1910* (co-edited with Claire White) (2018), and *William Morris's Utopia of Strangers* (2006).

A complete list of books in the series is at the back of the book.

THE CAMBRIDGE COMPANION TO WILLIAM MORRIS

EDITED BY

MARCUS WAITHE

University of Cambridge

CAMBRIDGE
UNIVERSITY PRESS

Shaftesbury Road, Cambridge CB2 8EA, United Kingdom

One Liberty Plaza, 20th Floor, New York, NY 10006, USA

477 Williamstown Road, Port Melbourne, VIC 3207, Australia

314–321, 3rd Floor, Plot 3, Splendor Forum, Jasola District Centre, New Delhi – 110025, India

103 Penang Road, #05–06/07, Visioncrest Commercial, Singapore 238467

Cambridge University Press is part of Cambridge University Press & Assessment, a department of the University of Cambridge.

We share the University's mission to contribute to society through the pursuit of education, learning and research at the highest international levels of excellence.

www.cambridge.org
Information on this title: www.cambridge.org/9781108832175

DOI: 10.1017/9781108939942

First published 2024

A catalogue record for this publication is available from the British Library

Library of Congress Cataloging-in-Publication Data
NAMES: Waithe, Marcus, editor.
TITLE: The Cambridge companion to William Morris / edited by Marcus Waithe.
DESCRIPTION: Cambridge, United Kingdom : Cambridge University Press, 2024. | Includes bibliographical references and index.
IDENTIFIERS: LCCN 2023042489 | ISBN 9781108832175 (hardback) | ISBN 9781108939942 (ebook)
SUBJECTS: LCSH: Morris, William, 1834–1896. | Morris, William, 1834–1896 – Criticism and interpretation. | Morris, William, 1834–1896 – Political and social views. | Morris, William, 1834–1896 – Homes and haunts. | Art and literature – England. | Arts and crafts movement.
CLASSIFICATION: LCC PR5083 .C27 2024 | DDC 821/.8–dc23/eng/20231003
LC record available at https://lccn.loc.gov/2023042489

ISBN 978-1-108-83217-5 Hardback
ISBN 978-1-108-94063-4 Paperback

In memory of Duncan Robinson CBE (1943–2022),
art historian, former Director of the Fitzwilliam Museum
and Master of Magdalene College, Cambridge

Contents

vii

Figures

Notes on Contributors

CAROLINE ARSCOTT is Professor Emeritus of The Courtauld Institute of Art, London. She is author of *William Morris and Edward Burne-Jones: Interlacings* (2008). Her recent publications include essays on William Morris and the poetics of indigo-discharge printing in *Nonsite #35* (May 2021) and on Whistler and etching in André Dombrowski (ed.), *Wiley-Blackwell Companion to Impressionism* (2021).

SARA ATWOOD teaches at Portland State University and Pacific Northwest College of Art. She is the author of *Ruskin's Educational Ideals* (2011) and has contributed essays to many books, including *William Morris and John Ruskin* (2019), and *Victorian Environmental Nightmares* (2019). She is a member of the Ruskin Art Club of Los Angeles and a Companion of the Guild of St George.

MATTHEW BEAUMONT is Professor of English Literature at University College London, where he is also Co-Director of the Urban Laboratory. He is the author of several books, including *Utopia Ltd.* (2005), *The Spectre of Utopia* (2012), and *Nightwalking: A Nocturnal History of London* (2015). He is currently writing *London: A Writers' City*.

FLORENCE S. BOOS is Professor of English at the University of Iowa. Her Morris-related publications include *History and Poetics in the Early Writings of William Morris* (2015) and editions of the *Socialist Diary* (2017), *The Routledge Companion to William Morris* (2020), and *William Morris on Socialism: Uncollected Essays* (2023). She is also the general editor of the William Morris Archive.

MARTIN DUBOIS is an Associate Professor in the Department of English Studies at Durham University. His first book, *Gerard Manley Hopkins and the Poetry of Religious Experience*, appeared in 2017. He is the author of several essays on Victorian poetry and is currently editing *Gerard Manley Hopkins in Context* for Cambridge University Press.

STUART EAGLES is an independent scholar specializing in John Ruskin. His publications include *After Ruskin: The Social and Political Legacies of a Victorian Prophet* (2011) and *Ruskin and Tolstoy* (2nd ed., 2016). He was formerly Secretary of Ruskin's Guild of St George. He is writing a study of Ruskin and Sheffield and runs the Ruskin Research Blog.

MARY GREENSTED was a curator at Cheltenham and has written widely on the Arts and Crafts, including *The Arts & Crafts Movement in Britain* (2010) and *Ernest Gimson: Arts & Crafts Designer and Architect* (2019) with Annette Carruthers and Barley Roscoe. She is a trustee at Court Barn Museum, Chipping Campden, and a patron of the Gloucestershire Guild of Craftsmen.

JULIA GRIFFIN is an art historian and museum curator (MA Courtauld; PhD University of the Arts London). She co-curated and co-edited *Young Poland* (joint winner of the Association for Art History's 2022 Curatorial Prize). Her PhD explored the cultural place-making of Kelmscott Manor (2022). She has published extensively on Morris and Rossetti, including contributions to the *Routledge Companion to William Morris* (2021) and the new edition of Linda Parry's *William Morris* (2021).

SIMON GRIMBLE is an Associate Professor in the Department of English Studies at Durham University. He is the author of *Landscape, Writing and 'The Condition of England': 1878–1917, Ruskin to Modernism* (2004) and editor of *Lives of Victorian Literary Figures: John Ruskin* (2005) and of *Brexit and the Democratic Intellect* (2017). He is currently writing a book on intellectuals and the politics of style.

INGRID HANSON is a Lecturer in English Literature at the University of Manchester. She has published on a range of Victorian and early twentieth-century writings on violence, peace, class, and social change. She is author of *William Morris and the Uses of Violence, 1856–1890* (2013) and editor of *William Morris: Selected Writings* (2024).

ELIZABETH HELSINGER is the John Matthews Manly Distinguished Service Professor Emerita at the University of Chicago. Her books include *Conversing in Verse: Conversation in Nineteenth-Century English Poetry* (2022), *Poetry and the Thought of Song* (2015), *Poetry and the Pre-Raphaelite Arts: Dante Gabriel Rossetti and William Morris* (2008), *Rural Scenes and National Representation, Britain 1815–1850* (1997), and *Ruskin and the Art of the Beholder* (1982).

RUTH LEVITAS is Professor Emerita of Sociology at the University of Bristol. She was the founding Chair of Utopian Studies Society – Europe, and Vice-Chair/Chair of the William Morris Society from 2004 to 2014. Her books include *The Concept of Utopia* (1990, 2005), *The Inclusive Society?* (1998, 2005) and *Utopia as Method* (2013).

ELIZABETH CAROLYN MILLER is Professor of English at the University of California, Davis. Her most recent book, *Extraction Ecologies and the Literature of the Long Exhaustion* (2021) received the Stansky Book Prize from the North American Conference on British Studies. She has published widely on William Morris and co-edited the volume *Teaching William Morris* (2019).

HEATHER O'DONOGHUE is Professor Emeritus of Old Norse at Linacre College, University of Oxford. Her research interests include the reception of Old Norse-Icelandic literature and the narratology of Old Norse sagas. Most recently, she has co-edited *The Cambridge History of Old Norse-Icelandic Literature* (forthcoming) and finished a book on *Beowulf* for Bloomsbury.

TONY PINKNEY retired from the Department of English Literature and Creative Writing at Lancaster University in 2020. He has published books on T. S. Eliot, D. H. Lawrence, and Raymond Williams. His work on William Morris includes *William Morris and Oxford: The Campaigning Years* (2007) and *William Morris: The Blog* (2011).

MICHAEL T. SALER is Professor of History at the University of California, Davis, where he teaches modern European intellectual and cultural history. His publications include *The Avant-Garde in Interwar England: 'Medieval Modernism' and the London Underground* (1999) and *As If: Modern Enchantment and the Literary Prehistory of Virtual Reality* (2012).

ZOË THOMAS is an Associate Professor in Modern History at the University of Birmingham. She is author of *Women Art Workers and the Arts and Crafts Movement* (2020), which won the Historians of British Art award for a single-author book with a subject between 1800–1960 and the Women's History Network Prize.

HERBERT F. TUCKER holds the John C. Coleman Chair in English at the University of Virginia, where he is also an editor for *New Literary History* and for the Victorian series of the university press. He has published and edited several books, most recently *Epic: Britain's Heroic*

Muse (rev., 2014), together with some hundred articles on topics in nineteenth-century studies.

ANNA VANINSKAYA is a Senior Lecturer in English Literature at the University of Edinburgh. She is the editor and co-translator of *London Through Russian Eyes, 1896–1914: An Anthology of Foreign Correspondence* (2022) and author of *Fantasies of Time and Death: Dunsany, Eddison, Tolkien* (2020) and *William Morris and the Idea of Community: Romance, History and Propaganda, 1880–1914* (2010).

MARCUS WAITHE is Professor of Literature and the Applied Arts at the University of Cambridge and a Fellow of Magdalene College. His books include *The Work of Words* (2023), *Words Made Stone* (co-written with Lida Cardozo Kindersley) (2022), *Thinking through Style* (co-edited with Michael Hurley) (2018), *The Labour of Literature in Britain and France, 1830–1910* (co-edited with Claire White) (2018), and *William Morris's Utopia of Strangers* (2006).

TESSA WILD is Director of the Attingham Trust Summer School, Editor of the magazine of the Society for the Protection of Ancient Buildings, and an independent curator. She is the author of William Morris and his Palace of Art (2018) and a trustee of Emery Walker's House. She was the curator of Red House, Bexleyheath, from 2003–16.

CLIVE WILMER, poet and critic, is Emeritus Fellow in English at Sidney Sussex College, Cambridge. He has written and lectured on many aspects of William Morris, editing his *News from Nowhere and Other Writings* for Penguin Classics in 1993. From 2009 to 2019, he was Master of John Ruskin's Guild of St George.

Acknowledgements

The editor would like to thank the Huntington Library, San Marino for the award of a William Reese Fellowship that greatly assisted the preparation of this volume. He gratefully acknowledges the following individuals for support, assistance, and advice provided along the way: Florence S. Boos, George Laver, Fern Leathers, Elizabeth Carolyn Miller, Bethany Thomas, and Clive Wilmer. He is likewise grateful to all the contributors, without whose generosity, understanding, and collegiality this volume would not have been possible.

Note on *The Collected Works*

Unless otherwise stated, all references to Morris's works come from *The Collected Works of William Morris*, edited by May Morris, 24 vols (London: Longmans Green and Company, 1910–15). This edition is available in its original printed form or as one of the facsimile reprints issued by Thoemmes Press (1992), Elibron Classics (2000–11), and the Cambridge Library Collection (2012) (also available electrically via Cambridge Core: www.cambridge.org/core).

Citations from *The Collected Works* appear parenthetically in the text. For the sake of economy, the volume and page number are given without further identification. The edition's contents are as follows:

Chronology

The following chronology charts the key turning points in Morris's life. Readers needing a more detailed source should consult: Nicholas Salmon, with Derek Baker, *The William Morris Chronology* (Bristol: Thoemmes Press, 1996).

1834 William Morris is born on 24 March at Elm House, Walthamstow, third child and eldest son to Emma (née Shelton) and William Morris (snr), a senior partner at City of London brokers Sanderson & Company.

1840 The family move to Woodford Hall, near Epping Forest, a Palladian mansion with extensive park and farmland.

1842 Morris visits Canterbury Cathedral, and goes brass rubbing.

1843 Morris rides each day to Miss Arundale's Academy for Young Gentlemen, Woodford, on a Shetland pony.

1846 Devonshire Great Consolidated Copper Mining Company is registered, a joint stock company in which Morris's father and uncle are major shareholders.

1847 Morris's father dies and is buried in Woodford churchyard.

1848 Morris is sent to the recently founded Marlborough College in Wiltshire, where he spends free time exploring local antiquities and prehistoric monuments. The Morris family moves to the Water House, now on Forest Road, Walthamstow.

1851 A 'rebellion' takes place among the boarders at Marlborough College, during which fireworks are let off.

1852 Morris begins private tuition under the Rev. F. B. Guy of Walthamstow.

1853 Morris goes up to Exeter College, Oxford, where he makes friends with Edward Burne-Jones. With a wider group of companions, they form The Set, and eagerly consume John Ruskin's 'The Nature of Gothic' chapter, just published in Volume II of *The Stones of Venice* (1851–3).

1854	Morris visits the major Gothic churches of northern France and Belgium. The cathedral at Rouen makes a particular impression.
1855	Morris begins writing poetry; and he resolves to become an architect after a second tour of northern French churches, this time with Burne-Jones and William Fulford. He thereby abandons his plan to take holy orders. Morris and Burne-Jones set a pattern for their literary interests on discovering Robert Southey's 1817 edition of Malory's *Le Morte d'Arthur* in Cornish's bookshop, Birmingham. In the autumn, Morris successfully passes his degree at the University of Oxford.
1856	Morris and his friends publish *The Oxford and Cambridge Magazine*, the first number of which includes Morris's 'The Story of the Unknown Church' and 'Winter Weather'. Morris joins the office of the Oxford architect G. E. Street and in London meets Dante Gabriel Rossetti. In the autumn, Morris and Burne-Jones move to lodgings at Red Lion Square, where they eventually design their own furniture. By the end of the year, Morris has abandoned his plan to become an architect in favour of the life of a painter.
1857	Morris meets Jane Burden, to whom he would propose in February 1858. He spends the early autumn painting frescos with his friends on the ceiling of the Oxford Union.
1858	Morris publishes *The Defence of Guenevere and Other Poems*.
1859	Morris marries Jane Burden and commissions his friend Philip Webb to design Red House – a family home situated at Upton in Kent. In this year, he also joins the Corps of Artistic Volunteers.
1860	Morris and his family move into Red House.
1861	The firm of Morris, Marshall, Faulkner & Company ('the Firm') is founded and establishes premises at 8 Red Lion Square, London. Morris's eldest daughter, Jane (Jenny) Alice Morris, is born.
1862	The Firm exhibits at the International Exhibition, South Kensington Museum, London. Morris's youngest daughter, Mary (May) Morris, is born.
1865	The Morris family moves from Red House to 26 Queen Square, London, to which the Firm had also moved its premises earlier the same year.

1866 Morris and Burne-Jones discuss an edition of *The Earthly Paradise* illustrated with wood blocks (later abandoned). The Firm decorates the Green Dining Room at the South Kensington Museum. In this year, it also contracts work on the chapel of Jesus College, Cambridge to the Cambridge firm of Frederick R. Leach.

1867 Morris publishes *The Life and Death of Jason*.

1868 Morris publishes volume I of *The Earthly Paradise* (Parts I and II). He also begins to learn Icelandic under the tutelage of Eiríkur Magnússon.

1869 Morris and Magnússon publish their translations of 'The Saga of Gunnlaug the Worm-tongue and Rafn the Skald', *Eyrbyggja Saga* and *Grettis Saga* (*The Story of Grettir the Strong*). Morris also publishes Volume 2 of the *Earthly Paradise* (Part III). In this year, the Morrises make a convalescent trip to Bad Ems, a spa town in Germany.

1870 Morris publishes a translation of *The Story of the Volsungs and Niblungs*. He embarks on experiments with calligraphy and illuminated manuscripts.

1871 Morris and Rossetti jointly acquire the lease on Kelmscott Manor, Oxfordshire. Around this time, Rossetti commences a romantic affair with Jane Morris. Morris makes his first visit to Iceland, accompanied by Magnússon, Charles Faulkner and W. H. Evans. He keeps an Icelandic journal.

1872 Morris publishes *Love Is Enough*. He completes a vellum illuminated manuscript of *The Rubaiyat of Omar Khayyam*. He also works on (but never finishes) *The Novel on Blue Paper*. Morris attends the annual general meeting of the Devon Great Consols Mining Company in his capacity as a director.

1873 The Morrises move to Horrington House, Turnham Green Road. Morris and Burne-Jones travel to Florence. Morris and Faulkner make their second expedition to Iceland.

1874 The Firm is commissioned to create a window for Christ Church, Oxford. Rossetti gives up his tenancy at Kelmscott Manor. Morris and his family visits Belgium.

1875 The firm of Morris, Marshall, Faulkner & Company is reconstituted as Morris & Company, with Morris taking full control. In this year, he publishes *Three Northern Love Stories & Other Tales* and *The Aeneids of Virgil*. Morris suffers an attack of gout and visits Leek in Staffordshire to receive instruction in dyeing from Thomas Wardle at the Hencroft Dye Works.

1876 Jenny Morris develops epilepsy, ending her plans for higher education. Morris enters the public debate on the Eastern Question surrounding Turkish rule in the Balkans and the massacre of Bulgarian Christians. In the autumn of this year, he publishes *The Story of Sigurd the Volsung and the Fall of the Niblungs*.

1877 Morris declines an approach about becoming Professor of Poetry at Oxford. He becomes Chairman of the newly established Society for the Protection of Ancient Buildings. Morris & Company open showrooms on Oxford Street. Morris publishes his translation of *The Odyssey*. At the end of the year, he delivers 'The Decorative Arts' before the Trades Guild of Learning, an early landmark in the public lectures that would span the rest of his life. He also gives his first political lecture, for the Eastern Question Association in Lambeth.

1878 Morris learns how to make hand-knotted carpets, and publishes *The Decorative Arts: Their Relation to Modern Life and Progress*. The Morris family travels to Italy, and they move into Kelmscott House (formerly The Retreat), Hammersmith.

1879 Morris completes the *Acanthus & Vine* tapestry, and becomes Treasurer of the newly founded National Liberal League. He protests against the planned restoration of St Mark's, Venice.

1880 The Morris family and some friends travel on a boat named the *Ark* from Kelmscott House in Hammersmith to Kelmscott Manor in Oxfordshire, a journey that prefigures the one made by William Guest in *News from Nowhere*. Morris & Company decorate the Throne Room at St James's Palace.

1881 Morris protests against the proposed widening of Magdalen Bridge in Oxford. Morris & Company open their works at Merton Abbey, South West London.

1882 Rossetti dies. Morris becomes Treasurer of the Icelandic Famine Relief Committee.

1883 Morris is elected an honorary fellow of Exeter College, Oxford. He joins the Democratic Federation (later, the Social Democratic Federation (SDF)), and having become a socialist proclaims this on the occasion of delivering his lecture 'Art Under Plutocracy' at University College, Oxford. In this year, he reads Karl Marx's *Das Kapital* in a French translation.

1884 Morris publishes *Chants for Socialists* in *Justice*, the campaigning
 newspaper of the SDF. He delivers his lecture 'Useless Work
 versus Useless Toil' at venues across the country. Morris, along
 with Ernest Belfort Bax, Edward Aveling, Eleanor Marx and
 others, leave the SDF and found the Socialist League (SL).

1885 Morris is arrested for crying 'shame' on hearing the verdict of
 a trial at Arbour Square Police Court. In a letter to Thomas
 Wardle, he denies suggestions that his wallpapers could cause
 arsenic poisoning. He is laid low by a particularly severe attack
 of gout. Morris begins publishing *The Pilgrims of Hope* in the
 campaigning newspaper of the SL, *Commonweal*.

1886 Morris and E. Belfort Bax publish *Socialism from the Root Up* in
 Commonweal. And Morris begins publishing instalments of *A
 Dream of John Ball*. He sustains an intense schedule of open-air
 speaking at socialist rallies around the country.

1887 Morris commences writing entries for his *Socialist Diary*. He
 publishes *The Odyssey of Homer* and writes a socialist play, *The
 Tables Turned; or Nupkins Awakened*, first performed at the SL
 Hall on Farringdon Road. Three people are killed by police and
 more than a hundred injured on 'Bloody Sunday' in Trafalgar
 Square; at a subsequent protest, mounted police run down a
 protestor named Alfred Linnell. Morris speaks at Linnell's funeral.
 In this year, the Arts and Crafts Exhibition Society is founded.

1888 Morris attends a lecture at the New Gallery by Emery Walker
 entitled 'Letter Press Printing', which would inspire him to set up
 the Kelmscott Press. Morris publishes *The House of the Wolfings*
 (dated 1889). He also publishes *A Dream of John Ball* in book
 form. Morris attends the Second International in Paris.

1889 Morris publishes *The Roots of the Mountains*.

1890 Morris publishes instalments of *News from Nowhere* in
 Commonweal and begins the serialization of *The Story of the
 Glittering Plain*. He renews purchasing incunabula and other
 rare books, and visits Joseph Batchelor's mill in Little Chart,
 Kent, in search of suitable paper for the Kelmscott Press. The
 Hammersmith Branch of the SL, headed by Morris, secedes to
 become The Hammersmith Socialist Society.

1891 *News from Nowhere* is published as a book by Reeves & Turner.
 Morris founds the Kelmscott Press, and the prints *The Story of
 the Glittering Plain*. Morris also publishes *Poems by the Way* at
 the Press. He begins publishing the multi-volume *Saga Library*.

1892 After the death of Alfred, Lord Tennyson, Morris declines his proposed candidacy as the next Poet Laureate. The Kelmscott edition of *News from Nowhere* is published.

1893 Morris publishes *Socialism: Its Growth and Outcome* (a revised version of *Socialism from the Root Up*). The Kelmscott edition of Thomas More's *Utopia* is printed.

1894 Morris publishes *The Wood Beyond the World* at the Kelmscott Press. His mother dies.

1895 Morris writes letters of protest about tree-felling in Epping Forest and also writes to the Thames Conservancy. He publishes *The Tale of Beowulf* at the Kelmscott Press and delivers 'The Woodcuts of Gothic Books' at Bolt Court Technical School, Fleet Street.

1896 The Kelmscott Press prints *The Works of Geoffrey Chaucer* and *The Well at the World's End*. Morris spends several months unwell and travels to Norway accompanied by a doctor. He dies at home on 3 October 1896. A doctor declares that 'the Disease is simply being William Morris, and having done more work than most ten men'. Morris is buried in the churchyard at Kelmscott. Morris's secretary, Sydney Cockerell, winds up the operations of the Kelmscott Press, including publishing *The Sundering Flood* and other works still moving through the Press on Morris's death.

Abbreviations

The following commonly cited works are given parenthetically in the text using the stated abbreviations. Other references appear as endnotes, initially in full and then following a short-title system.

Arnot	R. Page Arnot, *William Morris: The Man and the Myth* (London: Lawrence and Wishart, 1964)
Blue Paper	Penelope Fitzgerald, *The Novel on Blue Paper by William Morris* (New York: Journeyman Press, 1982)
CL	*The Collected Letters of William Morris*, ed. Norman Kelvin, 4 vols (New Jersey: Princeton University Press, 1984–96)
Henderson	Philip Henderson, *William Morris: His Life, Work and Friends* (London: Thames & Hudson, 1967)
Ideal Book	*The Ideal Book: Essays and Lectures on the Arts of the Book by William Morris*, ed. William S. Peterson (Los Angeles: University of California, 1982)
Journalism	*Journalism: Contributions to* Commonweal *1885–1890*, ed. Nicholas Salmon (Bristol: Thoemmes Press, 1996)
Lindsay	Jack Lindsay, *William Morris: His Life and Work* (London: Constable, 1975)
MacCarthy	Fiona MacCarthy, *William Morris: A Life for Our Time* (Faber and Faber, 1994)
Mackail	J. W. Mackail, *The Life of William Morris*, 2 vols (London: Longmans, Green, & Company, 1899)
Meier	Paul Meier, *William Morris: The Marxist Dreamer*, 2 vols, trans. Frank Gubb (Sussex: Harvester Press, 1978) (original French title: *La Pensée Utopique de William Morris* (1972))
Memorials	Georgiana Burne-Jones, *Memorials of Edward Burne-Jones*, 2 vols (London: Macmillan, 1906)

Peterson	William S. Peterson, *The Kelmscott Press: A History of William Morris's Typographical Adventure* (Berkeley: University of California Press, 1991)
PW	*Political Writings: Contributions to* Justice *and* Commonweal, ed. Nicholas Salmon (Bristol: Thoemmes Press, 1994)
Ruskin	*The Library Edition of the Works of John Ruskin*, eds E. T. Cook and Alexander Wedderburn, 39 vols (London: Allen, 1903–12)
Socialism	William Morris and E. Belfort Bax, *Socialism: Its Growth and Outcome* (London: Swan Sonnenschein, 1893)
Socialist Diary	*William Morris's Socialist Diary*, ed. Florence S. Boos (Iowa City, IA: Windhover Press, 1981)
Sparling	H. Halliday Sparling, *The Kelmscott Press and William Morris Master-Craftsman* (London: Macmillan and Company, 1924)
Tables Turned	Pamela Bracken Wiens (ed.), *The Tables Turned* (Athens: Ohio University Press, 1994)
Thompson	Paul Thompson, *The Work of William Morris* (London: Heinemann, 1967)
TSL	William Morris and Eiríkur Magnússon (eds), *The Saga Library*, 6 vols (London: Bernard Quaritch, 1891–1905)
UL	*The Unpublished Lectures of William Morris*, ed. Eugene D. LeMire (Detroit: Wayne State University Press, 1969)
WMA	*William Morris Archive*, ed. Florence S. Boos, http://morrisarchive.lib.uiowa.edu/
WMAWS	*William Morris: Artist, Writer, Socialist*, eds May Morris and Bernard Shaw, 2 vols (Oxford: Basil Blackwell, 1936)
WMM	Tony Pinkney (ed.), *We Met Morris: Interviews with William Morris, 1885–1996* (Reading: Spire Books, 2005)
WMRR	E. P. Thompson, *William Morris: Romantic to Revolutionary*, rev. ed. (London: Merlin Press, 1976)
Vallance	Aymer Vallance, *William Morris: His Art, His Writings and His Public Life* (London: George Bell and Sons, 1897)

Introduction
Morris in the Making

Marcus Waithe

Across the short span of his life, William Morris (1834–96) combined the roles of poet, author, painter, designer, translator, lecturer, political activist, journalist, weaver, bookmaker, and businessman. We might wonder what binding agent could connect this extraordinary array of skills. A compelling answer is supplied by the influential architect-educationalist W. R. Lethaby: 'it is a mistake', Lethaby proposes, 'to get into the habit of thinking of him as a "designer";' instead, 'he was a work-master – Morris the Maker!' (Sparling, 54). 'Morris the Maker!' is a resonant phrase. It also happens to be accurate, in that it alludes less to the demands of a particular trade than to a state of being. Understood as serving the general function of bringing beautiful things into the world, Morris was undoubtedly a maker. Indeed, he was among the nineteenth century's most talented.

In an important respect, though, the language of the workshop misleads. As the son of a wealthy stockbroker, Morris was a member of the upper middle classes. Educated at Marlborough College, and then at Oxford, he would never serve a tradesman's apprenticeship. In this regard, the word 'maker' is necessarily as well as suggestively generalized. No matter his renown as a man of practical ability, this unavoidable fact had ramifications. He felt it especially when addressing the audiences of working men that were attracted to his late lectures on politics and the crafts. Blaming 'the division of labour' in 'Making the Best of it' (1879) – a lecture delivered before the Trades' Guild of Learning and the Birmingham Society of Artists – he admits that 'I cannot claim to represent any one craft … I have been compelled to learn many crafts, and belike, according to the proverb, forbidden to master any, so that I fear my lecture will seem to you both to run over too many things and not to go deep enough into any' (xxii.82). Even before his conversion to socialism, there was a quality of passing about his wearing a workman's smock when busied with his various practical activities, extending as they did from woodcarving and pattern design to weaving, dying, and typography (we might also include

poetry, an activity that Morris ranked among the practical arts). And this accounts, perhaps, for his pleasure in relating the humorous story of being accosted in the street when wearing a seaman's jacket with the urgent enquiry 'Beg Pardon, Sir, were you ever Captain of the *Sea Swallow*?'[1]

So Lethaby's universal moniker – 'Maker!' – illuminates the awkwardness of Morris's lack of a workshop lineage, his untied status as a genteel journeyman. By the same token, though, such awkwardness witnesses a productive disruption of inherited roles. Morris's social background conferred on him a privilege that radiates outwardly as well as inwardly. Most notably, it allowed him to move between trades in a way that an apprenticed craftsman never could.[2] Though he honoured the memory of the guild system, there is something distinctively modern about his shifts between enthusiasms. His was a restless search for new knowledge that cut across the old divisions of trade. This marks him out as a 'new man' rather than a throwback. Relatedly, his socialism did not favour the route of trade unionism; his preference was for less organized forms of solidarity. Morris inhabits a freshly constituted role defined not by loyalty to a particular occupational group but by loyalty to the quality of the made object, and to the human dignity of the labour process. In this way, he was able to develop links and affinities that were otherwise neglected. This advantage applies not only to practical activities, but also to his way of linking them to the intellectual life. In a work apparently inspired by Lethaby's moniker – *The Kelmscott Press and William Morris Master-Craftsman* (1924) – Henry Halliday Sparling quotes from a review in the *Athenæum* that describes Morris as 'the very ideal, if not of the poet as *vates* [prophet], yet of the poet as "maker"' (Sparling, 48). Morris disdained the poetic theory of inspiration, in favour of workmanly method: 'That talk of inspiration is sheer nonsense', he declared, 'there is no such thing: it is a matter of craftsmanship' (Mackail, i.186). To be a maker in this context is to embrace the possibility of a poetry that looks not to the divine afflatus, but to the knowledge and procedures inherited from past workers in an avowedly artisanal enterprise.

The Making of Morris

Speaking after the poet's death, at an event to mark the opening of a memorial hall in Kelmscott, George Bernard Shaw sought to sum up the achievement of a lifetime. Most strikingly, he remarks of Morris's time as a student that 'Oxford can do many wonderful things, but it cannot turn out a man like Morris, except in the sense of turning him out of the door.'[3]

Whether or not this was true, it prompts at the very least a question about origins and influences. Certainly, Morris was a maker, but how was he himself made?

The question is worth asking because Morris shared his background and upbringing with a large family, many of whom pursued relatively conventional paths. His grown-up siblings included an Army officer (who rose to the rank of Colonel), another soldier, a gentleman farmer, a deaconess, an unmarried Catholic convert, and the wife of a vicar (MacCarthy, plates 3–10). What, apart from natural disposition, made Morris different, and how did his early experiences shape the singular trajectory of his life? As the eldest son, a route to worldly advancement was already laid out for him. It is glimpsed in the family expectation that he would take Holy Orders after completing his degree at Oxford. And it shows in his inheritance of shares that entitled him to a seat on the board of the mining company, Devon Great Consols. Morris did not follow his father's way into high finance, but he became a canny businessman all the same. At death, his personal wealth amounted to just over £62,000 (approximately £5 million in today's money).[4] It was at Oxford, where he soon gave up any real intention of entering the Church, that he began formulating a more singular trajectory. The adventures of his youth – haunting Epping Forest in a child's suit of armour, and visiting antiquities in the Wiltshire landscapes around Marlborough College – had for the most part been lonely. But now he found himself in a sympathetic group with similar literary and artistic interests, among whom Edward Burne-Jones and several others would prove friends for life. Nicknamed 'The Set', its two great literary discoveries were Ruskin's socio-architectural theories about the Gothic's 'confession of Imperfection' (Ruskin, x.214), and Thomas Malory's medieval epic of fellowship and social disarray, *Le Morte d'Arthur* (1469–70). In these respects Shaw's verdict is true only in so far as Morris disdained the University's narrow curriculum: the broader experience of being in the city amidst its medieval architecture was in every other respect formative (see Chapter 1).

The literary-artistic leanings of The Set led to the publication of *The Oxford and Cambridge Magazine* (January–December 1856), a journal in the mould of *The Germ* published between January and May 1850 by Dante Gabriel Rossetti and other Pre-Raphaelites. Morris's most serious deviation from parental expectations would also take inspiration from the anti-institutional impetus of Pre-Raphaelitism. Like other literary 'rebellions' of the Victorian age – notably, that of George Eliot in rejecting her father's Evangelical convictions, and Gerard Manley Hopkins's in

converting to Catholicism – Morris's form of stepping out appealed to older orthodoxies. His medievalism activates buried forms of continuity, while his related conception of brotherhood suggests a closed order unreceptive to change. Yet Morris's version of the Middle Ages was never a 'dream of order' in Alice Chandler's resonant phrase.[5] Rather, he viewed them through the literary lens of story and romance, and therefore of narrative events. These events, like the dissolution of the Round Table, typically focus on a conflict of laws between, on the one hand, brotherhood and fidelity, and on the other, the courtly love of medieval romance. The same division of loyalties troubles Morris's early poem 'The Defence of Guenevere' (1858). A love triangle's testing geometry likewise inspires the subject he painted on the roof of the Oxford Union, 'How Sir Palomydes Loved La Belle Iseult with Exceeding Love Out of Measure, and How She Loved Not Him Again But Rather Sir Tristram' (1857).

This notion, that one might simultaneously be in the wrong as well as the right, is at least as old as Greek tragedy. From medieval versions of this antagonism of valid claims, Morris derived an enduring attitude of compassion, and an unusual intellectual flexibility. This is a tendency worth stressing, because it stands so obviously in tension with the common assumption that medievalism springs necessarily from socially conservative impulses. Pre-Raphaelitism is part of this story. Typically, it found nobility in the mundane and workaday. Its extramural tendencies were expressed through a preference for working-class women in modelling mythic or noble heroines, and a related social conscience brought Morris in the way of his future wife, Jane Burden, the daughter of an Oxford stable hand. Crossing class boundaries proved but one example of a willingness to be flexible about the usual dividing lines. For instance, Morris would show tolerance – albeit mixed with acute pain – towards Jane's extramarital affairs. He led successive campaigns against famine, poverty, and sordid public conditions, but he believed that sexual passions could never be wholly tamed, and indeed that they were an essential part of what made stories readable. A case in point is his inclusion of a fatal quarrel between love rivals in *News from Nowhere* (1890; 1891) (xvi.166): even in a utopia, he implies, love will cause interpersonal friction. Morris's fascination with the love triangle that runs through the centre of *Laxdaela Saga* is fed by similar concerns (see Chapter 6).

After abortive stints as an architectural trainee and a would-be painter, Morris's life took a practical turn when he commissioned his friend Philip Webb to build a family home at Bexleyheath, Kent (see Chapter 2). Known as 'Red House', its French-medieval styling and 'pilgrim's rest'

porch instantiate a romantic medievalism whose influence would prove far-reaching.[6] Morris's not-wholly realized idea of an artists' community of friends would be taken up more vigorously in the early twentieth century by Eric Gill and Douglas Pepler's Guild of St Dominic, and by the Bloomsbury artists in Sussex. Also implicit is an idea of integrated design, embraced later by the Arts and Crafts movement and by modernism. At Red House, built-in furniture, window seats, and fireplace surrounds evoke a holistic interior scheme. Instead of a bare structure into which furniture is subsequently intruded, we glimpse the idea of a total house. The Burne-Jones family never moved in as planned, and this put paid to the dream of an artists' community. But the firm of Morris, Marshall, Faulkner, and Company effectively 'moved out': that is, Morris and his friends went from designing furniture and painting on Kentish weekends to setting up a firm of decorators in London.

The late 1860s and early 1870s were not happy years for Morris, largely because they coincided with Jane's affair with Rossetti. But they were highly productive in literary terms: *The Life and Death of Jason* (1867), *The Earthly Paradise* (1868–70) and *Love Is Enough* (1872) were all published in this period. After the commercial failure of *The Defence of Guenevere and Other Poems* (1858), Morris was experiencing literary fame. Meanwhile, the success of his business – reconstituted as Morris & Company in 1875 – brought him the financial security that allowed him to branch out. This, too, contributed to Morris's making. Another venture grew out of his friendship with the Icelandic scholar Eiríkur Magnússon. The two men collaborated on translations of the Icelandic Sagas, and they subsequently visited Iceland together: a land whose little-changed language and topographically definite Saga-sites gave him the sense of visiting a much-storied past.[7] Its literate, proto-democratic popular consciousness stirred the beginnings of Morris's social thinking, one strand of which was cultural and humanitarian. In 1877, he founded the Society for the Protection of Ancient Buildings in opposition to destructive 'restoration' practices. In 1882, Iceland was struck by famine, and it made sense to found an Iceland Relief Fund. A political strand was initiated in 1876 when Morris joined the Eastern Question Association, a body formed in protest against Benjamin Disraeli's Turkish policy. Morris emerged in the process as a supporter of Gladstone's Liberals – a position that pulled against the Radical Toryism of Ruskinian and Carlylean aesthetic sympathies, but which reflected his social position as the educated son of a mercantile family. This period is often treated passingly as a phase, but Morris's liberalism was never entirely extinguished, as witnessed by his

enduring attachment to political individuality and his suspicion of the state's agglomerated power: May Morris recalls her father pronouncing that 'if they brigaded *him* into a regiment of workers he would just lie on his back and kick' (xvi.xxviij). But he was now in search of solutions for the divided society that pained him even as he looked out from the windows of his Hammersmith home. A more radical shaking up of conditions seemed necessary. Crossing 'the river of fire' to socialism in 1883 (*WMRR*, 244), Morris joined H. M. Hyndman's Democratic Federation (later, the Social Democratic Federation), before joining a breakaway group in 1884, named the Socialist League. Like the Protestant sects that preceded them, a tendency towards factionalism and fragmentation was built into socialist organizations of the day, and having left the SDF, Morris himself was edged out of the SL in 1890 by its anarchist wing. He was left running his local branch, renamed the Hammersmith Socialists. There is a curious re-echoing here of his experience with the decorating business, in that his ability to bankroll his enthusiasms led him increasingly towards positions of ultimate responsibility, and as such a lonely pre-eminence. But the Morris who emerged was a fundamentally changed creature: a man who travelled the country to speak at street corners; a man whose attendance at demonstrations saw him tangling with the law – albeit from his protected position as a member of the moneyed classes – and a man who had turned, as editor of *The Commonweal*, from literary publishing and calligraphic manuscript work towards the smudged fingers of a propagandistic press.

Yet Morris never gave up on imaginative literature. *Sigurd the Volsung*, his poetic reworking of *Volsunga Saga*, appeared in 1876; and in the 1880s he commenced a series of long prose romances that began with the veiled political allegories *The House of the Wolfings* (1888) and *The Roots of the Mountains* (1889), and culminated in the more explicitly political romances, *A Dream of John Ball* (1886–7; 1888) and *News from Nowhere*. The last is striking for having developed from a newspaper serial into a book belonging with the fashionable literary utopias of the period, and finally a fine-printed volume with marginal rubrication issued by the Kelmscott Press. The more mythic and referred quality of the late prose romances of the 1890s, and the demands of Morris's new typographic venture, might imply a late withdrawal from campaigning fervour, apparently corroborated by renewed closeness with Burne-Jones, who never much approved of his political activities. But while Morris encountered severe disappointment in the turn of events at the League, and while the public momentum had shifted in favour of trades unionism, parliamentarianism, and the Fabian evolutionary model, his letters reveal that he was as politically engaged in

the 1890s as ever before. The Kelmscott edition of Thomas More's *Utopia* (1893) was lively enough to cause consternation at Eton College, which having requested forty copies, 'with the intention of distributing them as prizes among the boys of the college', promptly cancelled the order on discovering its politically combustible preface (Vallance, 149).

While the foregoing biographical survey traces a chain of formative events and influences, Morris's life can be understood in some quite different, but equally revealing, ways. We might, for instance, notice a slow geographical movement from east to west, with occasional steps back and along that axis. In *A Dream of John Ball*, the narrator-protagonist reports that 'I come not from heaven, but from Essex' (xvi.222). The remark doubles as a humorous nod to Morris's own origins in the wooded countryside east of London. His education at Marlborough, his lifelong affection for Oxford, and his summer retreat at Kelmscott Manor, all worked to align him with the west. But there is a sense in which Morris remained a Londoner. Keeping this in mind, we can read the movement along the Thames Valley that he rehearses in *News from Nowhere* – from the East End to the upstream shallows of Kelmscott Manor – as a mythic search for sources and fundamentals that refuses to renounce the world downstream. Politically, one might trace a dividing line between the past-orientated medievalism of his younger years, and the stadial Marxism that informs his conception of revolution. But Morris never repudiates his early interests, and he upholds several points of continuity. From Pre-Raphaelite brotherhood and Arthurian fellowship, for instance, we are led into socialist comradeship. And one quickly appreciates that Morris's past is also Morris's future: by abstracting the Gothic as a set of principles, rather as Ruskin had done, Morris posits that the architecture of the future could be Gothic: adaptable, integrated, mindful of natural and human settings (*WMAWS*, i.266–85). These principles find their natural culmination in Morris's conception of Kelmscott Church as a capacious and unfussy meeting place for the village folk: a thoroughly medieval idea, but also one that serves socialist and Arts and Crafts notions of communal space, where the symbols of feudality are repurposed to instantiate community rather than hierarchy.

Morris Making Us

Having considered Morris's identity as a maker, and the ways in which he was himself made, we can now consider his influence on us. In the archives of the Huntington Library in San Marino, California, sits an alluring cache of letters bequeathed by the prominent collectors of Morrisiana,

Sanford and Helen Berger. There are letters by Morris himself, and from these one gathers a lot: most notably, from his self-presentation in different situations. They reveal, for instance, the vocational doubts he suffered as a young man; his gradual development of a brusque and sometime gruff business persona; and the loving, playful, and supportive form of his interactions with his daughters, Jenny and May. But sometimes we can learn as much about people from the connections that form around them as from their own words, and this is one such case. Many of the Berger letters were penned decades after Morris's death by people who knew each other because of him. Immersing oneself in this correspondence offers a signal lesson in the paths of cultural influence. Some paths are reasonably direct and public in their effects: for instance, there are letters from May Morris to prominent figures she wished to enrol in the opening of the memorial hall at Kelmscott. There are letters that illuminate forms of belatedness or historical irony: particularly striking are those written by Sydney Cockerell in the early 1960s from his home at 21 Kew Gardens Road, Richmond: an influential former director of Cambridge's Fitzwilliam Museum, Cockerell began his career in the 1890s as the secretary of Morris's Kelmscott Press, and was instrumental in stewarding its legacy after the death of its founder. In one letter he calls himself 'a survival from the 19th century with hopelessly old-fashioned ideas'.[8] There is a sense of the miraculous about this living link with Morris still holding court in a London suburb on the brink of the Beatles' first hits. And it is even more striking to read the Berger archive's pasted obituaries, one of which notes the renown of Cockerell's son Christopher as the inventor of the hovercraft (an example of Arts and Crafts futurism that exceeds even Burne-Jones's illustration of the vast wicker structure that rotates in the air in the Kelmscott Chaucer's edition of *The House of Fame* (see Chapter 14)).[9] Some forms of influence are more subtle: the letterheads change from blackletter addresses in the 1860s and 1870s to the inventive designs of the 1890s, 1910s, and 1920s, many of them registering the centrality of domestic life in Arts and Crafts culture through their rendering of the address not as information but as homeplace. The signatures, too, make playful use of letter-forms to enshrine a graphic idea of personal identity. Such details are not so remarkable in isolation, but as they emerge across a collection of letters that represents a community – a kind of diasporic Arts and Crafts community – they tell us something about the wide dispersal of Morrisian design ideals, domestic ideals, and an ideal of friendship (still commended by Cockerell from 1960s Kew). All of this speaks eloquently of Morris's endurance: less through books and reading lists than through human lives.

And of course we can point to more familiar forms of influence. Morris's stock never declined so precipitously in the early twentieth century as that of Carlyle and Ruskin, with whom he is nevertheless linked. Certainly, the Arts and Crafts movement waned, and his longer poems fell out of fashion with the modernist turn towards concision and concretion. The pastoralism of his utopian visions also sat uneasily with the turn towards industrial agriculture and mass production after the Second World War. But Morris lingered in people's homes, and therefore in their hearts: his brilliance as a designer of pattern clung to domestic walls across the country's university suburbs, and although his brand of socialism fell out of favour with the advent of statist and parliamentary approaches, a folk memory of him as standing for the people guaranteed a place in the public mind. Among intellectuals, too, he retained an appeal. Ezra Pound may have had little time for *The Earthly Paradise*, but he cherished the vivid experimentalism of *The Defence of Guenevere and Other Poems*, and he found curious uses (and abuses) for his name amidst the diatribe of his 1940s propaganda broadcasts.[10] By the 1960s, Morris's stock was again on the rise. George Harrison's tailored jacket made from Morris's Golden Lily fabric (the Granny Takes a Trip boutique) put a further spin on the role of Victoriana in the decade's counterculture. A more suburban form of revival arrived in the 1970s via Laura Ashley floral domestic prints. Even in the 1980s – an era more obviously given to plastic futurism and financial hedonism, we find the artist and director Derek Jarman approving attempts to 'fuse … art and life' in his diary, with 'Blake and William Morris' among those who 'look backward over their shoulders – to a Paradise on earth'.[11] A new phase of interest commenced in 1996, with a successful V&A exhibition, and a major biography by Fiona MacCarthy. Morris had a genius for pattern-design, but the sheer range and reach of his achievement came back into view. His appeal has been bolstered further by political and social events that speak directly to his legacy, imbuing a Victorian voice with unexpected freshness. As a critic of capitalism, Morris's thinking has thrived in these years of financial crisis; as a theorist of work and craftsmanship, his legacy interacts with a more recent ethics of making that questions the values of 'off-shored' production; and as a protector of landscape and buildings Morris strikes a chord in an age of environmental crisis. The revival continues, witnessed by a robust spike in publications that began shortly after the millennium and which shows no sign of abating.

The Cambridge Companion to William Morris draws together many of the voices who have participated in this critical, political, and curatorial

resurgence. It reveals the breadth and contemporary resonance of Morris's legacy, but also sets him in his context. As such, it confounds the 'false friends' of hasty historical reception and reveals unexpected connections. It is striking, for instance, to find Martin Dubois tracing an echoed phrase from one of Morris's early poems – 'The Haystack in the Floods' – in Virginia Woolf's report on the aftermath of a bombing raid in the 1940s (Chapter 5). Elizabeth Carolyn Miller traces a quite different set of connections through the production history of the Kelmscott Press's red ink, and the far-flung sites of cinnabar extraction upon which it relied (Chapter 18). One of the unmistakable challenges of assembling a volume of this kind arises from the sheer range and reach of Morris's activity. It would not be possible to represent every aspect of his extraordinary output, but this volume identifies staging-posts that should help readers discern the shape of his achievement, while providing the tools and resources needed to find out more.

Part I, on 'Senses of Place', responds to Morris's almost spiritual sense of the resonant location, whether it be a house, a city, the path of a river or a whole landscape. Morris invested a lot of intellectual capital in the idea of fellowship and society, but he was also a loner. He liked nothing more than a solitary fishing trip. Perhaps he invested so much value in buildings and landscapes because he found people difficult, and perhaps, ultimately, that is a fault. But, as the chapters here reveal, the value that Morris invests in place is overdetermined precisely because it is an avowedly human significance that he finds there. Part II, on 'Authorship', records Morris's trajectory as a writer, from the condensed, surreal, and Browningesque language of *The Defence of Guenevere and Other Poems*, through the long story cycles and Norse epics of his mid-career, to the innovations of his political journalism, his lectures on socialism and on art, and his long prose romances. It also records an unusually dynamic relationship with literary genre: as with other aspects of his revivalism, Morris's preoccupation with the romance is never simply a reversion to a pre-modern form. His engagements with it make something new from old materials, and through the emergence of fresh expressive possibilities – notably, via the surreal, sensory, and somatic early poetry that inspired the modernists, and the later emergence of the fantasy genre – he practises a kind of experimentalism. Part III attends to Morris's relationship with 'The Practical Arts'. Evidently, this subject and its relationship to Morris & Company could fill many volumes in its own right. So the approach is to demonstrate intersections with the broadly literary focus of this series. Three key ideas emerge: decoration, pattern, and technology. In each case, a Morrisian concern with surface and visual effects adds an extra dimension to the

Ruskinian idea of deep structure. Part IV, on 'Movements and Causes', disentangles the intellectual history of Morris's alignment with such movements as socialism, and his contested engagement with incipient cultural developments such as the Arts and Crafts movement, feminism, and environmentalism. The volume's last part, Part V, provides an opportunity to survey the influence on Morris of key figures – notably Ruskin and Marx, and their respective brands of social analysis – and the ways in which he nevertheless inflects their influences in bestowing varied legacies across the long period since his death.

Notes

1 Quoted from Mackail Notebooks (MacCarthy, viii).
2 For further discussion, see Marcus Waithe, *The Work of Words: Literature, Craft and the Labour of Mind in Britain, 1830–1940* (Edinburgh: Edinburgh University Press, 2023), 117–35.
3 'William Morris; Prime Minister's Tribute; Memorial Hall Opened by Mr. G. B. Shaw', *The Times*, 22 October 1934.
4 Charles Harvey and Jon Press, *William Morris: Design and Enterprise in Victorian Britain* (Manchester: Manchester University Press, 1991), 221.
5 Alice Chandler, *A Dream of Order: The Medieval Ideal in Nineteenth-Century Literature* (London: Routledge & Kegan Paul, 1971).
6 See Marcus Waithe, 'The Stranger at the Gate: Privacy, Property, and the Structures of Welcome at William Morris's Red House', *Victorian Studies*, 46.4 (2004), 567–95.
7 See Lavinia Greenlaw, *Questions of Travel: William Morris in Iceland* (London: Notting Hill Editions, 2011); and Waithe, *William Morris's Utopia of Strangers: Victorian Medievalism and the Ideal of Hospitality* (Cambridge: Boydell & Brewer, 2006), 73–90.
8 Sydney Cockerell, 'To Muriel J. Hughes', 9 October 1959; Sanford L. Berger Papers, Huntington Library, San Marino.
9 Obituary, 'Sir Sydney Cockerell: Link with Art and Letters', 2 May 1962, Sanford L. Berger Papers; Geoffrey Chaucer, 'The House of Fame', *The Works of Geoffrey Chaucer* (Hammersmith: Kelmscott Press, 1896), 466.
10 Ezra Pound, 'How Come' (10 July 1942), in Leonard W. Doob (ed.), *'Ezra Pound Speaking': Radio Speeches of World War II* (Westport, CT: Greenwood Press, 1978), 195–7 (197). See Waithe, *The Work of Works*, 218.
11 Derek Jarman, '28 February 1989', in *Modern Nature: The Journals of Derek Jarman* (London: Vintage, 1992), 25.

PART I

Senses of Place

Oxford

Tony Pinkney

Oxford – and by that name I mean both city and university – is a place formative enough to hold great tracts of William Morris's life together. This is certainly true in a chronological sense: he took his matriculation exam for Exeter College in June 1852, at the age of eighteen, and he gave one of his very last political lectures at the Central School, Gloucester Green, Oxford in late October 1895, at the age of sixty-one (he died a year later). It is true in a spatial sense too: Morris's country retreat, Kelmscott Manor, which he first rented with Dante Gabriel Rossetti in June 1871, was only seventeen miles from Oxford – cycling distance for some of Morris's younger friends. Morris and his family would regularly pass through the university city on their way to and from Kelmscott, including twice by river rather than by rail. Decades later, in 1938, his daughter May attempted to formalize this spatial relationship by leaving Kelmscott Manor in trust to Oxford University.

But most importantly, Oxford brings Morris's life together ideologically, yoking his early undergraduate enthusiasms to the communism he promoted so energetically in his later years. It is no accident that his utopians pass through Oxford in the river journey of *News from Nowhere* (1890; 1891); for, as Malcolm Kelsall puts it, 'This communist future is founded on an intense nostalgia for an ideal past, as though all England were collegiate Oxford.'[1] We might want to probe the term 'nostalgia' in Kelsall's formulation, but the link he rightly observes here between Oxford and Morrisian communism is deep indeed. Given its twentieth-century history, 'communism' remains a provocative word to use in relation to Morris, though it was one that he often employed himself; indeed, in George Bernard Shaw's view, it was for Morris 'the essential term, etymologically, historically, and artistically … the only word he was comfortable with' (*WMAWS*, ii.ix).

What was it about Oxford, then, as both city and university, which in part prompted the radical political commitments of Morris's maturity?

One thing we can be sure of is that it was not the official teaching of the university, as he encountered it after going into residence at Exeter College to study theology in January 1853. The grindingly philological approach that Oxford tutors took to the classics swiftly destroyed whatever idealism undergraduates brought from school to the university. We have the testimony of J. W. Mackail, Edward Burne-Jones's son-in-law and Morris's first biographer, that 'to the end of his life the educational system and the intellectual life of modern Oxford were matters as to which he remained bitterly prejudiced, and the name of "Don" was used by him as a synonym for all that was narrow, ignorant, and pedantic'. Or, as Burne-Jones himself memorably put it, the two alienated undergraduates 'went angry walks [*sic*] together every afternoon' (Mackail, i.34–5).

Friendship rather than teaching, contemporaries rather than elders, proved decisive in Morris's experience of Oxford. He met Burne-Jones in his very first days at the university and the two Exeter men then gravitated towards a group of Burne-Jones's Birmingham acquaintances: William Fulford, Charles Faulkner, and Richard Dixon at Pembroke College, and later Cormell Price at Brasenose. If Morris and Burne-Jones strongly reinforced each other's incipient artistic interests, the other Birmingham men opened Morris's eyes to a wider social canvas. Brought up in one of Victorian England's major industrial cities, they were alert to issues of widespread poverty, sanitation, and Factory Acts, in a way that the more socially privileged Morris could never have been. The Crimean War of 1853–6 and the cholera epidemic of 1854, which for a while prevented Morris and Burne-Jones returning to university, surely broadened their thinking too.

Morris's social horizons were also extended by his friendship with Archibald MacLaren and his family in Summertown, a mile or so up Oxford's Banbury Road. We must forget the portly image of Morris, which we have from his mature years, and visualize a slim, energetic figure who trained regularly at MacLaren's gymnasium in Oriel Lane. Morris was a particularly vigorous proponent of singlestick – England's native martial art – hammering his opponents in a bruising and brutal manner. So it may be that this Oxford experience contributes to Morris's later ideals of combat. For the youthful Morris in MacLaren's gym, we can rewrite Descartes's *cogito* as 'I fight, therefore I am.'

Ideas of male brotherhood were strongly in the air among Morris's university friends and the notion of an intense and self-contained monastic male community could quickly open out towards the wider society, towards a more campaigning model of fraternity that anticipates Morris's

attraction to the small socialist parties of the 1880s. 'I have set my heart on our founding a Brotherhood. Learn "Sir Galahad" by heart', wrote Burne-Jones to Cormell Price in May 1853; and the reference to the Tennyson poem here shows that at this point the utopian ideal is still conceived in terms of religion and chastity. But when he wrote again, a few months later, 'We must enlist you in this Crusade and Holy Warfare against the age' (Mackail, i.63), we can sense an opening out to wider social purposes, and even something of the militancy that Morris would find again in the socialist movement of the 1880s.

If Oxford's official teaching did not contribute much to this sense of a 'crusade', the unofficial reading that Morris and his Pembroke friends were doing proved decisive. A heady mix of Thomas Carlyle, Charles Kingsley, John Ruskin, and Alfred Tennyson all fed into a developing critique of the narrowly acquisitive values of mainstream Victorian society. Probably the decisive text here was Ruskin's chapter 'The Nature of Gothic', in which the supposedly non-alienated creative labour of the medieval craftsman becomes the standard for a withering critique of the repressive inhumanity of Victorian capitalism; Morris would later celebrate this text as 'one of the very few necessary and inevitable utterances of the century', and he published a version of it from his own Kelmscott Press in 1892 (*WMAWS*, i.292). In January 1856 Morris and his allies, with one or two Cambridge recruits enlisted too, launched the short-lived *Oxford and Cambridge Magazine* to give their emergent crusade a medium and focus; and it was here that his first poems and short stories began to appear. It is worth noting that in the April issue the journal published an article entitled 'Oxford', which surveyed the history of the university, criticized its dysfunctional nature in the present, and concluded with both practical suggestions for reform and a brief utopian vision of a transfigured future Oxford.

Ruskin's 'The Nature of Gothic' comes from a larger work entitled *The Stones of Venice* (1851–3), and, more locally, Morris was certainly paying plenty of attention to the stones of Oxford. Nothing impinged on him so deeply during his undergraduate years as the physical ambience of the place. The architecture around him was at least as formative as the intellectual influences he was imbibing, and indeed through the figure of Ruskin they deeply reinforced each other. In his 1886 lecture 'The Aims of Art', Morris reflected back on his undergraduate holiday in northern France in the summer of 1854. It involved a visit to Rouen, 'then still in its outward aspect a piece of the Middle Ages', which he described as 'the greatest pleasure I have ever had'; and this exposure to French medieval architecture seems to have sharpened his sense of Oxford:

At that time I was an undergraduate of Oxford. Though not so astounding, so romantic, or at first sight so medieval as the Norman city, Oxford in those days still kept a great deal of its earlier loveliness: and the memory of its grey streets as they then were has been an abiding influence and pleasure in my life … a matter of far more importance than the so-called learning of the place. (xxiii.85)

On those 'angry walks' that Morris and Burne-Jones took together through Oxford, they had their sacred places in which, presumably, their anger with official Oxford could cool off. These included Merton College Chapel and the cloisters of New College (where Philip Webb much later wanted to have his ashes scattered). In later life Morris often insisted that it was not only the Oxford colleges that constituted the city's architectural glory, but its domestic vernacular buildings too. As a fine example of this, he would cite the houses of Holywell Street, which had always been an important venue for him. In an 1885 letter to the *Daily News* he spoke out on behalf of 'the little plaster houses in front of Trinity College or the beautiful houses left on the north side of Holywell Street. These are in their way as important as the more majestic buildings to which all the world makes pilgrimage' (*CL*, ii.493). In the Holywell Music Room Morris in his undergraduate days had practised Plain Song with Burne-Jones and attended meetings of the Oxford Architectural Society. In February 1885 he lectured on socialism in the building, with Edward Aveling and Eleanor Marx, to a rowdy audience of undergraduates, some of whom eventually disrupted the meeting by letting off a stink bomb.

Just opposite the Music Room is one of the most decisive sites of all for William Morris in Oxford: St Helen's Passage, where his future wife Jane Burden was born in an insanitary cottage in 1839. Her father, Robert Burden, worked as an ostler in Symonds's Livery Stable in Holywell Street. Morris's cross-class marriage to Jane in St Michael's Church, Oxford on 26 April 1859 was undoubtedly one of the most radical gestures of his life. In metaphorically crossing Holywell Street, from the Music Room he had frequented as a wealthy student to St Helen's Passage, where the Burdens had lived, Morris truly was 'crossing a river of fire', to use the image he later evoked for middle-class people who embraced the revolutionary socialist cause (xxii.131). Though Jane Morris in many ways later disowned her early working-class roots, we should note that Oxford remained important to her too. 'I had thought Oxford as an appropriate place for my belongings', she wrote to Sydney Carlyle Cockerell in June 1898.[2]

In January 1856 Oxford's medieval architecture, till then just an aesthetic passion and cultural influence, materialized itself as an actual career path for

the young Morris, for he articled himself to the Gothic revivalist architect G. E. Street, whose office was then in Beaumont Street, Oxford (though he would soon move to London, and Morris with him). At Street's he met another friend-of-a-lifetime, the Oxford-born architect Philip Webb who, like Charles Faulkner, would enthusiastically embrace socialism with Morris in the 1880s. The notion of a crusading male Oxford community reformed itself in a new way in the summer of 1857 when, under the leadership of Rossetti, Morris, Burne-Jones, and other friends worked on the decoration of the upper walls and roof of the Oxford Union Debating Hall. Morris soon abandoned architecture as a career, but not as a passion and a project. He founded the Society for the Protection of Ancient Buildings (SPAB) in March 1877, and endangered Oxford architecture would always thereafter have a key claim on his and SPAB's attention and resources. Morris's two most notable Oxford campaigns were in defence of Magdalen Bridge in 1881, when it was threatened with being widened, and of the crumbling statues at the top of St Mary's Church in 1893, when they were about to be replaced with modern stonework – or counterfeits, in Morris's uncompromising view. On this occasion he even climbed to the top of St Mary's with the architect Thomas Jackson to argue the issue, thereby enjoying possibly the first aerial view of his alma mater that he had ever had (at least, we don't hear of any earlier one). In both cases, however, Morris and SPAB's defence of the original features failed, and the changes they deplored went ahead.

Oxford's medievalism was not just a matter of the physical environment of the place, its grey streets, and its grey stones; it also inhered in the cultural treasures that some of these buildings contained. The Bodleian Library was of central importance to Morris here, and like so many other aspects of Oxford it establishes a strong thread of continuity across his life. Mackail has emphasized Morris's undergraduate 'study of medieval design and colouring in the painted manuscripts displayed in the Bodleian. One of these, a splendid Apocalypse of the thirteenth century, became his ideal book. Forty years later he went to Oxford to spend a day studying it' (Mackail, i.40). That later visit was actually on 28 November 1894, and Morris and Emery Walker travelled up to Oxford together, not just to disinterestedly admire the artistry of the *Douce Apocalypse*, but because they had a plan to produce a Kelmscott Press facsimile of it. Sadly, this project did not materialize. Morris's early Oxford experiences of medieval manuscript decoration in the Bodleian clearly played a role in his radical rethinking of all aspects of book production in the Kelmscott Press nearly forty years later.

Indeed, Morris seems over the decades to have had a need to regularly expose himself to the treasures of the Bodleian, as if to re-energize a medievalism that might grow dim without that recurrent contact. Thus, for instance, Mackail notes that 'his old fellow-pupil, Mr Bliss … met him in the Bodleian Library' (Mackail, i.293) at some point in the early 1870s; and he was there again, with Henry Hyndman, in late January 1884, in the wake of their political talk at the Clarendon Assembly Rooms the day before.[3] On this occasion the head librarian opportunistically seized on Morris to identify and date a set of illuminated medieval missals that the library had just purchased.

We ought not to ignore the beauty of Oxford's natural setting in thinking through its impact on the youthful William Morris and his friends. Burne-Jones would devote hours to sketching in Bagley Wood, and much time was spent, particularly by Morris and Faulkner, on the upper river. Aymer Vallance gives a fine account of how Oxford's natural beauty fed into Morris's later decorative work:

> Nor did the associations of his Oxford days fail to impress themselves upon Morris's art. Thus he made frequent use of the fritillary – or snake's-head, as it is popularly called – whose chequered purplish head is one of the characteristic sights in the grass-fields by the river-side, particularly at Iffley. Another favourite form of his was the long and slender spike of the wild tulip, which, as Morris must have been aware, although it is not proved that he ever saw it flowering there in his time, grew in the meadow bordering on the Cherwell, to the south of the Botanical Gardens at Oxford. (Vallance, 132–3)

The young Canadian poet Arthur Stringer gives us a memorable later vignette:

> I can remember … one bright morning on the High, in Oxford, as he [Morris] walked with his short, quick, stocky steps out across Magdalen Bridge, and let his eyes wander musingly along the waters of the Cherwell. He suddenly drew in a great breath of air, scented with the smell of flowers from the Botanical Garden, and gasped out: 'My eyes, how good it all is!'[4]

But we must think of the beauty of the city in a more structural sense too, not as just providing one or two local decorative motifs.

The origin of the utopianism that finds its full-fledged expression in *News from Nowhere* has often been traced to a speculation of Morris's in an 1874 letter to Louisa Baldwin:

> suppose people lived in little communities among gardens & green fields, so that you could be in the country in 5 minutes walk, & had few wants;

almost no furniture for instance, & no servants, & studied (the difficult) arts of enjoying life, & finding out what they really wanted: then I think one might hope that civilization had really begun. (CL, i.218)

It may well be that this image of communal life in the midst of nature has Oxford behind it as an inspirational image. To anyone who only knows the ugly, shapeless sprawl of latter-day Oxford, that may seem unlikely enough, so we need Mackail to take us back to the early 1850s:

> still in all its main aspect a medieval city … The railway was there, but had not yet produced its far-reaching effects … Children gathered violets on the Iffley Road within sight of Magdalen … beyond the grey walls of St. John's and Wadham all was unbroken country, and the large residential suburb and the immense pleasure ground that take their name from Fairfax's artillery parks were meadows and market gardens. (Mackail, i.28–30)

How do we move, then, from Oxford medievalism to Morris's communism of the 1880s and 1890s? As many commentators have shown, Morris's socialism is a rich, complex amalgam of John Ruskin and Karl Marx, which means that the reference back to a lost medieval past is as powerful within it as the vision of a new proletarian culture on the other side of working-class activism and revolution in the present. Indeed, proletarian revolution will, in Morris's view, reinstate the lost virtues of the Gothic age – pleasurable and creative work, richly inventive architecture, and so on – at a higher level of historical development, in a benign spiral upwards. Oxford, therefore, being the richest embodiment of medievalism in England, remains a crucial reference point for and impetus towards Morris's goal of communism. It is accordingly no surprise that his lecture on 'Art and Democracy' on 14 November 1883 at University College, Oxford, was a public avowal of socialism whose location had immense symbolic import. Morris returns repeatedly to the city itself in that lecture; for his subject – human dealings with the earth – is 'a solemn one when it is asked here in Oxford, amidst sights and memories which we older men at least regard with nothing short of love'.[5] And he famously (or notoriously) closed the lecture by declaring himself the agent of a socialist party and asking for funds for it – a gesture which seems to have caused a minor sensation among his middle-class academic audience. To the inherent symbolic value of this event, a great deal of subsequent mythology has attached itself, such as the idea that John Ruskin was in the chair for this lecture (he was there, but not in the chair).

Amy Morant gives us a memorable vignette of Morris's university campaigning when she evokes 'the strange days of the first Socialist mission to Oxford, when that giant fell among pigmies, and of that unwonted figure stamping about the pavement in unmeasured vituperation and unmitigated wrath, with my brother and two others as his bodyguard, before some more than ordinary barbaric piece of modern academic architecture'.[6] Her brother was Robert Laurie Morant (1863–1920), later a civil servant and educational reformer; he had been an undergraduate at New College. Amy Morant's term 'bodyguard' surely gives us pause here: had Morris really been considered to be in physical danger from political opponents when propounding socialism in Oxford? Those enemies may have hooted and jeered in meetings, and even occasionally let off stink bombs, but did they really constitute a physical threat to the speaker? And the violence here actually seems to be more on Morris's own part, as he wrathfully stamps about the pavement, as if it is almost Oxford's unattractive modern buildings that need bodyguards against *him*.

Morris lectured six times in Oxford on socialism, sometimes alone, sometimes with other London comrades, initially for the Democratic Federation, subsequently for his own Socialist League. Some of these lectures took place in university buildings and were aimed at a student audience – as if Morris wanted to intellectually capture idealistic young men such as he and Burne-Jones had been thirty years earlier – while others took place at public venues, such as the Central School in Gloucester Green, and sought to reach a socially more diverse audience. A central point of continuity here, reaching right back to Morris's own undergraduate days, was the presence and support of Charles Faulkner. He was now mathematics tutor at University College, he passionately took up the socialist cause at Morris's behest, and was the key figure in making the Oxford branch of the Socialist League a lively local organization for a few years. Faulkner's illness in 1888, followed by his death in 1892, was a grave personal and political blow to Morris, and must have felt like an important severing of some precious early Oxford links.[7]

To conclude this meditation on the role of Oxford in Morris's life and thought, I want to look at its presence in his literary work, above all in *News from Nowhere*. But we should note first that the time-travelling narrator of *A Dream of John Ball* (1886–7; 1888), a prose romance set in the fields of Kent during the Peasants' Revolt of 1381, has strong hankerings after the city. For when Will Green asks him, 'Hast thou seen Oxford, scholar?', he formulates one of Morris's most famous evocations of the city: 'a vision of grey-roofed houses and a long winding street and the sound of many

bells' (xvi.223). That winding street is presumably Oxford's High Street – Arthur Stringer's 'The High', in the local argot – which Nikolaus Pevsner would later describe as 'one of the world's greatest streets'.[8]

Let us turn, then, to what is by common consent Morris's finest literary work, his utopia *News from Nowhere*. At the start of this chapter I cited Malcolm Kelsall's observation that in 'this communist future' it is 'as though all England were collegiate Oxford'. Jeffrey L. Spear has made a similar, though more local, claim when he notes that Morris places the 'great rebellion' or civil war which brings a communist England into being 'on the centenary of his Oxford matriculation', the dates in question being 1852 and 1952.[9] We now need to follow such insights through more systematically.

Morris's narrator William Guest seems as alienated from the Socialist League meeting on the first page of *News from Nowhere* as the young Morris and Burne-Jones were from official Oxford teaching in the early 1850s; and afterwards he goes home angrily on the underground railway just as they went for 'angry walks' around Oxford every afternoon. The narrator's alienation manifests itself subjectively as silence followed by a wrathful outburst during the socialist debate, and then, objectively, by the journey back out to the western suburb he lives in. This return trip marks him out as a middle-class socialist, inhabiting the leafy suburbs rather than an inner-city room or flat; and we can go on to specify the variety of bourgeois education he has received, since his Oxford provenance comes out clearly in the imagery through which he processes unfamiliar details of the utopian London he encounters early in the book. At breakfast in the Hammersmith Guest House he notes the inscription on the panelling 'behind what we should have called the High Table in an Oxford college hall' (xvi.15); and when he and Dick Hammond happen upon the road-mending team on their trip across London, Guest reflects that they looked 'much like a boating party at Oxford would have looked like in the days I remembered' (xvi.47).

Let us try to imagine a first-time reading of Morris's utopia where, as William Guest, Dick, and Clara set off by boat from Hammersmith Guest House, we are not yet sure of what the final destination of their river journey may be. The only critic I know who has ventured at all in this hermeneutic direction is Norman Talbot, who observes that 'we feel certain the destination must be either Oxford or his beloved Kelmscott'.[10] Let us suppose, as a thought experiment, that it is indeed Oxford, that Morris's characters disembark in the university city and do not travel further upriver.

In the book as it stands, 'Sunset was in the sky as we skirted Oxford by Oseney; we stopped a minute or two hard by the ancient castle to put Henry Morsom ashore. It was a matter of course that as far as they could be seen from the river, I missed none of the towers and spires of that once don-bedridden city' (xvi.185). Then Guest, Dick, Clara, and Ellen pass through Medley Lock and row past Port Meadow, with Guest reflecting 'how its name and use had survived from the older imperfect communal period, through the time of the confused struggle and tyranny of the rights of property, into the present rest and happiness of complete Communism' (xvi.186). Morsom leaves the river journey in Oxford because he wants to get a book or two out of the Bodleian Library, and the fact that the Bodleian is now a lending rather than a reference library is about as much detail as Morris's utopia gives us as to how a communist Oxford would function. But Morsom had earlier said to his fellow travellers: 'I suppose you will sleep in the old city?' (xvi.180). Let us suppose that they do so, and then, moved by what they have seen there, decide to stay.

Would *News from Nowhere* be a better utopia if it had ended in Oxford, a place, we must suppose, of continuing mental energy rather than of the harvest work of Kelmscott itself? Morris would then have had the chance to show us in detail what a utopian socialist university looks like, just as Ernest Callenbach sketches the lineaments of an ecological research institute in his *Ecotopia* of 1975. We might have met some of the scientists who had developed those enigmatic but technologically advanced 'force-vehicles' (xvi.162) that Guest and his fellow travellers have seen on the Thames. A post-revolutionary Oxford might have suited Ellen nicely, given her own intellectual liveliness and her taste for long historical perspectives. She might successfully have reintegrated herself into Nowherian life here, after the spell of isolation with her grandfather at Runnymede.

We may even speculate as to whether the time-travelling William Guest might not have been able to remain in utopia if the book had ended in Oxford rather than Kelmscott. Might not the transfigured university have afforded him the chance of becoming a lecturer in history in the way that Edward Bellamy's narrator Julian West does in *Looking Backward* (1888), where he ends up teaching in the Historical Section of Shawmutt College in the future Boston of that socialist utopia? Ellen notes that Guest is too wrapped up in his endless past–present contrast to fully belong to the younger utopians in the Kelmscott fields, but this absorption might have been the very quality that would make him a vividly first-hand history lecturer at Oxford University, if the book had closed there. Indeed, the

benefits of ending in Oxford might have been felt not just by Guest, but by *News from Nowhere* itself. For one recurrent objection to Morris's utopia is that it is excessively pastoral, too placid and idyllic, too dismissive of intellectual debate and scientific innovation. To have closed in a university city rather than among the fields of Kelmscott would have made that charge against the book much harder to sustain.

Perhaps, then, given the centrality of Oxford to Morris's life which I have sought to demonstrate in this chapter, and above all to his distinctive brand of communism, the question we should finally be asking about his utopia is: why does *News from Nowhere* not end in Oxford, why do the travellers merely pass through it on their way to Kelmscott? Was a utopian elaboration of the city and university in the end too difficult for Morris because of an Oxford I have *not* focused on in this essay, the official Oxford that he hated and in the end, alas, could not ignore? Any study of Morris and Oxford has, I think, to end on a sour note, as did Morris's own relationship to the city, at least according to his friend and publisher F. S. Ellis: 'In his later years, Morris would earnestly deplore the ruthless spirit of change which had robbed Oxford of the charm it once had for him, and it was with difficulty that he could be persuaded to go thither.'[11]

Notes

1 Malcolm Kelsall, *The Great Good Place: The Country House and English Literature* (New York: Columbia University Press, 1993), 140.

2 *The Collected Letters of Jane Morris*, eds Frank C. Sharp and Jan Marsh (Woodbridge: The Boydell Press, 2012), 343.

3 It may be worth noting that, though Cambridge-educated himself, Henry Hyndman had significant Oxford connections too. As he notes in his *The Record of an Adventurous Life*, 'One of my brothers having been at Magdalen College, Oxford, and my other brother at St. John's I knew Oxford almost as well as I knew Cambridge' (London: Macmillan, 1911), 24.

4 Arthur Stringer, 'William Morris as I Remember Him', *Craftsman*, 4/2 (May 1903), 128.

5 William Morris, 'Art and Democracy', cited in Tony Pinkney, *William Morris in Oxford: The Campaigning Years* (Grosmont: Illuminati Books, 2007), 58–9.

6 Amy C. Morant, 'William Morris: In Memoriam', *Journal of the William Morris Society*, XVII/1 (Winter 2006), 45.

7 See Florence S. Boos, 'Morris's Truest Follower: Charles J. Faulkner', *William Morris Society in the United States Newsletter* (June 2014), 18–21.

8 Pevsner's remark is ubiquitously quoted in Oxford guidebooks. I take it from *Insight Guide Oxford*, eds Brian Bell (Singapore: Apa Publications GmbH & Co, 2006), 95.

9 Jeffrey L. Spear, *Dreams of an English Eden: Ruskin and His Tradition in Social Criticism* (New York: Columbia University Press, 1984), 231.

10 Norman Talbot, 'A Guest in the Future', in Florence S. Boos and Carole G. Silver (eds), *Socialism and the Literary Artistry of William Morris* (Columbia: University of Missouri Press, 1990), 45.

11 F. S. Ellis, 'The Life-Work of William Morris', *Journal of the Society of Arts*, 46/2375 (27 May 1898), 620.

Red House

Tessa Wild

I got a friend to build me a house very Mediaeval in spirit in which I lived for five years, and set myself to decorating it; we found, I and my friend the architect especially, that all the minor arts were in a state of complete degradation, especially in England.
 William Morris to Andreas Scheu, 15 September 1883 (CL, ii.228)

William Morris spent the summer of 1857 decorating the Debating Chamber of the newly erected Oxford Union with fellow artists including Dante Gabriel Rossetti and Edward Burne-Jones. This 'professional' work gave him a tangible sense of the pleasure to be found in painted schemes derived from literary sources and taught him the practicalities of building up colour and forming patterns. It was a critical moment in his artistic education and from it he developed a surer practical skill, a profound sense of the joy of shared labour and a desire to emulate the spirit of the enterprise on his own terms. That summer he also fell deeply in love with Jane Burden. Their engagement the following spring gave Morris the spur to create his long-hoped for 'Palace of Art', and he asked Philip Webb to design a house that he would decorate in his own taste.[1] Morris and Webb had met in George Edmund Street's Oxford office in 1856, when Morris began his short-lived architectural training before deciding to pursue a career as an artist. Their shared passion for vernacular buildings, the English countryside and its craft traditions led to a vital friendship and a working partnership that would endure for the rest of their lives.

Red House was the only house Morris ever commissioned and owned and was Webb's first independent work. Creating a house and garden presented an unrivalled opportunity for them – both individually and collaboratively – to give physical expression to their burgeoning architectural and artistic talents and myriad ideas about art and life. Whilst travelling in France in the summer of 1858, Webb made 'a hurried sketch … the first idea for the staircase projection at Red House' on the back of a

map in Morris's guidebook to France and thoughts of the new house were uppermost in their minds.[2] That autumn, they found an acre of orchard in the hamlet of Upton near Bexleyheath, Kent. The gently undulating Kentish landscape and the Chaucerian resonances of nearby Watling Street – the road medieval pilgrims walked to Canterbury Cathedral – had the attraction of being both rural and yet within reach of London by train from Abbey Wood station (Vallance, 43).

From the outset, Webb envisaged the house as integral to its setting and sought to ameliorate any rawness by specifying pear trees and climbing roses, jasmine, and passion flowers against the walls, so that the garden clothed the house. Webb's notebooks and drawings reveal that he devised a scheme that placed the house centrally to preserve the majority of the trees on site. He looked at local buildings as exemplars for materials and stylistic details and drew on the domestic and school buildings he admired by his former master Street and fellow architect William Butterfield in his design process. By July, designs for the house, stable, entrance gates, and conical-roofed well – suggestive of Kentish oast houses – were complete.[3]

Webb purposefully avoided polychromy and stone detailing, ensuring that the simplicity of the brick elevations possessed the unadorned quality he and Morris admired. He brought movement and vitality to the whole composition with sweeping tile-hung roofs, a stair tower, and the interplay of gothic-headed sash, lancet, and casement windows. There is a clearly expressed hierarchical distinction of spaces and functions within, with sash windows signifying principal rooms and leaded lights indicating passages and service areas.

The main entrance faces north and is approached directly from Upton Lane but shielded from it by a high red brick wall. The house is designed in an L-shape, with two wings meeting in a well-lit central staircase hall. The ground-floor accommodation comprises the entrance porch, a 'living' hall, dining room, waiting room, bedroom, a passage leading to the garden porch and a door at the rear of the hall separating the family accommodation from the service areas.[4] The oak stair rises through three sides of a square, with a half-landing giving onto a passage leading to two west-facing bedrooms overlooking the bowling green. At the head of the stair lies the drawing room, landing, main bedroom with adjoining dressing room, upper passage, and study. To optimize the light and views across the surrounding countryside, Webb placed the drawing room and the study (studio), in which he anticipated Morris would paint, on the first floor. Each wing is one-room deep, with wide passages on both floors overlooking the well and garden to the west and south.

Internally, Webb employed a distinct repertoire of details with patterned red brick fireplaces; exposed lintels to doors; a canted cornice detail to ground-floor ceilings and dramatic sloping ceilings on the first floor. One unusual element of Webb's building contract is his direction to the plasterer to 'provide stamps of 3 different patterns [to] stamp the ceilings with the Same' by pressing a patterned tool into the damp plaster.[5] This gave a grid of stamped holes, enabling three painted patterns of Morris's bold, repeating designs to be readily executed as the first element of the interior decoration.

Whilst awaiting completion of the building, Morris and Jane moved to Upton and rented the neighbouring villa, Aberleigh Lodge. Morris's impatience to take possession and begin work on the interior must have been palpable. In his deliberations about the appearance of the house and the detailed narratives he wished to convey, he drew on the eclectic visual and literary memory he had amassed since childhood. The vast lexicon of influences from which he derived inspiration included Arthurian romances, illuminated manuscripts, Chaucer's tales, details of cathedrals and churches, the Bayeux Tapestry, Pre-Raphaelite art and medieval stained glass.

When Morris and Jane moved in, in late summer 1860, he was an ebullient young man of twenty-six, a graduate of Exeter College, Oxford, newly married, independently wealthy, part-trained as an architect, a published poet, and an aspirant artist. The long-planned 'jovial campaign' of decorating and furnishing the house and of making it a home demanded his immediate attention. Within days, the Burne-Joneses arrived for an extended stay of several months. Webb ensured the stamped ceilings were ready for painting by specifying that two coats of whitewash were applied as a ground for Morris's intricate pattern-making. Charles Faulkner (an Oxford contemporary and mathematician), Webb, Rossetti, and Elizabeth Siddal all visited and contributed to the decoration as often as time would allow. Intense periods of work were punctuated by forays into the surrounding countryside, hearty meals, games of bowls, apple fights, and schoolboy pranks.

Morris's deeply personal and highly expressive unified vision of house, contents, decoration, and garden, was to come to fruition during the five short, but highly industrious and creatively charged, years he spent living there. His friends – artists and amateurs – worked together to create a place of extraordinary character, redolent with meaning. This was the moment in the lives of Morris and Jane, Webb, Georgiana and Edward Burne-Jones, Rossetti, Elizabeth Siddal, and Faulkner when they were establishing their own personal paths as artists, writers, architect, and designer. It was a time

of youthful exuberance and opportunity, great personal happiness and devastating loss. Red House encapsulates these hopes and aspirations, for it was born of optimism and creativity and the desire of each member of the group to contribute his or her own artistry to the greater work of art and the happy home.

Although the house and garden have survived remarkably intact there have been many owners since 1865 and changing tastes and fashions have eroded Morris's original vision. It now takes a considerable effort of the imagination to visualize the interior and garden of 1860–5. Recent research has sought to determine what survives of the striking interiors and intimate garden rooms and to untangle myth and reality.[6] Many of the contemporary accounts are anecdotal or were recalled after a distinct passage of time. The most revealing sources are the letters of Rossetti and William Bell Scott and the recollections of Webb and Edward and Georgiana Burne-Jones. Preparatory studies for Burne-Jones's wall paintings in the drawing room and Morris's sketches for ceiling patterns and the embroidery scheme for the dining room are critically important but unfortunately there are no other known contemporary drawings, watercolours, or photographs and there is no detailed account by Morris.

Architectural paint analysis of the wall surfaces and study of the painted furniture undertaken in the decade since the National Trust acquired Red House in 2003 have revealed that the original decorative finishes have survived to a surprising degree, providing tantalizing glimpses of the rich polychromatic interiors. This research shows Morris's love of earthy colours, flat patterns, and figurative painting and his innate skill as a colourist, evident in his designs for Morris, Marshall, Faulkner and Company (known as 'the Firm'), that he founded from Red House in 1861. Rather than a series of discrete decorative schemes in each individual room, as was once thought, there was a carefully controlled fluency and strong visual movement between each space. Light passages gave into richly patterned, intensely coloured rooms of warm reds, yellows, greens, blues, and browns, with through-decoration in the form of repeated stylistic motifs and settings. In uniting the known furnishings and contents with this much fuller understanding of the decorative schemes, an overarching theme that connects the figurative painted decoration and the embroidered figures envisaged for the principal rooms of the house – the hall, the dining room, the drawing room, and the main bedroom – has been revealed. Love, in its many different guises, is inherent to all these works and reflects Morris's preoccupation with building his own house after his decision to make a romantic marriage to Jane.

In tandem with the decoration, Morris directed plans for the furnishing of the house, bringing with him the furniture he had designed for his lodgings in Red Lion Square and *The Prioress's Tale* wardrobe designed by Webb and painted by Burne-Jones as a wedding present.[7] This is a spectacular and seminal piece that stands as a prelude to Red House and gave a stylistic lexicon for what was to come. In 1859–60, Morris commissioned from Webb furniture wrought specifically for the house, notably the Hall settle, Dining Room dresser, and two dining tables with edges bound in iron. Alongside these imposing pieces, Webb designed built-in wardrobes, smaller tables, brass and copper candlesticks, and a variety of table glass. Morris and Webb collaborated on the designs of stained glass windows in the upper and lower passages with two figure panels of *Love* and *Fortune* added to Burne-Jones's design in c. 1863–4. Burne-Jones also contributed geometric patterned tiles for fireplaces and Morris designed three tiles for the fixed oak bench in the garden porch. These bespoke pieces were supplemented by furniture given by Morris's mother, eastern carpets, his first embroideries, his collection of manuscripts and armour, and his growing art collection which included *April Love* by Arthur Hughes, five watercolours by Rossetti, *The Hayfield* by Ford Madox Brown, engravings by Dürer, pen and ink drawings by Burne-Jones, and his own painting of his wife as *La Belle Iseult*.

The Decoration of the Principal Rooms

The Hall

The Hall is dominated by the broad oak stair and Webb's built-in settle, which survives in its original position. It is a highly practical, composite piece with a bench seat, drawers, and cupboards designed to be decorated with flat, repeating patterns. The largest pair of cupboard doors is painted with a tableau of nine figures, identified as Mary Nicholson (Morris and Burne-Jones's maid at Red Lion Square and an embroiderer), Morris or Faulkner, Jane, Edward and Georgiana Burne-Jones, and Elizabeth Siddal, in a garden setting based on Red House. The other three figures have blank faces. This composition is believed to be by Morris with the hands and faces attributed to Rossetti. The unfinished picture has become a pictorial metaphor for the closeness of the friends and the incomplete decoration of the whole house (see Figure 2.1).

Burne-Jones and Morris discussed a series of paintings depicting the story of Troy for the hall and stairs although these were never executed.

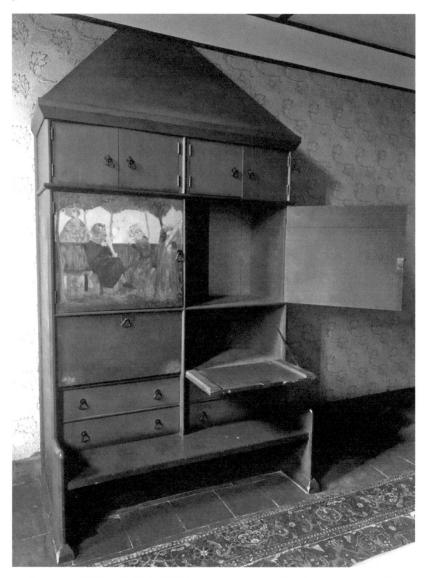

Figure 2.1 Hall settle, Philip Webb, 1860, painted wood with painted patterns by
William Morris and figurative painting by William Morris and attributed to Dante
Gabriel Rossetti, c. 1860; credit: Tessa Wild

The ceiling soars high into the stair tower and retains its original decoration
of two contrasting repeating designs. The flat is an alternating green and
blue weave-like pattern on an off-white ground and the angled sides have

snaking green and blue stylized flowerheads. It is at once strikingly bold in its apparent simplicity and evocative of medieval precedents.

The Dining Room

With Morris's munificent hospitality in mind, Webb created a generously proportioned dining room running parallel with the hall with views out to the bowling green and herbers to the north. Pencil sketches on Webb's floorplan denote the position of the fixed gothic dresser and two robust oak trestle tables he designed for the room. The monumental scale of the dresser is harmoniously balanced by the tall red-brick fireplace with pointed relieving arch and herringbone tympanum. The deep 'dragon's blood red' dresser retains its original single colour. No plans were made to enliven it with patterned decoration or a figurative composition because of the twelve female figures divided by trees that Morris devised to hang against the reddish-brown walls. In his lecture 'The Lesser Arts of Life' (1882), Morris argued passionately for the importance of textile hangings with patterns drawn from nature or figurative scenes. His sequence of embroidered hangings foreshadowed his later words: '[t]o turn our chamber walls into the green woods of the leafy month of June … a solemn procession of the mythical warriors and heroes of old; that surely was worth the trouble of doing' (xxii.254). Morris made a deeply personal selection of female heroines for his dining room, in choosing women from literature, history, mythology and the Bible whose characters and actions spoke eloquently of enduring love. The figures and their corresponding trees were embroidered by Jane and her sister Bessie Burden, who were accomplished needlewomen, with contributions from Georgiana Burne-Jones. Seven figures were worked at Red House, namely St Catherine, Guenevere, Penelope, Aphrodite, Lucretia, Hippolyte and Helen of Troy and three trees – a lemon, an orange and a pomegranate tree. The five unexecuted subjects are believed to have included Artemis, St Cecilia and possibly Mary Magdalene. Morris's scheme was a considerable undertaking, especially when considered in the light of the concurrent decorations underway in other rooms of the house, and was undoubtedly disrupted by the births of Jenny and May Morris in 1861 and 1862 respectively.

Had Morris's entire composition been completed, all the figures and trees would have been appliquéd to woollen serge panels and enhanced by embroidered floral decoration. The garden setting for the scheme continued a theme found in the figurative decoration on walls and furniture in the hall, drawing room, and main bedroom and reinforced the sense of fluency

between interior spaces. Morris ensured that the embroidered hangings would create a strong visual link between the internal walls and the flowery meads and orchard trees visible outside the windows and that art and nature were visually linked.

The Drawing Room

Morris's most ambitious plans were for the decoration of the first-floor drawing room. He envisaged a rich, glowing interior with flower and foliate patterns on the ceiling, floral decoration above the settle, seven scenes from the poem *Sir Degrevaunt* to be painted by Burne-Jones on the walls, and the panelled alcove to the oriel window to be decorated with gold leaf and repeating foliate patterns. The settle he had designed for Red Lion Square was to be refashioned by Webb with the addition of a minstrel's gallery and enhanced by the addition of a third panel painting by Rossetti depicting the Italian poet Dante's love for Beatrice. A strong sense of the passionate enthusiasm with which Burne-Jones and Morris embraced the interiors is evoked in Burne-Jones's recollections:

> As we talked of decorating … plans grew apace. We fixed upon a romance for the drawing room, a great favourite of ours called Sir Degrevaunt. I designed seven pictures from that poem, of which I painted three that summer and autumn in tempera … The great settle from Red Lion Square, with the three painted shutters above the seat, was put up at the end of the drawing-room … Morris painted in tempera a hanging below the Degrevaunt pictures ….[8]

The resultant interior was complex and densely layered, exploiting the high ceilings and oriel window to dramatic effect. Repeating flat patterns abut figurative wall paintings, which were positioned alongside panel paintings depicting scenes from literary texts that held potent meanings for Morris, Burne-Jones, and Rossetti. On the ceiling, Morris and Jane painted a repeating pattern of stylized spiky flower heads on wavy stems, set within horizontal and vertical bands and repeating geometric fan-shaped motifs in brown, yellow, and red on a cream limewash ground.[9]

Burne-Jones only found the time to complete three of his proposed seven wall paintings in 1860: *The Wedding Ceremony*, *The Wedding Procession*, and *The Wedding Feast*. These were placed sequentially to either side of the settle with extracts from the corresponding verses painted above each scene. In the first two paintings, the bride and bridegroom – Sir Degrevaunt and Melidor – are a handsome youth and pretty red-headed maiden. By contrast, in *The Wedding Feast*, Sir Degrevaunt and

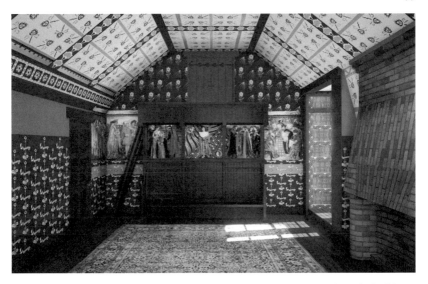

Figure 2.2 A digital reconstruction of the drawing room showing the rich, highly patterned decoration prior to 1863, when the panel paintings by Dante Gabriel Rossetti were removed from the settle; reproduced by kind permission of John Tredinnick

his bride are portrayed as Morris and Jane. Burne-Jones makes a visual association between the virtuous love and ensuing happy marriage found in *Sir Degrevaunt* and the union of the recently married Morrises. The remaining four wall paintings were never executed.

The all-encompassing decorative scheme Morris created, with critical contributions from Rossetti and Burne-Jones, was one of arresting juxtapositions, patterns, colours, and textures. It was a paean to the constancy of love as expressed in the poetry of Dante, Chaucer and the anonymous poet of the Arthurian poem of *Sir Degrevaunt*. Morris saw his love for Jane mirrored in the works of these great poets and extended this connection further in the main bedroom. The drawing room is an exultation of pattern-making and a fusion of visual art and literature (see Figure 2.2).

Main Bedroom

The decoration of the main bedroom was conceived for Morris's wife and augmented the link between Jane and Melidor. He countered the cool north light by creating a rich, intimate room of wall paintings, textile

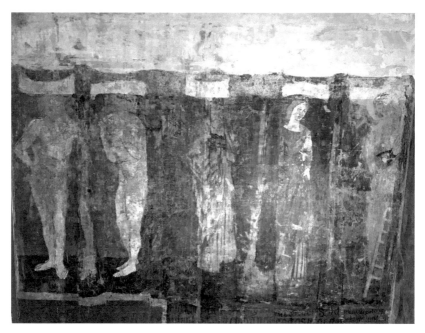

Figure 2.3 Detail of the figurative wall painting in the main bedroom, by William
Morris, with potential attributions to Elizabeth Siddal, Edward Burne-Jones, and Dante
Gabriel Rossetti, c. 1860–1, tempera on plaster; credit: Tessa Wild

hangings, and painted furniture. His intriguing decision to adorn one wall
with a wall painting of Old Testament figures is derived from the literary
precedent of Melidor's lavish chamber in *Sir Degrevaunt*. It also provides
a counterpoint to the miracle of the Virgin, glorified in paint in the
Prioress's Tale wardrobe which stood in the room. The wall painting is a
sophisticated composition: an illusionistic textile hanging, that comprises
five figures against a dark blue background separated by trees. They are
(left to right) Adam and Eve standing on a grassy lawn, on either side of
the Tree of Life, around which the serpent is twisted; then Noah cradling
a small ark, and Rachel and Jacob with a ladder (see Figure 2.3).

A deep red scroll with a dull gold border lies beneath Adam and Eve
but there is no evidence of a painted inscription. Below Noah, Rachel, and
Jacob there is a scroll inscribed with verses from *Genesis* that do not run
consecutively because of the illusionistic folds of the hanging.[10]

Whilst Morris is credited with the overall conception, the authorship
of the wall painting has proved difficult to determine. Study of the
painting technique has shown it was a collaborative effort with probable

contributions from Morris, Elizabeth Siddal, Burne-Jones, and possibly Ford Madox Brown (one of the co-founders of the Firm and Morris's drawing tutor). Morris conceived and Jane embroidered stylized daisies on dark blue woollen serge hangings that were hung around the walls of the room, continuing the theme of rich textiles established by the wall painting. The flat of the ceiling was stamped with a pattern of simple repeating arcs (which also features in the adjoining passage and study) in yellow and white.

The Garden

The house and garden were designed as complementary parts of a world all of its own. From the moment you stepped inside the gates, you entered a reimagining of a *Hortus Conclusus*. Morris understood the religious meaning with which medieval gardens were invested, where the enclosed garden stood as both a metaphor for virginity (as personified by the Virgin Mary – the new Eve) and the prelapsarian Garden of Eden. His garden was modelled on his love of illuminated images and imbued with his strong sense of pattern, texture, movement, and colour. The design of the garden was highly distinctive and highly influential and due to its ephemeral nature it has altered markedly over time.

A series of herbers based on medieval precedent lay to the north of the house. These were intimate enclosed gardens with lawns, paths, and flowery meads. On the east side was the orchard and, closer to the house, the well was enclosed with a wattle fence or trellis to make a large herber. There were flower gardens to the south and the bowling green to the west. Apple, plum, damson, cherries, and hawthorn were among the eighty trees Webb noted on the plot, with apples accounting for nearly half the number and plums and damsons for a quarter. Most of the retained trees were arranged in rows running north to south on the east and west sides of the house, bordering the well-court and the bowling green. The sea of blossom in spring, the rich crop of apples, plums, and damsons and the heady summer scents of bergamot, jasmine, passion flower, and roses provided a rich sensory experience. The character of the house set in its abundant garden is evocatively captured in the recollection of a visitor, in 1863:

> The first sight of the Red House … gave me an astonished pleasure. The deep red colour, the great sloping tiled roofs … the surrounding garden divided into many squares, hedged by sweetbriar or wild rose, each enclosure with its own particular show of flowers; on this side a green alley with a bowling green, on that orchard walks amid gnarled old fruit trees; – all struck me as vividly picturesque and uniquely original. (Vallance, 49)

Garden settings and plants feature prominently in the decorative schemes that were planned and executed inside the house, contributing to the deep sense of interconnectedness of house and garden. The earliest of the Firm's wallpaper designs – *Trellis* in 1862 and *Daisy* in 1864 – both drew on Red House's garden as a source of inspiration. In *Trellis*, Morris was responsible for the design of stylized rambling roses weaving through the trellis and Webb contributed the birds. Glancing out of any window at Red House, a parallel image of birds on fences covered in a riot of roses might have been witnessed.

Morris, Marshall, Faulkner & Company – 'the Firm'

The idea of establishing a distinct and collaborative business venture appears to have been first mooted in 1860. It was precipitated by, and naturally flowed from, the experience of decorating and furnishing Red House. The first months there were highly productive, heady times charged with creative urgency. The shaping of the interior of Morris's house fuelled the friends' shared sense of what could be achieved by combining their talents in a crusade against the prevailing fashions of their age and in the promulgation of good design through their artistic lead. In 1861, with Morris's pattern-making on the walls at Red House still fresh and the interior schemes yet to be completed, the list of services offered by the Firm was headed by 'Mural Decoration, either in pictures or in Pattern Work, or merely in the arrangements of Colours, as applied to dwelling-houses, churches, or public buildings.'[11]

With the advent of the Firm, Morris shifted his focus to encompass both the new business enterprise and the ongoing decoration of his own house. The synthesis between the two was mutually enriching. Many of Red House's design motifs and subjects form the basis for the earliest productions of the Firm and work for the Firm became part of the fabric and domestic furnishings of Red House. The house acted as a showroom; a creative work in progress illustrative of what could be achieved. Morris threw himself into his new work, which drew him physically and mentally away from his preoccupation with Red House. From Easter 1861, he spent considerable time commuting to Red Lion Square in London. While the other partners had their own separate careers, ensuring the Firm's success was Morris's chief occupation. Inevitably, work on Red House progressed in a more episodic fashion. Weekends were still hospitable but there was a shift in focus from the shared activity of decorating the house to designing for the Firm and building a business.

Although Morris was forced to shore up the Firm's finances; church and domestic commissions kept it in constant work after 1862. By early 1864, new premises were needed as they had outgrown their building in Red Lion Square. Morris alighted on the solution offered by Red House and proposed that it be extended to accommodate the Burne-Joneses and that the Firm's works move close by so that he was on hand to supervise. Webb is believed to have designed Red House with this eventuality in mind and proposed turning it into a semi-detached villa. The new house was to extend out from the original building to the east and south, creating a three-sided courtyard around the well. Morris's study was to be given up, with this room and the bedroom below becoming the Burne-Joneses' drawing room and dining room respectively. Morris was happy to forego these rooms to ensure a balanced design that would provide his friends with the accommodation they needed.

Webb's considered design met with approval but proved too expensive for the Burne-Joneses. He revised his scheme and building was planned for spring 1865. Sadly, fate intervened. Georgiana Burne-Jones gave birth to her son Christopher prematurely and he died after three weeks. Shattered by their tragedy, the Burne-Joneses pulled out of the plan and Webb's extension was never built. Morris, for his part, realized that his wearisome commute, and the social isolation Jane must have hoped would be relieved by having their dear friends as neighbours, were taking their toll. In summer 1865, he decided to move back to London. The house never failed to sustain him but, as the Firm and his family grew, Red House was no longer the right place to be and it had to be sacrificed for the greater good.

The halcyon days of Red House were over, but it remained in the memory of all who had lived and stayed there and contributed to its unique character: a youthful creation which embodied the romantic ideals and combined skills of a circle of immensely talented friends bound by deep ties. For Morris, relinquishing the house and garden he had created as a paean to love and a realization of his artistic prowess was charged with poignancy. Nonetheless he looked ahead and immersed himself in work and in composing *The Earthly Paradise*. Red House was but one critically important chapter in his extraordinary life.

The significance of Red House cannot be underestimated. Decorating and furnishing the house and creating the garden revealed Morris's artistic talent, his belief in the importance of art in everyday life, and the joy to be derived from purposeful labour – ideas that would deeply influence his later socialism and writing on art and society.[12] It is a vital precursor to the Arts and Crafts movement and was the crucible for the founding of the Firm

that became the hugely important Morris & Company, revolutionizing and influencing taste in Britain and abroad. Although its rural setting has gone and it now sits enveloped by suburbia as part of Greater London, the house and garden have survived remarkably intact and still resonate. Red House stands today as a rich source for understanding Morris, his romantic medievalism, his influences, and his extraordinary achievement, and as the place of great experimentation and discovery where he found his vocation.

Notes

1 Morris first expressed his hope for a 'Palace of Art' in a letter of July 1856, taking inspiration from Alfred Tennyson's poem, *The Palace of Art, 1832* (*CL*, i.28).

2 W. R. Lethaby, *Philip Webb and His Work* (London: Oxford Union Press, 1935), 26.

3 These drawings are in the Victoria and Albert Museum E.58-1916 – E.71-1916.

4 The 'waiting room' was a small reception room in which tradesmen, potential clients, and possibly artist's models could wait.

5 'Building Contract, Dated 16 May 1859, Mr Willm Kent and Mr Wm Morris Esq.', National Trust Archive, Red House, 8.

6 See Tessa Wild, *William Morris and His Palace of Art* (London; Philip Wilson, 2018).

7 *The Prioress's Tale* wardrobe is in the collection of the Ashmolean Museum, Oxford.

8 Georgiana Burne-Jones, *Memorials of Edward Burne-Jones*, 2 vols (London: Macmillan & Co, 1904), i.209.

9 This decoration had been obscured by 1897 but was rediscovered and photographed in 1957 before being painted over and forgotten until 2004, when vestiges of the original decoration were uncovered.

10 Genesis 7:5, 30:6, 28:12.

11 Christine Poulson (ed.), *William Morris on Art and Design* (Sheffield: Sheffield Academic Press, 1996), 22–3.

12 For more on Red House, see: Edward Hollamby, *Red House: Bexleyheath 1859 Architect Philip Webb* (London: Architecture Design and Technology Press, 1991); Edward Hollamby, Trevor Garnham, and Beth Dunlop, *Arts & Crafts Houses I: Philip Webb, William Richard Lethaby, Sir Edwin Lutyens* (Phaidon Press, 1999); Jan Marsh, *William Morris & Red House* (National Trust Books, 2005); Marcus Waithe, 'The Stranger at the Gate: Privacy, Property, and the Structures of Welcome at William Morris's Red House', *Victorian Studies*, 46.4 (2004), 567–95; Anna Mason (ed.), *William Morris* (London: Thames and Hudson Ltd, 2021); Linda Parry, *William Morris Textiles* (London: V&A Publishing, 2013) and Wild, *William Morris and His Palace of Art*.

Kelmscott Manor

Julia Griffin

William Morris viewed the home as an art form and an attribute of a fulfill-ing life: 'If I were asked to say what is at once the most important produc-tion of art and the thing to be most longed for, I should answer, A beautiful House' (Peterson, 4). Morris further specified that 'the best work of art of all' was in fact 'a Gothic house'.[1] As a vernacular building in the remote Oxfordshire countryside, Kelmscott Manor became an exponent of Morris's architectural ideal, as well as the emblem of his identity. As I have shown elsewhere, however, the nature of Morris's relationship with Kelmscott was complex and not always idyllic.[2] The Manor bore witness to several suppressed narratives that are irreconcilable with romanticized notions of the Morrises' carefree domesticity at Kelmscott – not least as a site of Jane Morris's (1839–1914) infidelities and as a hideaway for Jenny Morris (1861–1935) who suffered from violent epileptic fits. Moreover, Morris spent little time there until his semi-retirement from Morris & Company and never considered or referred to it as his home, but rather as a rural getaway.[3]

This chapter argues that it was William Morris himself who laid a strong foundation for the deep-seated biographical and pastoral myth of Kelmscott in the last seven years of his life. He did so mainly by creating or commissioning influential representations of the Manor, in both textual and visual form: namely, the utopian romance *News from Nowhere* (1890; 1891), and the antiquarian article 'Gossip about an Old House on the Upper Thames' (1895).[4] Crucially, the images he had a part in creating for these texts became influential 'templates', inviting prolific reprinting in most subsequent accounts of the house. Having endowed Kelmscott with particular values and meanings, these texts and images entered the popular imagination, inviting symbolic and biographical readings. They ensured the Manor's lasting place in the public consciousness and its role as a potent memorial to Morris long after his death.[5] They also represent a methodological opportunity, a lens through which to explore the recurrent mediation of this ancient dwelling on the upper reaches of the Thames.

News from Nowhere: Textual Portrayal
of Kelmscott Manor

Soon after its publication in book form in March 1891, *News from Nowhere: or, an Epoch of Rest, being some Chapters from a Utopian Romance* became William Morris's best-known and most reprinted literary work (MacCarthy, 587). Both its text and, most importantly, its subsequently added frontispiece were to become pivotal in the formation of Kelmscott's iconic status in the Victorian and Edwardian periods, as well as subsequent decades, largely contributing to the Manor's fame. The utopian narrative culminates in the protagonists' arrival at Kelmscott Manor in the penultimate chapter entitled 'An Old House amongst New Folk'. Morris's literary vision effectively portrays Kelmscott as an ideal of the carefree, beautiful, post-industrial rural England of the future, whilst evoking certain aspects of an earlier, pre-industrial England. The vital role of the literary account of the Manor behind its iconic place in public consciousness cannot be overstated.

Crucially, literature has greater power to shape public memory than historiography.[6] This is effectively accomplished through the 'experiential mode of narratology', which represents the past as apparently 'lived through experience'.[7] *News from Nowhere* is told in the past tense, and it relates a dream. But the detailed first-person account, complete with dialogue and adverbs such as 'presently', creates a prime example of experiential narratology, and with it a particularly memorable text. This not only enhanced the story's memorability, but also created unprecedented egalitarian access to the house. Through his evocative and multisensory real-time narrativization, Morris effectively offers a virtual tour of Kelmscott, which could be experienced and enjoyed by every Victorian reader, just as it was available to the 'new folk' of the future. In this way, he democratically shares the experience in print, hence accomplishing his utopian vision of a house belonging to everyone. The house thus offers voyeuristic escapism from the ugly and troublesome present.

The general portrayal of the house conveyed in the text of *News from Nowhere* is of a never-ending idyllic summer, and of cherishing a simple yet artistic existence enhanced by historic and/or vernacular furnishings, and being close to nature whilst the children are playing in the garrets. To the narrator, the house and village encapsulate the pinnacle of a happy existence within the new utopian order. Many of the featured locations became iconic of Kelmscott: the door into the walled garden; the garden itself with its stone path and roses; the porch; the garrets; the Tapestry Room. The house and its setting trigger reflections on history, vernacular architectural tradition, and the nature of Englishness. Morris's literary representation of Kelmscott

is dominated by several recurrent qualities – namely, age, beauty, happiness, simplicity, and relative smallness – combined with a sense of homeliness and domesticity. Kelmscott thus became a symbol of a future social order. It acquired this signification by virtue of its beauty, its traditional construction, its being at one with unspoilt countryside, and, most importantly, on account of its role as the catalyst of pleasurable communal work.

News from Nowhere: The Frontispiece

In his influential study *Mythologies* (1957), Roland Barthes specifies that 'myth prefers to work with … incomplete images, where the meaning is already relieved of its fat, and ready for a signification, such as caricatures'.[8] He postulates that stylized illustrations have a far greater myth-making potential than more literal ones. In this respect, the graphic technique of the *News from Nowhere* frontispiece as a black-and-white line drawing, intended for a woodcut, with only minimal hatching and shading, makes it a particularly powerful myth-making vehicle (see Figure 3.4).

Figure 3.4 Final *News from Nowhere* frontispiece and caption, Kelmscott Press edition, woodcut in a printed book, drawing designed by Charles March Gere in collaboration with William Morris; woodcut by William Harcourt Hooper, 24 March 1893; © William Morris Gallery, London Borough of Waltham Forest

Indeed, its depiction of the house at the height of summer with the stone path, porch, roses, and doves, is now the best-known and most recognizable part of the book. The dominant influence of the frontispiece is all the more striking because the *Commonweal* 'serial' publication of 1890 and multiple British and American book editions of the utopian romance were disseminated and received before the illustration was created.

Morris commissioned the image from the twenty-three-year-old painter and illustrator Charles March Gere (1869–1957), whom he had met at the Birmingham School of Art.[9] First published in the Kelmscott Press edition of this prose romance (spring 1893),[10] the woodcut was prepared by the wood engraver William Harcourt Hooper (active 1893–1911), an important figure in the Press's history who was engaged to carve its woodcut illustrations between 1891 and 1896 (Peterson, 147). Whereas the literary portrayal of Kelmscott in *News from Nowhere* was Morris's idea, using the house as an illustration for the Kelmscott Press edition of the book was suggested by Morris's friend and private secretary, Sydney Carlyle Cockerell (1867–1962).[11] Though something of an afterthought, Morris was nevertheless prepared to incur a four-month delay to the edition's planned issue date in order to perfect the image's iconography in close liaison with Gere. This is evidenced by the colophon, Morris's correspondence and his diary: the colophon states that the book had been printed according to plan by 22 November 1892, whilst Morris's diary records that the separate printing of the frontispiece finished on 7 March 1893,[12] the complete volumes being issued on 24 March 1893.[13]

Morris exerted scrupulous editorial control over the image's character, having selected the view of the front of the house from several preliminary drawings provided by Gere – a choice dictated partly by the pre-set shape and size of the woodcut block, but no doubt mostly by the drawing's intended effect and atmosphere. He also requested changes to the selected view and made a trip to Kelmscott to work with Gere on refinements. Morris's letters for the period from 5 November 1892 to 1 April 1893, together with Gere's working designs for the frontispiece, preserved at the Wilson Art Gallery & Museum Archive in Cheltenham, provide a detailed record of his requirements and input. As not all of Gere's preliminary drawings appear to have survived, it is not always possible to determine which sketches Morris is referring to in consecutive letters. However, an attempt will be made to match individual drawings with comments in the correspondence. The surviving drawings include the preliminary sketch (see Figure 3.2b); the penultimate drawing (see Figure 3.3a) – which displays some alterations from the final version – and further preliminary sketches of alternative, less picturesque views (see Figure 3.1).

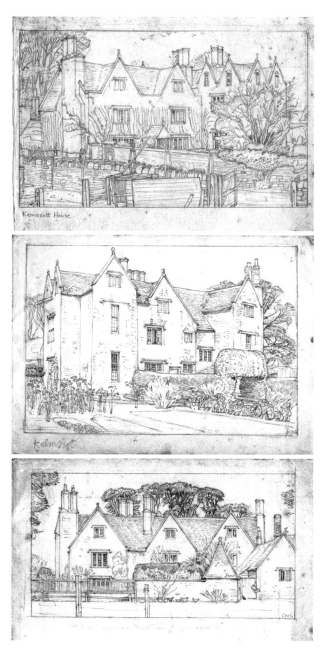

Figure 3.1 Charles March Gere, unused preliminary designs for *News from Nowhere* frontispiece, featuring different viewpoints rejected by William Morris, November 1892, pencil on paper; The Wilson Art Gallery and Museum, Cheltenham. (a) South-east view of Kelmscott Manor – from the farm; inventory number 1993:320; (b) North-east view of Kelmscott Manor; inventory number 1993:318; (c) West view of Kelmscott Manor – from the meadow, inventory number 1993:319

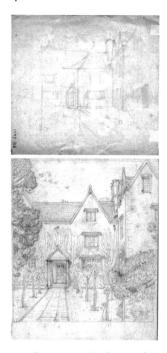
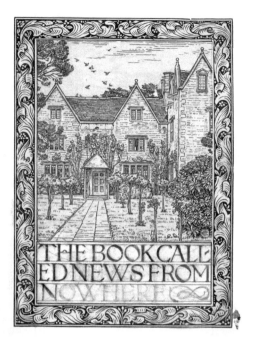

Figure 3.2 Evolution of the *News from Nowhere* frontispiece design by Charles
March Gere (decorative border and lettering by William Morris). (a) (top left): Early
compositional sketch for the *News from Nowhere* frontispiece, 1892; inventory number
1993:316.2 (verso of 1993:316.1), The Wilson Art Gallery and Museum, Cheltenham; (b)
(bottom left): Preliminary design for *News from Nowhere* frontispiece, November 1892;
inventory number 1993:317, The Wilson Art Gallery and Museum, Cheltenham. (c)
(right): Pasted-up proof/ trial sheet for *News from Nowhere* frontispiece illustration design
with the earlier version of the inscription, 1893; William Morris Papers, The Huntington
Library, San Marino, California

The latter were rejected by Morris without much consideration, demon-
strating that from the start he had a particular effect in mind. On the back
of the penultimate drawing is a very loose compositional sketch (see Figure
3.2a) which demonstrates that the viewpoint had changed from a sideways
view to a head-on one, a revision that ultimately caused the stone path to
become the focus of the vanishing perspective.

Morris's original letter of commission (5 November 1892) offered Gere a
lot of creative freedom. 'What I want you to do', he explained, 'is to make
drawings (sketches) of the house from any points that you think would
do for an *ornamental* drawing for a book of mine (News from Nowhere)
now in press – to be cut in wood by the way.' (*CL*, iv.463). However, by 14
November, Morris was giving him specific instructions, mostly based on

the technical requirements of the woodcut and his preoccupation with the depiction of the house's historical features:

> I have your drawings of the house and think them very good & pretty; but I doubt if any of them will *quite* do for the formation of our cut. [see Figure 3.1] … the one of the entrance front of the house [see Figure 3.2b] is the only one which is about the right shape for the cut, and … this must be the view taken only if something more could be got of in the tapestry block, and of the 2nd gable to the S. it would be better. (*CL*, iv.466–7)

By 30 November Morris was acknowledging receipt of two new designs and reporting that although he 'liked them both very much on the whole; … there are one or two things in them might be bettered' (*CL*, iv.111). The two designs appear to be untraced.

Having been subsequently sent the revised version of the drawing, Morris wrote on 20 December to request a great number of further changes, including alterations to the architectural details, the representation of vegetation, and the style of drawing:

> The chimney-stack mixes up too much with the gable, & is much too small I should say. The markings of the stone work joints are too black and heavy, and would give the block a sooty look. The copings of the gables are wrong I should say; I think some indication of their mouldings must be shown … the stone path up the porch might be drawn with more literality. Again the plants … are *vines* and should have some indication of the habit of vines. (*CL*, iv.482)

Morris included with this letter a sketch of a correctly drawn coping. The drawing in Figure 3.3a reveals extensive retouching using a white ink wash to make the stonework joints look less prominent. Morris's description must therefore be referring to it, but in an earlier stage of completion – prior to the implementation of all the required alterations. Figure 3.3a also shows pencil corrections to the position of one of the copings, and a small practice sketch of the correct relationship between the chimney and the gable (in the margin).[14] These annotations may well have been carried out by Morris himself during his meeting with Gere at Kelmscott, demonstrating his previous comments on the actual drawing.

Judging by the high finish of this drawing, Gere may have created it as the final design, but it ended up being the penultimate version due to the sheer number of corrections from Morris, all of which were implemented in the final frontispiece (see Figure 3.4; see also the compositional comparison of Figure 3.3b vs. 3.3c). According to Morris's unpublished diary, their site visit took place on 25 January 1893.[15] The optimum design was finally accomplished by 6 February 1893 when Morris wrote: 'Your drawing <to>

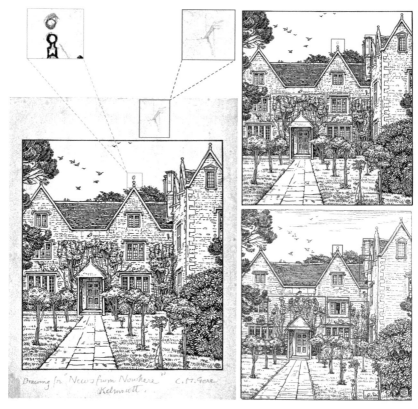

Figure 3.3 William Morris's readjustment of the penultimate *News from Nowhere* design
drawing into the final version. (a) (left): Charles March Gere, penultimate design for
News from Nowhere frontispiece with pencil annotations attributed to William Morris,
December 1892, reworked January 1893, inventory number 1993:316.1; The Wilson Art
Gallery and Museum, Cheltenham; (b) (top right) and (c) (bottom right): Juxtaposition
of the penultimate drawing (The Wilson Art Gallery and Museum, Cheltenham) and the
final printed frontispiece (final drawing untraced) (© William Morris Gallery, London
Borough of Waltham Forest), with differences highlighted

safe to hand. I think it very satisfactory now: <u>indeed you have done exactly
what was wanted to make it come *right*</u>' (*CL*, iv.17; emphasis added).

The last phrase suggests a specific conception for creating a public
image-cum-emblem of Kelmscott Manor. In addition to the changes
Morris requested in rendering architectural features and botanical forms,
there are further differences between the penultimate Gere drawing and
the published woodcut (see Figure 3.3a vs 3.4; see also Figure 3.3b vs 3.3c).

The composite image in Figure 3.3 outlines them. These include the opening of a previously closed window on the first floor, to the right of the front door, conveying the sense of the house being lived-in and welcoming. Moreover, the preliminary drawing showed barren wintertime vegetation (see Figure 3.2b), whereas the penultimate and final versions showed the garden in full bloom, despite the design being worked on in the winter. It is not documented whether these changes were also requested by Morris, but they are consistent with the allusion in *News from Nowhere* to windows open 'to the fragrant sun-cured air'. The final version of the woodcut also depicts a pair of doves in the bottom right corner, not previously featured. Figure 3.3 juxtaposes the differences between the penultimate and final drawing, clearly demonstrating that Gere implemented all of the instructions that Morris issued in their surviving correspondence, and suggesting that the above-mentioned revisions – not recorded in the letters – would also have been made at Morris's request.

Apart from pursuing what Mary Greensted calls 'a precise sense of place', Morris's approach to image-building endowed Kelmscott with particular romanticized connotations and symbolic values.[16] The iconography of the final version of the frontispiece is based on symmetry, controlled order, harmony, and pairings. It highlights a number of traditional 'Old English' vernacular features, such as gables, chimney-stacks, porch, mullioned windows, and the stonework of the walls and path, in combination with the orderly (rather than overgrown) vegetation in the charming garden populated by pairs and flocks of birds. The image conveys the quaint antiquity of the house and its olde-worlde homeliness, additionally evoked by the head-on perspective of the path, as if inviting the viewer to step into the picture and go inside. The orderly house is shown in harmony with orderly nature, in turn evoking the well-ordered personal life of its occupants, whilst the two pairs of doves and rose bushes may symbolize a loving relationship. Morris's insistence on avoiding a 'sooty' look seems to reflect his predilection for the countryside over the city as a place of clean air. On the whole, whether read alongside the novel or viewed autonomously, the frontispiece conveys a sense of idyllic tranquillity, peacefulness, and domesticity.

As was the case with all Kelmscott Press publications, the *News from Nowhere* edition was small: it comprised 300 books on paper and 10 on vellum. However, the image had a wide scope of influence.[17] Due to broad public appeal, the frontispiece soon took on a life of its own, being disseminated in countless publications unrelated to the literary work, reproduced without its Kelmscott Press caption or the decorative border, and inscribed just as 'Kelmscott Manor'. In *Slow Print: Literary Radicalism and*

Late Victorian Print Culture, Elizabeth Miller discusses the materiality of the finished frontispiece, crucially pointing out that the leafy border framing serves the function of 'demarcating the image's artificiality by cordoning it off'.[18] In this light it is notable that the frontispiece's independent dissemination involved its detachment from the leafy border, or any other references to the literary work, resulting in decontextualized documentary readings (as a topographical record of Kelmscott). In such cropped-down form it was to illustrate Morris's own antiquarian article about Kelmscott, 'Gossip about an Old House on the Upper Thames' (Morris 1895), discussed later, as well as Aymer Vallance's *The Art of William Morris* (1897) and *William Morris: His Art, His Writings and His Public Life* (1897) and other posthumous books, reviews, and articles.[19]

This dissemination process was an early indication of Kelmscott's wide public appeal, as well as of the house beginning to stand for Morris, as if evoking his identity in retrospect. However, the frontispiece's existence as an autonomous entity had, in a way, already been foreshadowed by Morris when he replaced the original caption intended to appear underneath it – 'The book called News from Nowhere' (see Figure 3.2c) – with the revised inscription: 'This is the picture of the old house by the Thames to which the people of this story went. Hereafter follows the book itself' (see Figure 3.4).

'Gossip about an Old House on the Upper Thames': Textual and Visual Portrayal of Kelmscott Manor

Five years after immortalizing Kelmscott in a work of fiction, Morris published a factual, illustrated article about the house. 'Gossip about an Old House on the Upper Thames' appeared in *The Quest* magazine in November 1895, less than a year before his death. Apart from representing another vehicle for memorializing Kelmscott, it set a precedent for autobiographical readings of *News from Nowhere* that connect Morris's life to his utopian hopes, and his utopian hopes to the house. Though he presents the topic from a primarily antiquarian viewpoint – focusing on the local topography, architecture, history and dating of the house, as well as the design of the garden – the article is written in the first person, in the present tense, directly addressing the reader in the form of an intimate chat about the Manor, and borrowing the experiential mode of narratology and informal language previously used in *News from Nowhere*. In this respect, it employs the then fashionable mode of autobiographical 'gossip', a genre discussed by Julie Codell in her typology of Victorian life writings.[20] Among other

things, such 'gossip' 'symbolized artists' entrepreneurship' at communicating with their public. The effect is to place Morris at the centre of the story. As the tenant of Kelmscott Manor, he was uniquely placed to be the guardian of the building's memory, sharing and shaping knowledge about it.

The article had not been planned and came into existence by chance – due to wet weather. Morris had originally intended to contribute a piece about the Great Coxwell Barn nearby instead. With this in mind, he commissioned *The Quest* illustrator Edmund Hort New to produce drawings of it. New was just to be staying at Kelmscott Manor, but because of particularly bad weather Morris decided to change the subject of the article to the house itself. New's diary reports the new resolution that 'I should draw inside the house and Mr M. should write an article on it instead of on the barn.'[21] As previously in *News from Nowhere*, Morris offers a very detailed account of the garden as well as the interiors, this time entering the house through the north rather than the south door. He reveals details of further rooms such as the great parlour with white panelling, the old parlour, or the kitchen, whilst remediating already-familiar spaces evoked in *News from Nowhere*. Once again describing the attic, Morris explains:

> It is most curiously divided under most of the smaller gables into little chambers where no doubt people, perhaps the hired field labourers, slept in old time. The bigger space is open, and is a fine place for children to play in, and has charming views east, west and north: but much of it is too curious for description.[22]

The article recalls a number of themes previously portrayed in *News from Nowhere*, effectively remediating them, and causing both narratives to converge. In so doing, it consolidates the Morris-centred public narrative of Kelmscott. Both accounts discuss the Manor's seemingly organic nature and its role as the ornament of country life by virtue of its vernacular beauty. Building on *News from Nowhere*, Morris draws here on a striking parallel between the 'sized down' stone slates of the roof and the 'orderly beauty' of a fish's scales or a bird's feathers. He is delighted by the fact that the walls lean back a little:

> we must suppose that it is an example of traditional design from which the builders could not escape. To my mind it is a beauty, taking from the building a rigidity which could otherwise mar it; giving it … a flexibility which is never found in our modern imitations of the houses of this age.[23]

Reiterating the literary evocation of the Tapestry Room, 'Gossip' extols its unique charm, romance, and unity with surrounding nature in a passage that is worth quoting at some length. Morris states that the tapestries lend

an air of romance to the room which nothing else would quite do. Another charm this room has, that through its south window you not only catch a glimpse of the Thames clover meadows and the pretty little elm-crowned hill over Berkshire, but if you sit in the proper place, you can see not only the barn ... with its beautiful sharp gable, the grey stone sheds, and the dove cot, but also the flank of the earlier house and its little gables and grey-scaled roofs, and this is a beautiful outlook indeed.[24]

By informally addressing the reader in the second person and revealing the best viewing position from the room, Morris takes the reader into his confidence, offering second-hand familiarity with the house.

The article's factual account unexpectedly culminates in Morris's declaration of his deep love for the house. This excerpt, again, has been repeatedly reprinted, largely contributing to Kelmscott's 'idyllic' public image, both as a counter-present myth – providing an appealing alternative to social discontent and poverty – and in biographical terms:

> Here then are a few words about a house that I love; with a reasonable love I think; for though my words may give you no idea of any special charm about it, yet I assure you that the charm is there; so much has the old house grown up out of the soil and the lives of those that lived on it; needing no grand office-architect, with no great longing for anything else than correctness ... but some thin thread of tradition, a half-anxious sense of the delight of meadow and acre and wood and river...[25]

The passage reiterates the qualities that Morris most valued in Kelmscott, namely its antiquity, its vernacular architecture, its unostentatious and unpretentious craftsmanship, its fitness for purpose, and its synergy with nature. Written in the final year of Morris's life, this account provides the reformer's last words on his relationship with the Manor.

Morris's article was illustrated with three pictorial (re)mediations of the house. Most significantly, it featured the first (re)mediation of the *News from Nowhere* frontispiece, inscribed with the documentary caption 'A View of the Manor House at Kelmscott, in Oxfordshire, from the Garden Gate' (see Figure 3.5a). Morris thus changed the status of this utopian illustration into that of a topographical record, setting the precedent for its numerous biographical readings. 'Gossip' was also accompanied by two specially commissioned illustrations of Kelmscott by E. H. New. Given the nature of Morris's collaboration with Gere, it is likely he also micro-managed the execution of New's drawings. This is evidenced by the fact that each of the illustrations functions as a visual (re)mediation of a specific passage from the article. Moreover, entries in New's diary suggest he had been briefed on the building's key properties.

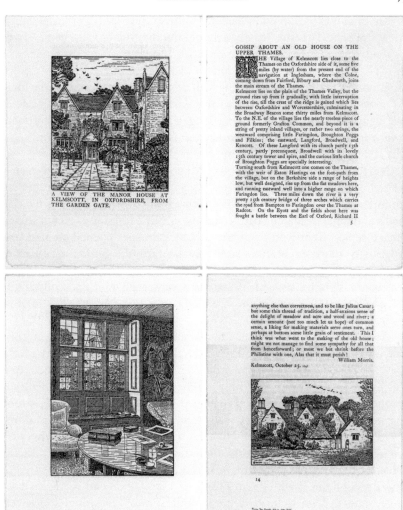

Figure 3.5 E. H. New, representations of Kelmscott in the 'Gossip about an Old House on the Upper Thames' article, *The Quest*, vol. 2, no. 4, November 1895, Clark (William Andrews) Memorial Library, University of California, USA. (a) (top): Opening spread, where Morris set the precedent for using the *News from Nowhere* frontispiece as a topographical record complete with a documentary caption; (b) (bottom left): Illustration of Morris's favourite view from the Tapestry Room; (c) (bottom right): Illustration of the house seen from the west, from 'the field by the newly planted orchard'

The first illustration complements Morris's description of his favourite view from the Tapestry Room, overlooking the Manor's old wing as well as the barn and dovecot (see Figure 3.5b). Morris reassures the reader that 'Mr New will, I am sure, give you a good idea of this – at least as much of it as the limits of his drawing will admit.'[26] New's diary entry for 9 October 1895 includes a record of this drawing, revealing he was aware of the significance of the earlier wing: 'began a drawing in the Tapestry room which looks out on the front garden and is in the wing added about 1630; the rest of the house dating from 1570 or thereabouts'.[27]

New's illustration conveys the Manor's ordered beauty, romance, and antiquity, but also indicates its symbiosis with the surrounding countryside: he lays some emphasis, for instance, on the house's ivy-clad walls and an elm tree in close proximity. In similar fashion, New's second image depicts Kelmscott from 'the field by the newly planted orchard' and appears to illustrate Morris's statement likening the garden to 'a part of the house yet at least the clothes' (see Figure 3.5c).[28] Here, the vegetation harmoniously coexists with Kelmscott's vernacular outline. Collectively, New's illustrations convey the key qualities outlined in Morris's essay as well as in *News from Nowhere.*

According to Astrid Erll, 'remediation tends to solidify cultural memory, creating and stabilizing certain narratives and icons of the past'.[29] By offering complementary textual and visual (re)mediations of Kelmscott, Morris not only strengthened the overall mnemonic properties of 'Gossip', but also helped consolidate the house's strong presence in public memory. *The Quest*, for its part, was a short-lived magazine founded in November 1894. Its main subjects were contemporary poetry, historic literature and historic houses. Richly illustrated by artists including Charles March Gere, it was printed at the Press of the Birmingham Guild of Handicraft and seems to have been modelled on Kelmscott Press publications.[30] Despite its relatively small print run of 300 copies, 'Gossip about an Old House on the Upper Thames' became one of the most collectable representations of Kelmscott amongst Morriseans and bibliophiles alike.

<p style="text-align:center">***</p>

William Morris made Kelmscott famous in his lifetime, and he laid the foundations of the Manor's pervasive romanticized image by means of his writings and commissioned illustrations, endowing it with specific values. By evoking the medieval and artisanal qualities of the Manor, the character of the Kelmscott Press itself, which issued an edition of *News from Nowhere,*

also contributed to the process. His representations of Kelmscott became 'templates' for its lasting fame, continuing to provide the basis for the house's public memory today. *News from Nowhere* and 'Gossip about an Old House on the Upper Thames' were to give rise to biographical readings, including the notion of Kelmscott as Morris's domestic idyll, being reprinted many times across his posthumous life writings. However, as a fictional vision of a utopian future, and a glimpse into Morris's attitude to the house in the last year of his occupancy, these texts should never be considered reliable records of Morris's twenty-five-year tenure. By virtue of his ownership of Kelmscott and his authorship (and commissioning) of the representations discussed in this essay, Morris forged a memorial association between the Manor and his person that is at once powerful and consciously constructed. He simultaneously played a pivotal role in reversing the mnemonic significance of Kelmscott Manor – from the object of Morris's memorialization to the vehicle of his own commemoration.[31]

Notes

1 Anon., *Daily Chronicle*, 9 October 1893, 3.

2 See Julia Griffin, 'Kelmscott Manor: Mr Morris's Country Place (1871–1896)', in Florence S. Boos (ed.), *The Routledge Companion to William Morris* (London: Routledge, 2021), 88–144.

3 Ibid., 87–144.

4 William Morris, 'Gossip about an Old House on the Upper Thames', *The Quest* (November 1895), 5–14.

5 For public representations of Kelmscott and the Manor's role in the commemoration of Morris, see my PhD thesis, 'Dante Gabriel Rossetti, William Morris and the Making of Kelmscott Manor. Between History, Memory and Cultural Forgetting, 1871–1914' (Central Saint Martins, University of the Arts London, 2022). It employs modern cultural memory theory – developed by Ann Rigney and Astrid Erll – to examine the cultural place-making of Kelmscott.

6 Ann Rigney, 'The Dynamics of Remembrance: Texts Between Monumentality and Morphing', in Astrid Erll and Ansgar Nünning (eds), *A Companion to Cultural Memory Studies* (Berlin: Walter de Gruyter, 2010), 345–53; Astrid Erll, *Memory in Culture* (London: Palgrave Macmillan, 2011), 151–2.

7 Erll, *Memory in Culture*, 157–8.

8 Roland Barthes, *Mythologies* (1957), trans. Annette Lavers (London: Vintage, 2000), 127.

9 Edmund Penning-Rowsell, 'Charles Gere and William Morris', *Journal of William Morris Studies*, 8.4 (Spring, 1990), 1–30 (30).

10 William S. Peterson, *A Bibliography of the Kelmscott Press* (Oxford: Clarendon Press, 1984), 33–4.

11 Ibid., 33–4.

12 BL MP AddMS45409.

13 Ibid., 33–6. The date of the colophon has since given rise to scholarly confusion, leading to the perpetuation of the erroneous dating of the frontispiece as 1892.

14 The present visual analysis counters John Cherry's postulation, regarding the imagery of the final frontispiece in relation to the above letter, that 'Gere seems to have accepted only some of Morris's suggestions.' See John Cherry, 'Kelmscott Depicted', in Alan Crossley, Tom Hassall and Peter Salway (eds), *William Morris's Kelmscott: Landscape and History* (London: Windgather Press in association with the Society of Antiquaries of London, 2007), 166.

15 BL MP Add MS 43409.

16 Mary Greensted, 'William and May Morris: Images of Kelmscott', in Mary Greensted and Sophia Wilson (eds), *Originality and Initiative: The Arts and Crafts Archives at Cheltenham* (Cheltenham: Cheltenham Art Gallery and Museum, 2003), 24.

17 The great majority of subsequent nineteenth- and early twentieth-century editions of *News from Nowhere* remained unillustrated. The first American edition illustrated with the Gere frontispiece did not appear until 1926.

18 Elizabeth Carolyn Miller, *Slow Print: Literary Radicalism and Late Victorian Print Culture* (Stanford: Stanford University Press, 2013), 66.

19 Aymer Vallance, *The Art of William Morris* (London: Chiswick Press / George Bell & Sons, 1897).

20 Julie Codell, *The Victorian Artist: Artists' Life Writings in Britain c. 1870–1910* (Cambridge: Cambridge University Press, 2003), 165–8.

21 David Cox (ed.), 'Edmund New's Diary of a Visit to Kelmscott Manor', *The Journal of William Morris Studies*, 3.1 (Spring 1974) (from a manuscript of 1895), 6.

22 Morris, 'Gossip about an Old House', 12.

23 Ibid, 7–8.

24 Ibid, 11–12.

25 Ibid, 13–14.

26 Ibid, 12.

27 Cox, 'Edmund New's Diary', 6.

28 Morris, 'Gossip about an Old House', 9.

29 Erll, *Memory in Culture*, 141.

30 It was published by G. Napier and Company, Birmingham.

31 Many thanks to my PhD supervisors, Prof. Caroline Dakers and Judy Willcocks as well as friends and mentors for their encouragement with this research: the late Linda Parry (to whose memory this chapter is dedicated), Professor Florence Boos, Dr Alison Smith, Patricia O'Connor, Carien Kremer, Christina Bradstreet, Anna Mason and Abigail Grater. I am grateful to Professor Ann Rigney for consultations in cultural memory theory. Special thanks to Rowan Bain and Roisin Inglesby at the William Morris Gallery; Sarah Francis, Karla Nielsen, Melinda McCurdy and Stephanie Arias at the Huntington Library, San Marino, California; Scott Jacobs at the Clark (William Andrews) Memorial Library, University of California; and Kirsty Hartsiotis and Emalee Beddoes at the Wilson Art Gallery and Museum, Cheltenham for their generosity with the images and object information.

The Thames Basin

Clive Wilmer

A Love Story

In Chapter XXVII of *News from Nowhere* (1890; 1891), the narrator William Guest finds himself alone with Ellen, the beautiful young 'woman of a new type', in a boat on the upper reaches of the Thames.[1] He is falling in love, not only with Ellen but with the changed England she represents for him. Betrayed by his emotion, Guest unintentionally reveals his true character as a visitor from the nineteenth century: 'I know these reaches well;' he reminisces, 'indeed … I know every yard of the Thames from Hammersmith to Cricklade' (xvi.184). He then confesses that he knows the river, not from books or pictures but from experience, and already loves it in its perennial aspect:

> I have not read any books about the Thames: it was one of the minor stupidities of our time that no one thought fit to write a decent book about what may fairly be called our only English river. (xvi.184)

Since there are many English rivers, that last phrase calls for interpretation. At 215 miles, the Thames is by a fair distance the longest of them – the Severn, though longer, is partly in Wales – and with 51 tributaries, as important to Morris as the parent river itself, the Thames basin occupies a larger area than any other in Britain.

But do we not also feel in Guest's declaration the warmth of an unconscious emotion that Morris as a socialist would normally have avoided? I mean a kind of patriotism – a sense that the Thames exemplifies qualities not only of landscape but of national character, much as they were evoked in 1642 by the Cavalier poet Sir John Denham in his classic prospect poem, 'Cooper's Hill'. Denham praises the great river for exercising his power with responsible generosity, nourishing the land he flows through but not smothering it with 'unexpected inundations': a beneficence which, as the waterway broadens into the sea, justifies an imperial role for the nation.[2]

I doubt if Morris knew this hymn to the Thames, which, at once histor-
ical and ahistorical, celebrates the timeless virtues of the river as its author
awaited the outbreak of civil war, but it represents a tradition of political
and historical thinking on the face of it antithetical to Morris's, anticipat-
ing the Tory paternalism of Edmund Burke and Benjamin Disraeli. But,
though *News from Nowhere*, in contrast, speaks for the overthrow of hier-
archy and imperialism, there is nonetheless a patriotic feeling to Morris's
story that is never fully articulated: not a political patriotism, but the love
of a landscape with which the author/protagonist identifies and associates
with timeless forms of behaviour he admires. Morris's Thames is quite as
much as Denham's a national artery.

It is a feature of this outlook that the object of emotional attachment,
being modest and unsensational, fails to attract the passionate admiration
it deserves. This is why Morris, writing what is in a sense a book about
the Thames, deplores the shortage of other books on the subject. This,
his protagonist suggests, is because the river is only appreciated for its
utilitarian value. If its ecology and the human landscapes it has nourished
were as highly regarded as they deserve to be, he seems to say, it would not
have become 'the foul and putrid river' that Morris deplored.[3] Because
the beauty of this landscape resides in its uneventful qualities, it is under-
appreciated, and Morris proposes to alter that by writing a book about it:
the book we are reading, in fact, *News from Nowhere*.

But Guest's protest was not entirely justified and, as it happens, soon to
be answered, perhaps in response to Morris's writing and sensibility. As a
matter of fact, the Thames features in a good many works of Victorian fic-
tion, though rarely romanticized in Morris's way. The outstanding exam-
ple is the later novels of one of Morris's heroes, Charles Dickens. Dickens's
Thames, however, is not the pastoral dream of Morris's Oxfordshire but
the mighty, polluted, tidal river, recently embanked, that flows through
the Port of London. It stands for the harsher realities of nineteenth-
century life – the brutal competition, exploitation, crime, smog, filth and
despair. In *Great Expectations* (1860–1), it flows from the City to the des-
olate marshes on either bank of the estuary, while *Our Mutual Friend*
(1864–5) centres on the poisoned waterway that ran through the slums of
the East End with the corpses of suicides afloat on it. There is reason to
think that Morris had *Our Mutual Friend* in mind when he wrote *News
from Nowhere*, because one of his characters, an occasional ferryman, is
nicknamed Boffin, the name of 'the Golden Dustman' in Dickens's book,
a figure of complex significance.[4] This inescapably reminds us of those
aspects of the Thames that Morris excludes from his book, rather as the

Prologue to *The Earthly Paradise* reminds us of 'the hideous town' (iii.3) by urging us to forget it. Morris the conservationist and Morris the socialist are alike revolutionary in their insistence on the possibility of a better world, thereby discouraging representations of the abused world we actually live in and may hope to change. Whether this is a flaw in Morris or not, it may cause us to connect his imaginative writings with his work as a designer. In this context, the work of Morris & Company can also be seen as of revolutionary significance. By representing natural forms exclusively and in their full beauty, the designer reminds us that we live – did we but know it – in paradise.

Morris implicitly comments on this in the opening of an essay written for the *Commonweal*, 'Under an Elm-tree; or, Thoughts in the Countryside' (1889):

> Midsummer in the country … And all, or let us say most things, are brilliantly alive. The shadowy bleak in the river down yonder, which is – ignorant of the fate that Barking Reach is preparing for its waters – sapphire blue under this ruffling wind and cloudless sky, and barred across here and there with the pearly white-flowered water-weeds, every yard of its banks a treasure of delicate design, meadowsweet and dewberry and comfrey and bed-straw – from the bleak in the river, amongst the labyrinth of grasses, to the starlings busy in the new shorn fields, or about the grey ridges of the hay, all is eager, and I think all is happy that is not anxious.[5]

The passage seems to have been sparked off by an Arcadian summer day beside the Upper Thames, with Morris the designer of floral patterns relishing a glimpse of paradise, yet unable entirely to forget the fate awaiting the rural stream in the East End of London, the two words 'Barking Reach' being enough to evoke the grimness of the Victorian city and the mighty river pushing through to the sea.

Morris's call for books celebrating the Thames was being answered even as he wrote and, partly through his influence, the publication of such writings – already considerable despite Guest's complaint – gathered pace soon after his death. One wonders if Morris had read 'The Modern Thames', an essay by the novelist and nature writer Richard Jefferies, which appeared in Jefferies' collection *The Open Air* in 1885. Morris was impressed by Jefferies' dystopian novel *After London; or Wild England* (also of 1885), which imagines an England fallen back into wilderness and barbarity, almost the polar opposite of Morris's romance, but sharing some of its preoccupations. Jefferies' essay, a near-idyllic account of boating on the river, anticipates the boat trip in *News from Nowhere*, though Jefferies' vulnerable riverscape is constantly under threat from precisely those agencies that

Morris excludes from his – the profiteering exploiters, the holiday-makers, the boating parties. Like Morris, Jefferies was responding to the new craze for boating on the Thames, which followed the success of the Thames Conservancy Board in cleaning up the river in the 1860s and 70s. The popular humorist Jerome K. Jerome was similarly inspired; his vastly successful comic novel, *Three Men in a Boat*, was published in 1889, the year before *News from Nowhere* began appearing in the *Commonweal*. Between them, different as they are, Jerome and Morris seem to have spawned a remarkably varied range of books. Two of these books have become classics: *Heart of Darkness* by Joseph Conrad (1899), which though mainly about the Congo, begins with a scene of businessmen boating on the Thames, and *The Wind in the Willows* by Kenneth Grahame (1908), which includes the famous pronouncement that 'there **is** *nothing* – absolutely nothing – half so much worth doing as simply messing about in boats'.[6]

Shortly after Morris's death, a fashion developed for topographical works of a literary character, many of which are marked by his influence. The most notable was perhaps Macmillan's Highways and Byways series (many of them illustrated by such alumni of the Arts and Crafts movement as F. L. Griggs and E. H. New). Several of these include reflections on the Thames. The description of Hammersmith in the Middlesex volume leads us to the author's inspiration:

> Kelmscott House – with a name borrowed from a beautiful spot many miles upstream, on the furthest limits of Oxfordshire – which is on the Upper Mall, within the limits of London, was for nearly twenty years the residence of William Morris, the poet who sang of the *Earthly Paradise*, and who sought to bring an earthly paradise about by means of beautiful art and by striving towards a social ideal.[7]

It is as if Morris, in his life-long endeavour to turn dream into reality, had become in death the genius of the place.

A Life in the Thames Basin

Kelmscott Manor in Oxfordshire, which Morris took on as a country retreat in 1871, is situated (in his words) 'within a stone's throw of the baby Thames' (*CL*, i.153). Kelmscott House, purchased in 1878, is even nearer the river. But for the whole of his life, Morris lived and worked within reach of the Thames or one of its tributaries.

Walthamstow, a village on the outskirts of London when Morris was born there, is on the longest of the tributaries, the River Lea. In the course

of those sixty-two years, what he had known as a rural community was transformed into a working-class commuter suburb and, in the twentieth century, absorbed into Greater London. It was on the banks of the Lea and in nearby Epping Forest that the boy Morris acted out his medievalizing fantasies – often anchored to real survivals such as 'the Greate Standynge', the royal hunting lodge of 1542 – and 'the broad marshlands round the river Lea' (i.319) have a disturbingly symbolic role to play, not paradisal at all, in the strangest and most modern – which is to say, least medieval – of his so-called early romances, 'Frank's Sealed Letter' (1856).

Morris's education took him to Marlborough in Wiltshire, a fine old country town near the source of the River Kennet, which enters the Thames at Woolhampton in Berkshire. The school seems to have allowed him the freedom to explore the surrounding countryside with its unique collection of neolithic monuments: the stone circle at Avebury, West Kennet Long Barrow, Silbury Hill, and so on. He clearly found time to walk the Ridgeway – the prehistoric path that leads from the environs of Marlborough to Wantage on the Thames in Oxfordshire, not far from the setting of 'Under an Elm-tree'.

Already we can see an antithesis forming in Morris's imaginative life between the Upper Thames of unspoiled nature haunted by human antiquity and the broad tidal river that rolls through Westminster, the Port of London, and the estuary with the Essex marshes to the north and the Dickensian landscapes and townscapes of the Kentish coast to the south. Although Morris was conscious of that Dickensian dimension, it was the world upriver that drew his imagination, the counties of Berkshire, Oxfordshire, Gloucestershire and Wiltshire, near the junction of which, in 1871, he was to chance upon Kelmscott Manor. The next stage of his life took him further into his paradise by landing him in Oxford, still essentially a medieval city, described by the narrator of *A Dream of John Ball* (1886–7; 1888) as 'a vision of grey-roofed houses and a long winding street and the sound of many bells' (xvi.223). Still higgledy-piggledy with old buildings in everyday use and as yet no industrial developments, it was situated on two rivers: the Thames itself, traditionally referred to by Oxonians as the Isis, and the Cherwell, which rises in Northamptonshire and joins the Isis in Oxford.

But the need for an artistic career of some sort took Morris back to London and the Lower Thames. In 1860, soon after marrying Jane Burden, he moved from his lodgings in Holborn, just north of the river, to Red House at Upton in rural Kent, then a hamlet and now absorbed into the London Borough of Bexley – not far from the confluence of the River

Cray and the River Darent, which then flows north into the Thames near Dartford. When the family moved back to London – first to Bloomsbury, then to Turnham Green – they were obviously close to the river all the time. But Morris had little to say of that – except to express a desire to escape from it, as in the Prologue to *The Earthly Paradise* (1868–70):

> Forget six counties overhung with smoke,
> Forget the snorting steam and piston stroke,
> Forget the spreading of the hideous town;
> Think rather of the pack-horse on the down,
> And dream of London, small and white and clean,
> The clear Thames bordered by its gardens green;
> Think, that below bridge the green lapping waves
> Smite some few keels that bear Levantine staves,
> Cut from the yew wood on the burnt-up hill,
> And pointed jars that Greek hands toiled to fill,
> And treasured scanty spice from some far sea,
> Florence gold cloth, and Ypres napery,
> And cloth of Bruges, and hogsheads of Guienne;
> While nigh the thronged wharf Geoffrey Chaucer's pen
> Moves over bills of lading—mid such times
> Shall dwell the hollow puppets of my rhymes. (iii.3)

This paragraph includes a structure of thought typical of Morris. It begins with an example of *paralipsis*, the rhetorical figure whereby a writer, by seeming to dismiss a topic, draws it to our attention. Instructed to forget the smoke, the reader cannot help but call it to mind and, with it, the squalor and misery of industrial London in a bleakly competitive era. At the same time, as in most of Morris's imaginative writings, the chief motive is escape. He reminds us of 'the hideous town' but does not dwell on it, preferring to focus on a London of the past, imagined not as a fairy palace or the new Jerusalem, but as a credibly real place with a prosperously functioning economy, in which it is possible for a great poet to participate, as Chaucer probably did. With a touch of the technical skill for which Morris the poet is rarely credited, it is Chaucer's *pen* which hovers at the end of the fourteenth line, so that we anticipate work on the poem he is writing rather than what we get, his role in the state bureaucracy, thus suggesting a possible society – not a fantastic one – in which art and economics are in harmony, and exotic beauty co-exists with flourishing trade.

At the same time, this is not the evocation of a real time and place, but an attempt to describe a society the poet imagines to be possible: not a fantasy, but a kind of retrospective utopia. The picture of village London

with its clear river and clean buildings is not of a place that ever existed, though with a change of heart (as Morris might have thought in 1868) or a revolution (as he was later to believe) it might become possible in the hoped-for future. The real source of it is in the illuminated manuscripts of fourteenth- and fifteenth-century Burgundy with their sparkling images of a real world cleansed of squalor and misery. In this way, the passage anticipates the garden city of the future, both as imagined under social-ism in *News from Nowhere* and in the social and architectural experiments inspired by Morris in the early twentieth century.

But then, largely by sheer good luck, Morris gained access to three riv-erside properties, all rich in association. He took out a lease on Kelmscott Manor, which he at once recognized as his 'heaven on earth' (*CL*, i.133), then, seven years later, a lease on Kelmscott House. Soon afterwards, in 1881, he bought the site of a cloth-printing works at Merton Abbey on the River Wandle, a picturesque setting for the Firm's factory which, including a dye-works, profited from the steady flow of water. For twenty-five years, that is to say, Morris both lived and worked a few yards from the Thames.

The Tributary Designs

Morris's love for the Thames had many sources – nostalgic, aesthetic, recreational, and practical. There were childhood associations; he felt deep love for the soft green landscape of the Upper Thames and the grey stone of its vernacular buildings; the river was often his main source of relaxation, since he loved to row and to fish; and it provided him with material for his work, both in the practical way – he learned to make natural dyes by boiling up willow twigs from the river banks, for instance – and as an inspiration for design work: the famous *Willow* design (1874), used for both wallpaper and printed fabric, owes everything to the riverside setting of 'THE OLD HOUSE BY THE THAMES'.[8]

He felt driven to defend the river against bureaucracy. Morris the defender of ancient buildings appears (for example) in the failed campaign to save the medieval Magdalen Bridge, spanning the Cherwell in central Oxford, from plans to rebuild it and widen the road.[9] That was in 1881. In the same decade, we find Morris the environmental campaigner at odds with – surprisingly – the Thames Conservancy Board, which had met with some success in cleaning up the river. In Morris's view, it was exceeding its brief by cutting down the wild flowers on the riverbanks 'and clear[ing] the stream of its pleasant flowering reeds and rushes...' (Henderson, 371). Earlier, in 1881, the painter William Blake Richmond

had combined with Morris to 'protest against the cutting down by the Board of an avenue of willows along the towpath between Hammersmith Bridge and Barnes – that is, on the opposite side of the river to Kelmscott House' (Henderson, 269).

Morris's attention to the riverside trees and flowers brings to mind his work as a designer of floral patterns with their intense feeling for the particulars of nature. Between 1883 and 1885, the period of his struggles with the Conservancy Board, he designed nine printed fabrics which bear the names of nine Thames tributaries: *Evenlode, Wey, Loddon. Kennet, Windrush, Wandle, Cray, Lea* and *Medway* (see Figure 4.1).

It is hard to say what precisely is to be understood by these names. Morris's designs for rugs, textiles, and wallpapers were usually named after a dominant motif – *Daisy* or *Trellis* and (more playfully) *Brother Rabbit* or *Strawberry Thief*. The tributary designs appear to call on associations with named locations. Predominantly floral, like most of the Firm's textile designs, they no doubt represent flowers observed in the localities in question, including perhaps the very flowers that were always being cut down. At the same time, like the flowers in other Morris designs, they evoke the paradisal potential of the Thames basin, the dangers and filth of the lower river being (as one would expect in decorative work) absent. Moreover, as one writer puts it, 'the marked diagonal characteristic of so many patterns from 1883 to 1890 – both in wallpapers and in printed chintzes such as *Wey, Evenlode* and *Wandle* – almost certainly derived from the similar design structure of a fine piece of Italian cut velvet which the [South Kensington] Museum acquired in 1883'.[10] This diagonal emphasis enabled Morris to generate a flowing rhythm, as of floodwater tugging at vigorously thriving flowers.

Unlike many of the most progressive designers of his day – Christopher Dresser, Owen Jones, and others – Morris was not in favour of abstract patterns. He argued that the purpose of decorative art was to *remind* us of things that please us in the natural world, but to do so by simplifying natural forms and restricting the scope of evocation, so that no discomfort or anxiety is felt and nothing is allowed to disturb our well-being. This is why Morris speaks of the decorative arts, in the title of a seminal lecture, as 'The Lesser Arts' (1877) (xxii.3–27) in contrast to the fine arts, which are open to the whole of life – to suffering as much as to joy – and his own art is so enduringly effective precisely because, evocative as it is, it only goes so far.

Morris's tributary designs typify his understanding of decorative art and its purposes. Reminding us of the beauties of the riverside ecology, they evoke the paradise that might be, if only the ills of life could be excluded – as if to say in the words of *The Earthly Paradise*:

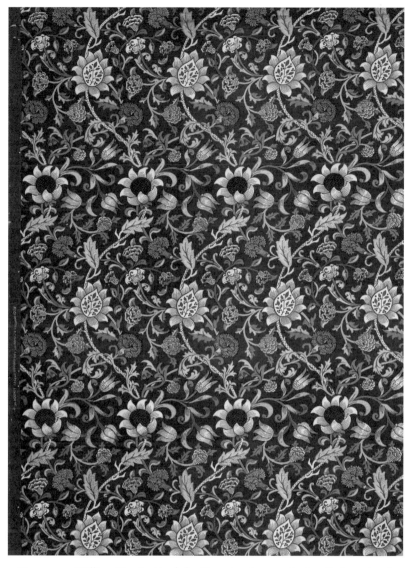

Figure 4.1 William Morris, *Evenlode*, 1883, printed cotton (indigo discharged and block printed); courtesy of the Whitworth, University of Manchester

thou couldst not know
To what a heaven the earth might grow
If fear beneath the earth were laid,
If hope failed not nor love decayed.

('The Love of Alcestis', iv.95)

When the purpose is decoration, the exclusion of great and complex human emotions cannot be condemned as escapism. As Morris says in his lecture 'Some Hints on Pattern-Designing' (1881):

> it is good for us all that [great art] should be at hand to stir our emotions: yet its very greatness makes it a thing to be handled carefully, for we cannot always be having our emotions deeply stirred ... therefore we must provide ourselves with lesser (I will not say worse) art with which to surround our common workaday or restful times; and for those times, I think, it will be enough for us to clothe our daily and domestic walls with ornament that reminds us of the outward face of the earth, of the innocent love of animals, or of man passing his days between work and rest as he does. (xxii.176–7)

Man, he goes on to say, is 'an animal that longs for rest like other animals' (xxii.177), and 'rest' is a word that Morris returns to, both in this lecture and elsewhere, rather as he returns to certain other generalities, which, appearing vague, turn out to be deeply pondered: growth, hopes, fears and, the word to which rest is complementary, work. One of Morris's late poems, 'For the Bed at Kelmscott' (1893), begins with the loved riverside landscape disturbed by wild weather. But the old grey house and his bed at the heart of it are safe from pain and anxiety:

> The wind's on the wold
> And the night is a-cold,
> And Thames runs chill
> Twixt mead and hill,
> But kind and dear
> Is the old house here (xxiv.417)

And he concludes:

> Night treadeth on day,
> And for worst or best
> Right good is rest. (xxiv.417)

The most important of Morris's last literary works, *News from Nowhere* (1890; 1891), is subtitled *An Epoch of Rest*. It reminds us that good work generates satisfying rest, and asks us to imagine a period of release from capitalism and the burdensome toil it generates. The release, though, is more than a holiday. The citizens of Nowhere have awakened to a new condition of life in which there are no holidays, because work itself has become a source of pleasure.

News from Nowhere

There must have been symbolic value for Morris in the relation between one Kelmscott and the other, uniting the rural stream in the Cotswolds with the great metropolitan waterway – two dimensions of his life and personality. In 1880, he decided to celebrate the link by bringing together a party of family and friends and rowing from Hammersmith to Oxfordshire. It was also an occasion for 'fellowship', a high value in Morris's life and work. 'Fellowship is life', he says in *A Dream of John Ball* (xvi.230).

But more than that, there was the joy of being on the river, leaving London and the tidal river behind and making for its source – penetrating, as it were, the interior. The season was also important: the weather was June at its best and haymaking was underway on the farmland they passed – haymaking providing a traditional occasion for rejoicing and celebration after days of back-breaking communal labour, everyone working to help one another.

All these things resurfaced a decade later in *News from Nowhere*. William Guest's journey through Nowhere falls into three parts: the journey by cart from Hammersmith to Bloomsbury, his interrogation of Old Hammond (metaphorically a journey) and the boat-trip from London to the Upper Thames. It is the third part that concerns me here. The first two journeys have ends in view, the third does not. It is an archetypal voyage, in which Guest seeks not a particular place or object, but the source of his (or Morris's) emotion. The country around Kelmscott Manor – the Cotswold Hills, the source of the Thames, perhaps the city of Oxford – has sometimes been called 'the heart of England', but Morris is concerned with England not as a nation but as the name given to a certain piece of nature, a chunk of earth. The climax of the book may be said to come when Guest and Ellen arrive at the house we know to be based on Kelmscott Manor.

> She led me up close to the house, and laid her shapely sun-browned hand and arm on the lichened wall as if to embrace it, and cried out, 'Oh me! Oh me! How I love the earth, and the seasons, and weather, and all things that deal with it, and all that grows out of it, – as this has done!' (xvi.201–2)

The passage, with its strongly erotic charge, is surely meant to recall an earlier passage in which Hammond is speaking of the life that directly followed the revolution:

> The spirit of the new days, of our days, was to be delight in the life of the world; intense and overweening love of the very skin and surface of the earth on which man dwells, such as a lover has in the fair flesh of the woman he loves… (xvi.132)

What these passages suggest is that, most of the time, commercialism inhibits such vitality, getting between desire and the object of desire, and that the purpose of politics – whether that means the ill-tempered arguments with which *News from Nowhere* begins or the revolutionary violence that brings the changed society to birth – is to bring about a new order in which politics is no longer necessary. It is like returning to childhood.

And it is usually to the Thames or to his childhood by the Lea that Morris returns when he tries to capture the reality of the earthly paradise. There is just one moment in *News from Nowhere* when Guest finds himself alone in paradise and at peace. It is when he wakes in Ellen's house after the first day of the boat trip:

> I wandered down over the meadow to the river-side, where lay our boat, looking quite familiar and friendly to me. I walked up stream a little, watching the light mist curling up from the river till the sun gained power to draw it all away; saw the bleak speckling the water under the willow boughs, whence the tiny flies they fed on were falling in myriads; heard the great chub splashing here and there at some belated moth or other, and felt almost back again in my boyhood. (xvi.154)

This recalls the passage from 'Under an Elm-tree' quoted earlier; both passages perhaps record a recent epiphany that briefly restored a moment of childhood blessedness. It is, at any rate, the world untouched by commerce on the one hand and politics on the other. It is the heaven on earth that Morris associates with the Thames and its tributaries and the life on their banks.

Morris is often said to have cared for physical things – for natural phenomena and human artefacts – as much as he cared for people. If this is so, it should be added that they were almost always specific things. No doubt he subscribed to Romantic doctrines of the love of nature, but he had little to say of such Wordsworthian generalities as 'meadow, grove, and stream,/ The earth, and every common sight'.[11] In the passage just quoted from *News from Nowhere*, he is emotionally stirred by particulars – by willow boughs, 'the bleak', the great chub, some tiny flies, the belated moth. Through these things, taken together, he recovers a child's freedom from adult cares, which is also freedom from want and a society shaped by the profit motive. That freedom, Morris seems to think, is the only true happiness and, if it were universal, the world could resume its original condition, which is the paradise of myth: the Golden Age and the Garden of Eden. Being a lover of particulars, though, Morris can only envision paradise as a real place. For him, that place was always the Thames valley.

Notes

1 William Morris, *News from Nowhere* (Hammersmith: Kelmscott Press, 1892), 264 (marginal rubrication).
2 Sir John Denham, 'Cooper's Hill', in *The Poetical Works of Sir John Denham* (New Haven: Yale University Press, 1928), 75.
3 Jeremy Lewis, Introduction to Jerome K. Jerome, *Three Men in a Boat* (London: Penguin, 2004), xvii. I am indebted to this informative essay throughout.
4 Charles Dickens, *Our Mutual Friend*, ed. Michael Cotsell (Oxford: Oxford University Press, 2008), 210.
5 *Commonweal*, 5.182 (6 July 1889), 212.
6 Kenneth Grahame, *The Wind in the Willows*, 39th ed. (London: Methuen, 1931), 8.
7 Walter Jerrold, *Highways and Byways in Middlesex* (London: Macmillan, 1909), 381–2.
8 Morris, frontispiece, *News from Nowhere*.
9 See Tony Pinkney, *William Morris in Oxford: The Campaigning Years, 1879–1895* (Glyndŵr, Grosmont: Illuminati Press, 2007), 25–45.
10 Norah C. Gillow, Introduction to William Morris, *Designs and Patterns* (London: Bracken Books, 1988), 5.
11 William Wordsworth, 'Ode: Intimations of Immortality from Recollections of Early Childhood', in Stephen Gill (ed.), *William Wordsworth* (Oxford: Oxford University Press, 1984), 297.

PART II

Authorship

Experimental Medievalism
The Defence of Guenevere and Other Poems (1858)

Martin Dubois

William Morris's first book of poetry, *The Defence of Guenevere and Other Poems*, was the earliest volume of Pre-Raphaelite poetry to appear. Christina Rossetti and Swinburne did not publish their first volumes until 1862 and 1866 respectively; Dante Gabriel Rossetti not until 1870. While the Pre-Raphaelite presence in the visual arts was by this point established enough to have entered a second phase, Pre-Raphaelite poetry remained unknown in print outside of magazines. This made for a difficult early reception for Morris's volume. Poems that had been lauded within his circle encountered scepticism beyond it, in part because of Morris's medievalism. *The Defence of Guenevere* reworks chivalric legends and histories drawn particularly from Thomas Malory's version of Arthurian legend, *Le Morte D'Arthur* (1485), and Jean Froissart's fourteenth-century record of the Hundred Years War in the *Chronicles*. These were familiar sources for the Victorian medieval revival, Malory especially, but Morris's treatment appeared recondite to some of the volume's more hostile reviewers. Considering that 'a poet's work is with the living world of men', the *Saturday Review* objected that *The Defence of Guenevere* offered only 'pictures of queer, quaint knights, very stiff and cumbrous, apparently living all day in chain armour, and crackling about in cloth of gold – women always in miniver, and never in flesh and blood'.[1] A more frequent complaint concerned the manner of Morris's writing. In the volume's combination of 'fantasy on stilts and common-place lying flat', the *Athenaeum*'s reviewer found 'not inspiration', but 'stark, staring nonsense'.[2] '[T]he style is as bad as bad can be', lamented the *Spectator*: 'Mr. Morris imitates little save faults. He combines the mawkish simplicity of the Cockney school with the prosaic baldness of the worst passages of Tennyson, and the occasional obscurity and affectation of plainness that characterize Browning and his followers.'[3] For the *Saturday Review*, the poems had the 'disadvantage of having no story to tell, and of telling the no-story by broken hints and jerks of allusion, and what is meant to be suggestive'.[4]

Such strangeness is now more likely to appear as the volume's special quality. Morris's verbal cuts and disrupted story-telling begin early in *The Defence of Guenevere*, with the opening line of the title poem beginning mid-scene: 'But, knowing now that they would have her speak, | She threw her wet hair backward from her brow' (i.1). Here, as also in a later poem, 'Concerning Geffray Teste Noire', which likewise starts with a conjunction – 'And if you meet the Canon of Chimay' (i.75) – there are no preliminaries: we are instead thrust into action or speech seemingly already underway. Mostly compact in scale, at least when seen against Morris's later turn to writing long narratives, these are poems indeed often left 'stark', as the *Athenaeum*'s reviewer noticed, offered without roundedness in story or scenario. Part of their challenge to poetic convention instead involves foregrounding more erratic processes of thought and memory. '[H]e's dead now—I am old', ends 'Concerning Geffray Teste Noire' (i.81), abruptly, with a contrast that explains little about the poem's subject, but in its suddenness discloses something of the unsteadiness of its speaker. Crucial here is the influence of Robert Browning's dramatic monologues on Morris, an influence Morris himself acknowledged: 'The Defence of Guenevere', in particular, is supposed to have been said by him to be 'More like Browning than any one else, I suppose' (Mackail, i.132). Of the poems in *The Defence of Guenevere*, only 'Concerning Geffray Teste Noire' has the full range of attributes usually claimed to represent the dramatic monologue in pure form, including the presence of a silent auditor and a specific situation for speech. Several others, however, are marked by Browning's example in offering dramatizations of voice that foreground individual self and psychology in their lack of accompanying context and in the marginalization of narrative content.

These poems also resemble Browning in the digressions and convolutions of the speech they represent. 'Concerning Geffray Teste Noire' has only a limited concern with Geffray Teste Noire, a real historical figure whose story Morris knew from Froissart's *Chronicles*. Its speaker, Sir John of Castel Neuf, is instead led to recall more fully and vividly a violent massacre witnessed in his childhood, as well as fantastical imaginings he once sprung from a pair of skeletons discovered while waiting in unsuccessful ambush for the bandit Geffray. Believing the skeletons to be the remains of a knight and his lady, Sir John first conjures their love and the circumstances of their deaths, before inserting himself into the fantasy:

> Your long eyes where the lids seem like to drop,
> Would you not, lady, were they shut fast, feel
> Far merrier? there so high they will not stop,
> They are most sly to glide forth and to steal

Into my heart; *I kiss their soft lids there,*
　And in green gardens scarce can stop my lips
From wandering on your face, but that your hair
　Falls down and tangles me, back my face slips.　(i.80)

In its contorted syntax and tangled speech, this might be the sort of passage had in mind by the *Saturday Review* when it complained of the deviation from story in Morris's poems by means of 'broken hints and jerks of allusion, and what is meant to be suggestive'. The effort to capture the bandit Geffray, ostensibly the poem's subject, recedes from view, giving way to something far stranger, a type of necrophiliac fantasy – a fantasy so intense and singular it requires to be isolated from the rest of the poem and placed in italics. Seen against its disturbing eroticism, Sir John's building of a memorial to house the remains of the doomed lovers, which (as the poem later describes) comes complete with a sculpture in which 'they lay, with stone-white hands | Clasped together' (i.81), appears less honouring than cleansing, an effort to dispel the haunting vision of the lady and the fascination held for him by her eyes, lips, face, and mouth. Morris again emphasizes the movement of mind at the expense of the development of narrative.

'Concerning Geffray Teste Noire' is far from the only poem in *The Defence of Guenevere* in which story is either deflected or stalled, whether by the exploration of alien and historically remote subjectivities or by the vivid strangeness of particular images and formulations of language. Both elements are present in 'The Wind', with the weirdness of its imagery making for a particularly enigmatic exploration of psychological disturbance and guilt. As he recalls the death of his lover, the poem's speaker is seated on a chair, on which apparently balances an orange, an orange 'with a deep gash cut in the rind':

If I move my chair it will scream, and the orange will roll out far,
And the faint yellow juice ooze out like blood from a wizard's jar;
And the dogs will howl for those who went last month to the war.　(i.107)

The malaise that induces such hallucinations remains obscure, as shame, violence, and sexual frustration twist together disjointedly and without resolution in the speaker's memories. So it is that, towards the end of the poem, when the orange falls exactly as had been feared, its rolling off the chair is described in lines that closely reprise the speaker's earlier foreboding: 'The faint yellow juice oozed out like blood from a wizard's jar; | And then in march'd the ghosts of those that had gone to the war' (i.109). Such a return to previous phrasing has the lines feel

less like a progression or development than as a kind of haunting by peculiar imagery.

A similar point might be made about the poem's refrain, a refrain that gives the poem its title: '*Wind! wind! thou art sad, art thou kind?* | *Wind, wind, unhappy! thou art blind,* | *Yet still thou wanderest the lily-seed to find*' (i.107). Refrains play a significant role in Morris's volume. Elizabeth K. Helsinger describes a 'concern with the conceptual and thematic possibilities of that which repeats, recurs, or resembles' as one of the main ways in which Pre-Raphaelite poets and artists sought to refresh modes of artistic and literary perception: the refrains that embellish the poems collected in *The Defence of Guenevere* fulfil exactly this function.[5] Most bear oblique or even incongruous relation to the surrounding text, such that attention becomes more nearly focused on the repetition of sequences of sound and imagery. The refrains include those that feature in the ballads 'The Sailing of the Sword', which has the refrain '*When the sword went out to sea*' (i.102), and 'The Tune of Seven Towers', which has the refrain '"*Therefore,*" *said fair Yoland of the flowers,* | *"This is the tune of Seven Towers*"' (i.114) ('*Therefore*' as a logical connective in this case puzzles rather than clarifies). Perhaps most memorable is the refrain in 'The Gilliflower of Gold', a poem Ezra Pound in the early twentieth century was recalled to have read in unique style, 'in an orchard under blossoming—yes, they must have been blossoming—apple trees', by his fellow modernist poet (and one-time fiancé) Hilda Doolittle: 'He literally shouted "The Gilliflower of Gold" in the orchard. How did it go? *Hah! Hah! la belle jaune giroflée.*'[6] '*Hah! Hah! la belle jaune giroflée*' (i.90): the refrain may be owed to the image that sustains the speaker on his way to victory in a knightly tournament, of a woman with her head 'Bow'd to the gillyflower bed, | The yellow flowers stain'd with red' (i.91), but as the memory of Pound's recitation suggests, its resonance goes beyond any role in the progression of the poem's story. Repetition here extends rather than explains the suggestiveness of the poem's central image.

Given the nature of that image, part of the effect is also to foreground patterns of colour, another important aspect of Morris's method. Colour animates and structures the speaker's work of memory in 'The Gilliflower of Gold' – as it does in several of the poems in *The Defence of Guenevere*. Morris's volume participates in the Pre-Raphaelite ambition to reconceive relations between the verbal and the visual: his writing has an intensely pictorial quality. This is most evident in poems that take direct inspiration from paintings by the volume's dedicatee, Dante Gabriel Rossetti, as is the case for 'The Blue Closet', 'The Tune of Seven Towers', and likely

also 'King Arthur's Tomb', each of which in different ways has visual detail and patterning offset narrative directness and clarity (Morris had himself commissioned two of the Rossetti works on which these poems are based, the watercolours *The Blue Closet* and *The Tune of the Seven Towers*, both dating from 1857). But the visuality of *The Defence of Guenevere* also extends beyond Morris's Rossetti-inspired works to other poems in the volume that engage colour symbolism and imagery. One such poem is 'Golden Wings', which breaks its description of a lady's sorrow at the absence of her knightly lover to imagine the 'wild words' with which she desires his return:

> Gold wings across the sea!
> Grey light from tree to tree,
> Gold hair beside my knee,
> I pray thee come to me,
> Gold wings!
>
> The water slips
> The red-bill'd moorhen dips.
> Sweet kisses on red lips;
> Alas! the red rust grips,
> And the blood-red dagger rips,
> Yet, O knight, come to me! (i.119)

Emotional extremity is here represented by vividness of colour, with the shift from shining gold to lurid red suggesting a movement between opposed poles of feeling. What matters in these lines may be less the items detailed or the actions recorded – the grouping of which is lent an arbitrary aspect by the tripping rhymes – than the visceral rendering of colour to evoke psychological disturbance. The same colours return quite differently later in the poem, at the point at which the speaker of the earlier lines, Jehane du Castel beau, takes charge of her situation, depart-ing sword in hand from the castle in which she has until now forlornly awaited her lover:

> O Jehane! the red morning sun
> Changed her white feet to glowing gold,
> Upon her smock, on crease and fold,
> Changed that to gold which had been dun. (i.122)

Jehane's decision to act will eventually lead to her death, but in this moment of freedom it elevates and glorifies. Pre-Raphaelite painters achieved a brilliantly luminous colouring by applying undiluted colours

on to a white, still wet, background; Morris seeks here to attribute Jehane's transcendence of her situation with an equivalent lustre and intensity. It is an effort to foster in poetry the expressiveness of colour that featured so largely in Pre-Raphaelite visual art.

The change that comes upon Jehane arrives at dawn, as is typical for Morris in *The Defence of Guenevere*. His volume is repeatedly drawn to the interstices of night and day: to the time (as described in 'Rapunzel') when '[i]t grows half way between the dark and the light' (i.69). 'Summer Dawn' is another poem to be set at the moment when 'The summer night waneth, the morning light slips' (i.144), as is 'The Wind': 'For the dawn just now is breaking, the wind beginning to fall' (i.107). 'He did not die in the night, | He did not die in the day', we are told of the execution of the knight Sir Hugh in 'Shameful Death':

> But in the morning twilight,
> His spirit pass'd away,
> When neither sun nor moon was bright
> And the trees were merely grey. (i.92)

The importance of the period 'twixt the light and shade', as it is called in 'Rapunzel' (i.72), lies for Morris in its uncertainty, as a time in which the dream-world of the night encounters but is not yet overcome by the clarity of the day. The promise and possibility of dreams persist at such moments, as the prince in 'Rapunzel' finds:

> I must have had a dream of some such thing,
> And now am just awaking from that dream;
> For even in grey dawn those strange words ring
> Through heart and brain, and still I see that gleam. (i.64)

'Rapunzel' was singled out for unhappy notice in the review of *The Defence of Guenevere* that appeared in the *Athenaeum*, disparaged as a tale of 'enchantment' that illustrated everything wrong with Morris's method: for the *Athenaeum*'s reviewer, the poem showed how Morris had taken Tennyson's model in 'The Lady of Shalott' (1833), a model that already 'quivers on the furthest verge of Dream-land to which sane Fancy can penetrate', and developed it to new excess.[7] But for all that *The Defence of Guenevere* is undoubtedly occupied with the power and possibility of dreams, the medieval world Morris imagines into being is actually the opposite of ethereal or insubstantial. Instead, it is fraught with passion, cruel violence, and treachery: a world of disturbing intensity and extremity.

The contrast with Tennyson's medievalism is revealing here. While clearly indebted to Tennyson's early reworkings of Arthurian material in 'The Lady of Shalott' and 'Morte D'Arthur' (1842), *The Defence of Guenevere* offers a harsher, fiercer, less pristine interpretation of the life of the Middle Ages. The harshness is already apparent in the poems that, like Tennyson, have their source in Malory's *Le Morte D'Arthur*; but it comes to the fore especially in those either derived from or inspired by Froissart's *Chronicles*. This is nowhere more the case than in the stunningly brutal violence of 'The Haystack in the Floods'. The poem describes the ambush of Jehane, a Frenchwoman, and her English lover, Robert, as they attempt to escape French territory after the English defeat at the battle of Poitiers. They are captured by the French knight Godmar, apparently a rival for Jehane's love, who faces her with a terrible dilemma: either she gives herself to Godmar, and Robert's life is saved, or she will see Robert immediately put to death. This is to choose between 'sin and sin' (i.126), as Jehane recognizes; but eventually she refuses Godmar, and reaches out, in an act of parting, for Robert's touch. Godmar's response is sudden and savage:

> With a start
> Up Godmar rose, thrust them apart;
> From Robert's throat he loosed the bands
> Of silk and mail; with empty hands
> Held out, she stood and gazed, and saw
> The long bright blade without a flaw
> Glide out from Godmar's sheath, his hand
> In Robert's hair; she saw him bend
> Back Robert's head; she saw him send
> The thin steel down; the blow told well,
> Right backward the knight Robert fell,
> And moaned as dogs do, being half dead,
> Unwitting, as I deem: so then
> Godmar turn'd grinning to his men,
> Who ran, some five or six, and beat
> His head to pieces at their feet. (i.128)

The focus of the poem is above all on Jehane's decision, and its result is witnessed emphatically from her perspective, in lines that insist on her viewpoint ('she stood and gazed, and saw', 'she saw him bend', 'she saw him send'). Although he invites sympathy for the impossibility of the choice, Morris does not allow it much dignity: the manner of Jehane's refusal has been subdued, appearing 'strangely childlike' (i.127), and the report of the death that follows is unsparing in its rendering of Robert's humiliation

(the comparison of his cry to the moaning of dogs is an especially cruel detail). The poem ends not only without moralizing the events described, but adopts something like the 'bald' style resented by Morris's early reviewers. Its conclusion has an almost exaggerated flatness that seems to underline the refusal to draw out a lesson from what the poem has narrated: 'This was the parting that they had | Beside the haystack in the floods' (i.128).

The violence of 'The Haystack in the Floods' may be extreme, but the poem is typical of *The Defence of Guenevere* in how it treats of the pastness of the medieval. Here Morris's difference from Tennyson is again significant: 'The Haystack in the Floods' is a long way removed from both the allegorized insubstantiality of 'The Lady of Shalott' and the idealized chivalric and moral code of Tennyson's *Idylls of the King*. Whereas *Idylls* imbues the Arthurian legend with the gentlemanly values and imperial ambition of Tennyson's own day, Morris's poems achieve a stranger, starker effect that instead accentuates the distance of the medieval from the Victorian. The unlikeness of the past is what ensures the volume's freedom from existing conceptions.

The difference of the medieval is seen in the ferocious and chaotic violence of 'The Haystack in the Floods' and a number of other poems; it is also apparent in Morris's attention to transgressive sexuality, most famously in the title poem, 'The Defence of Guenevere'.[8] This poem, which counts among Morris's best-known and widely anthologized works, is one of several in *The Defence of Guenevere* to be concerned with the nature of female desire. Part of the poem's fascination is that it stands out in a crowded field. The Guinevere legend featured heavily in the Victorian medieval revival, notably in Tennyson's *Idylls*, but also in a host of other literary and artistic works drawn to the possibility of exploring the status of the fallen and adulterous woman at large historical distance ('Guinevere's prominence in the British cultural imaginary of adultery makes her Madame Bovary's more potent double', comments Stefanie Markovits).[9] In Tennyson's rendering, marriage is the bedrock of the social order, with Guinevere's illicit liaison endangering not just her own personal relations, but the harmony of the culture at large: she is likened by Arthur in his famous denunciation of her to 'a new disease' that 'Creeps, no precaution used, among the crowd', poisoning 'half the young'.[10] Morris's formal experimentation, developed from Browning's example, affords a quite different treatment of the same legend. The monologue-like structure means the bulk of the poem is given over to Guenevere's speech, a speech given 'with no more trace of shame' over her adultery with Launcelot, but instead 'With passionate twisting of her

body there': 'Whatever may have happen'd these long years', she tells her accuser Gauwaine, 'God knows I speak truth, saying that you lie!' (i.2). It may be too simple to say that the poem is a vindication of Guenevere, for as with Jehane's fateful decision in 'The Haystack in the Floods', Morris's emphasis appears to be rather on the emotional charge than the moral basis of individual action. Guenevere's defence, for all its feeling and openness, is also by her own account incomplete: 'By God! I will not tell you more to-day', she declares, breaking off, 'Judge any way you will— what matters it?' (i.10). But the truth or otherwise of the claim made against her is not, in the end, the poem's main focus: more significant is the passion and defiance of her speech. Aside from the poem's framing by an unnamed speaker at its start and end, hers is the only voice we hear in the poem (we know of the accusations made by Arthur's knights by Guenevere's report of them). What fascinates Morris is above all the revelation of individual psychology made possible by a situation of such intense tension and depth of emotion.

His most striking innovation is that Guenevere's passionate sexuality, rather than representing for her a source of guilt, is made a reason for her defiance. From the very start of the poem, even in advance of her speech, Guenevere's body is alive with feeling:

> But, knowing now that they would have her speak,
> She threw her wet hair backward from her brow,
> Her hand close to her mouth touching her cheek,
>
> As though she had had there a shameful blow,
> And feeling it shameful to feel aught but shame
> All through her heart, yet felt her cheek burned so,
>
> She must a little touch it; (i.1)

At the moment at which she is expected to offer her plea, Guenevere remains silent; the conflict in her emotions is instead realized through the movements of her body. Its contortions are mirrored by those of the verse itself, in frequent and idiosyncratic departures from the iambic pattern of the poem's terza rima metre: Walter Pater might have been thinking of these same opening lines when he described 'The Defence of Guenevere' as 'a thing tormented and awry with passion, like the body of Guenevere defending herself from the charge of adultery, and the accent falls in strange, unwonted places with the effect of a great cry.'[11] To adapt Pater's remark, the poem's opening already indicates how Guenevere's body will be her defence, for it immediately registers the intensity of the

physical and sensory life she experiences, describing a touch that appears more like a mode of emotional perception in itself than a secondary reflection of a mental state. Her marriage, she goes on to explain, was the product merely of 'Arthur's great name and little love' (i.3), and thus a distortion of her bodily nature. This nature Guenevere displays to her audience of knights:

> "Therefore, my lords, take heed lest you be blent
>
> "With all this wickedness; say no rash word
> Against me, being so beautiful; my eyes,
> Wept all away to grey, may bring some sword
>
> "To drown you in your blood; see my breast rise,
> Like waves of purple sea, as here I stand;
> And how my arms are moved in wonderful wise,
>
> "Yea also at my full heart's strong command,
> See through my long throat how the words go up
> In ripples to my mouth; how in my hand
>
> "The shadow lies like wine within a cup
> Of marvellously colour'd gold; yea now
> This little wind is rising, look you up,
>
> And wonder how the light is falling so
> Within my moving tresses: will you dare,
> When you have looked a little on my brow,
>
> To say this thing is vile?" (i.8)

The association of beauty with goodness was traditional in medieval culture, but Morris has Guenevere play on it in sensual rather than spiritual manner, drawing the gaze of her listeners to her body as she enumerates the appeal of its different parts. This appeal draws on Morris's familiar evocation of strong feeling by vivid colour. It also extends in unlikely directions: so powerful is the charge of Guenevere's sexuality that even her production of speech is made to seem erotic ('See through my long throat how the words go up | In ripples to my mouth'). The poem's monologue-like form is not of a kind to yield a decisive view of her transgression – 'The Defence of Guenevere' cannot quite be called a defence of Guenevere – but Morris's inclusion of this proud affirmation of physicality shows his difference from the Victorian medievalism that sought to secure cherished values of the present day by anchoring them in an imagined national past.

The modernity of this and other poems included in Morris's *The Defence of Guenevere* comes instead from their disruptive distance from nineteenth-century ideals.

It would be another eight years after *The Defence of Guenevere* before Morris published another volume of poetry. This came in a very different guise to *The Defence of Guenevere*. *The Life and Death of Jason* (1867) signals a turn in Morris to the long narrative as the preferred form of his poetic writing. In contrast to *The Defence of Guenevere*, *The Life and Death of Jason* was generally well received, as was the poem Morris began to publish the year after, of which *The Life and Death of Jason* had originally formed a section, *The Earthly Paradise* (1868–70). That the respective fortunes of these volumes were reversed in the twentieth century, so that poems from *The Defence of Guenevere* came to be valued above Morris's narrative works, is owed partly to the frustration that arose in this period with the perceived artificiality of his later poetry and prose romances ('The realism which was the very salt of Morris's youthful poetry is deliberately abandoned', E. P. Thompson, writing in 1955, commented of Morris's change to long narrative poetry, 'and the tension between the closely-imagined detail and the atmosphere of dream is broken' (*WMRR*, 118)). It was also, however, the result of a growing appreciation of the experimentalism of Morris's first volume, and of its avoidance of idealization. When in 1940 Virginia Woolf witnessed the banks of the River Ouse burst after damage from bombing, it was to Morris that she turned to describe a scene of strange allure. 'The haystack in the floods is of such incredible beauty', Woolf noted in her diary of a local farmer's haystack, risen above the water, 'Oh may the flood last for ever—a virgin lip; no bungalows; as it was in the beginning.'[12] And in a letter to her friend Ethel Smyth, she wrote: 'to my infinite delight, they bombed our river. ... It was, and still is, an island sea, of such indescribable beauty ... how I love this savage medieval water.'[13] In Morris's coupling of brutality with melancholic beauty, Woolf found a means of orienting herself to the mixed feelings this instance of war's destruction inspired in her. 'How I love this savage medieval water': Woolf's imagining of the river's ferocious reclamation of the land as a redress of the medieval past to the present moment is deeply authentic to Morris's example. The manner of experimentation seen in *The Defence of Guenevere* may not have been repeated in Morris's writing thereafter, but in the next century it would ensure for this earliest of his literary works an influence and significance unique among all of his poetry.

Notes

1 'Morris's Defence of Guenevere', *Saturday Review*, 6.160 (November 1858), 506–7 (507).

2 [Henry Fothergill Chorley], 'The Defence of Guenevere, and Other Poems', *The Athenaeum*, 1588 (April 1858), 427–8 (428).

3 Unsigned notice, *The Spectator*, 31.1548 (February 1858), 238 (238).

4 'Morris's Defence of Guenevere', 507.

5 Elizabeth K. Helsinger, *Poetry and the Pre-Raphaelite Arts: Dante Gabriel Rossetti and William Morris* (New Haven: Yale University Press, 2008), 6.

6 H. D., *End to Torment: A Memoir of Ezra Pound*, ed. Norman Holmes Pearson and Michael King (New York: New Directions, 1979), 22–3.

7 [Chorley], 'The Defence of Guenevere', 427.

8 Morris's spelling is 'Guenevere': I keep to this except when discussing the legend generally, and Tennyson's interpretation of it, when I use the more common 'Guinevere'.

9 Stefanie Markovits, *The Victorian Verse-Novel: Aspiring to Life* (Oxford: Oxford University Press, 2017), 65.

10 Alfred Tennyson, 'Guinevere', in *The Poems of Tennyson*, ed. Christopher Ricks (Harlow: Longman, 1987), ll. 515–16; 519.

11 [Walter Pater], 'Poems by William Morris', *Westminster Review*, 34.2 (October 1868), 300–12 (301).

12 Cited in Emily Kopley, *Virginia Woolf and Poetry* (Oxford: Oxford University Press, 2021), 291.

13 Ibid., 291.

Troubling the Heroic Ideal
Morris's Midlife Poetry

Florence S. Boos

In the six years between 1867 and 1873, William Morris composed an astounding quantity of his best poetry – *The Life and Death of Jason* (1867), a poetic epic; *The Earthly Paradise* (1868–70), a twenty-five-tale poetic narrative united by a meditative frame; and *Love Is Enough* (1872), an allegorical masque on the topic of love (despite repeated frustrations), as well as several additional long narratives and personal lyric poems largely unpublished in his lifetime. Still in his thirties, Morris repurposed the poetic forms and legends of prior European traditions for what he viewed as the urgent needs of his own age. 'Of Heaven or Hell I have no power to sing', *The Earthly Paradise*'s speaker proclaims at the outset of his epic as Morris's poems of the period confront the question: In the absence of the orthodox religious and political ideals that suffused past literature, how can a modern poet best represent the struggles of his contemporaries toward meaningful lives? Is heroism still possible and, if so, what should be its qualities? Paradoxically, even as his answers celebrate myth and romance as models for present-day living, they proclaim the need for individuals to accept incompletion and partial defeat in the service of ultimate aims. Rather than offering solutions, then, literature provides companionship: empathizing with others who have faced similar impasses in the past can embolden individuals to act, knowing that their lives form part of a communal, transhistorical pattern.

Though later admired for its originality and intensity, Morris's first volume of poetry, the *Defence of Guenevere* (1858), had faced mixed reviews. Critics found its medievalism affected, its language abrupt, and its plots obscure – one reviewer even professed to be unable to make sense of 'Rapunzel', a poem based on the well-known fairy tale of that name.[1] In response, Morris stubbornly preserved the medievalism and historicism central to his ideals, but henceforth strove to make his plots more accessible by providing fuller contexts and frames. *The Life and Death of Jason* and *The Earthly Paradise* are remarkably lucid – as his friend Swinburne

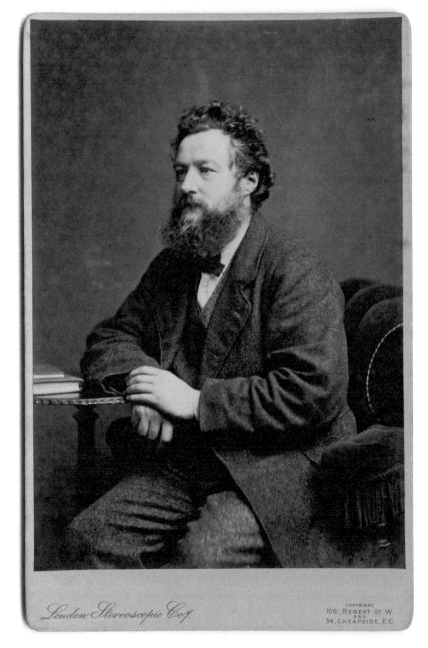

Figure 6.1 London Stereoscopic & Photograph Company, *William Morris*,
14 March 1877, portrait photograph; copyright National Portrait Gallery, London

wrote, 'fresh as wind, bright as light, and full of the spring and the sun'[2] – and even *Love Is Enough*, if relatively plotless, appeals directly to readers' emotions through its musicality and interpretive passages. In contrast to *The Defence*, the guiding metaphors of these longer works have shifted from battle and conflict to those of journey and search, emphasizing life's open-endedness and the need for persistence.

Morris's *Earthly Paradise* is also impressively ambitious in its tripartite structure. At the first level stands the figure of the 'idle singer', or narrator, who opens the epic with his 'Apology' and bids it farewell in 'L'Envoi'. As the cycle progresses, the singer introduces each monthly tale with a three-stanza, twenty-one-line poem expressive of his own emotions and, between the inset stories, a third-person narrator provides interconnective passages detailing the auditors' changing responses to the stories over time. The singer's personal lyrics tether the poem to an evolving present, as each successive interlude records his mounting sense of isolation within an unresponsive universe. His fears reach their apogee in November's 'changeless seal of change' (v.206): 'Bright sign of loneliness too great for me' (v.206, 210). The mood of the poem's elderly audience also shifts in contrapuntal response to the stories' darkening contents, as they experience the calming effects of shared emotions; at first restless and unhappy, they ultimately achieve a measure of acceptance through empathy:

> And these folk—these poor tale-tellers, who strove
> In their wild way the heart of Death to move,
> E'en as we singers, and failed, e'en as we,—
> Surely on their side I at least will be,
> And deem that when at last, their fear worn out,
> They fell asleep, all that old shame and doubt,
> Shamed them not now, nor did they doubt it good,
> That they in arms against that Death had stood. (vi.329)

The third level of the poem consists of the stories themselves, a series of twenty-four paired narratives recounted by twelve Greek elders and twelve Norwegian refugees who, after a long voyage, have landed in Greece. The cycle is preceded by an introductory narrative, 'Prologue: The Wanderers', in which the Norse voyagers first explain their journey and intentions, as they have sought to escape the ravages of the Black Death and reach an ever-deferred 'Earthly Paradise'. The two groups then agree to meet monthly to recount stories from their respective cultures, sharing one classical and one medieval tale for each month.

These interwoven narrative voices are crucial to the poem's tone of alternating involvement and *estrangement*, providing simultaneous layers

of nostalgia, *déjà vu*, and *jetztzeit* intensity. The frames within frames create variety, but also suggest reflection: should one respond with regret, despair, or hopefulness to so fraught a human condition? For if a few of the cycle's protagonists are both heroic and externally successful, many are not, and the secondary characters in their stories often undercut the achievements and aims of their ostensible heroes. The tales themselves, then, become invitations to meditate on the variety of human passions, to empathize with their auditors' self-reflections and, by implication, to add one's own. Herbert F. Tucker has observed that the characters in Morris's *Sigurd the Volsung* (1876) perceive that their lives must be spent 'all for the tale';[3] and one might similarly claim that the stories of all twenty-five *Earthly Paradise* narrators and their protagonists exist chiefly as aids to reflection for their imbricated audiences and listeners.

Although originally intended as part of *The Earthly Paradise*, Morris's first-completed narrative, 'The Life and Death of Jason', grew to such length that he issued it in 1867 as a separate work in seventeen 'books' (chapters), comprising 296 pages in the *Collected Works* edition. As a classical tale, its plot was familiar to its Victorian audience because Apollonius Rhodius's third-century BCE *Argonautica* was a standard school text and, thus, *Jason* avoided any potential problems caused by the retelling of lesser-known medieval tales. Reviewers were charmed. Joseph Knight paid tribute in the 9 June 1867 *Sunday Times*: 'Musical, clear, and flowing, strangely imaginative and suggestive, presenting pictures of almost incomparable beauty, it is a work of which an epoch may be proud.' In the October 1867 *North American Review*, Henry James exclaimed that: 'To the jaded intellects of the present moment, distracted with the strife of creeds and the conflict of theories, it opens a glimpse into a world where they will be called upon neither to choose, to criticise, nor to believe, but simply to feel, to look, and to listen.'[4]

The epic's overt storyline consists of a marvels-and-adventure plot in which Jason, a disinherited heir to the throne of Colchis in Thessaly, proves his valour by completing a series of mandated feats that include theft of a golden fleece from its temple abode. Afterwards, the resolute and self-promoting Jason seeks to ascend to the highest levels of Grecian power through marriage to Glauce, daughter of the king of Corinth. Morris does well by the heroic tale itself; his Jason is fearless, ingenious, and eager to work out the fate ordained for him, although also restless and fickle. Yet Morris shifts the focus of his epic inwards by giving prominence to two alternate voices. The first is that of Orpheus, the Argonauts' meditative singer, whose songs woo the Argonauts away from the Sirens' seductive

promises of a supra-terrestrial world free of toil and death. Instead, Orpheus resolutely proclaims the poem's metaphysical ground: our lives are earthly, of the earth:

> Ah, verily
> If it shall happen unto me
> That I have thought of anything,
> When o'er my bones the sea-fowl sing,
> And I lie dead, how shall I pine
> For those fresh joys that once were mine,
> On this green fount of joy and mirth,
> The ever young and glorious earth; ...
> Yes, this our toil and victory,
> The tyrannous and conquered sea. (ii.203–204)

Only through effort and labour can we come to appreciate life's finite preciousness.

A contrasting alternative voice is that of Medea, Jason's first love and the repeated enabler of his crimes and adventures, whose rage at his desertion of her in favour of a Corinthian princess leads to his ignominious death. Morris softens his heroine from Apollonius's original to emphasize her passionate love for Jason, her courage in furthering his interests, and her grief at his casual disregard of previous vows.[5] Whereas, in Apollonius, Medea savagely murders her children in front of Jason as an act of revenge, Morris's Medea kills her sons offstage, believing that they would otherwise become victims (presumably under the new Corinthian regime), and sincerely mourns their deaths. After Glauce's horrific incineration in the wedding dress Medea has provided, however, Jason can find no rest despite external honours and, as he sleeps on a nearby beach, he is ignominiously stabbed to death by the rotting prow of his old ship, Argo, 'Crushed, and all dead of him that here can die' (ii.296). Morris's alteration of the poem's original title in draft, 'The Deeds of Jason', to *The Life and Death of Jason*, emphasizes his nuanced judgement of his hero's achievements. In the end, the epic becomes less a triumphal account of successful machismo than a tragedy of failed ideals.

Remarkably, *Jason* was only one of several narratives originally written for *The Earthly Paradise* during the years 1866–70 that were excluded from the final twenty-four-tale sequence.[6] Those that were ultimately retained vary in metre and stanza form, are arranged in a rough progression in tone, and increasingly recast their original sources. As Morris would later advise his daughter, May, 'When retelling an old story, shut the book, and tell it again in your own way' (iii.xxii). Arguably, by rendering his

characters more believable and less spectacular than their originals, they evoke greater reader identification; if Medea were merely a savagely plotting witch, for example, it would be difficult to respect the protagonists' initial love or to sympathize with her pain at Jason's desertion. The spring narratives include some relatively straightforward didactic tales (e.g., 'The Proud King', 'The Writing on the Image') that echo the perspectives of their source materials but, as the cycle progresses, the narratives offer more complex expressions of Morris's humanist ethic of sympathetic communion across time and cultures.

Many of the tales centre on the search for love, not fame, and the need for resolute action to overcome the obstacles posed by inherited tyrannies to the attainment of a successful mutual union. In the early tales, such as 'Atalanta's Race' and 'The Doom of King Acrisius', the protagonist defies a royal or parental decree to rescue a daughter condemned to celibacy or death. The figure of Venus also enters as an ironic troubling presence in several tales; she is a stern taskmaster in 'The Story of Cupid and Pysche', a fatal temptress in 'The Watching of the Falcon', a harmful obstruction in 'The Ring Given to Venus', and a heedless object of tormented desire in 'The Hill of Venus'. Morris pays special attention to the physical and emotional restrictions placed on women, who are often subject to abuse and confinement: even gentle heroines such as Psyche ('The Story of Cupid and Psyche') and Philonoë ('Bellerophon in Lycia') are nonetheless resolutely assertive in the pursuit of love; and his vengeful and tormented heroines (Oenone in 'The Death of Paris' and Stenoboea in 'Bellerophon at Argos') are granted a measure of empathy and understanding.

Several of these features appear in the classical tale for May, 'The Story of Cupid and Psyche', a revised version of its source text, Apuleius's *Metamorphoses, or the Golden Ass*. The gentle and lovely Psyche ('soul', 'mind') embodies the fullness of nature and 'innocent desire', and her story allegorizes the painful process of female maturation under familial and social constraints. At his people's bequest, a king accedes to their demand that he order the ritual sacrifice of his daughter to a supposed monster, but at the place of execution she is, instead, abducted by the unseen presence of Venus's son, 'Love', subject to the prohibition that she cannot gaze directly upon him. Spurred by her suspicious sisters to disobey this proscription, Psyche accidentally awakes her sleeping lover, at which Cupid departs, condemning her to punishment by the Fates. She then loyally begins a long and harsh journey through earth and Hades to regain her love by first obtaining a symbolic casket from Persephone, Queen of the Underworld. As she faints on her return from Hades, her lover

relents and beseeches Jove to promote her to divinity. The newly immortal Psyche experiences an inner transformation; her past life 'all seemed changed in weight and worth, / Small things becoming great, and great things small' and, although now freed from time, 'godlike pity touched her therewithal / For her old self, for sons of men that die' (ii.2475–8). Once again, Morris has transformed his source, in which Cupid himself is tauntingly capricious and sadistic, Venus an unhinged dominatrix and Psyche herself a vengeful and dishonest schemer. In Morris's version, by contrast, the heroine's courageous journey to the underworld and her eventual apotheosis represent a persistent theme of *The Earthly Paradise*: the struggle to transcend the limits of time and death through love.

Similar in celebrating the moral triumph of its unassuming heroine, the classical tale for June, 'The Love of Alcestis', is another narrative of misplaced royal power and contrasting female sacrifice. Admetus, king of Thessaly, entertains Apollo unawares and, in return, the latter helps him gain the hand of Alcestis and provides him with a sheaf of arrows to burn if his life is threatened, '[t]hat thou mayest gain thy uttermost desire' (i.877). When, after many years, Admetus contracts a fatal illness, he burns the arrows in the presence of his wife and receives the message that his life will be saved if another will die for him. Alcestis experiences a moment of bitterness: 'now I durst not look upon his face, / Lest in my heart that other thing have place, / That which I knew not, that which men call hate' (ii.1168–70). Accepting death, she then lies down beside her husband and, when the unsuspecting Admetus rises, cured from his illness, he grieves for her loss and continues his prosperous reign. Over time, however, his name is forgotten and that of Alcestis lives on 'in the hearts of far-off men enshrined' (i.1289). This tale of wifely devotion (and husbandly heedlessness?) might have been one of Morris's less remarkable tales were it not for the response of its audience. For the first time in the sequence, its listeners are roused to full identification, as 'scarce their own lives seemed to touch them more, / Than that dead Queen's beside Boebëis' shore' (ii.20–21). Paradoxically, these elderly male auditors seem able to empathize *more* across barriers of gender, age, time, and life circumstances than with the more active heroes of prior tales, a process embodying Morris's ideal of the healing power of art. Once again, Morris has altered his sources, Apollodorus's *Bibliotheca* and Euripides' *Alcestis*. He removes from Admetus's character its craven selfishness, heightens the couple's grief at impending separation, and omits a *deus-ex-machina* resurrection at the end that would have undermined the poem's focus on life's frailty and evanescence.

'The Lovers of Gudrun', *The Earthly Paradise*'s medieval tale for November, was described by Morris to a friend as 'on the whole the most important thing I have written' (*CL*, i.82). A story of triangular desire and kinship destroyed by a revenge culture, the narrative reflects Morris's increased interest in Icelandic sagas, which he had begun to co-translate in 1869.[7] Based on the *Laxdaela Saga*, its plot follows an interior frame in which the young Gudrun recounts to an elderly visitor to her home at Bathstead, Guest, that she has experienced a series of troubling dreams. Wise in dream-lore, he interprets these as foretelling four marriages with ominous outcomes (ii.331–32). In the central plot, close male friends are estranged as Gudrun goads her husband Bodli to kill her former lover Kiartan. Years later, when her now-grown son, Bodli, asks the elderly Gudrun which of her lovers/husbands she has loved most, she replies enigmatically, in words which directly translate the Saga original, 'I did the worst to him I loved the most' ('*Ég gerði Þeim verst, sem ég unni mest*'). Though, presumably, Gudrun refers to Kiartan, one might argue that the reluctant Bodli was equally wronged. In any case, Morris maintains sympathy for all of the narrative's central characters: the narrator specifically exempts Gudrun from blame, attributes no serious fault to Kiartan, and presents the final murder scene as a quasi-redemptive immolation-rite. With its compounding ironies and compulsions, Morris's medieval tale for November offers a painful concatenation of cross-purposes, self-inflicted destruction, and futile regrets, in which humans are fated to work out their restless passions in a realm beyond morality or redress.

'The Lovers of Gudrun' deviated strongly from the spirit of the original saga, transforming a series of inter-familial disputes over property and power into a story of betrayed friendship and unrequited love. Morris remarked in a lecture that 'the Lax-dalers' story contains a very touching and beautiful tale, but it is not done justice to by the details of the story' (*UL*, 197) and he used all his skills as a realist to provide plausible motivations for its characters. He omits many of Gudrun's vices; the saga-Gudrun is vain, greedy, duplicitous, and scheming – reflecting a recurring misogynist motif in which women goad their reluctant menfolk into heinous deeds. The saga-Kiartan is entirely unromantic: he leaves Gudrun for Norway without regret; plots to burn his Norwegian royal host and his retainers in their palace; and, in his final clash with Bolli (Morris's Bodli), is prompted by a petty property dispute. Bolli is, in fact, the more heroic, as he acts calmly and consistently to defend his family within the constraints of his shame- and honour-obsessed society. Morris has thus shifted the focus of the saga from its economic and cultural

underpinnings to emphasize the destructive effects of frustrated female passions and competitive male desires.

The sequence's final narrative is 'The Hill of Venus', the medieval story for February. The topic of an elusive erotic deity was fraught for Morris, for although he began on the poem relatively early in the composition of his epic, he composed nine prior drafts before finally inserting it as the sequence's final tale.[8] Based on the legend of the thirteenth-century poet Tannhäuser and, more immediately, on 'The Mountain of Venus' in Sabine Baring-Gould's *Curious Myths of the Middle Ages* (1868),[9] the narrative follows Walter, a pilgrim who boldly enters the dangerous Venusberg cave and encounters the divinity herself. He is then frustrated when, despite passionate love-making, the immortal goddess seems impervious to his desire for reciprocity (ii.597–601). The disillusioned Walter then exits the Venusberg to join a troop of pilgrims en route to Rome, where he seeks absolution for his past sexual behaviour. As he faces the pontiff, however, a vision of the goddess reappears to him and, moved by love and compassion for her (his fellow pariah from the Christian order), he unexpectedly delivers to his astonished auditor an impassioned apology for his 'love, that never more shall bring / Delight to me or help me anything' (ii.1328–9). When the Pope exclaims that Walter can no more be redeemed than fruit and flowers can blossom from his dry staff, Walter departs in desperation to seek Venus again in her cave. Meanwhile, the staff blooms and, although the Pope repentantly sends messengers to search for Walter, the latter remains unfound, forever suspended between love, frustration, and despair. Morris thus ends his great cycle rather unexpectedly with an appeal to the open-endedness and ambiguity of moral issues, as well as a more modern definition of heroism as persistence in upholding one's inner values, in spite of hostile social conventions (or the absence of reciprocity). If *The Earthly Paradise*'s classical narratives more often celebrate the attainment of a worthy external life, then, Morris's last medieval tale ponders the more difficult path of introspection and steadfastness in the face of emotional loss.

Although Morris is generally viewed as the author of narrative and dramatic poems, from 1868 or 1869 until the mid-1870s, he composed more than three dozen personal poems: lyrics and short meditations spoken in what seems a near-unmediated authorial voice. Several of these poems remained unpublished during his lifetime or were included only in *A Book of Verse* (July 1870), a hand-illuminated fifty-one-page volume containing poems of the period offered as a gift to Georgiana Burne-Jones on her thirtieth birthday. Psychologists have noted a phenomenon of the

'happiness curve' – whereby persons experience increasing dissatisfaction at a middle stage of life and career – and this arc is strongly reflected in Morris's poems of this period, during which he added to the burdens of job and family his unhappiness at his wife's detachment and her affair with his erstwhile friend and mentor, Dante G. Rossetti. By 1869–70, the period of the composition of the fall and winter tales of *The Earthly Paradise,* several protagonists express uncomforted, raw despair at the loss of love or hope for its renewal. Poems from *A Book of Verse* echo these sorrowful themes, but also suggest healing through acceptance, sublimation, and a celebration of love itself. In 'Hope Dieth, Love Liveth', the speaker affirms the power of love to survive rebuff and loss.

Several *Book of Verse* poems were later included as monthly lyrics within *The Earthly Paradise* and, as we have seen, these enact an experience of grief set against a backdrop of ceaseless change. Similarly, Morris's verses inscribed to his daughters at Christmas in 1870 (accompanying the first edition of *The Earthly Paradise*) meditate on the restorative nature of tales of struggle and loss. One of his later lyrics, 'O Fair Gold Goddess', possibly composed in 1873 before a trip to Iceland, describes his conscious search for kinship within the literature of another time and culture, in this case, the medieval sagas. It was not until *Love Is Enough* (1872), however, that Morris was able to channel his turbulent emotions more coherently into an ethical ideal of displaced and self-generating love.

Morris began the latter, his most personal long poem, in September 1871, directly after his return from Iceland, though he did not bring it to finished form until 1872. The many drafts now preserved in the Huntington Library indicate both the difficulties of its topic for Morris and his determination to present it in a form worthy of its significance.[10] Originally intended as part of an illustrated edition with woodcuts designed by Burne-Jones, *Love Is Enough* is also Morris's most musical long narrative, with intricately elaborate metrics set within a carefully echeloned frame. As a masque, the poem is designed for oral, dramatic performance, with two mysterious masked figures, 'Love' and 'The Music', interpreting its inner allegorical plot. The poem's 'Argument' is deceptively simple: 'The story … showeth of a king whom nothing but Love might satisfy, who left all to seek love, and having found it, found that he had enough, though he lacked all else' (ix.3). Like *The Earthly Paradise, Love Is Enough* is carefully framed with counterpointed inner and outer voices; the outer layer presents two newly married couples of differing social stations, an Emperor and Empress and the peasants, Giles and Joan, who together watch and react as local burghers and artists perform the pageant of Pharamond and Azalais in the

inner frame. The outer layer's three lyrics – two sung by 'The Music' and one by 'Love' – indicate more clearly what is to follow, a tale in which the lovers meet only briefly and are never thereafter physically reunited but remain faithful in spirit. The progression of the seasons suggests the hope that human emotions may also renew themselves, as 'earth threatened often / Shall live on for ever' (ix.10). The inner layer of *Love Is Enough* is structured in five scenes, each of which opens with one or more interludes by Love and closes with an interpretive melody sung by The Music. As we enter the masque's inner plot, King Pharamond's loyal follower, Oliver, serves as narrator, chorus, and mourner. In the opening scene, Oliver reports to the king's councillors that the latter has been overcome by dreams of love, and, consumed by loneliness, has become unable to perform his royal duties. Pharamond then departs with Oliver to seek the original of his vision, and the allegory moves forward as Love reveals his identity: 'I am the Life of all that dieth not; / Through me alone is sorrow unforgot' (ix.22). Note that Love promises no literal resurrection, only recognition and memory; paradoxically it is the memory of sorrow, not happiness, that is most prized. Over time, the soliloquies by Love and The Music and the remarks of the pilgrims blend into one another until the voices of The Music, Love, Pharamond, and Azalais are harmonized into a single antiphon of celebrated, but postponed, desire displaced from time.

Meanwhile, Pharamond and Oliver undertake a more extended symbolic journey over land and sea until they reach the world's end, and Pharamond, still bereft of what he has sought, prepares to die: 'If I wake never more I shall dream and shall see her' (ix.45). Before reaching the 'land where Love is the light and the lord' (ix.47), however, he must confront the dark side of Love, as in a grim parody of crucifixion imagery the latter enters with bloody hands, holding a cup of bitter drink: 'What? – is there blood upon these hands of mine? / Is venomed anguish mingled with my wine?' (ix.48). Here 'Love' articulates and embodies the problem of causation faced in every theodicy since Job: how can love-as-compassion become detached from love-as-ineluctable fate? He and Music then directly enter the plot at the approach of Azalais, herself, who as the incarnation of spiritual healing expresses herself less through words than melody. The arc of the lover's day together – the only one they will have – is traced in their shared songs of dawn, noon, evening, and night respectively (ix.58).

Allegory now overtakes plot, as Love demands the lovers' separation on the grounds that the king must return to his former duties, a rationale unconvincing on the literal level, since presumably Azalais could have accompanied him. Even Love cannot understand the workings of fate:

'Well, he [Pharamond] and you [the audience] and I have little skill / To
know the secret of Fate's worldly will …' (ix.65). In another irony, on
returning to his kingdom, he finds it ruled by a certain Theobald, who is
more corrupt, but also more popular, than his predecessor. Pharamond's
return has thus served no practical purpose. At least he has remained true to
his ideals in attempting to unite the twin poles of his life: action and love.
The lovers continue to seek each other and remain united on a spiritual
level and, in return for the deprivation he has imposed, Love permits their
search to retain its initial freshness, as Pharamond anticipates 'Each long
year of Love, and the first scarce beginneth' (ix.75).

At its best, the love retained is a process of devotion; a labour and a
trust; a journey, not an arrival. The poem ends with Love's final speech, of
which May Morris remarked that 'If love is enough, it is not the world's
love and contentment, but that final absorption in eternal good, that
something-beyond-all for which the speech of man can find no defining
words' (*WMAWS*, i.441–42). Love is seen as a force of compassion-within-
things, an intrinsic form of attachment that cannot allay its own pain but
struggles to endure, refine itself, and express its uneven worth:

> Lo, for such days I speak and say, believe
> That from these hands reward ye shall receive.
> —Reward of what?—Life springing fresh again—
> Life of delight?—I say it not—Of pain?
> It may be—Pain eternal?—Who may tell?
> Yet pain of Heaven, beloved, and not of Hell. (ix.77)

The Earthly Paradise's most despairing heroes, such as Walter in 'The
Hill of Venus', dread not the loss of a *particular* love, but of love itself –
the possibility that love and fidelity *themselves* may not exist. The final
consolation of *Love Is Enough* is that this is impossible – '[N]either died
this love, / But through a dreadful world all changed must move' (ix.78).

Throughout his long epics and shorter verses of this important period,
then, Morris refined his definition of the heroism appropriate for 'an
empty day'[11] through poems that celebrate the essential incompleteness
and uncontrollability at the core of life. His major poems offer his
contemporaries not closure, but *understanding*, providing a form of
psychological realism through myth and fantasy. In *Love Is Enough*,
Morris re-enacted in symbolic form many of the ethical and philosophical
conundra that underlay his previous narratives and, as it were, conquered
his own dark angel to internalize an essentially regulative ideal. These
preoccupations – the nature of love and the need for deferral – would

accompany him through later embodiments of his convictions. These include, among other things, his final tragic epic *Sigurd the Volsung*; the organic processes infused in his art; the dedication of his political work; the creation of new artifacts at the Kelmscott Press; and the visionary breadth of his utopian *News from Nowhere* (1890; 1891).

Notes

1 Richard Garnett, *Literary Gazette*, xlii (March 1858), 226–7.
2 A. C. Swinburne, *Fortnightly Review*, viii (July 1867), 19–28.
3 Herbert F. Tucker, '"All for the Tale": The Epic Macropoetics of Morris's *Sigurd the Volsung*', *Victorian Poetry*, 34.3 (1996), 369–94.
4 Henry James, *North American Review*, cvi (October 1867), 688–92.
5 Florence S. Boos, 'Jason's "Wise" Women: Gender and Morris's First Romantic Epic', in David Latham (ed.), *Writing on the Image: Reading William Morris* (Toronto: University of Toronto Press, 2007), 41–58.
6 The excluded tales were 'The Wooing of Swanhild', 'The Story of Orpheus and Eurydice', 'The Story of Aristomenes' and 'The Story of Dorothea'. The titles of others are mentioned, but no texts have survived.
7 *The Story of Grettir the Strong*, trans. William Morris and Eiríkr Magnússon (London: F. S. Ellis, 1869).
8 Florence S. Boos, 'Ten Journeys to the Venusberg: Morris's Drafts for "The Hill of Venus"', *Victorian Poetry* 39.4 (2002), 597–615.
9 Florence S. Boos (ed.), *The Earthly Paradise* (London: Routledge, 2002), ii, 714–15. See also Julian Fane and Robert Lytton, *Tannhauser: or, the Battle of the Bards* (London: Chapman and Hall, 1861).
10 Huntington Library, HM6422.
11 The speaker of the *Earthly Paradise*'s opening 'Apology' regrets his limitations as 'the idle singer of an empty day' (iii.1), but by 'L'Envoi' he has gained a sense of pride: 'No little part it was for me to play – The idle singer of an empty day.'

Skaldic Morris
Translations from Old Norse

Heather O'Donoghue

William Morris's passion for Old Norse literature has been well documented. J. W. Mackail quotes Morris's own description of his Norse muse as 'Mother, and Love, and Sister all in one' (Mackail, i.39). May Morris describes his encounter with Old Norse literature in the original language as 'a wonderful moment – a poet's entering into possession of a new world' (vii.15) and more prosaically, but no less tellingly, J. G. Swannell, in an address to the William Morris society, said that 'Old Norse is the small change of his conversation'.[1] Old Norse was simply Morris's 'greatest single inspiration'.[2] In this piece, I shall begin by briefly characterizing the scope and quality of Old Norse literature, and move on to describe Morris's first engagements with it, analysing his translation methods, and the controversial features of the wide range and large number of saga translations he embarked on. Finally, I shall focus on his translations of Old Norse poetry, arguably more successful than his prose translations, although attended to less often.

Some naming practices need clarification at the outset. Nowadays, the literature of medieval Iceland is termed 'Old Norse-Icelandic literature'. Iceland was settled around 870 AD, and after its conversion to Christianity in the year 1000 AD, it developed an extraordinarily productive literary tradition, no longer oral, but written. For this reason, the literature was sometimes termed 'Old Icelandic'. But as well as initiating some wholly new and unique literary genres – pre-eminently, the Icelandic family sagas – writers in Iceland also wrote up, and thus preserved, oral literature which may (or may not!) have pre-dated its settlement (largely from Norway and from secondary Hiberno-Norse colonies in Ireland and Scotland). Early on, Iceland and Norway shared a common language, Old Norse, so the literature may also be termed 'Old Norse'. Morris uses simply 'Icelandic', and this accords well with his sense that both the language and (though less justifiably) the social norms of Victorian Iceland were little changed from his beloved medieval saga-age. Another terminological quirk is that

Icelanders – now, just as in the Middle Ages – do not use surnames, but patronymics, and the convention is to refer to Icelanders by given name only, or given name plus patronymic. Polite Victorian references to 'Mr Magnusson' to refer to Morris's collaborator Eiríkur sound strange and even jarring to the ears of scholars and present-day Icelanders. I follow Icelandic convention here, though this can sound oddly chummy, and use the modern Icelandic spelling of his given name. Finally, the definite article is no longer used with Old Norse titles (*the Laxdœla saga; the Heimskringla*) although it was standard in the nineteenth century.

Skaldic verse is the name given to the highly cryptic poetry in Old Norse that was at first used (and mostly by Icelandic poets) to praise the rulers of Norway. This poetry was never anthologized, but was copiously quoted by medieval Icelandic historians of Norway to substantiate their work. The greatest of these historical compilations is the thirteenth-century *Heimskringla* (named after its grand opening words, *Kringla heimsins*, the orb of the world), the work of the Icelandic author Snorri Sturluson. Snorri had a remarkable knowledge of skaldic verse, and also produced another major work in Old Norse: his *Prose Edda*, in which he tells the mythological stories behind Old Norse poetry, and explains the elaborate, riddling diction of skaldic verse. Also dating from the thirteenth century are the so-called 'family sagas', in Icelandic, *Íslendingasögur*, or sagas of Icelanders, semi-historical and naturalistic novelistic chronicles of life in Iceland in the Middle Ages. Many of these works also quote skaldic strophes in their prose, but more often as the (somewhat improbable) dialogue of the saga characters. Morris's translations of Icelandic sagas therefore also required him to tackle these very difficult strophes. One notable subset of Old Norse sagas is the so-called *skáldsaga,* or 'poet saga', incorporating strophes traditionally associated with Icelandic poets – most often, verses in praise of a female beloved (or lamenting her absence, or jealously decrying her husband).

There were also *fornaldarsögur,* or 'sagas of olden times'; these were far less naturalistic than the family sagas, included supernatural events and characters, and were usually set outside Iceland in a legendary and imaginary 'north'. Perhaps the most celebrated *fornaldarsaga* is *Völsunga saga,* the saga of the Volsungs, which is itself based on Old Norse poetry – not skaldic, but eddic. Unlike skaldic verse, eddic poetry was anthologized – at least, most of it – in a collection now usually called in English the *Poetic Edda*, thirty-one poems preserved in a thirteenth-century manuscript. Eddic (or eddaic) poetry is much less cryptic than skaldic, with simpler diction and looser metres. It includes entertaining

mythological narratives, dialogues of fierce and sometimes funny invective, accounts of legendary conflicts, and sombre and moving laments. Around half of the poems have mythological themes, and the rest retell the high points of heroic Germanic legend associated with Sigurðr, Brynhildr, and Guðrún. Some poems which are eddic in form and style are preserved in other manuscripts. Old Norse prose literature also included short stories called *þættir* (singular *þáttr*), meaning strands, once thought to be the building blocks of longer sagas. An impressive array of religious Christian and latinate prose and poetry was also produced in medieval Iceland, but very little had been translated into English in the nineteenth century, and Morris showed no interest in it.

From early on, Morris had a remarkable knowledge of Iceland and its medieval literature. At Oxford, his friend Edward Burne-Jones introduced him to Benjamin Thorpe's recently published *Northern Mythology* (1851). Its subtitle gives an idea of its eclectic range – *Comprising the principal popular traditions and superstitions of Scandinavia, North Germany, and the Netherlands* – but it begins with a coherent and learned survey of Old Norse myth and includes retellings of various Old Norse materials, such as the story of the Volsungs and paraphrases of some eddic poems. Morris knew Amos Cottle's greatly underrated 1796 translation of the *Poetic Edda*, George Webbe Dasent's monumental translations of the great family sagas *Njáls saga* (1861) and *Gisla saga* (1866), and *Northern Antiquities* (1770), Bishop Percy's hugely influential eighteenth-century translation of Paul-Henri Mallet's treatise on Old Norse literature and religion. The 1847 edition contained Walter Scott's summary of *Eyrbyggja saga*.[3] Samuel Laing's *Heimskringla* (1844) – a translation of a Norwegian translation of the original – was also available. According to Eiríkur, Morris had also read 'modern books of travel on Iceland', and knew a good deal about the country's history (vii.16).

Morris wrote two long poems based on Icelandic sagas: 'The Lovers of Gudrun' (collected in *The Earthly Paradise*), a surprisingly close retelling of *Laxdœla saga,* and *Sigurd the Volsung*, based on *Völsunga saga* and regarded by many critics as his masterpiece. He learnt to read and speak Icelandic (the language spoken in Iceland in post-medieval times is very little changed from its saga-age state) with Eiríkur Magnússon, and the two men together translated over thirty Old Norse sagas, and a considerable amount of eddic verse, at what Swannell called 'a stupefying rate'.[4] I will now set out the material they engaged with, correlating Morris's translated titles with the titles by which the texts are now usually known.

It is extremely difficult to date or to order chronologically Morris's translations. The texts were not published in the same order as they were translated; at various times Morris made elaborate and very beautiful calligraphic copies of some translations that were not published commercially; and some texts were republished in different collections and series, notably *The Saga Library*, which ran to only six volumes (although many others were projected), and which came out decades after the first translations were completed. Morris engaged constantly in revisions. Further, the sheer volume of the translations, and the rate of production, means that he and Eiríkur often seem to be working on several different things at once. But we can piece together the story of this astonishing enterprise by picking up allusions in Morris's letters, and his friends' memoirs, and May Morris's prefaces to the *Collected Works*.

According to Eiríkur, when he and Morris first met in the autumn of 1868, they began work on 'The Story of Gunnlaug the Wormtongue' (*Gunnlaugs saga ormstungu*; Eiríkur calls him 'Snaketongue' here) (*TSL*, vi.xiii). This was first published in the *Fortnightly Review* in January 1869, and later included in the collection *Three Northern Love Stories*, in 1875. It is one of the small group of poet sagas, interspersed with Gunnlaugr's skaldic love verses to the fair Helga, and, like the other poet sagas, its narrative is a variation on the love triangle theme, in which a male lover – the poet – and his rival vie for the attentions of a woman. Very shortly after this, 'The Story of the Ere-Dwellers' (*Eyrbyggja saga*) was completed, but not published until 1892, as Volume Two of *The Saga Library*, in a revised form, along with 'The Story of the Heath-Slayings' (*Heiðarvíga saga*). *Eyrbyggja saga* is skilfully woven from a number of narrative threads, and one of them is a brief version of the love triangle theme, supported by striking skaldic love verses. 'The Story of Grettir the Strong' (*Grettis saga*) was published next; its preface is dated April 1869. In the spring–summer of 1869, Morris was drafting 'The Lovers of Gudrun', and working on a never-published translation of its source, *Laxdæla saga*. That same summer, he and Eiríkur were translating 'The Story of the Volsungs and the Fall of the Nibelungs' (*Völsunga saga*) and this was published in 1870. Appended to the volume were ten eddic poems from the heroic section of the *Poetic Edda*. The saga is based on these poems, and some stanzas are quoted in the saga prose. The appended poems are: 'The Second Lay of Helgi Hunding's-bane' (*Helgakviða Hundingsbana II*); 'Part of the Lay of Sigrdrifa' (*Sigrdrífumál*: the rest of the poem is quoted in the saga prose); 'The Lay called the Short Lay of Sigurd' (*Sigurðarkviða hin skamma*); 'The Hell-Ride of Brynhild' (*Helreið Brynhildar*); 'The Lay of Brynhild' (*Brot af Sigurðarkviðu*); 'The

Second or Ancient Lay of Gudrun' (*Guðrúnarkviða II*); 'The Song of Atli' (*Atlakviða*); 'The Whetting of Gudrun' (*Guðrúnarhvöt*); 'The Lay of Hamdir' (*Hamðismál*) and 'The Lament of Oddrun' (*Oddrúnargrátr*). Finally, Morris also translated some mythological poems from the *Edda* – 'The Prophecy of the Vala' (*Völuspâ*); 'Baldur's Dream' (*Baldrs draumar*); and 'The Lay of Thrym' (*Þrymskviða*). None of these was published in his lifetime.[5]

By the summer of 1871, when he made his first Iceland expedition, Morris had already translated 'The Story of Frithiof the Bold' (*Friðþjófs saga*), first published early in 1871, and later included in *Three Northern Love Stories. Friðþjófs saga*, 'with its valiant and handsome hero, its setting in a hazy Scandinavian past, its supernatural incidents and its focus on the love affair between Friðþjófr and the princess Ingibjörg', was tremendously popular in Victorian England. It is a classic *fornaldarsaga,* but with a twist, because like the poets' sagas, it is essentially a troubled love story, with verses spoken by the main characters.[6]

Back from Iceland, Morris and Eiríkur worked on Snorri's huge compilation of biographies of Norwegian rulers, *Heimskringla,* but the whole thing was not finished until it was included as volumes 3, 4, and 5 of *The Saga Library* in 1893–5. In 1873, Morris went to Iceland for a second time, and on his return the two men seem to have been working on three family sagas which were published much later, in 1891, as the first volume of *The Saga Library.* These were 'The Story of Howard the Halt' (*Hávarðar saga Ísfirðings*); 'The Story of the Banded Men' (*Bandamanna saga*); and 'The Story of Hen-Thorir' (*Hænsa-Þóris saga).* At around this time Morris also translated with Eiríkur some *þættir,* or short stories: 'The Tale of Hogni and Hedinn' (*Sörla páttr*); 'The Tale of Roi the Fool' (*Hróar páttr heimska*); and 'The Tale of Thorstein Staff-Smitten' (*Þorsteins páttr stangarhöggs*). These were included in the 1875 *Three Northern Love Stories* volume, along with 'The Story of Viglund the Fair' (*Víglundar saga*), another romantic tale. And in 1874, he translated, but never published, one further *páttr*, *Halldors páttr Snorrasonar.* Finally, during these years, 1873–4, Morris began – but did not finish – translating *Egils saga* (managing no more than a couple of pages); *Vápnfirðinga saga* (entitled in the calligraphic copy, 'The Story of the Men of Weaponfirth'); and *Kormáks saga.* This latter saga is another poet saga, with verses and a love triangle theme. Clearly, something was unravelling here, with the stalled *Heimskringla,* the short stories, and the unfinished translations. In a letter written in February 1873, Morris signalled that things were going wrong: 'My translations go on apace, but I am doing nothing original; … sometimes I begin to fear I

am losing my invention.' As Paul Acker suggests, 'It may indeed have been the massive *Heimskringla* that bogged him down.'[7]

This impressively lengthy list of translations, crammed into less than a decade, is also formidable in its range: family sagas, poet sagas, *þættir*, historical compilations, *fornaldarsögur*, and an enormous amount of associated skaldic and eddic verse. Nevertheless, the whole list is dominated by one archetypal story element: the love triangle theme, with two male lovers competing for one woman. At the risk of repetition, the dominance of this theme can be easily demonstrated. The very first saga Morris and Eiríkur tackled was *Gunnlaugs saga*, a classic of the love triangle genre. One of the narrative strands in *Eyrbyggja saga* follows the love triangle pattern, and *Víglundar saga* presents another version of it. *Laxdœla saga*, although a family saga, being set in a naturalistic recreation of early medieval Iceland, is a clever and subtle transmutation of heroic legend into a domestic setting, for Gúðrún, its heartbreaking heroine, hopes to be married to the pre-eminent hero Kjartan, but he is deceived by a rival who marries Guðrún himself, and Kjartan marries a good but less impressive woman. This story pattern echoes what has been called the 'love quadrangle' theme in Old Norse literature – essentially, the story of Sigurdr and Brynhildr, star-crossed lovers who each marry another, and are united only in death.[8] And this, of course, is the tragedy of the Volsungs, and the eddic lays which inspired it, and the tragedy of Morris's great poems 'The Lovers of Gudrun' and *Sigurd the Volsung*. It is tempting to suppose that Morris's passion for Iceland and its literature was fired by this story element, and where it was lacking (in *Heimskringla*, e.g., or the strangely off-colour and perhaps even parodic sagas which made up the first volume of *The Saga Library*), his passion cooled.

Eiríkur Magnússon first came to England as a bible translator, and later worked in Cambridge University Library. The first meeting between him and Morris is well known from Eiríkur's own lively account, with its attractive description of Morris, and powerful impression of Morris's wild enthusiasm for Icelandic language and literature (*TSL*, vi.xii ff. and vii. 15ff.). Eiríkur also includes many invaluable comments on their methods of translation, and how the collaboration worked in practice. His most striking observation was how quickly Morris could 'see through' the language, and could translate 'with an intuition [and Eiríkur repeatedly uses this word of Morris's linguistic abilities] that fairly took me aback' (*TSL*, vi.xiv). And although Eiríkur reports Morris's impatience with formal, grammatical language learning – 'I can't be bothered with grammar; have no time for it. You be my grammar as we translate' (*TSL*, vi.xiii) – it's quite clear that

Morris rapidly developed a very thorough knowledge of Icelandic. Their method of working changed as Morris became ever more proficient, but to begin with they would read through a saga together. Eiríkur would then work on a literal translation, and Morris would produce a version 'emended throughout in accordance with his own ideal', as Eiríkur puts it, working with a copy of the text in the original language beside him. We can see this process at work from a surviving manuscript of their translation of one of the verses in *Heimskringla*: on the right-hand side of the page, we have Eiríkur's neatly written out translation, crossed out, underlined and annotated in Morris's hand, and on the left-hand side of the page, Morris's own version.[9] And this brings us to the key issue in any consideration of Morris's translations from Old Norse: what exactly was 'his own ideal' of translation? As Eiríkur explains, 'His style is a subject on which there exists a considerable diversity of opinion. In either direction people have gone to extremes' (vii.17).

Morris's style of translation is much easier to illustrate than to describe. But in sum: firstly, Morris translated literally (and remarkably accurately; there are hardly any mistakes in translation, and we see that he even corrected mistranslations in Eiríkur's prose which very occasionally arose because of Eiríkur's non-native English). Secondly, he echoed Old Norse syntax in his word order. Thirdly, he used archaic – that is to say, medieval, and largely Chaucerian – grammatical forms. And fourthly, he tried, whenever possible, to use words in his translations which he supposed (most often rightly) to be cognate with Icelandic words, even if they were archaic or dialectal. This produced a strange medievalized version of English which one contemporary reviewer notoriously called 'Wardour Street' English – that is, fake antique, named after the second-hand furnishings once sold there.[10] There is an obvious irony in the implied charge of fakery here and Morris's ethic of authenticity with regard to his medievalist material craftsmanship, which I will pick up on at the end of this piece. And although the Icelandic scholar Guðbrandur Vigfússon (Eiríkur's great rival) accused Morris of producing 'pseudo-Middle English' he was countered not only by the ever loyal Eiríkur, but definitively by Karl Litzenberg, who has shown that Morris did not regularly invent fake medieval words, and that there are only a handful of actual neologisms in the whole translated corpus.[11]

As well as the charge of being a sham replica of medieval English, Morris's translations were also criticized for being hard to read. His saga prose is not especially difficult to follow through a whole narrative, though it is very idiosyncratic. A short passage from his translation of *Eyrbyggja*

saga makes this clear. The hero Biorn is meeting his married lover Thurid. The anglicization of the proper names (from *Björn* and *Þuríðr*), plus the semi-translated place-names (Frodis-water from *Fróðá*) will be familiar from Morris's translated saga titles:

> On a time Biorn came to Frodis-water and sat talking with Thurid. And Thorod [the husband] was ever wont to be within doors when Biorn was there; but now they saw him nowhere. Then Thurid said: "Take thou heed to thy faring, Biorn; whereas I deem that Thorod is minded to put an end to thy coming hither; and I guess they have gone to waylay thee; and he will be minded that ye two shall not meet with an equal band." (*The Story of the Ere-Dwellers*, TSL, ii.73)

The syntax and sense follow the original Old Norse very closely.[12] Some of the archaisms both echo the Old Norse and replicate early English grammar because of the fundamental similarities in the two languages: the use of 'thy' and 'thou', for instance, or the imperative form 'Take thou heed'. Some cognate words are easier to recognize than others. 'Farings' is cognate with the Old Norse plural noun *ferðir* (journeys); 'was ever wont' corresponds to *var jafnan vanr* (was always used to).

One can always produce short, out-of-context quotations which demonstrate the opacity of some of Morris's English. But if he was not aiming at fluent readability, as most modern translations are, what *was* he trying to do? One of the commoner criticisms of Morris is that his translations of saga prose give the impression that the sagas were somehow quaint in their day, whereas in fact saga authors 'used the language of their own time, almost the language of everyday use'.[13] This may be true, but it's hard to be certain how the style of saga prose might have struck its original audience. Litzenberg supposes that Morris 'tried to give the reader the feeling of the English language which was contemporary with the ON from which he was translating'.[14] Ian Felce argues that he was hoping to make his translated prose sound familiar to modern readers, to connect them to their 'kindred culture', but made a colossal misjudgement.[15] At the other extreme, the translations are fascinating for those who already know Old Norse, and the close relationship between the two languages – medieval(ized) English and Old Norse – is brilliantly demonstrated, but this specialist philological exercise cannot have been part of Morris's aim. Randolph Quirk long ago proposed an intriguing middle way which seems to me to capture the essence of Morris's method: 'He wants to make us share the acute pleasure which the forms and arrangements of the Icelandic have upon him'. Quirk concludes that the translations are 'a sensitive attempt at transmitting the experience of a scholar-poet reading

the literature of a people and an age that he loved' – that is, thirteenth-century Iceland.[16]

As we have seen, Morris translated Old Norse poetry as well as prose narrative. So I turn now to Morris's translations of eddic and skaldic verse, and I begin with the first strophe of the last poem in the *Poetic Edda*, 'The Lay of Hamdir' (*Hamðismál*). This poem tells the story of Guðrún's attempt to wreak vengeance on the Gothic tyrant Jörmunrekkr, who had savagely executed her daughter by Sigurðr, Svanhildr, by sending her sons – her last living relatives – on a doomed mission to kill him. This is the last act in the whole heroic cycle of the Volsungs.

Morris translates:

> Great deeds of bale
> In the garth began,
> At the sad dawning
> The tide of Elves' sorrow
> When day is a-waxing
> And man's grief awaketh,
> And the sorrow of each one
> The early day quickeneth.[17]

Morris preserves the basic metre of this poem, in which each short line has two stressed syllables, and one of them alliterates with the stressed syllable in the next – Great/garth; sad/sorrow, etc. We have the usual grammatical archaisms – the -eth ending of the verbs, and the a-prefix. Cognate archaisms feature too – 'bale' for the Old Norse *böl,* for instance, or 'quicken' for *kveykva*. But the translation is surprisingly free in terms of its ordering of elements, as one can see from a literal translation of the stanza:

> Sprouted at the threshhold
> tragic tasks
> weeping of elves
> joy-stemmed.
> Early in the morning
> of human harms
> all griefs
> kindle sorrow.

In the original, the imagery underlines the strophe's status as the beginning of the end, and Morris carefully preserves this: 'dawning'; 'waxing'; 'waketh'; 'early'; 'quickeneth'. The elves' tears are magnified into a tide, and we lose the organic imagery of new shoots, and the paradoxical elements of water and fire. But without the imperative to produce natural-sounding prose,

Morris the poet constructs, here as throughout his eddic translations, a kind of poetic language which captures very well the spirit of the original. Moreover, it is likely that eddic style sounded remote and high-flown and archaic even to its original audience.

Skaldic poetry would certainly have sounded strange and difficult to a saga-age audience, and by the thirteenth century Snorri was writing a treatise for Icelanders themselves on how to decode its complex poetic diction. The metre and the strange word order are evident from this original stanza – a love-verse from *Eyrbyggja saga* – alongside my word-for-word English translation:

*Gul*s mundum **vit** *vil*ja	Gold would we two wish
*vi*ðar ok blás í *mi*ðli,	forest and the dark between,
gr*and* fæ'k af **st**oð **st***und*um	– pain get I from the prop sometimes
str*eng*s, þenna dag *leng*stan,	of ribbon – this day the longest,
*all*s í **a**ptan, þ*ella*,	while at evening, fir tree,
e*g teg*umk sjalfr at drekka	I ready myself to drink
opt h*orf*innar *erf*i,	often-gone funeral toast,
arml*inn*s, gleði m*inn*ar.	of the arm-serpent, of my joy.[18]

Here we can see the eight short lines of a strophe, always divided into two complementary or opposing halves, each short line having six syllables and ending with a trochee. We can see too the patterns of internal full and half rhyme (italicized) and the alliteration (in bold). This metre – *dróttkvætt* – is almost impossible to preserve in a translation which also makes any sense at all in an uninflected language like English in which word order is mostly fixed. It seems that Eiríkur would puzzle out the word order, then translate the stanza into English, and that Morris would then 'metrify' it.[19]

Dizzyingly shuffled word-order is a very distinctive feature of skaldic verse. Another is the cryptic and often metaphorical poetic circumlocutions called kennings. In simple kennings, such as 'tree of riches', the base word 'tree' denotes an upright, arguably beautiful living thing, and its determinant, 'of riches', indicates that the metonymic referent of the whole kenning is 'woman', conventionally adorned with gold jewellery. Skaldic kennings can be very complex, often having more than the minimum two elements, such as in the strophe quoted: 'the serpent of the arm' is a bracelet encircling it, and so 'the fir-tree of the serpent of the arm' is a woman.

When Morris first translated the verses in *Eyrbyggja saga* he kept the lines short, but made relatively little attempt to reproduce the metre, even to the extent of introducing end rhyme, almost unknown in skaldic

poetry. Further, he tended to resolve the kennings. This necessarily led to a rather free translation. But when he and Eiríkur revised the translation for inclusion in the later *Saga Library* series, Morris took the bold step of lengthening the line, and translating each element of the kennings, without resolving them.[20] As Eiríkur notes, Morris in this way offers 'both a translation and a sort of commentary', the longer lines enabling 'freer play' with the kennings.[21]

The effect is quite different from what Felce rightly calls 'the sanguine, jaunty quality' of earlier versions,[22] and captures an important element in the original too often overlooked by translators, the expressive and almost musical fall at the end of each line:

> O ground of the golden strings, might we but gain it
> To make this day's wearing of all days the longest
> That ever yet hung twixt earth's woodland and heaven –
> Yea, whiles yet I tarried the hours in their waning –
> For, O fir of the worm that about the arm windeth,
> This night amongst all nights, 'tis I and no other
> Must turn me to grief now, and drink out the grave-ales
> Of the joys of our life-days, full often a-dying.[23]

Alliteration is evident, but not all-consuming, and there is a subtle echo of skaldic full internal rhyme in Morris's rather daring repetition of almost the same word in some lines (day's/days; nights/night). We can also spot plenty of Morris's characteristic archaisms. But most striking is the degree of sympathetic interpretation here. Morris has plainly engaged very closely with a strange and difficult verse form, and produces a version which, as Litzenberg said of his saga translations, did not 'simply … *approximate* a medieval or antique spirit' but managed to '*preserve* the medieval spirit which the documents already had'.[24] We can link this to Morris's work in material, rather than literary, medievalism: restoration or mere copying was anathema to him (Mackail, ii.40).

On his first expedition to Iceland, Morris reports that an Icelandic farmer laughed at his attempt to mount a horse '*more Icelandico*' (in the Icelandic way; like an Icelander), and remarked to Eiríkur Magnússon 'The Skald is not quite used to riding, then' (Mackail, ii.257). Of course there's rich irony in Morris's failed attempt to be Icelandic, and there is also the (very significant) implication that Morris understood what was being said, but the farmer's half-mocking dubbing of Morris as a *skáld* (arch-poet) contains more truth than has usually been recognized by readers of his saga translations.

Notes

1 J. G. Swannell, *William Morris and Old Norse Literature* (London: William Morris Society, 1961), 2.

2 Ibid., 21.

3 Thomas Percy, *Northern Antiquities*, revised edition, ed. I. A. Blackwell (London: Henry G. Bohn, 1847), 517–40.

4 Swannell, *William Morris,* 15.

5 See Paul Acker, 'William Morris's Translation of Völuspá', in *Useful and Beautiful* 2016.1 (Winter, 2016), 18–22. www.morrissociety.org/publications/useful-beautiful/.

6 See Heather O'Donoghue, *Old Norse-Icelandic Literature: A Short Introduction* (Oxford: Blackwell, 2004), 122–4.

7 Paul Acker, 'A Very Animated Conversation on Icelandic Matters: The Saga Translations of William Morris and Eiríkr Magnússon', in Florence S. Boos (ed.), *The Routledge Companion to William Morris* (London: Routledge, 2021), 332–42, 338.

8 See Heather O'Donoghue, 'From Heroic Lay to Victorian Novel: Old Norse Poetry about Brynhildr and Thomas Hardy's *The Return of the Native*, in Tom Birkett and Kirsty March-Lyons (eds), *Translating Early Medieval Poetry: Transformation, Reception, Interpretation* (Woodbridge: Boydell and Brewer, 2017), 183–98.

9 See James L. Barribeau, 'William Morris and Saga-Translation', in R. Farrell (ed.), *The Vikings* (Cornell University Press, 1983), 239–61. Barribeau's manuscript reproduction (at 261) shows that in this case Eiríkur also copied out the original text.

10 See Karl Litzenberg, 'The Diction of William Morris', *Arkiv för Nordisk Filologi* 9 (1937), 327–63 (329).

11 *TSL*, vi.vii, and Litzenberg, 'Diction'.

12 See *Eyrbyggja saga*, eds Einar Ól. Sveinsson and Matthías Þórðarson, Íslenzk fornrit 4 (Reykjavík, 1935), 78.

13 John Kennedy, *Translating the Sagas* (Turnhout: Brepols, 2007), 32, quoting E. V. Gordon.

14 Litzenberg, 'Diction', 331.

15 Ian Felce, 'The Old Norse Sagas and William Morris's Ideal of Literal Translation', *Review of English Studies* 67, (2016), 220–36, and his *William Morris and the Icelandic Sagas* (Woodbridge: Boydell and Brewer, 2018), especially chapter 4.

16 Randolph Quirk, 'Dasent, Morris, and Problems of Translation', *Saga-Book of the Viking Society* 14 (1953–57), 64–77 (76–7).

17 *Völsunga Saga: The Story of the Volsungs and Nibelungs, with Certain Songs from the Elder Edda* (London: Ellis and White, 1870), 244.

18 *Eyrbyggja saga,* 78.

19 Barribeau, 'William Morris', 249.

20 See Felce, *William Morris,* 121ff., for a detailed analysis of this develop-
 ment, and Gary Aho's Introduction to *Three Northern Love Stories* (Bristol:
 Thoemmes Press, 1996), xv–xvi, for a description of a similar change in the
 treatment of kennings in two versions of *Gunnlaugs saga.*
21 *TSL,* vi.ix–x.
22 Felce, *William Morris,* 122.
23 *The Story of the Ere-Dwellers,* 73.
24 Litzenberg, 'Diction', 331.

'The Whole Man'
Morris's Public Lectures

Simon Grimble

Writing in *Culture and Society* in 1958, Raymond Williams made the following claim about what he considered to be the most important parts of William Morris's work:

> I would willingly lose *The Dream of John Ball* and the romantic socialist songs and even *News from Nowhere* ... if to do so were the price of retaining and getting people to read such smaller things as *How We Live, and How We Might Live*, *The Aims of Art*, *Useful Work versus Useless Toil*, and *A Factory as it might be*. The change of emphasis would involve a change in Morris's status as a writer, but such a change is critically inevitable. There is more life in the lectures, where one feels that the whole man is engaged in the writing, than in any of the prose and verse romances.[1]

Williams's analysis here is based on a broader contention about what was most valuable in Morris's work and how this had been subject to 'dilution'.[2] He argues that Morris's reputation had been too much associated with 'a campaign to end machine-production'.[3] For Williams, there are two problems here. Firstly, the emphasis on Morris as handicraftsman with his supposed opposition to machines enables readers to imagine him as sentimental, nostalgic, and impractical, rather than to take seriously 'the scale and nature of his social criticism'. Secondly, there is a problem in some of Morris's actual work in that 'the prose and verse romances [are] so clearly the product of a fragmentary consciousness', and, more generally, 'his literary work bears witness only to the disorder which he felt so acutely'.[4] So, if his work as a handicraftsman and as a literary figure are compromised for these reasons, then what is left are the lectures and Morris as 'a fine political writer': 'it is on that, finally, that his reputation will rest'.[5]

If Morris's lectures, as part of his work as a 'political writer', are his central achievement, then it is obviously important to take them very seriously. Williams sees his other work as in some way a displaced activity whilst the lectures are 'directly in the heat and bitterness of political struggle', a place

where 'the whole man is engaged in the writing'.[6] In that sense, Williams is producing a vision of Morris as 'the Hero as Man of Letters', as Thomas Carlyle had described it in his lecture on the topic in 1840, where Morris enters into the public sphere of political debate and attempts to win victories for his cause. The mode is therefore manly and chivalric: 'the whole man' going into danger against a known if rather generalized enemy, putting both his mind and body at risk. Whilst important elements of Williams's ideas here are insightful – Morris certainly did see his lectures and political speaking as a central task once 'I fell into *practical* Socialism' (xxiii.278) – a more complete portrait would see the lectures as themselves also composed of the uncertainty, ambiguity, and tension that we also find – along with his confidence, artistry, and skill – in his other works.

One place to start would be to think of Morris's ambivalence about taking up the role of the public lecturer. This ambivalence was in fact widely shared amongst such 'public men' as Victorian men of letters. Whilst Carlyle had seemed to announce the inauguration of the era of 'the Hero as Man of Letters', he himself seemed to have had very mixed feelings about both the phenomenon in general and his own embodiment of it in particular. After his first lecture in the series of what would become, on book publication, *On Heroes, Hero-Worship, and the Heroic in History*, Carlyle wrote to his sister:

> I thought I should get something like the *tenth part* of my meaning unfolded to the good people; and I could not feel that I *had* got much more. However, *they* seemed content as need be; sat silent, listening as if it had been gospel: I strive not to *heed* my own notions of the thing,—to *keep down the conceit* and ambition of me, for that is it! I was not in good trim; I had awoke at half past 4 o'clock &c. … What the papers say for or against, or whether they say anything, appears to be of no consequence at all.[7]

This passage discloses a series of key reasons for that ambivalence. Firstly, the fear that the audience will not understand you completely: that either through their levels of education or intelligence or sympathy, it will not be possible for the lecturer to communicate their message. Behind this, of course, may also lie a fear that the lecturer could also be at fault for the fact that the audience may only get 'something like the *tenth part* of my meaning'. Secondly, there is a relation here between the figure of the public lecturer and that of the preacher or religious minister. Carlyle's audience seem to be at church: they 'sate silent, listening as it had been gospel'. This may be useful in terms of a respectful hearing but perhaps they will end up being too 'content', and will not be thinking hard enough about what is said. Just as the audience may dutifully go to church or chapel,

they may dutifully go to a public lecture and the effect may be roughly the same. On the other hand, the public lecturer may also feel that they are something of an impostor in their imitation of the position of the religious minister, and that there may be an ungodly element in that. Furthermore, it is noticeable that Carlyle is fearful of the temptation of the sin of pride if, in fact, the lecture does go well: 'I strive not to *heed* my own notions of the thing, *to keep down the conceit and ambition of me,* for that is it.' The Devil seems to be somewhere in the lecture room, drawing Carlyle towards 'conceit and ambition'. And then the passage considers the stress and anxiety that goes into the process of lecturing that is felt in the body: 'I was not in good trim. I had awoke at half past 4 o'clock.' And, finally, there is the concern about the broader reception of the lecture, which would have been attended by representatives of a series of newspapers and periodicals, who would write up their own accounts of what Carlyle said and how he said it: Carlyle may appear not to care 'what the papers say for or against', but as a proponent of what would come to be called 'social criticism', who wished to have his criticism not just understood but in some sense acted upon, we know that the not caring really does not apply.

All of these questions – about reception, delivery, and the capacities of the audience – would press on William Morris too. There is an additional element of comparison that applies not just to Carlyle and Morris, but also to other social critics such as John Ruskin and Matthew Arnold. This is the fact that each turned to this kind of direct intervention in the public sphere in middle age after having established their reputations in related but more specific domains: for Carlyle as an essayist and historian, for Ruskin as a critic of art and architecture, and for Arnold as a poet and as a writer of literary criticism. Morris had established his reputation as both a poet and as a handicraftsman, although this position was in itself ambiguous in the case of Morris, as he shared both some of the characteristics of the artisan and those of the bourgeois, capitalist man of business. But, unquestionably, through these various endeavours Morris had established his 'title to be heard',[8] so in that sense the lectures were indeed the culminating and central point of his whole career, the point at which the hero as man of letters literally came before the public, to take up the cudgels, and to right public wrongs. So, the timing of Morris's first taking up of this position can be dated precisely: to 4 December 1877, when Morris delivered 'The Lesser Arts' before the Trades Guild of Learning. The Guild itself was a combination of middle-class philanthropy and trade union organization: initiated by the Revd Henry Solly, a Unitarian clergyman, it intended to provide vocational and further education supported by the

funding and organization of affiliated trade unions. Morris's lecture came after the trade unions had asserted themselves in terms of controlling the activities of the Guild, following the resignation of Solly – as representative middle-class philanthropist – at the end of 1873.[9] So, in that sense, the split nature of Morris's identity as a worker was also reflected in the nature of the organization that he was addressing on that night in 1877.

Morris's feelings about this movement into an explicit engagement with public life were complex. 'The Lesser Arts' was delivered as Morris's engagement with public controversy was heightening – via both his work for the Society for the Protection of Ancient Buildings and through his engagement with the Eastern Question Association, a liberal pressure group that sought to promote resistance to Benjamin Disraeli's alliance with Turkey. On 24 October 1876 he had written to the *Daily News* about his fear that 'England' was drifting into war, giving the following insight into how his feelings were developing:

> I who am writing this am one of a large class of men – quiet men, who usu-
> ally go about their business, heeding public matters less than they ought,
> and afraid to speak in such a huge concourse as the English nation, however
> much they may feel, but who are now stung into bitterness by thinking how
> helpless they are in a matter that touches them so closely. (MacCarthy, 380)

Evidently, Morris felt that his position as one of the 'quiet men' must now end. It is noticeable as well that Morris connects political articulation with feelings of 'bitterness': implicitly, he seems to be saying that it should not be necessary for him to speak out, but, as that is not the case, he will need to speak out whilst carrying the feelings of bitterness with him. In that sense we can also see the repressed temper of Morris who really wishes to be 'quiet'. So, in that sense the quietness partly generates the bitterness: in a better ordered state, it would not have been necessary for him to speak. But speaking in public, even bitter speaking, has become a duty. As Fiona MacCarthy wrote in her biography of Morris, 'it seems as if Morris, through the late 1870s, was shedding one persona and making himself a new one, deliberately preparing for a new role in the world' (MacCarthy, 382) and public speaking was the articulation of that role.

However, 'speaking out' is not quite as straightforward as this implies. There are many factors that have to be borne in mind: the nature of the audience you are addressing (which may also be divided in their views in different ways), the question of the content of what the speaker is trying to relay and the question of the modes to be used by the speaker, which in Morris tend to move between explication, lyricism, and denunciation.

'The Lesser Arts' in its published version begins with the first of these categories, as Morris begins to establish his reasons for focusing on the decorative arts, making his key claim that 'it is only in latter times' these arts have become harmfully separated from architecture, sculpture, and painting, from their previous position of unity with them (xxii.3). Morris then attempts to combat this condition of separation by, firstly, showing why the decorative arts are important in themselves and, secondly, by showing how the condition of separation between those arts and these more elite aesthetic modes is in itself a problem and a crucial indicator of the 'signs of the times' in contemporary England. To do this, he first needs to establish that his audience of artisans at the Trades Guild of Learning are the contemporary practitioners of these arts, who like those arts themselves, need to be appropriately valued, and that he, Morris, declares himself to be one of them:

> Nor must you forget that when men say popes, kings, and emperors built such and such buildings, it is a mere way of speaking. You look in your history-books to see who built Westminster Abbey, who built St. Sophia at Constantinople, and they tell you Henry III., Justinian the Emperor. Did they? or, rather, men like you and me, handicraftsmen, who have left no names behind them, nothing but their work? (xxii.6–7)

The radical lecturer must therefore be concerned with getting beyond the 'mere way of speaking' which makes us think that Henry III and Justinian built Westminster Abbey and St Sophia rather than the 'handicraftsmen' who have left 'no names' but who have left these great works of architecture. Of course, Morris is deviating here from any 'great man' theory of history (as expressed by Carlyle himself) to refocus on the people and their creative labour. He is also trying to reforge solidarity between the elite practitioner, in the form of Morris, and these artisans, 'men like you and me', and to see all of them as involved in a singular creative practice. His reasons for his desire for such a reunification become clear in a later moment of the lecture:

> The artist came out from the handicraftsmen, and left them without hope of elevation, while he himself was left without the help of intelligent, industrious sympathy. Both have suffered; the artist no less than the workman. It is with art as it fares with a company of soldiers before a redoubt, when the captain runs forward full of hope and energy, but looks not behind him to see if his men are following, and they hang back, not knowing why they are brought there to die. The captain's life is spent for nothing, and his men are sullen prisoners in the redoubt of Unhappiness and Brutality. (xxii.9)

The metaphors here are expressive of Morris's position. Through a process of economic change, the artist has become separated from the handicrafts-man, from their previous position of similarity. Morris does not describe the process here, but it bears a relation to how Ruskin had described the transition from the collective, social world of the Gothic to the individu-alized, and also prideful and sinful world of the Renaissance, where artists become feted as 'great men' or geniuses. Morris's second metaphor is a martial one: he imagines the artist as the captain leading his company onward into an attack on a 'redoubt' (a type of temporary fort), where he runs forward, but 'they hang back, not knowing why they are brought there to die'. The artist dies 'for nothing', and the handicraftsmen end up as the 'sullen prisoners' of the 'redoubt of Unhappiness and Brutality' that they were supposed to be attacking.

It is worth breaking down some of Morris's thinking here. The cap-tain (who we could assume is some version of Morris himself) is left as a fallen hero, a kind of heroic failure, whilst it is his men who are the source of his betrayal. Morris does not elaborate on ideas of betrayal in the lec-ture, but it is clear that whilst the artist and the handicraftsmen may have been originally the same, the artist is now in this position of lonely lead-ership, vulnerable to the lack of confidence of his troops. He worries that their attacks will not lead to success but to death and separation. In one sense this is exactly what is at stake in Morris's public lecture. As the days of equality between artists and handicraftsmen are now over, Morris has to lead the charge, but fears his ventures into the 'heat and bitterness of political struggle' will end up as stories of failure and betrayal. And whilst Morris desperately wanted to be one of the 'handicraftsmen' he cannot help but imagine the artist (and himself as a public lecturer) as in this sol-itary role of fateful leadership.

In these senses, a public lecture was always possibly an experience of fail-ure for Morris. Rereading these lectures, we can always feel the changing temperature of Morris's thoughts, through confidence and ringing asser-tions to doubt and anger. Towards the end of 'The Lesser Arts' we hear one of Morris's most famous formulations that confirms the new prospective that Morris was trying to create – 'I do not want art for a few, any more than education for a few, or freedom for a few' (xxii.26) – but lectures are composed of more than such moments of lucidity and incision. It may be worth considering the fact that whilst Morris from the late 1870s thought of public lecturing and political activity as a public duty that he had to take up, he also felt very great resistance to this particular role. This resis-tance can be seen in various aspects of both his lectures and his expressed

attitudes towards them. Firstly, it should be noted that lectures are an explicitly rhetorical form, in that they use various techniques to educate, cajole, and persuade their listeners to agree with the speaker. On the other hand, Morris tended to feel resistance to rhetoric as such.[10]

What was this resistance to rhetoric about? It should be considered that, for Morris, rhetoric and the rhetorician are closely related to everyday politics and the politician, modes in which the speaker is trying to achieve some limited short-term gain, possibly through the use of deceitful or underhand methods. As, and increasingly into the 1880s, Morris wished to overthrow rather than honour the modes of public speech that were associated with parliamentary democracy, he did not wish to use rhetoric as such. This is a problem as lectures are necessarily rhetorical, even if the modes used can be very various indeed. And as we reread his lectures, we can see that this resistance shapes the lectures themselves, in the sense that Morris tends not to be concerned with the overall organization of his argument. This means that in a lecture such as 'The Beauty of Life' that argument can become quite discontinuous: we move through various fascinating thoughts on the failures of the Renaissance, the nature of Birmingham (where this lecture was first delivered), his hope that the nineteenth 'Century of Commerce' will be replaced by the twentieth 'Century of Education', his fears of the development of the 'residuum' ('an ugly word for a dreadful fact' [xxii. 65]),[11] before we arrive at the central and memorable peroration (another rhetorical form) on how 'if you want a golden rule that will fit everything, this is it':[12]

> Have nothing in your houses that you do not know to be useful or believe to be beautiful. (xxii.76)

'A golden rule', presumably, is a rule that cannot be argued about, that is not to be subject to the contestation of politics, but Morris's statement can also be viewed as what would become a political 'slogan'. This term had by the late nineteenth century moved from its earlier definition as 'a war cry or battle cry' to its contemporary meaning as 'a motto associated with a political party or movement or other group, or a short and striking or memorable phrase used in advertising' (*Oxford English Dictionary*). We can see that Morris would have seen his golden rule having something in common with both definitions of the word slogan – he wanted both the 'war cry' and the 'memorable phrase'. He is trying to make a type of affirmative speech that somehow changes normal speech, which is of course implicated in the disastrous society in which Morris lived. Writing about the figure of the poet, Morris had said that 'before he can even begin

his story he must elevate his means of expression from the daily jabber to which centuries of degradation have reduced it. And this is given to few to be able to do' (*CL*, ii.483). Morris's assertive 'golden rule' may not seem necessarily to be a type of elevated speech, but its emphasis, clarity and confidence is an attempt to challenge an everyday language too much exposed to 'centuries of degradation'.

Morris's attempts to escape this 'daily jabber' are also connected to his growing belief that ordinary democratic politics should be overwhelmed. Current constructions of both language and politics limit human capacity, to his mind. This was particularly the case after he was fully 'converted' to the socialist cause in the early 1880s. As he later wrote in 'How I Became a Socialist', Morris viewed even extra-parliamentary politics of the type that he had been involved with as 'cumbersome and disgustful', even if 'necessary' (xxiii.278). It is also true that Morris thought of rhetoric as having a class basis that he would altogether wish to avoid. For George Bernard Shaw, the issue was one of how Morris saw his fellow participants in the social struggle: 'He could be patient with the strivings of ignorance and poverty towards the light if the striver had the reality that comes from hard work on tough materials with dirty hands, and weekly struggles with exploitation and oppression; but the sophistications of middle class minds hurt him physically' (*WMAWS*, ii.xviii). In the same light, Morris wished his lectures to be more concerned with questions of justice, with the struggle between social good and social evil, than with the fine calibrations of rhetorical sophistication.

In practice, though, an opposition between justice and rhetoric is a false one. Morris's lectures are works of rhetoric even as they are concerned with justice. His socialist conversion had the effect of stabilizing his lectures as he by then knew at which point he always wished to arrive. But, on the other hand, they could also have the effect of making them repetitive: as he wrote, 'after all I have only one thing to say and have to find divers ways to say it' (xvi.xv). The most striking of the lectures tend to be those that had the most dramatic quality, where Morris was particularly focused on the audience and occasion he was speaking to, rather than feeling he was repeating old material. A particular example of this is his lecture on 'Art and Democracy', given at University College, Oxford in November 1883. Morris wrote before the lecture: '… I intend making this one more plain-spoken; I am tired of being mealy-mouthed' (*CL*, ii.175). At the mid-point of the lecture, Morris makes a symbolic unveiling: 'For I am "one of the people called Socialists" …' (xxiii.172). Morris is trying to speak clearly and directly, and without the mask imposed upon him and others by class

society. But of course at this point he is also enjoying the tension that existed between him and the Oxford setting: Oxford being both a place he dearly loved and an extreme embodiment of the divided society he wished to criticize. At the lecture's conclusion, he begins his final paragraph with an almost plaintive, defeated hope: 'Art is long and life is short; let us at least do something before we die' (xxiii.191). He then tries to establish the terms of his appeal to his audience, using, perhaps surprisingly for Morris, a type of flattery: 'Help us now, you whom the fortune of your birth has helped to make wise and refined' The attempt is to ally this audience with Morris's 'us' of the workers and the socialists so that together they can 'break the spell of anarchical Plutocracy'. This is the very end of the speech:

> One man with an idea in his head is in danger of being considered a mad-man; two men with the same idea in common may be foolish, but can hardly be mad; ten men sharing an idea begin to act, a hundred draw attention as fanatics, a thousand and society begins to tremble, a hundred thousand and there is war abroad, and the cause has victories tangible and real; and why only a hundred thousand? You and I who agree together, it is we who have to answer that question. (xxiii.191)

We go from the isolated single man 'in danger of being considered a mad-man' through these developing dimensions of engagement before the revolutionary cause becomes a general and dynamic one. And, by the end, the pronouns demonstrate that 'you and I' have now become 'we'. Morris's hopes for the future are now not fragmented but present in the room.

It was of course difficult to maintain the revolutionary upsurge of the end of 'Art and Democracy'. Ordinary life swiftly resumed, even if socialist agitation became a characteristic part of that daily life for Morris. In 1887, in his 'Socialist Diary', Morris writes of giving his 'Monopoly' lecture at the Borough of Hackney Club, 'a dirty wretched place enough': 'the meeting was a full one, and I suppose I must say attentive, but the comings and goings all the time, the pie boy and the pot boy, was [sic] rather trying to my nerves: the audience was civil and inclined to agree, but I couldn't flatter myself that they mostly understood me, simple as the lecture was' (Socialist Diary, 45). Here, the romance of the cause is not present, and the condition of separation of 'you and I' obvious. Such moments led Morris to doubt whether this type of political engagement could ever work; after one lecture Morris wrote that 'I felt very down cast amongst these poor people in their poor hutch ...' (Socialist Diary, 33–4). On another occasion, following an exchange at a lecture with a member of the audience, the sympathy could turn into a kind of depressed social Darwinian contempt:

'A fresh opportunity (if I needed it) of gauging the depths of ignorance and consequent incapacity of following an argument which possesses the uneducated averagely stupid person' (*Socialist Diary*, 42). Equality seems to fade away as Morris despairs of the capacities of his audience. What he seemed not to realize was that his grand presence itself could have intimidated his working-class audience and prevented them from showing their intelligence, or at least in a way that he would have recognized. Morris came instead to prefer speaking at open-air mass protests, distant from the 'pie boy and the pot boy': according to MacCarthy, 'he could communicate most forcefully, and most emotionally, at a little distance from the crowd' (MacCarthy, 559). Speaking in Northumberland in 1887, political life seems to be turning into a medieval pageant:

> Then we started without any show or banners or band, and consequently without many with us: about halfway however we picked up a band and a banner and a lot of men, and soon swelled into a respectable company: the others had got there before us and lots more were streaming up into the field: the day was bright and sunny, the bright blue sea forming a strange border to the misery of the land. We spoke from one wagon Fielding of the SDF in the chair, then Mahon then me then Hyndman then Donald. It was a very good meeting ... (*Socialist Diary*, 53)

In this case, Morris seems to be more engaged with the assembling of the company, a 'Gideon's band' of adventurers (xxii.117), than with the speaking itself: the portraiture of the scene here reminds us of the printed books of Kelmscott Press, with 'the bright blue sea forming a strange border to the misery of the land'. But the whole scene is dynamic and alive, as if Morris can imagine this event itself as the crossing of a 'strange border': he has finally arrived at a place where art, public speaking and the condition of the people are now integrated and not separated. But the entry ends and 'the next day I went up to London and got to the Council in time to come in for one of the usual silly squabbles about nothing ...' (*Socialist Diary*, 54). Hope for this utopian potential future turns back into the grind of routine, contestation and disappointment. Morris's lectures are, as Raymond Williams argued, a central achievement, where 'the whole man' did both speak out and make available for others similar tools for understanding the world in which they lived. Looking back at these lectures now, in a world so full of the very concerns that Morris tried to grapple with, we can agree and disagree with many of his lessons because 'it is good for a man who thinks seriously to face his fellows, and speak out whatever really burns in him, so that men may seem less strange to one another, and misunderstanding, the fruitful cause of aimless strife, may be avoided' (xxii.49).

Notes

1 Raymond Williams, *Culture and Society, 1780–1950* (London: Hogarth Press, 1992), 155–6.
2 Ibid., 155.
3 Ibid., 155.
4 Ibid., 155, 156.
5 Ibid., 156.
6 Ibid., 155.
7 Thomas Carlyle, letter to Jean Carlyle Aitken, 6 May 1840, in *Carlyle Letters Online* (dukeupress.edu).
8 Stefan Collini, *Public Moralists: Political Thought and Intellectual Life in Britain* (Oxford: Clarendon Press, 1993), 199–202.
9 For details on the Guild, see W. P. McCann, 'The Trades Guild of Learning', *The Vocational Aspect of Secondary and Further Education*, 19.42 (Spring 1967), 34–40.
10 See, for example, Morris's views on John Milton: 'I did not care for Milton; the essence of him was rhetoric, though he was of course a wonderful versifier' (xxii.xxxi).
11 'residuum': The late Victorian term for the 'underclass', initially defined by John Bright MP in debates over the Second Reform Act in 1867 as 'those of almost hopeless poverty and dependence' (*3 Hansard* 186: 636–7, 26 March 1867).
12 'peroration': 'A concluding part of a speech or written discourse which sums up the content; a rhetorical conclusion, esp. one intended to rouse the audience' (*Oxford English Dictionary*).

Northern Epic
Sigurd the Volsung (1876)

Herbert F. Tucker

William Morris's *Sigurd the Volsung* (1876) is a poem that cleaves with extraordinary intensity to the investment epic makes in narrative, which operates simultaneously as the radical of knowledge, the exemplar and proof of morality, and the vehicle whereby a culture reproduces the lore and values that define it.[1] The poem is unified by a heroic ethos that valorizes such action as may deserve – together with action's entailed complements passion and suffering – commemoration in a heroic story. Protagonists get included in the tale that posterity tells because they have most vividly known themselves, and have most intimately known each other, to be already included in the epic logic by which they are summoned. Conversely villains, whose greed and false scheming encumber heroic generosity and divert the narrative flow, ultimately enrich these values in spite of themselves, having by their interference furnished negative illustrations that throw the affirmations of epic into higher relief. Morris's fluency in an elder diction and syntax keeps the narrated events from a bygone day at art's length but within ready imaginative reach.[2] His words ride all the while on a couplet-rhymed prosody that relaxes the classic hexameter into two equal halves of 4/3 vernacular balladry (three beats till a medial caesura counts four, three more to the end of the line). This versification presents the fortunes of Morris's Nordic royals as the people's story too, which is what he insisted any true epic must be. And his versatile handling of duple and triple feet imparts to the line a freedom that fosters not forgetfulness of verse's mediation, but an easy habituation to verse's way of putting things. Language and prosody alike wrap the reader in a heterocosm that enacts its own reason for being. Embraced by this self-reinforcing surround of content and form, we make Morris's legend ours; to that extent, we play a part in its heroic universe (see Figure 9.1).

Figure 9.1 Prints of frontispiece of William Morris, *The Story of Sigurd the Volsung and the Fall of the Niblungs* (Hammersmith: Kelmscott Press, 1898): (a) verso and (b) recto

The Impagination of the Reader

The sumptuous 1898 Kelmscott Press edition of *The Story of Sigurd the Volsung and the Fall of the Niblungs* offers, in the magnificent two-page opening that strikes up the overture to the tale, a breathtaking bifold revelation of the values that inform Morris's masterpiece. These values are profoundly ethical, if often shockingly so. But they are in the first instance aesthetic, pitched to the eye with an intricacy of detail that would merely dazzle were its manifold design less harmonious, its abundance less tempered by symmetry and proportion. Within the stylized spontaneity of a border of twining vines, each folio page of the opening frames a rectangle of text that stakes out the dimensions of the planar field within which the following 200 pages of verse will appear. The left-hand text is pictorial: W. H. Hooper's engraving of a drawing by Edward Burne-Jones that replicates internally, and many times over, the picture's nestedness within its white-on-black border. As the frame reaches out to the page's last half-inch of white margin, so the picture fills its rectangle, with the view through an arched window whose columns flank a hall lined by benches and dining tables that recede in perspective past a brace of upper windows toward

a tapestried rear wall. Commanding this three-dimensional chamber is a massive tree, which we are about to meet as the Volsung Branstock, its trunk rising through the floor, its upper reaches at ceiling level crowded with a tangle of branches and leaves, which are flocked in turn with black hawks. The birds in the foliage on the tree in the room through the window in the picture in the border on the folio page compose, as in recursive fractal ratio, an ordered poise that stills the cognitive overload of the amazed viewer's first exposure.

Something analogous takes place within the rectangle on the right-hand facing page, this time in the currency of word rather than image, print rather than engraving. For it is this page's business to accustom the reading mind gradually, by way of the eye and then of the ear, to the medium of verse. Where Burne-Jones's image mobilizes an in/out axis of visual penetration, Morris activates the reading vectors that run from top to bottom of a text, and from left to right, even as he attunes the reader by degrees to the rhythmic pulse that will govern his epic narration. Two lines in the book's largest type proclaim the title of the work and of its first Book, followed by several lines of plot overview, in a font half as large and in prose. The printer's authority, not the poet's, dictates a hyphen in 'Vol-sungs' and then, once prose has had its say, inserts a gratuitous half-line reprise of the vine motif from the paginal border, bespeaking a remarkable diligence to load every rift in the inked page with forms. A numbered, rubric-red chapter title meets this requirement snugly in the line that follows. (It concurrently, like the title of the entire work, admits of scansion into the hexameter that remains, at this point, in abeyance.)

Next the down-clambering reader arrives at the most conspicuous feature in the entire print rectangle, a huge block that seems to have strayed over from the left-hand page but proves to be a coup of calligraphy: an enormous decorated T, figurehead to the 'There was' that now launches the narrative proper. This alphabetic behemoth crowds across eight-plus lines of all-caps type that it takes some effort to recognize – with the enigmatic prompt of a sprinkling of leaf-shaped punctuation marks – as the first four verses (two initial couplets) of Morris's poem. Only once a fifth verse has been conscripted to fill out the block of type commandeered by the giant T does the Kelmscott *Sigurd* settle at last into the norms for printed verse to which Morris had conformed the conventionally typeset first edition: a majuscule letter at the head of each line on the left, a varied terrain of white space on the right where shorter or longer lines end. This familiar layout persists henceforth across the entire poem, but only after the deliberate dis-orientation which we have just negotiated,

Figure 9.2 Prints of tailpiece of William Morris, *The Story of Sigurd the Volsung and the Fall of the Niblungs* (Hammersmith: Kelmscott Press, 1898): (a) verso and (b) recto

and which moreover deposits gently estranging reminders on every page that follows. One of these is the recurrence of enlarged flush-left capitals to mark the start of each new strophe or verse-paragraph, which the 1876 edition had marked in the usual way with blank space of the sort we have seen the Kelmscott *Sigurd* so zealous to eliminate. This density of presentation emerges more subtly in the fact that at no point in the poem is a fully flush-left verse ever carried over into a second line of print. Defining exceptions to this rule occur where oversize decorated capitals that begin Books II, III, and IV again crowd lines far to the right, and where, at the very finale, a bordered rectangle facing a second Burne-Jones image uniquely impounds the printed text in a space so strict that a few lines must be run on (see Figure 9.2a).

Taken together, these typographical curiosities – within a book so scrupulously executed right after Morris's death by his associates and heirs in the printing craft – constitute a strong and instructive bibliographical interpretation of the poem he had written decades before. The symmetrical interplay between type and engraving, in which the beauty of the font steadily participates, and which the decorated capitals subliminally re-enact at every appearance, both preludes and underscores the equilibrium

of *Sigurd*'s hexametric balladry. At a different level of textual performance, the masonry of the page, the seamless mortise of its blocks of verse, brings out the premium Morris placed on *plenitude*, as a quality at once of his epic's manner and its matter. Morris's telling makes, out of a saga compounded from violence and betrayal, greed and vengeance, heartbreak and renunciation, a work whose sorrowing equanimity, while brightened by beams of tragic joy, finds its sustaining warrant in the sheer epic function that is the telling itself. The construction of events, causes, and consequences is, like the verse that bears the story along, ample but not diffuse; thrifty but unhurried. This at last is the sense in which the poem's aesthetic and ethical values suffuse one another. The plot of *Sigurd* is centrally concerned with the fulfilment of promises, which even when they are thwarted or broken – perhaps especially then – achieve fulfilment in that deferred keeping of faith which is their narrative recounting, and in which Morris contrives that the reader too shall immersively participate. Bare of explanatory notes and translator's glosses, the poem concedes so little to the modern temperament that, before we can begin to understand it, we are obliged to inhabit the tale's account of itself. We, for our part, also have work to do and promises to keep. Our answering commitment redeems the lot on which the Volsung and Niblung heroes have staked their lives. This is why the Kelmscott edition presents, not an editorial apparatus, but a scripted induction that interprets, by bibliographical rites of passage, the integrative plan of the whole.

The Tally of Totality

The recursive, inclusive totality of *Sigurd* gets represented locally more than once in the poem, and in more than one way. The first is synchronically panoramic, offering a microcosmic inventory of the known world, to which by long-standing generic licence the epic claims full access. Morris renders such a microcosm in the ancient Gripir's crystal ball '[t]hat is round as the world of men-folk, and after its image made', replete with 'ocean' and 'forests', crops and ore (xii.98). This synoptic inventory figures, even as it assays, the omniscience that epic shares with such later genres as the atlas or encyclopedia. Its catalogue, while brief, might go anaphorically on forever, inasmuch as it credits the 'all-wise' Gripir with an authority that, like that of the 'omniscient narrator' dear to literary theory, is strictly speaking tautological: the everything that epic knows is neither more nor less than everything that the epic knows; the epic world and epic text are coextensive.[3] Gripir's inexhaustible vista comes, all the same, at the cost

of an impotent disengagement from it: 'For all his desire was dead, and he lived as a god shall live' – a condition Morris highlights by contrasting Gripir to the young Sigurd beside him, armed and mounted and bristling with impatience yet, so far, with nowhere to go.

The plot is not stalled for long, however. For Gripir advances from the spatial mode of totality to a different, temporal one, exchanging a surveyor's tally of current events for a prophet's telling of things to come. In a page-long oracle (xii.99–100) the sage rehearses the future climaxes of Sigurd's career, from the slaying of Fafnir the dragon to his love for Brynhild and at last his own murder at treacherous Niblung hands. These episodes are obscurely ordered in Gripir's visionary foretelling; that it will be the business of the eventual tale to get things right is the burden of his repeated phrase 'Short day and long remembrance' and his admonition that Sigurd 'smite now', 'Lest the dear remembrance perish, and today not come again' (xii.99). Gripir can hardly fear that Sigurd will forfeit his opportunities by neglect, so the real anxiety is on behalf of the tale, without whose long and dear remembrance the short day will not 'come again' in the deferred bequest of legendary tradition. The omniscient, omnipresent 'now' of the crystal ball is, while beautiful, by the same token pointless; only the iron of human limitation can render golden the 'now' of mortal deeds, in an act of faith that will be made good by the sustaining tale it inspires. To see 'as a god' – a recurring temptation to which antagonists succumb and protagonists say no – proves incompatible with epic heroism.

These counterpoised totalities of space and time return at the summit of Hindfell, where Sigurd wins his way through fire to awaken Brynhild in the fastness Odin has built her. Having rapidly fallen in love, the pair climb up to a panorama like the crystal ball's, including farmland, forest, coast, island, and what human craft has made of these resources (xii.129). Book II ends within a page of this gorgeous vista, at a climactic midpoint that might have concluded the lesser, happier poem that we know *Sigurd* cannot rest in being. We know this because Brynhild has just taught it to Sigurd, in an extended passage of 'And she told …' anaphora epitomizing the ways of the world (xii.128). The verb 'told' is not casually used: Brynhild's seamless digest of cosmology, sociology, and psychology propounds at once an outline of Viking history and a prediction reminiscent of Gripir's. Her survey of the human prospect gravitates toward narrative, and its recognition of 'the lurking blinded vengeance' that sponsors a culture so radically retributive as was that of the Vikings ends nevertheless with that best revenge which is telling well: 'how man shall measure it all, the wrath, and the grief, and the bliss'. When a symmetrically placed

passage early in Book III shows Brynhild at the loom, weaving a tapestry whose shining panels resume, as in a slideshow, the plot of the first two books, we hail the poignancy of her ambition to arrange into order a narrative that dark forces are about to hijack (an effect distilled by omitting a passage from the Icelandic source in which Brynhild foretells, in fast-forward overview, the rest of the plot).[4]

Morris, who regarded weaving and poetry as comparable arts of linear registration and composition, lent himself to so many crafts that he became acutely conscious both of the distinction between synchronic and serial patterning and of how, within a mixed medium like verse narrative, that distinction can also engender dynamic tension. Much as rhythm can animate a wallpaper design and flow through a type-form, so echoic sympathy can link rhymes in a couplet; likewise, early and late images in a poem, or episodes in a story, can match each other as if, within the space of the artwork, they are not distant but mutually superimposed.[5] Take, for example, the architecture that houses so much of the poem's action. The hall of King Volsung takes pride of place in the Kelmscott frontispiece as it does in the poem's first lines. Book II starts with mention of the 'house' of Helper and Elf, presiding over a sequestered realm at peace. The second half of *Sigurd* describes 'the Niblung hall' on the opening pages of Books III and IV, while the final chapter recounts the consummate destruction of the palace of Atli in a fire set by Gudrun his indignant queen, the former Niblung princess and still grieving widow of our Volsung hero. In this conflagration all the great royal halls burn as one before the transfixed reader's mind, cued by the place they hold in the poem's construction, and finally by the Burne-Jones tailpiece depicting Gudrun the arsonist, a live torch in her hand, statuesque amid the flaming chamber at the same focal point on the page where the frontispiece planted the Branstock tree (see Figure 9.1a). Each retake of the long story erects a version of the same scenario, building thereby toward the destined catastrophe – further foreshadowed during Book I by Queen Signy's gleeful immolation, cool as a Volsung, inside the fiery palace of her despised husband Siggeir: 'She said: 'Farewell, my brother, for the earls my candles light, / And I must wend me bedward lest I lose the flower of night' (xii.41).

These houses are works of architecture, and their mutual relationship is a matter of literary architecture, a network of structural correspondence that spans the poem.[6] But the Volsung or Niblung 'house' is something else as well, a lineage: a vector of genealogy intending not a home, but a history, and unfolding along the duration of the tale rather than across the folds of the book. The stakes of royal lineage gradually mount, or decline,

from the beleaguered Volsungs' against-the-odds triple succession to a two-generation Niblung dynasty-in-the-making to, in Atli's case, a dead-end empire, a hoard without issue. Finally no 'house', in this genealogical sense, fares any better than its ruined real estate. So *Sigurd* passes summary judgement against the misery, which is the miserliness, of tight-fisted accumulation and its short-term expedients. Siggeir and Atli the petty and grand acquisitors, Regin the instrumentalizing designer, and Grimhild the toxic dynastic witch, all intervene to mar the circulation of honour and joy that actuates their heroic counterparts. By a radical irony, the worse these interventions prove for our protagonists the better they are for the epic, whose long view of narrative redress each impasse only further lengthens. This long view moreover validates the fullness of present absorption in which true craft works, and in which Morris's poem offers his reader an open, collaborative share. Mere craftiness, subordinating means to ends, gives ulterior motives priority over the living present and so occludes authentic relation to the world and to others. In contrast the now of heroic action and the now of its narrative representation remain in close touch. Morris's heroes abide in the poem because they have known how to dwell in the world, not just as the inmates or agents of a house.

A Tale of Two Genres

Epic superintends an anthology of genres, lesser or rival forms of writing that it metabolizes as organic functions within its own more capacious system. Sigurd's hymn of cosmology and ancestry (xii.165), and the great valedictory song of self that Gunnar chants at the eleventh hour from the snakepit to which Atli has condemned him (xii.297–9), participate in a venerable tradition of embedded odes, elegies, and psalms that epoists exalt yet also circumscribe by narration; characteristically, both these songs in *Sigurd* occur just before the heroism they kindle is to be extinguished by inimical events. We have already noted similar subgeneric ingredients in the prophecy of Gripir and the ekphrasis of Brynhild's tapestry. Lymdale, where that tapestry is wrought, represents a pastoral retreat from the epic acts Brynhild weaves; in two other episodes *Sigurd* again shelters a vulnerable queen from epic trauma in pastoral seclusion – the pregnant Hiordis (xii.61–7), the widowed Gudrun (xii.248–50) – but, given the overriding exactions of epic, interludes are all these episodes can be. The backstory engrossing Book I abounds with folk-tale material, signally the transformation of Sigmund and Sinfiotli into wolves (xii.32–3), and Signy's covert mission of sibling incest through a body-swap with a

witch-wife (xii.27–8). This is the stuff of romance, as of course is Sigurd's
archetypal dragon-slaying quest in Book II. For all the romantic appeal
of such extravagant incidents, it remains their generic destiny to be over-
taken by the options that belong to epic, which centrally narrates human
realities, and which the otherness of dragons, giants, dwarves and magic
serves to define.

As with the constituent subgenres we have just sampled, so it fared
with the Victorian epic's chief rival, prose fiction. Morris bypassed the
bourgeois novel not by disregarding it but by taking it in.[7] For a while,
that is, *Sigurd* exploits the novel's powers, and respects its limits, only
to transcend them in a final outburst that reclaims epic's early charter
to limn humanity as a wilder, more elementally severe compound than
novel-readers of Morris's time, or ours, have been accustomed to suppose.
The ordeal by fiction is one that every Victorian epic needed to undergo;
EBB's *Aurora Leigh,* Browning's *The Ring and the Book*, and Tennyson's
Idylls of the King had all done so during Morris's earlier writing career.
His generic itinerary was, if anything, more exigent than theirs because
he was drawing mainly on Icelandic materials, whose first reception by an
English readership took place during the heyday of the novel. Nothing
about the sagas struck home more keenly than their combination of
ferocity with domesticity, their portrayal of family and marriage as the
arena where loyalty and treason, revenge and remorse, were played out at
incandescent intensity.

Books III and IV enact, respectively, fiction's domestication of romance
and epic's supersession of fiction. The migration of Sigurd (and *Sigurd*) to
the house of the Niblungs in Book III not only shifts the main theatre of
action from outdoors to indoors but also changes the very key in which
action is rendered, from objective exteriority to the subjective inwardness
of the domestic novel. The drug-crossed wooing of Brynhild, the insolu-
ble four-way marital mismatch that ensues, the endurance unto death of
Sigurd then Brynhild, even Gunnar's clueless stolidity: these register as
interior, psychological phenomena, of a kind that has rarely concerned the
world-hardened doers of deeds who people the first half of the poem. A
contrasted pair of passages will illustrate this generic change. Afar on the
Glittering Heath, on the second Book's high plateau of romance, Sigurd
kills Fafnir, then Regin. The mythic reciprocity between these exploits is
clear enough, but we glean little or nothing about how carrying them out
affects Sigurd himself. He remains imperturbably outward-bound, keenly
but solely aware of what lies before him – in the passage that follows, the
corpse of a dragon that has just wailed its uncanny last:

And over the Glittering Heath fair shone the sun and the day,
And a light wind followed the sun and breathed o'er the fateful place,
As fresh as it furrows the sea-plain or bows the acres' face. (xii.112)

Vivid sensation fills the lines as it does the hero's mind, in response to the
magical display of a world full of wonders. Yet see next how differently
Sigurd tangles with magic when Grimhild's potion takes hold in Book
III. Morris devotes a passage too long for quotation to a detailed pageant
of symptomatic introspection: what Sigurd sees under the influence, what
he gazes at, tries to focus on, forgets, remembers, feels. The middle of the
passage renders a consciousness of loss as comprehensively privative as the
plenitude Sigurd knew on the Glittering Heath, only now the annihilation
of the world stands proxy for a sense of self-annihilation:

And no world is there left him to live in, and no deed to rejoice in or rue;
But frail and alone he fareth, and as one in the sphere-stream's drift,
By the starless empty places that lie beyond the lift:
Then at last is he stayed in his drifting, and he saith, It is blind and dark.
(xii.188)

The bare words Sigurd finds for his own nothingness crown the overcom-
ing of ontology by epistemology, of the known by the knower, of the
heroic feat by the novelistic sophistication of intra- and inter-personal
relations.

From this existential crisis of identity Book III carries novelistic sub-
jectivity and its discontents deeper into the domain of bourgeois realism.
When Brynhild arrives to marry Gunnar, Sigurd's long-erased memory of
their Book II trothplight suddenly returns; and the succeeding interview
between the two teases out with virtually Jamesian finesse the question of
who knows what about whom, together with the balked couple's unspeak-
able conviction that by now nothing to the purpose can be said about
any of it (xii.200–1).[8] Moments before this exquisite interview, Brynhild
has been reduced to the humiliating ritual of complimenting her despised
in-laws-to-be 'with voice unfaltering', and then has passed through a ves-
tibule featuring bizarre echo effects, as 'the whispering wind of the may-
tide from the cloudy wall smote back, / And cried in the crown of the
roof-arch of battle and the wrack' (xii.198). This is epic foreshadowing,
to be sure, of the domestic destruction that will ensue. But the novelized
protocols of Book III dispose us to wonder – as Book II never bothers to
wonder – in whose mind, if anyone's, these auditory portents take shape.
Later Morris trespasses so far into domestic fiction as to stage a catfight at
the swimming-hole between the two young queens, one of whom Sigurd

silently loves while he has wed the other. Before the low-mimetic comic business of the chapter is done, they are scrapping over a piece of 'linen raiment'; and Gudrun tells Brynhild to go to hell after Brynhild has told her, not quite in so many words, to go fuck herself (xii.212–13). Fictional realism, to the fingernails – and with a vengeance.

At the end of Book III Brynhild and Sigurd, perished martyrs to an impossible love, burn on one pyre in a consummation that frees them from the purlieus of Niblung domesticity into the larger second life of the epic tale. By this point maintenance of the house of fiction has devolved on Gudrun, who has been the proper heroine of Morris's embedded novel all along. Her complex, ripening love for Sigurd – part girlish hero worship, part aristocratic status pride, part highly credible sexual passion – falls within the parameters of the realist novel, whose techniques of incident, dialogue, and inner surveillance all conspire to develop in her a flawed, fictionally rounded character. For just this reason it is on Gudrun that *Sigurd* centres its Book IV pivot from novelistic into epic realism. In the course of the book she ascends a ladder of genres, advancing from pastoral retreat through the high life of a second courtly marriage into the terrible beauty of a vast redress convulsing the world she has inhabited.

One late passage measures in narrative irony the distance traversed by Gudrun's metamorphosis from a fictional into an epic heroine. As her thuggish husband Atli sets about torturing Gunnar for intelligence about the long since drowned hoard of Andvari gold (xii.264), he couches the interrogation in the novel's terms of subjectivity: 'What thoughtest thou, Gunnar, when thou lay'st in the dust e'en now?' (xii.290). Atli's sadistic curiosity about what his victim thinks shows what he himself thinks: that they are both still characters in a novel, albeit one of detection and espionage. Upon this venal psychodrama Gudrun looks impassively from her throne, where she has been ominously ensconced since the Niblungs' arrival. The figure of 'A white queen crowned, and silent as the ancient shapen stone' (xii.276) has presided over each stage of her brothers' betrayal and captivity. Is she passively exacting payback for their collusion in the assassination of her adored Sigurd? Quite possibly, but we no more know what she is thinking in Book IV than the Niblungs and Atli do. Throughout Atli's twisted inquisition, 'nought she stirreth yet' (xii.290) – where that ambiguous 'yet' combines 'however' with 'thus far', at a stroke locking us out of her mind and preparing us to look ahead, and to look for deeds rather than thoughts. Only once her brothers are killed does she unleash flame and sword on Atli and his plunder, and only once the deed is done does Morris give her a speech that outlines, after the fact, her

long-deferred plan to act, in the name of her 'ancient fathers' and of the time when 'I dwelt with Sigurd alone' (xii.304). Epic realism, at the last – and with a vengeance.

PS: Pausation

On the verge of this final soliloquy, Gudrun stops in the hall before her fire. 'Still she stands for a little season' (xii.304). What transpires during this pause at a culminating juncture of the poem remains a mystery; we cannot fill in the blank with cognitive or affective content the way we can often do within the psychological labyrinth of Book III. Indeed, the passage more nearly recalls Sigurd's inscrutably neutral prospect across the romantic Heath as we visited it in Book II. Both are pockets of narrative resistance to psychological reduction, and Morris scatters comparable lacunae like them throughout the poem. Suspending the plot for 'a little season', or 'moment' (Hogni, xii.280), or 'while' (Sigmund, xii.8), or 'space' (Regin, xii.103), or simply 'a little' (Gunnar, xii.294), these passages temporarily zero out character and bid us attend to plottedness as such. They chiefly pertain not to given incidents or persons but to the shaped pattern of the whole, which breathes through the interstitial pause like a living form. Within the plot line they function much as the medial caesura does within a line of Morris's verse: a weightless, empty place-holder; a textual interval that, unmarked itself, nevertheless marks time within the larger design, and without which the adjacent slacks and stresses would miss their step.[9]

I have dwelt here on how *Sigurd* vindicates an aesthetic and an ethic of *fullness*: comprehensiveness of genre, continuity of through-line, wholeness of outlook, integrity of commitment, and plenitude of textual presentation. These were the virtues that drew him to the northern sagas, and he took great care to fulfil their promise as he took up the old stories in his own way for his own time. Let me subjoin to this thesis something else. That is the role Morris found, amid the repletions of epic unity, for repletion's dialectical contrary: a hesitation, a hitch in the plot, a pause in the line, even a certain riddling perforation in the book that comprised plots and lines together. For all its textual density, the Kelmscott edition includes on almost every page one or more of those minuscule leaf shapes, glanced at above, that are to be seen in Figures 9.1b and 9.2a. These usually betoken, like the quotation marks in a conventional book, vocal shifts where the narrative is handed over to a character or taken back; very occasionally they indicate a metrical caesura, as in Book I (this may be as far

as Morris's active oversight of the folio *Sigurd* had lasted before illness and death prevented his intervening further). In every case they at once interrupt the uniformity of the page and replenish it; just where the text is differing from itself for a little space, that space is inked in more fully than it would be by an alphabetic letter. The foliated icon both diversifies the folio page and deepens its visual gravitas. As Morris knew, letting the tale go forward entailed letting go of it now and then.

Notes

1 See Herbert F. Tucker, 'All for the Tale: The Epic Macropoetics of Morris's *Sigurd the Volsung*', *Victorian Poetry*, 34 (1996), 373–94; and *Epic: Britain's Heroic Muse 1790–1910* (Oxford: Oxford University Press, 2008), 510–26.

2 See Karl Litzenberg, 'The Diction of William Morris', *Arkiv for Nordisk Filologi*, 53 (1937), 327–63.

3 See Simon Dentith, 'Morris, "The Great Story of the North," and the Barbaric Past', *Journal of Victorian Culture* 14 (2009), 243, on the poem's project of 'immersing itself in the world it seeks to evoke'; also Ian Felce, *William Morris and the Icelandic Sagas* (Cambridge: Brewer, 2018), 149–50.

4 *Völsunga Saga: The Story of the Volsungs and Niblungs with Certain Songs from the Elder Edda*, trans. Eiríkur Magnússon and William Morris (London: Walter Scott, 1888), 87.

5 See Elizabeth Helsinger on the work done by decoration in *Sigurd*, in 'A Question of Ornament: Poetry and the (Lesser) Arts', in Florence S. Boos (ed.), *The Routledge Companion to William Morris* (New York: Routledge, 2020), 271.

6 See William Whitla, '"Sympathetic Translation" and the "Scribe's Capacity": Morris's Calligraphy and the Icelandic Sagas', *Journal of Pre-Raphaelite Studies*, 10 (2001), 33.

7 For contemporary (and diametrically opposed) objections to this strategy of generic supersession, see *William Morris: The Critical Heritage*, ed. Peter Faulkner (London and Boston: Routledge and Kegan Paul, 1973), 247 and 262. On this subject, see also Felce, *William Morris and the Icelandic Sagas*, 110, 145; Ingrid Hanson, *William Morris and the Uses of Violence* (London: Anthem, 2013), 84–91; and Simon Dentith, *Epic and Empire in Nineteenth-Century Britain* (Cambridge: Cambridge University Press, 2006), 80–1.

8 May Morris writes that 'in all its epic simplicity, its terse bitterness … the things unsaid were no doubt unsayable' (xii.xxvi).

9 Cf. Florence S. Boos on the poem's recurrent 'frieze-frame of recumbent stasis': '"The Banners of the Spring to Be": The Dialectical Pattern of Morris's Later Poetry', *English Studies*, 18 (2000), 23–4.

Utopian Fiction
News from Nowhere (1890; 1891)

Matthew Beaumont

In his inaugural lecture as Rector of Edinburgh University in 1891, the statesman and businessman George Goschen, who was Chancellor of the Exchequer at the time, observed that, 'from Plato the philosopher, to William Morris in our own day, social reformers with literary powers and imaginative minds, have aspired to frame ideal states, ideal societies, and have engaged their constructive faculty in the description of conditions removed from the ordinary experience of the times in which they lived, and of the ages of which history holds record'.[1] In the past, Goschen explained, 'the creators of these older Utopias laid their fanciful communities in contemporary, but distant islands'. He is thinking, especially, of Thomas More's seminal *Utopia* (1516), which is set on a newly discovered island in the so-called New World. But a spate of recent utopias is rather different. The 'latest specimens of this kind of literature', instead, 'deal with the future'. They set their polities a century or so from the present: 'They are prophetical, they are evolutionary and revolutionary.'

'The prophetic romance is indeed becoming a feature of the literature of to-day', Goschen concluded, rather caustically adding that 'as a rule it is also propagandist romance'.[2] He was conscious that, in the late nineteenth century, utopian fiction was both a publishing phenomenon and a political one. Because of this, it is important to remember that, exceptional though it is both in formal and political terms, Morris's *News from Nowhere*, whose subtitle indicates that it is to be read as 'Some Chapters from a Utopian Romance', was one of hundreds of fantastical novels, many of them set in the future, that appeared as more or less explicitly political interventions in the final decades of the nineteenth century. From Edward Bulwer-Lytton's *The Coming Race* (1871) and Samuel Butler's *Erewhon* (1872) to H. G. Wells's dystopian fiction, up to and including *When the Sleeper Wakes* (1899), the prophetic or utopian romance was a positively fashionable form, especially in its least crudely propagandist forms. Proof of this is to be found not simply in the bibliographic statistics from this

time but, more punctually, in one of a series of articles on 'What the People Read' printed in the Academy in 1898.[3] There, 'A Wife' is asked whether she 'likes novels about the future'. 'She pondered a moment, wrinkling her brows', the anonymous journalist reports: '"Well, I can't say that I exactly like them," she said; "but one has to read them, because everyone talks about them."' If the popularity of utopian fiction declined rather steeply after the turn of the century, as the tide of political millenarianism receded, the hopes that it articulated were only finally trampled underfoot during the apocalyptic events of the First World War. Ever since this time, fiction set in the future, after Wells's example, has been decisively dysto-pian in outlook.

In the closing decades of the nineteenth century, then, there was News from Everywhere (perhaps this is to be expected in an epoch when the newspaper industry, like the telecommunications industry more gener-ally, experienced rapid expansion, not least in an imperial context). From far-distant islands, far-distant planets, and, above all, from numerous different futures – certainly, no other period in literary history has pro-duced such a concentration of utopian fiction. Why is this the case? The third quarter of the century, roughly between the revolutions in Europe in 1848 and the brief victory of the Paris Commune in 1871, was a period in which, aside from its innately competitive character, the industrial capitalist system seemed relatively stable. These were comparatively affluent decades for the manufacturing middle classes; and the working classes, for their part, benefitting in certain limited, temporary respects from this stability, as well as bruised by the defeats of the late 1840s, adopted a broadly defensive, as opposed to openly confrontational, rela-tionship to capitalism. The demise of Chartism in Britain after 1848, and the assimilation of its political energies to the middle-class movement for electoral reform, is exemplary in this respect. This kind of accommoda-tion between labour and capital, albeit uncomfortable, did not lead to the kind of contradictory, unstable social conditions in which the utopian imagination is customarily stimulated. As the historian E. H. Carr neatly formulated it, 'the failures and disillusionments which followed the revo-lutions of 1848 created a climate unpropitious to Utopias'.[4] In sum, from the end of the 1840s to the beginning of the 1870s, an era of social and economic stabilization, capitalism seemed for the first time not merely militant but triumphant. And there are, in consequence, relatively few utopian fictions from this time.

The events of the early 1870s threatened this brittle settlement. Perhaps the most dramatic development, in this respect, was the irruption, in

the aftermath of the Franco–Prussian conflict, of the Paris Commune. Before the ferocious suppression of this brief experiment in proletarian democracy, when more than 15,000 Parisians were killed by French troops led by General Thiers, the Commune opened up the prospect, horrifying or inspiring depending on the onlooker's politics, of a post-capitalist future. For the first time since 1848, 'the spectre of revolution once again irrupted into a confident capitalist world', as Eric Hobsbawm once put it.[5] Furthermore, the effects of this political shock to the European ruling class, apparent in the United States as well as throughout the continent and in Britain, were reinforced by the series of economic recessions that defined capitalism in the epoch of the Great Depression, from approximately the early 1870s to the early 1890s. And these economic recessions, in turn, created unstable political conditions throughout the capitalist nations. The 1880s and early 1890s, in particular, were marked by the emergence both of more militant forms of trades unionism and of small but not uninfluential socialist organizations, which in Britain included the Social Democratic Federation and the Socialist League, to both of which Morris was central as an organizer and thinker. These years were also marked by strikes, riots, and demonstrations, the most spectacular of which, in November 1887, became known as Bloody Sunday because of the brutal treatment of protestors by the police. As a result of these economic, social, and political disturbances, to cite Hobsbawm once more, the bourgeoisie 'was a little less confident than before, and its assertions of self-confidence therefore a little shriller, perhaps a little more worried about its future'.[6] Loosening their relationship to the capitalist system, which no longer seemed to be the permanent fate of the advanced nations, this encouraged people either to fear or hope for an alternative future. Simplifying the matter only slightly, Wells remarked in an article on 'Utopias' in 1939 that 'the more disturbed men's minds are, the more Utopias multiply'.[7]

The *fin de siècle*, then, in contrast to the third quarter of the nineteenth century, was distinctly propitious to utopias, to employ Carr's terms. The most striking indication of this was the remarkable success of the American journalist Edward Bellamy's *Looking Backward, 2000–1887* (1888), the novel that inspired Morris to produce a polemical response in the form of *News from Nowhere*. Bellamy's prophetic or utopian romance, which was especially popular in its second edition, sold some 200,000 copies in the United States during its first year in print. In Britain, where the *Review of Reviews* reported sales of some 100,000 copies by 1890, it was almost as successful. There, the first generation to have benefitted from the limited achievements of the Elementary Education Act of 1870, energized

or agitated by the rise of socialism and the New Unionism, formed an enthusiastic readership for its visions of a democratic, egalitarian future. The 'Bellamy Library of Fact and Fiction', a series of cheap, pocket-sized books curated by the British publisher William Reeves over the course of the 1890s, catered specifically to this constituency. Its sixpence edition of *Looking Backward* included both an index of ideas and an additional chapter comprising a précis of the book's politics, making it a useful tool both for autodidacts and for radicals or socialists leading discussions of its contents in public meetings. Incidentally, it was Reeves's father, of the firm Reeves & Turner, who in 1891 first published *News from Nowhere* in book form. Morris's utopian romance had originally appeared on a serial basis in the pages of *Commonweal*, the organ of the Socialist League, alongside reports on the ongoing international class struggle, from January to October 1890.

In addition to attracting hundreds of thousands of readers, from the working as well as middle classes, *Looking Backward* inspired hundreds of writers. Morris, then, was only one of these. Some of these books marketed themselves as direct responses to Bellamy's utopia. In 1890 alone, for instance, *Looking Further Backward*, *Looking Backward and What I Saw* and *Looking Further Forward* all appeared in print. Others, including *News from Nowhere*, adopted a more oblique relationship to *Looking Backward*. Beyond the Anglosphere, meanwhile, the Hungarian-Austrian economist Theodor Hertzka's *Freeland: A Social Anticipation* (1889) rapidly sold tens of thousands of copies in its German edition, earning its author the soubriquet 'the Austrian Bellamy'. The years from 1888 to 1898 – when Bellamy, the accidental leader of a not insubstantial political movement associated in the United States with the Populists, finally died of tuberculosis – were utopian fiction's *anni mirabili*. A decade after its first printing, more than 500,000 copies of *Looking Backward* had been sold in the United States, and it was well on its way to becoming only the second novel published there, after *Uncle Tom's Cabin* (1852), to sell a million copies. 'Taking the test of direct intellectual influence', the sober-minded English economist J. A. Hobson attested in a useful survey of 'The Utopian Romance' in 1898, 'we must account "Looking Backward" one of the most important literary events of the century'.[8] But readers' romance with the utopian or prophetic romance probably faded from this point on. In 1898, Wells published his *War of the Worlds*, a compelling dystopian vision of the Martian invasion of Britain, intended to shock it out of its imperial complacency. In the same year, Ebenezer Howard published *To-Morrow: A Peaceful Path to Real Reform*, his conspicuously pragmatic programme for what came to be

called the 'garden-city movement'. Utopianism was edged out at the end of the nineteenth century by a potent anti-utopianism on the one hand and a polite, if assertive, social reformism on the other.

What was it that made *Looking Backward*, set in Boston at the turn of the twenty-first century, so influential in the late 1880s and 1890s, stimulating the political imaginations of thousands of readers and prompting Morris and many other authors to respond directly or indirectly to its utopian proposals? Some of the novel's strength undoubtedly lies in its non-utopian, or realist, content. Its final chapter, for example, contains a powerful evocation – hallucinatory in its force – of the horrors of everyday life in a nineteenth-century city riven by class conflict. But this sort of description, which Bellamy's biblical references render the more apocalyptic, is plentiful enough in contemporaneous naturalist fiction; so, even if its sociological and even psychological interest imparts a rare, distinctly concrete sense of urgency and intensity both to the narrative and politics of this utopian romance, it cannot itself explain the book's popular impact. Nor can its more theoretical critique of capitalism, which Morris admitted was 'forcible and fervid' (*PW*, 425), for this was common enough in late nineteenth-century socialist polemics. The appeal of *Looking Backward* to late nineteenth-century readers resided, instead, both in its clever formal conception, as a utopia set in a credible, half-recognizable future city little more than a century from the time in which the book appeared in print, a social projection that plausibly captured a sense of the political optimism of those sceptical of capitalism's promise at that historical moment; and, related to this, in the comparatively tame character of its socialist politics. In the aftermath of the Haymarket Affair of 1886, Bellamy was careful to name the ideas that shape his utopian society 'Nationalist' as opposed to 'socialist', since the second of these terms, as he explained to one correspondent, 'smells to the average American of petroleum, suggests the red flag, with all manner of sexual novelties, and an abusive tone about God and religion'.[9] In *Looking Backward*, Bellamy successfully cleansed socialism of these toxic associations for the benefit of the middle classes.

The 'latest specimens' of utopian fiction, to repeat Goschen's remark in his inaugural lecture of 1891, 'are prophetical, they are evolutionary and revolutionary'. Bellamy's utopia, which Goschen proceeded to compare scrupulously to Morris's, was very definitely evolutionary rather than revolutionary. As Bellamy's time-travelling hero discovers on arriving in Boston in 2000, over the course of the twentieth century, and as a result of a gradual and orderly process, the United States has evolved into a rationally

planned, democratic society in which corruption and competition is a
distant memory. Here is Bellamy's summary:

> The industry and commerce of the country, ceasing to be conducted by a
> set of irresponsible corporations and syndicates of private persons at their
> caprice and for their profit, were intrusted to a single syndicate representing
> the people, to be conducted in the common interest for the common profit.
> The nation, that is to say, organized as the one great business corporation in
> which all other corporations were absorbed; it became the one capitalist in
> place of all other capitalists[10]

Despite its inspiring effect on late nineteenth-century radicals, then,
twenty-first-century Boston constitutes not a socialist society but a crypto-
capitalist one whose contradictions have simply been eradicated – cap-
italism without competing capitals or conflicting classes. Production
and consumption, for their part, are administered on ruthlessly efficient,
rationalistic lines in Bellamy's utopia. Labour, for example, is orga-
nized – according to the 'principle of universal military service' – into
what Bellamy designates an 'industrial army'.[11] This type of scientific man-
agement, comparable to the roughly contemporaneous innovations of the
apostle of business rationalization F. W. Taylor, is the archetypal social
arrangement at the centre of Bellamy's utopian blueprint. It is, however, in
its descriptions of consumption, not production, that the prose of *Looking
Backward* appears to come alive. Strikingly, there are no accounts of the
labour process in the novel; but, as befits a romance written during the
ascendency of consumer capitalism, there is instead a lavish description of
the hero's trip, with his utopian host's eligible daughter, who is 'an inde-
fatigable shopper', to the department store that stands resplendent at the
symbolic centre of twenty-first-century Boston.[12] This is a 'vast hall full of
light' from which the commodities themselves, available via a streamlined
system of 'pneumatic transmitters', have been discreetly erased, like the
labour process itself.[13] Here is a sleek, futuristic form of capitalism. Five
years after the book's publication, this logic was articulated by George W.
Wyman when he built the Bradbury Building in Los Angeles, an elaborate
construction whose geometric, glass-roofed interior was based directly on
Bellamy's utopian department store.

Morris was fairly scornful of Bellamy's utopia – even though it did in
due course prompt him to respond with his own prophetic or utopian
romance. If *News from Nowhere* built on both *A Dream of John Ball* (1886–
7; 1888) and his less explicitly political fantasies in prose, such as *The House
of the Wolfings* (1888) and *The Roots of the Mountains* (1889), and if it can
therefore be seen as part of his anti-realist project to restore the romance

form to prominence in late nineteenth-century literature, then *Looking Backward* nonetheless provided the book's immediate impetus. It provoked it. In his review of Bellamy's book in *Commonweal* in 1889, Morris emphasized from the start that its success was chiefly a consequence of its timeliness, since socialism had only recently become a pressing matter of 'public interest' (*PW*, 419). 'I am sure that ten years ago it would have been very little noticed, if at all', he noted; 'whereas now several editions have been sold in America, and it is attracting general attention in England' (*PW*, 419). At a time when the public's understanding of socialism was poor, in part because it was demonized in the press, this made it imperative to critique the book carefully and thoughtfully. Morris, who was determined not to assign too much importance to it, approached *Looking Backward* as 'the expression of the temperament of its author'; but he nonetheless conceded that, as its reception no doubt indicated, Bellamy's 'temperament is that of many thousands of people' (*PW*, 420). He characterized this 'temperament', with only a trace of contempt, as 'the unmixed modern one, unhistoric and unartistic' (*PW*, 420). Its 'owner', he explained, as if to hint that under capitalism even one's temperament is a kind of commodity, is 'perfectly satisfied with modern civilization, if only the injustice, misery, and waste of class society could be got rid of' (*PW*, 419–20). What this meant in practice was that Bellamy's utopia – 'that of the industrious *professional* middle-class men of to-day purified from their crime of complicity with the monopolist class' – could conceptualize nothing more than a modification of 'the mere *machinery* of life' (*PW*, 421). In short, Bellamy's future was quantitively but not qualitatively different from the present. And for this reason, Morris concluded, though the book 'is one to be read and considered seriously', 'it should not be taken as the Socialist bible of reconstruction' (*PW*, 425).

In his utopia, Morris sought to represent a future that was qualitatively rather than quantitatively different from the present. He was not interested in modifying 'the mere *machinery* of life' – a phrase that refers both to capitalist society's superstructure, or institutional apparatuses, and the 'machine-life', or mechanical technologies, that shape it (*PW*, 423). He was committed to rethinking not the mechanics but the aesthetics of living. He hoped to communicate to his readers a sense of the very texture of everyday life in a socialist or, more exactly, communist society, which in *News from Nowhere* he formulated in terms of 'the present pleasure of ordinary daily life' (xvi.72). This is what it will feel like to walk the street of a communist city, to eat and talk in a communist society. His utopia is not, then, a blueprint; or what Goschen, in his

account of *Looking Backward*, categorized as 'the organisation of labour and distribution in the most complete form imaginable'.[14] Instead, as a dream-vision or utopian romance, *News from Nowhere* is distinguished by what Norman Talbot, discussing *The Water of the Wondrous Isles* (1897), identifies as 'richness of texture and efficient psychological and narrative development'.[15] Goschen made a misleading claim, then, when he argued in his disparaging comparison of the two utopias that, in their 'use of the imagination', both are 'architectural, not pictorial'.[16] By this he seems to have meant that their 'constructive faculty', as he calls it, is abstract and clinically objective, with the consequence that 'the men and women are nearly all alike, alike among themselves, alike in the different books'.[17] But if this impression of uniformity is characteristic of Bellamy's conception of post-capitalist equality, it misrepresents Morris's. In Morris's utopia, equality is inseparable from diversity. In this respect, *News from Nowhere* is, precisely, 'pictorial'. It is scrupulously attentive to difference, especially where this is manifest in what one of its characters calls 'all the detail of the life about one' (xvi.190). Of course, Morris's experience both as a former Pre-Raphaelite and a professional designer makes him peculiarly well qualified to produce a pictorial utopia; one that is strikingly concrete in its visual and textural effects.

But, in addition to Morris's graphic evocation of what can be characterized as the lived experience of utopia, it is important to set out a couple of the other, more concrete ways in which, pointedly enough, he responds to *Looking Backward* in *News from Nowhere*. These can be summarized by returning to Morris's insistence that Bellamy's 'temperament', which he suggests is typical of late nineteenth-century bourgeois ideology in so far as it is decidedly 'modern', is 'unhistoric and unartistic'. Morris's utopia is, it might be said, 'historic and artistic'. What does this mean, in practice? His 'historic' approach, to take this aspect of the book first, is apparent in the prominence he ascribes to the process whereby, in the future he portrays, capitalist society collapses and socialist society starts to appear. *News from Nowhere* is structured in three acts or movements. The first of these, running from chapters I to VIII inclusive, centres on the induction of Morris's protagonist, William Guest, in Nowhere, that is, twenty-second-century London. It starts off in Hammersmith, where Guest has gone to sleep one night in the present after a meeting of the Socialist League, and where he returns to consciousness, a curious state of dream-consciousness, in the future; but it entails, too, a journey through the streets of the metropolis, which has become pleasingly pastoral, to meet with an antiquarian called Old Hammond, who is the great-grandfather of Dick, Guest's cicerone or

guide in utopia. The second, most substantial section, from chapters IX to XX, is set in the British Museum, where Old Hammond, who it is hinted might be a descendent of Guest, both explains a number of aspects of life in communist society and, more significantly, reconstructs the political events and social processes that have led to its development. This, then, is the historic core of the book. The third and final section, from chapters XXI to XXXII, comprises another journey, one that Guest takes up the Thames by boat, with Dick, Dick's lover Clara, and, latterly, a charismatic woman named Ellen; a journey from Kelmscott House in Hammersmith to Kelmscott Manor in Oxfordshire, that is, from one of Morris's homes to the other.

If the first and third sections of Morris's romance are journeys through space, then the second, comparatively static section is a journey through time. Its longest and most important chapter is entitled 'How the Change Came', and it is here that Old Hammond narrates the revolutionary political events and the evolutionary social processes that have led from the class society of the nineteenth century to the classless one of the twenty-second century; from capitalism to 'pure Communism' (xvi.104). He explains that, from the late nineteenth century, in part because of an economic crisis at once chronic and acute, class conflict between the workers and their masters intensified, most punctually over the length of the labouring day. In this increasingly catastrophic situation, as the first half of the twentieth century advanced, 'the spread of communistic theories, and the partial practice of State Socialism[,] had at first disturbed, and at last almost paralysed the marvellous system of commerce under which the old world had lived so feverishly' (xvi.109). This social and economic crisis subsequently culminated in 'the crash' of 1952 (xvi.111). As Old Hammond tells Guest – speaking to him as if he is 'a being from another planet' (xvi.54) – a series of demonstrations soon pitched the people against armed battalions of police. The result of this was that 'the Government proclaimed a state of siege in London', further polarizing the class forces confronting one another (xvi.113). These forces finally clashed irreversibly with one another in the 'massacre of Trafalgar Square', where more than a thousand protestors were killed, precipitating the 'civil war' that, escalated by a General Strike, led in the fulness of time to the collapse of capitalism and, over the course of more than a century, the institution first of socialism and then of communism (elsewhere Morris calls the latter the 'completion' of the former) (xvi.117).[18] Morris's vivid, compellingly coherent description of an entire epoch of revolution is unprecedented in utopian literature. Exercising his remarkable historical imagination, which was shaped both

by his own experience of violent demonstrations in the late 1880s and his understanding of the Paris Commune and other paradigms of social transformation, Morris thus offered a carefully calculated rebuke to Bellamy's 'unhistoric' attitude. Brilliantly, he succeeds in this section of *News from Nowhere* in historicizing the future.

What about Morris's critique of the 'unartistic' attitude exhibited by Bellamy in *Looking Backward*? *News from Nowhere* is 'artistic' in a double sense. First, at the level of form, it is the work of a self-conscious, highly skilful artist, one who is committed to seducing the reader's political imagination with his beautiful prose, in striking contrast to those contemporaneous 'social reformers' who, to paraphrase Goschen, are without 'literary powers and imaginative minds'. In his review of Bellamy's book, Morris had complained of the lack of 'care and art' with which he handled the narrative conventions of utopian fiction (*PW*, 420). Second, at the level of content, *News from Nowhere* is a novel that places art at the absolute centre not simply of everyday life in communist society but of its entire mode of production. For the founding principle of Nowhere is that labour, no longer alienated or distorted by capitalist social and economic relations, is completely inseparable from artistic creation. Morris stated this position in other contexts, including his lecture 'Useful Work versus Useless Toil' (1884), where he insisted that, instead of inducing despair, as it does under capitalism, work should entail 'hope of rest, hope of product, hope of pleasure in the work itself' (xxiii.99). In *News from Nowhere*, he dramatized his conception of non-alienated labour in the chapter entitled 'A Little Shopping', where Guest enters a shop in central London and chooses a pipe and some tobacco. To Guest's consternation, the children who run the shop do not expect him to pay for these items, even though the pipe, which he profoundly admires for its craftsmanship, is 'carved out of some hard wood very elaborately, and mounted with gold sprinkled with little gems' (xvi.37). The pipe is thus stamped, to transfer a phrase from 'Useful Work versus Useless Toil', 'with the impress of pleasure' (xxiii.114). Emancipated from a competitive commercial system in which the products of labour are commodities sold for the sake of profit, ordinary objects such as this have become expressions of the individual labourer's manual and intellectual creativity. Morris's utopia is 'artistic', then, in the sense that it identifies art, and not the commodity form critiqued by Karl Marx, as the secret of post-capitalist society.

To the 'historic' and the 'artistic', as defining features of Morris's vision of the future in *News from Nowhere*, one additional term can be added in conclusion. This is the 'erotic'. In his review of *Looking Backward*, Morris

commented that its reception demonstrated that 'it is the serious essay and not the slight envelope of romance which people have found interesting' (*PW*, p. 420). And it is indeed the case that the romantic plot of Bellamy's novel, which involves the time-traveller falling in love with his utopian host's daughter, is neither compelling nor emotionally convincing. So when Morris subtitles his book 'Some Chapters from a Utopian Romance', he indicates that, in response to this uninspiring precedent, he means to make the romance form, and the romantic plot that shapes it, positively constitutive of his utopian fiction. His innovation, in fact, is not simply to offer a profoundly moving description of Guest falling hopelessly in love with Ellen, the most attractive and mysterious of the Nowhereans he meets, as they travel up the Thames – though, painfully enough, the novel does provide that in its final chapters. It is to make this process allegorical of the longing that he himself feels, and that he hopes his readers will feel, for the communist future. He wants them to yearn for this future as a lover yearns for their loved one. Erotic desire, in *News from Nowhere*, is thus a correlative of political desire. It stands in for it, and articulates it, at an affective level. As Old Hammond informs Guest in 'How the Change Came', reflecting on the preconditions of the systemic social transformation that has taken place, 'looking back now, we can see that the great motive-power of the change was a longing for freedom and equality, akin if you please to the unreasonable passion of the lover, a sickness of heart that rejected with loathing the aimless solitary life of the well-to-do educated man of that time' (xvi.105). In contrast to Bellamy and so many other social reformers of the late nineteenth century, who seek to persuade their readers through reasonable social planning, in cool, bloodless prose, Morris instils his utopian romance with an irresistible passion for the post-capitalist future.

Notes

1 George Goschen, *The Use of the Imagination in Study and in Life* (Edinburgh: Harrison, 1891), 25–6, 27, 28.
2 Ibid., 28.
3 Anonymous, 'What the People Read XL – A Wife', *Academy* 53 (12 March 1898), 293–4.
4 E. H. Carr, 'Editor's Introduction', in N. Bukharin and E. Preobrazhensky (eds), *The ABC of Communism*, trans. Eden and Cedar Paul (Harmondsworth: Penguin, 1969), 15.
5 E. J. Hobsbawm, *The Age of Capital, 1848–1875* (London: Weidenfeld & Nicolson, 1962), 248.

6 Ibid., 308.
7 H. G. Wells, 'Utopias', in Patrick Parrinder and Robert M. Philmus (eds), *H.G. Wells's Literary Criticism* (Brighton: Harvester Press, 1980), 198.
8 J. A. Hobson, 'Edward Bellamy and the Utopian Romance', *Humanitarian*, 13 (1898), 179.
9 Quoted in Arthur E. Morgan, *Edward Bellamy* (New York: Columbia University Press, 1944), 374.
10 Edward Bellamy, *Looking Backward, 2000–1887*, ed. Matthew Beaumont (Oxford: Oxford World's Classics, 2007), 33.
11 Ibid., 36.
12 Ibid., 59.
13 Ibid., 60, 63.
14 Goschen, *The Use of the Imagination*, 33.
15 Norman Talbot, '"Whilom, as Tells the Tale": The Language of the Prose Romances', *Journal of the William Morris Society*, 8 (1989), 25.
16 Goschen, *The Use of the Imagination*, 35.
17 Ibid., 35–6.
18 See William Morris, 'Communism', in A. L. Morton (ed.), *Political Writings* (London: Lawrence & Wishart, 1973), 233.

Morris's Prose Romances and the Origins of Fantasy

Anna Vaninskaya

Fantasy is a notoriously difficult genre to define. Some literary critics trace its roots back to Homer; others only as far back as the 1960s or 70s when it emerged as a recognizable marketing label in the anglophone world; others still to the eighteenth or nineteenth centuries and the Romantic revolt against the Enlightenment or the rise of realism. But however its genealogy is conceived, few literary histories fail to mention William Morris's seminal role in the genre's formation.[1] For just as no history of British socialism, of the Arts and Crafts movement, or of heritage preservation can be written without according a prominent place to Morris, so no history of English-language fantasy can count itself complete without giving Morris's 'prose romances' their due. The composition of these works bookended Morris's working life. The earliest and shortest of them were published two years before *The Defence of Guenevere* (1858); the last ones appeared posthumously in the two years after his death. But long or short, early or late, they were all tales of love and war set in wholly or partly imaginary medieval worlds and written in an artificially 'archaic' English; and they all incorporated the magical artefacts, supernatural creatures or adventure quest structures of the sagas, folktales and romances that inspired Morris's creative endeavours in other fields. These were the tales that retrospectively earned Morris the title of 'inventor' of British fantasy.

Romance and Fantasy

The first to canonize Morris in this fashion, before academic literary critics arrived on the scene, were the American and British writers and editors who established the parameters of fantasy as a publishing category.[2] When J. R. R. Tolkien's *The Lord of the Rings* (1954–5) reached the peak of its popularity in the 1960s, publishers rushed to reprint Morris's romances, dubbing them forerunners of Tolkien's fantasy epic. Lin Carter, the editor of the influential Ballantine Adult Fantasy Series, summarized

the prevailing view in his 1971 Introduction to the Ballantine reprint of
Morris's *The Water of the Wondrous Isles* (1897):

> Morris is of the greatest historical importance to the evolution of the
> imaginary-world novel, for … he was its inventor. … Only through reading
> his great fantasy romances can one understand the origin of modern works
> such as *The Lord of the Rings* … they are recent additions to a fine old tra-
> dition founded seventy-seven years ago when [Morris's] *The Wood Beyond
> the World* was first published. … Morris conceived of the notion of a story
> laid in a world made up by its author, but based on the kind of world and
> age described by the romancers of the Middle Ages. This was his principal
> innovation, and it was a fertile one.[3]

Carter's last point bears emphasizing. There were other writers work-
ing in Britain in the late nineteenth century who, like Morris, produced
adult fiction with fantastic elements, but they did not take medieval
romances as their main model or set their stories in entirely invented
worlds. Morris's acquaintance George MacDonald wrote about contem-
porary Victorian protagonists who had to find their way through magical
landscapes inspired by the Bible and the Romantics as much as by medi-
eval sources, while H. Rider Haggard placed most of his supernatural
stories in non-European settings, even though he shared Morris's fasci-
nation with the Northern European past. Other authors, such as Oscar
Wilde, Arthur Machen, F. Anstey and H. G. Wells, wrote contemporary
urban fantasies with elements of horror or light-hearted humour or devel-
oped what were known at the time as 'scientific romances' (early science
fiction). But it was Morris with his medieval wonderlands who exerted
the greatest influence on Tolkien and thereby inadvertently transformed
the history of the fantastic in ways that continued to bear fruit in the
works of his successors a long time after his own works had fallen out of
general circulation.

 Tolkien, a conservative Catholic who viewed history as a 'long defeat',
was, perhaps, a surprising candidate to inherit the mantle of a revolution-
ary socialist and atheist who looked to the past in order to open up new
ways into the future. But ideological differences did not prevent Tolkien
from acquiring and reading most of Morris's works, acknowledging his
debt to Morris in his letters and explicitly modelling his first piece of prose
on Morris's 1888 romance *A Tale of the House of the Wolfings*. Much of
Tolkien's writing, including *The Lord of the Rings*, is full of unconscious
echoes and conscious adaptations of Morris's nomenclature, language,
imagery, narrative forms and plot elements, and Tolkien's contemporar-
ies, no less than subsequent critics, recognized the affinities from the start.[4]

And just like Morris, Tolkien called his stories 'romances', in recognition not just of those medieval works that served them both as inspirations but of the broader meaning the term had acquired over time.[5]

In the eighteenth century, Samuel Johnson had defined romance as a 'military fable of the middle ages; a tale of wild adventures in war and love'.[6] But in the early nineteenth century, Walter Scott, the father of the 'historical romance' and popularizer of pseudo-medieval adventure in works like *Ivanhoe: A Romance* (1819), expanded this definition to take in any kind of 'fictitious narrative … the interest of which turns upon marvellous and uncommon incidents'. Scott contrasted it with the novel, a type of narrative 'accommodated to the ordinary train of human events, and the modern state of society'.[7] He was not the first to do so. Several decades earlier, Clara Reeve's *The Progress of Romance* (1785) drew essentially the same distinction:

> The Romance is an heroic fable, which treats of fabulous persons and things. – The Novel is a picture of real life and manners, and of the times in which it is written. The Romance, in lofty and elevated language, describes what never happened nor is likely to happen. – The Novel gives a familiar relation of such things, as pass every day before our eyes.[8]

By the second half of the nineteenth century, when Morris was writing his romances, this definition of what constituted the genre with regard to both style and content had become ubiquitous. But the 'fabulous' and the 'uncommon' could mean all sorts of things – from fairy-tale transformations to the temporal and geographical displacements of utopias, time-travel narratives or adventures set in exotic locales and past historical periods. Morris's contemporaries applied the designation 'romance' to all these types of fiction – *vide* Wells's 'scientific romance' or MacDonald's 'faerie romance' – and Morris did the same, subtitling his socialist utopia *News from Nowhere* (1890; 1891) 'A Utopian Romance'. In this sense, therefore, Morris's 'prose romances' are a category that includes not just those works that directly influenced Tolkien and other fantasy writers such as C. S. Lewis, and that harked back to actual medieval precursors, but also those that are usually viewed as part of his political *oeuvre*. If Morris's tales of adventure in imaginary worlds introduced the new generic possibilities that spurred the development of what Tolkien called 'secondary world' fantasy, his political romances opened up different avenues for followers in other fantastic fields. The next two sections will consider each kind of romance in turn, beginning with the works that Morris wrote in the final years of his life.[9]

The Romances of the 1890s and the Germanic Romances

In an 1887 article entitled 'Realism and Romance', the critic and collector of fairy tales Andrew Lang contrasted the realist novel with romance in its narrower sense: 'tales of swashing blows, of distressed maidens rescued … of magicians and princesses, and wanderings in fairy lands forlorn'.[10] The series of prose narratives with magical medieval settings that Morris published in quick succession from 1890 onwards conformed very closely to Lang's description. These were *The Story of the Glittering Plain* (1890), *The Wood Beyond the World* (1894), *The Well at the World's End* (1896), *The Water of the Wondrous Isles* (arguably the first adult fantasy novel with a female protagonist) and *The Sundering Flood* (1897) (which featured one of the first examples of a fantasy map). To these one may add several romances that remained unfinished at Morris's death, such as 'Giles of the Long Frank' and 'Kilian of the Closes'. Most of these works were printed by Morris's Kelmscott Press with his own designs and with illustrations by his friend, the Pre-Raphaelite painter Edward Burne-Jones, or by fellow socialist Arts and Crafts artist Walter Crane. Unlike the trade editions in which these romances also circulated, released by mainstream Victorian publishers such as Longmans, Green and Company, the Kelmscott editions were *objets d'art* whose fifteenth-century-style blackletter typefaces and crowded decorative surfaces created a kind of material correlative for the medievalist effects of the narratives they enshrined. The process of defamiliarization from the 'ordinary' and the 'modern' begun by the 'marvellous' plots and 'elevated language' of the tales themselves was completed by their physical embodiment in the Press's aesthetically 'uncommon' printed volumes.

It was these romances that, owing partly to their influence on Tolkien, established some of the key conventions of twentieth-century immersive fantasy, while retaining their own uniquely Morrisian flavour. Their plots take place in imagined realms whose connections to a European past are signalled by eclectic borrowings from Old Norse literature and the Matter of Britain and England, among other sources, as well as by 'archaic' syntax and vocabulary and linguistic devices derived from Morris's translations of Icelandic texts. There are no representatives of the real modern world in these romances, though characters do journey through many lands, some of which are decidedly more fantastical than others (think of the contrast between the Shire and the rest of Tolkien's Middle-earth). 'Fabulous persons and things', 'distressed maidens' and 'fairy lands' abound. Tropes taken at will from

Thomas Malory's *Le Morte d'Arthur* are interspersed with loans from the legendary sagas (*fornaldarsögur*). Readers meet good and evil knights, king's sons and merchant's sons on quests, in battles, and wandering mad in the woods; they also meet priests, barons, thralls, and pastoral shepherds; beautiful maids and cruel ladies; immortal gods, nature spirits, and faery wights; evil dwarfs, giants, and witches; sorceresses, skin-changers, sendings, and fetches. They encounter magical potions, fountains of youth, enchanted boats, and rings of invisibility and travel across seas, wastelands, and impassable mountain ranges, through free towns with their craft guilds and among abbeys and castles. They traverse an eclectic mix of pagan and Christian societies, encounter grisly forms of death and violence, but also many forms of sensual love. Several of the romances, including *The Story of the Glittering Plain*, *The Well at the World's End*, and *The Water of the Wondrous Isles*, have a circular there-and-back structure, and all focus on the individual exploits of the central male and female protagonists whose (qualified) happy endings often lead to wider social regeneration.

Morris had honed this formula after composing two other romances in the late 1880s that were rooted much more explicitly in actual history than the undatable medievalist fantasias that followed them. These were his so-called 'Germanic' romances: *The House of the Wolfings* and *The Roots of the Mountains* (1889), loosely based on the conflicts between the Goths and the Romans and Huns in late antiquity. Much that would become familiar to readers of the later romances was already present in the earlier ones: the love triangles, the cross-dressing weapon-wielding heroines (Tolkien's Éowyn had several prototypes in Morris's fiction), and the supernatural elements (a Valkyrie lover, a dwarf-wrought hauberk, prophetic visions, the 'Doom' or 'Weird' that drives characters along their destined paths). But the environments in which these elements appeared were palpably older than the stylized Arthurian-cum-Icelandic worlds of the 1890s, and the narratives were framed much more explicitly as oral productions. These were 'tales told' about people who themselves burst into verse at every opportunity, who wove or sang their stories communally instead of writing them down in illuminated manuscripts.

Indeed, the outlook of the Germanic romances was much more communal than that of the 1890s fantasies in every respect. *The House of the Wolfings* and *The Glittering Plain* both turn on the temptation to escape from death offered to the story's protagonist by a supernatural being. But whereas the latter book is about a hero on a quest to rescue his beloved,

who is lured against his will to a land of youth ruled by an immortal king, the former centres on a tribe's fight for survival against a destructive foe, in which the main character's dilemma (should he magically preserve his own life or perish to succour his people?) is subordinated to the larger story of the Folk. Similarly, in *The Roots of the Mountains*, the romantic complications and marriages of the protagonists serve to drive forward the plot of the unification of kindred peoples. The romance concludes with the words of the marriage service adapted to the joining of separate communities in bonds of brotherhood: 'they were friends henceforth, and became as one Folk, for better or worse, in peace and in war, in waning and waxing' (xv.411). Though the romances of the 1890s also frequently conclude with the rejuvenation of a kingdom or of a personal fellowship stemming from the union of lovers, none share the 'national preservation' overtones of the two Germanic romances. The fate of a whole way of life is at stake in *Wolfings* and *Roots*. It is the life of 'our forefathers': rooted in the cycle of the seasons and the generations (xiv.7), the cultivation of the earth and the crafts of the hand, the worship of gods and ancestors, communal working, feasting and decision-making, and relative gender and social equality. If the hero must die so that his people may live and 'thr[i]ve in field and fold' free from violent exploitation by alien invaders (xiv.208), then die he will – to be commemorated in the songs of those who remain to rebuild what was saved by his sacrifice and that of countless others. This sacrificial ethic may still be glimpsed in the individual quest romances of the 1890s, where knights and ladies are ever willing to lay down their lives for their homes and loved ones, but it never again attains the existential quality that characterizes it in the war stories of the Germanic tribes.

The Political Romances and the Romances of the 1850s

Many critics have linked the communal ethic of the Germanic romances to Morris's formulation of a socialist worldview in his other writings of the period, and the dates certainly coincide. For in the second half of the 1880s Morris also published two political romances of the past and the future in his socialist newspaper *Commonweal*: *A Dream of John Ball* (1886–7; 1888) and *News from Nowhere*. Though they too appeared in due course in Kelmscott Press editions, these were romances in the expanded sense: not medievalist 'wild adventures in war and love' but timeslip dream visions featuring first-person Victorian narrators as authorial stand-ins. As befit their origin in a propaganda publication aimed at

the working class, these stories focused on drawing explicit political lessons from the events described and abjured all supernatural elements apart from the timeslip conceit itself. The settings – Kent during the Peasants' Revolt of 1381 and London and its environs in a twenty-first-century post-revolutionary England – were not vague but temporally and geographically specific. Yet these were still, identifiably, romances: they depicted a stylized past and a speculative future – rather than 'the modern state of society' – in a manner reminiscent of other stories of sleep-induced time travel published in these years.

The two most obvious counterparts to Morris's *John Ball* and *News from Nowhere* are both American: Mark Twain's satirical romance *A Connecticut Yankee in King Arthur Court* (1889) and Edward Bellamy's utopia *Looking Backward: 2000–1887* (1888), one of the books that inspired Morris to proffer his own version of a socialist future. Twain's eponymous Yankee finds himself in what is essentially Malory's version of Camelot, just as Morris's dreamer finds himself in an idealized fourteenth-century England – and both narratives offer their readers plenty of thees and thous and bows and arrows. Bellamy's sleeper awakes in a future social-ist America, acquires a love interest and is instructed in the ways of the new society by an authoritative guide, just like Morris's William Guest in *Nowhere*. But there the resemblances cease, for Twain's Yankee ends by 'exterminat[ing] the whole chivalry of England' and sleeping away the intervening centuries like an ironic double of Arthur himself,[11] only to die before the pitying gaze of the frame narrator; while Bellamy's Julian West remains in the future without doing anything, as he guiltily admits, to bring the utopia about. Morris's approach is very different. He sends his Victorian dreamers there and back again – to the past or the future and then again to the present day – with a purpose, precisely as he would later send so many of his fantasy heroes to travel in fabulous distant lands before coming back to their points of origin. For in the course of those travels, evil would be routed and societies transformed for the better. Just so in *John Ball* and *News from Nowhere*, the narrators return to inspire political change at home by sharing what they have learned from their conversations with the medieval priest and with the inhabitants of utopia. The priest's vision of fellowship and the utopians' life of fellowship in action are even more 'marvellous' – from the stand-point of Victorian capitalist society – than the most magical wonders encountered by the heroes of the fantastic romances. And Morris's hope is that the readers of his political romances will help to turn the vision into reality.

All of Morris's romances of the 1880s and 90s, whether explicitly political or not, share a certain kind of optimism. And this is perhaps their greatest difference from his first attempts in the genre some three or four decades earlier, long before he had discovered the promise of social rejuvenation through fellowship. The short prose romances Morris published as a student in 1856 in *The Oxford and Cambridge Magazine* – 'The Story of the Unknown Church', 'A Dream', 'Gertha's Lovers', 'Svend and His Brethren', 'Lindenborg Pool', 'The Hollow Land' and 'Golden Wings' – look forward in many respects to the fantasies of his final years. They too draw on Scandinavian and Arthurian sources, feature knights, ladies, bloody battles, adventures in love, supernatural occurrences, seekers of wondrous lands, medieval pageantry, inset verses, and once-upon-a-time fairy-tale settings. But the love stories, more often than not, end in tragedy and the tomb; the narrators speak from beyond the grave; the dream visions are grotesque or gothic; the violence largely unredemptive. There are few happy or hopeful returns here: knights come back centuries later to their land only to sail away again after finding the streets still 'red and wet with [the] blood' of an ancient war (i.244). Lovers unite or reunite magically only to die – for no larger cause, for no kindred or Folk – or if not to die, to remain together 'alone' so that 'no soul will ever be able to tell what we said, how we looked' (i.290). There is little sense of a larger community in these tales in relation to whose lives the trials and tribulations of the heroes and heroines can take on meaning. It seems that near the end of his own life, Morris discovered a new purpose for the romance genre and put many of the tropes he had already perfected in his twenties to much happier uses.

A Case Study: *The Story of the Glittering Plain, or The Land of Living Men*

The final section of this chapter will take a closer look at *The Glittering Plain*, a late romance that forms a bridge between Morris's Germanic and 1890s periods and a telling counterpoint to the romances of the 1850s. Its hero, a young man named Hallblithe, is tricked into travelling to the eponymous Plain or 'Acre of the Undying' – an earthly paradise where the old regain their youth, ruled by an immortal king whose daughter has fallen in love with Hallblithe's portrait from afar. When the Ravagers, a Viking-like people who serve the Undying King, kidnap Hallblithe's

betrothed, he must set off on his quest across sea and land to find her and bring her back to the kindred and the ancestral home, where 'men die when their hour comes' (xiv.212). In the process, he must spurn the temptations of an eternal life of pleasure in the Glittering Plain that so many of the characters around him seek.

The notion of two realms – one of mortality and one of changeless immortality – existing within the same physical world and the centring of narrative interest on getting into or out of the latter were not Morris's innovations, but it was in no small part thanks to him that they became key tropes of much subsequent fantasy. In fact, during his journey Hallblithe goes through a number of adventures, such as almost dying of hunger and thirst in a 'stony waste' on the borders of the Glittering Plain, that would strike twentieth-century readers of the genre as very familiar (xiv.280). But the narrative constantly upends a modern reader's expectations. There is surprisingly little action for a story whose hero is a young warrior with a spear. Perhaps because the Glittering Plain is continually associated with illusions, 'false dreams', and 'images', with deceptive enchantment or 'beguiling', Hallblithe accomplishes his quest not by fighting but by remaining true and telling the truth. And what he remains true to are the values celebrated in the Germanic romances of the 1880s.

Romantic love is not the only, or even the main motivating force driving Hallblithe along in his quest. Even more important is his desire to return to his family and people, to the 'House of the Kindred' in Cleveland by the Sea, 'to behold the roof of his fathers and to tread the meadow which his scythe had swept, and the acres where his hook had smitten the wheat' (xiv.263). An ancestral way of life, closely tied to the land and its changing seasons (there are no seasons in the eternal summer of the Glittering Plain and no sowing or reaping), is the real object of the quest. Marriage to a woman of the House 'wherein it was right and due that the men of the Raven should wed' is simply part of this way of life. The easily available women of the Plain, 'whom [his] kindred knoweth not, and who [were] not born in a house wherefrom it hath been appointed [him] from of old to take the pleasure of woman', do not entice Hallblithe (xiv.211, 256). And just like the choice of spouse, acceptance of mortality is also part of this customary mode of existence. The seekers after eternal youth whom Hallblithe meets at the beginning of the story complain that 'though the days of the springtide are waxing, the hours of our lives are waning' (xiv.211) – they fail to recognize that human lives are part of the natural cycle too.

That point is driven home by Morris's deft use of serpent/dragon/ring imagery – so typical of later fantasy – to illustrate the contrast between

mortal and immortal existence. The lonely Princess of the Glittering Plain laments that 'life shall grow huger and more hideous round about [her], like the ling-worm laid upon the gold, that waxeth thereby, till it lies all round about the house of the queen entrapped, the moveless unending ring of the years that change not' (xiv.266). The stifling cycle of immortality dooms the Princess to eternal solitude; but in the mortal world the natural cycle of the seasons makes it impossible to hoard existence. When Hallblithe is finally reunited with his betrothed and she asks him to prove his identity by telling her what happened to her golden ring when they were little, he replies: 'I put it for thee one autumntide in the snake's hole in the bank above the river ... that the snake might brood it, and make the gold grow greater; but when winter was over and we came to look for it, lo! there was neither ring nor snake ... for the flood had washed it all away' (xiv.316). The lovers will not be suffocated by the golden ring of the changeless years; no metaphorical or legendary serpent can make their days wax unnaturally. Instead, they will be washed away on the stream of time just like the everyday snake and ring had been washed away in their childhood by the floods of spring.

When asked by the inhabitants of the Glittering Plain, 'what shall all thy toil win thee?', Hallblithe replies, 'Maybe a merry heart, or maybe death' (xiv.295). The calm acceptance of either outcome is what characterizes him from the outset, and Hallblithe never agonizes over the choice presented to him in the Undying Land. He is as steadfast in his devotion to a finite life of toil and accomplishment (there is no toil and no deeds to do in the Acre of the Undying) as he is in his devotion to his betrothed, for both allegiances are natural and hallowed by his kindred. He just desires to be, as his name betokens, *blithe* [happy] in his ancestral *hall*, for as long a span as shall be allotted to him. The final words of the romance are not 'they lived happily ever after', but 'neither they nor any man of the Ravens came any more to the Glittering Plain, or heard any tidings of the folk that dwell there' (xiv.324). People content with the 'home [of their] Kindred and the Roof of [their] Fathers of old time' have no need of the dreams of immortality (xiv.297). Those who regain their youth in the Glittering Plain pay for it by losing the memories of their past and, by extension, their identities as members of a greater community. The kind of happiness offered by the Plain: 'plenty and peace and good will and pleasure without cease', in the King's words (xiv.272), lacks not just the satisfaction given by an active life but also the deep connections forged through communal undertaking across the generations. The inhabitants of the Plain 'play'

together, but they do not work together or form families together to bear children; neither do they fight and die together.

There is a lot of fighting and dying in all of Morris's romances, early and late (*The Glittering Plain* is, in this sense, something of an exception). But what makes the late romances – the fantasy ones that influenced Tolkien and Lewis no less than the ones that were written for a socialist audience – unique is their celebration of the meaning given to life by genuine human fellowship.

Notes

1 See James Gifford, *A Modernist Fantasy: Modernism, Anarchism, and the Radical Fantastic* (Victoria, BC: ELS Editions, 2018); Jamie Williamson, *The Evolution of Modern Fantasy* (New York: Palgrave Macmillan, 2015); Brian Attebery, *Stories about Stories: Fantasy and the Remaking of Myth* (Oxford: Oxford University Press, 2014); Farah Mendlesohn and Edward James, *A Short History of Fantasy* (London: Middlesex University Press, 2009); Lilla Julia Smee, 'Inventing Fantasy: The Prose Romances of William Morris', PhD dissertation, University of Sydney, 2007; Colin Manlove, *The Fantasy Literature of England* (Basingstoke: Macmillan, 1999).

2 See Lin Carter, *Imaginary Worlds: The Art of Fantasy* (New York: Ballantine Books, 1973) and L. Sprague de Camp, *Literary Swordsmen and Sorcerers: The Makers of Heroic Fantasy* (Sauk City, WI: Arkham House, 1976).

3 William Morris, *The Water of the Wondrous Isles* (London: Ballantine Books, 1972), xiii–xv.

4 See Richard Mathews, *Fantasy: The Liberation of Imagination* (New York: Twayne Publishers, 1997); Brian Rosebury, *Tolkien: A Cultural Phenomenon* (Basingstoke: Palgrave Macmillan, 2003); and Kelvin Lee Massey, 'The Roots of Middle-earth: William Morris's Influence upon J. R. R. Tolkien', PhD dissertation, University of Tennessee, 2007.

5 See Goran Stanivukovic (ed.), *Timely Voices: Romance Writing in English Literature* (Montreal: McGill-Queen's University Press, 2017); Corinne Saunders (ed.), *A Companion to Romance: From Classical to Contemporary* (Oxford: Blackwell Publishing, 2004); Helen Cooper, *The English Romance in Time* (Oxford: Oxford University Press, 2004); and Gillian Beer, *The Romance* (London: Methuen, 1970).

6 'romance 1' in Jack Lynch (ed.), *Samuel Johnson's Dictionary* (Delray Beach, FL: Levenger Press, 2004), 439.

7 Walter Scott, 'Romance', *The Miscellaneous Prose Works of Sir Walter Scott* (Edinburgh: Robert Cadell, 1841), i.554.

8 Clara Reeve, *The Progress of Romance* (1785), in Stephen Regan (ed.), *The Nineteenth-Century Novel: A Critical Reader* (London: Routledge, 2001), 14.

9 Key critical texts dealing with Morris's romances include Phillippa Bennett, *Wonderlands: The Last Romances of William Morris* (Oxford: Peter Lang, 2015); Ingrid Hanson, *William Morris and the Uses of Violence, 1856–1890* (London: Anthem Press, 2013); Anna Vaninskaya, *William Morris and the Idea of Community: Romance, History and Propaganda, 1880–1914* (Edinburgh: Edinburgh University Press, 2010); Marcus Waithe, *William Morris's Utopia of Strangers: Victorian Medievalism and the Ideal of Hospitality* (Woodbridge: D. S. Brewer, 2006); Amanda Hodgson, *The Romances of William Morris* (Cambridge: Cambridge University Press, 1987); Carole Silver, *The Romance of William Morris* (Athens: Ohio University Press, 1982); and Charlotte H. Oberg, *A Pagan Prophet: William Morris* (Charlottesville: Virginia University Press, 1978). See also Florence S. Boos (ed.), *The Routledge Companion to William Morris* (New York: Routledge, 2021).

10 Andrew Lang, 'Realism and Romance', *Contemporary Review* (July/December 1887), 684–5.

11 Mark Twain, *A Connecticut Yankee in King Arthur's Court* (New York: Bantam Books, 1981), 274.

The Practical Arts

Morris & Company
The Poet as Decorator

Elizabeth Helsinger

A boy in knight's armour sallies forth into the forest on his pony. It is the 1840s, however, not the 1540s. The boy is in search of adventure, riding into a fantasy world of romance he has read of in the poetry and fiction of Sir Walter Scott. But this boy is distracted from his questing goals by an encounter with what he would later call the pure 'eventfulness of form' (xxii.5): the twisty tracery of Epping Forest itself, its foliage full of the hidden life of flowers, birds and beasts. In an abandoned Tudor hunting lodge the boy discovers the living forest brought indoors in a set of faded but still splendidly intricate tapestries hung about its tower walls. A densely woven pattern of foliage, birds and beasts (real and imagined) forms the ground against which human figures act out their stories, turning (as Morris later described it) the 'chamber walls into the green woods of the leafy month of June, populous of bird and beast' (xxii.254). In the remains of those once resplendently colourful hangings, the boy, could he have known it, was looking at his future: designing settings for romance – or more pragmatically, reimagining beauty to repair damaged senses in the later nineteenth century.

At his death in 1896 Morris was principally known as a maker of beautiful things, from poems to books to wallpapers: the 'poet and paper-maker', Henry James called him.[1] In the half century that followed, however, he was remembered less for the aesthetics of what he had made than for what he seemed to have foreseen as a prescient critic and theorist: Nikolaus Pevsner's influential book names Morris as one of four great *Pioneers of Modern Design* (1936), while E. P. Thompson's *William Morris: Romantic to Revolutionary* (1955) considers him the great moral force behind modern British socialism. This chapter will focus on Morris the Victorian maker of beautiful things, whose seminal importance to both the Aesthetic or Artistic House movement of the 1870s and 1880s, and the more globally influential Arts and Crafts movement of the 1880s and 1890s, has been increasingly appreciated by art and design historians since the middle of

the twentieth century. For these historians, Morris is the designer of genius whose visual sensibilities, disseminated through the products of a successful furnishing business, shaped tastes and markets. No account of Morris's career as a maker of beautiful objects, however, can adequately gauge his successes and failures in isolation from his other activities. Some of his most arresting visual designs can be found in early poems that already register the destructive effects of social conditions on aesthetic perception, while the vision of a socialist future for which he worked tirelessly in the 1880s might be said to follow from principles established in his work as a designer and decorator. Morris the designer and maker *is* Morris the poet and Morris the socialist, for reasons that will take us to the heart of his ambitions for the decorative arts and the nature of his practice.

Translating the boy's early impressions of romance into material forms for modern living posed multiple challenges. Morris's work in the visual and tactile arts of decoration and design, like his poetry and his prose romances, takes as its larger subject the workings of a desire for beauty in an often unlovely world. This was the world shaped by the industrial revolution and driven by an optimistic capitalism. It created scenes that provoked new feelings of awe but also a profound disorientation. The later paintings of J. M. W. Turner, attacked by many as crude chemical explosions of paint or as the visions of a madman, forced viewers to consider the aesthetic possibilities of bridges, dams, canals, railways, steamships, mines, and factories. His vast landscapes and seascapes dissolving in clouds of smoke and steam induced in observers a kind of perceptual and cognitive vertigo. *Rain, Steam, and Speed – The Great Western Railway* (1844), for example, captures the exhilaration of an onrushing train enveloped in its own smoke but also the dizzying disturbances of figure and ground experienced by spectators.[2] Any secure sense of an individual self might be dislocated or lost, absorbed into this new world of energy and steam. Morris, faced with such modern experiences of cognitive and perceptual vertigo, responded by resisting the substitution of a technically mediated aesthetic for one derived from nature patterned on a human scale. He was not opposed to the use of machinery, but he was opposed to using it to make inferior things – and to an exaggerated sense of its powers. His designs for wallpapers and textiles sought to make possible fresh encounters with the non-human forms of the natural world. He put his faith in the restorative powers of a quietly decorative art, giving back to those who made it, and lived with it, a stable but not exaggerated sense of our place in a larger natural order.

Morris's poetry explored such perceptual disturbances in his first collection, *The Defence of Guenevere* (1858), with its disturbing, highly visual,

medievalizing imagery. It was followed a decade later by the extraordinary visual and narrative intricacy of the verse romances in *The Earthly Paradise* (1868–70) and, in the late 1870s, by the stark colour oppositions of his tragic epic in verse, *Sigurd the Volsung* (1876), an allegory of the destructive effects of industrial greed. Each of these poems pointed to a hunger for beauty distorted by oppressive political and economic forces at earlier historical moments, distortions that affected minds as well as bodies. So in *The Defence of Guenevere,* colour explodes in startling combinations into a grey world, registering the stresses on minds caught between dreams of love and beauty and a grim reality. The poetic structures of *The Earthly Paradise* grow ever more complex to convey a fractured sensibility: frames within frames, where lyric song alternates rapidly with narrative. In both *The Earthly Paradise* and *Sigurd the Volsung,* description, verbal ornament and a complicated architecture of different meters and styles, no less than the varying material forms of manuscript or printed page to which Morris devoted great attention, are essential to each poem's efforts to realize the desire for beauty as a fundamental but often twisted human drive. The perceptual disturbances his poems register, as Morris came to realize, were not merely those of the past, nor attributable to a single individual's aberrant psychology: they were rooted in the social and economic conditions of the larger societies his poems depicted. His designs in the visual arts, like his poetry, balance attention to troubled sense perceptions against a more harmonious order glimpsed through pattern and design.

The 1851 Crystal Palace Exhibition in London was not an aesthetic success, despite the efforts of design reformers at work in Britain since the 1830s. The Great Exhibition of the Works of Industry of All Nations, as it was officially titled, made clear that British design could not match the best products of countries with established artisan traditions like France and India. While the Exhibition indeed demonstrated Britain's industrial and technological superiority, it also displayed the inferiority of much British decorative work: its loud demands to be noticed and lack of respect for the shapes and functions of the objects to be decorated. Critics (including the young Morris) were appalled at the garish colours, insensitively applied patterns, and absurdly elaborated shapes of many of the British-made objects on display. Elizabeth Gaskell – an acute observer of domestic décor and its effects on minds and bodies – captured the often-dismaying results of the proud technology on display in a scene from her novel *North and South* (1854). The heroine Margaret Hale, reporting to her father that she has finally found a house at an affordable rent on the outskirts of industrial Milton (Manchester), cannot repress her dismay at what covers its walls:

'But the papers. What taste! And the over-loading such a house with colour and such heavy cornices! ... that gaudy pattern in the dining room [!]' ... [Margaret] had never come fairly in contact with the taste that loves orna-ment, however bad, more than the plainness and simplicity which are of themselves the framework of elegance.[3]

Wallpaper matters.

It is against this background of aesthetic recoil that we can situate the ambitions of Morris and his artist friends when, in 1861, they set out to elevate the lesser arts of decoration and design to what Morris believed to be their rightfully central place in human culture. The decorative furnish-ings business they founded – 'the Firm' of Morris, Marshall, Faulkner and Company (later Morris & Company) – grew out of earlier, joyfully collaborative projects: painting the debating chamber of the new Oxford Union building in 1857 and decorating Red House, designed for Morris and his new wife by his friend Philip Webb in 1860 to be both a home and an experiment in shared social and professional living. In these pro-jects of making beautiful things together, as in the business that extended their activities into the commercial world, Morris and his friends sought to demonstrate the importance of aesthetically pleasing work and surround-ings to mental and physical well-being. The Firm's first commissions were for churches but it soon expanded to offer furniture, tiles, stained glass, wall and floor coverings, and other objects to decorate Victorian homes. In 'that great body of art, by means of which men have at all times more or less striven to beautify the familiar matters of everyday life' (xxii.4), Morris situated the work of the Firm.

Great art makes great demands on us, Morris later wrote (xxii.176–7): demands of time and attention, because art challenges us to envision great acts, conceive great ideas and experience great emotions. The lesser or dec-orative arts, by contrast, are meant to 'amuse, soothe, or elevate the mind' in its hours of work and leisure; these are arts we can live with (xxii.23). They should properly remain in the background, introducing imagina-tive play while satisfying our desires for order and beauty even when we are doing something else. Morris began with high hopes for decoration not only as a sociable but as a truly popular art. As an admirer of the influential art and social critic, John Ruskin, he believed strongly that 'To give people pleasure in the things they must perforce use, that is the one great office of decoration; to give people pleasure in the things they must perforce *make,* that is the other use of it' (xxii.5). In Ruskin he found the less usual argument that ornament is not only a means of affecting the minds and bodies of those who live with it but also an index to the

conditions of labour under which it is made. The startling colour contrasts, abrupt shifts in perception, and sudden juxtapositions of sexuality with violence in Morris's early poems from *The Defence of Guenevere* had pointed to the proximity of death and desire in the feudal world of those poems. As Morris came increasingly to believe, however, his contemporaries suffered their own forms of oppression with no less disruptive effects on their desires and perceptual capacities. The joyless, repetitive, divided nature of the work in modern factories and the disappointing quality of much of what they produced affected everyone. He was convinced that living with beautiful things and making them under decent working conditions could have a therapeutic social purpose, restoring numbed senses and feeding starved imaginations with better fare than the violent stimulations (aesthetic and otherwise) sought by those with the unnaturally dulled and easily irritated senses of modern labourers and consumers. It was to address his contemporaries' forced insensibility to the quieter pleasures of beauty, order, mystery, and imagination that he and his partners at the Firm believed they were working.

The difficulties Morris encountered at the Firm, as many critics have noted, were both practical and moral. He wrestled first to find good quality materials and adequate technologies to make the things he wanted, recovering knowledge sometimes only recently forgotten in the shift to cheaper materials and more rapid methods amenable to the divisions of labour required for mass manufacture. He had also to recruit, train, and provide decent conditions for workers with the skills to realize the Firm's designs. These challenges he welcomed, extensively researching the possibilities of natural dyes like indigo, for example (and spending months with his hands blue to the elbow), or teaching first himself and then his workers how to embroider, engrave, print (on paper and fabric), weave, and paint on tiles and stained glass. He also analysed historical examples of glass, paper, ceramics, and textiles (printed, embroidered, and woven), some found on his travels and many in the collections of the British Museum or the South Kensington (now the Victoria and Albert). Morris was never, however, a strict historicist; he assimilated what he found to produce original designs that could be rendered into objects for his contemporaries. His interest was in how decorative arts from different cultures, using various materials and methods, might be recruited to the making of beautiful things for modern life.

Morris had to struggle, however, to reconcile his aesthetic and social aims with the economic realities of running a retail and commission business (on whose income he became more reliant in the 1870s, after the value

of mining shares he had inherited was radically reduced). Inevitably, meeting his high standards for design and production meant that much of the work done by the Firm was too expensive for many whom he had hoped to reach. Though some of his retail lines in wallpapers, chairs, and furnishing fabrics were competitively priced for the middle classes, they were out of reach for the average worker or the poor. At the other end of the economic and social scale, commissions for entire rooms or houses, where the Firm had more scope for creating the kinds of living spaces they imagined, meant working for the wealthy, whose wishes might be at odds with the aesthetic and social reforms Morris hoped to bring about.

'One of the chief uses of decoration, the chief part of its alliance with nature … [is] to sharpen our dulled senses' in respect to the 'eventfulness of form in those things which we are always looking at', Morris wrote (xxii.5). But could the decorative arts really repair the damage to minds and bodies he saw around him – the aberrations of perception and distortions of desire that he believed to be the product of mindless, repetitive labour, cheap materials, and short-cut technologies? This was Morris's problem: not only did his work at the Firm not reach the homes of the poor but even for those who could afford it, it might not be enough. A retail business cannot control the use clients make of its products. Pleasing patterns did not necessarily prevent their misuse or overuse, and Victorians, for whom house decoration was also a sign of economic and social status, often ignored his urging of simplicity to cover every available surface in an excess of colours and patterns and an accumulating clutter of things. With commissions for wealthier clients, the Firm had more control over the overall harmony of a room, but had also to satisfy those clients' tastes for rich effects. Could the Firm's products work on minds and bodies that were *not* in a healthy state? The therapeutic functions of the lesser arts in which Morris had believed seemed more and more out of reach to him in the later 1870s, when Morris took on a new role as public educator, lecturing (separately) both to those who made British furnishings and to those who bought and consumed them.

By the early 1880s, however, he had concluded that a revolution in existing social and economic arrangements would be needed before healthy minds and healthy art would once again be possible. One can trace the growth of his pessimism in his lectures within a few short years, from the first in 1877 ('The Lesser Arts'), where Morris called for cooperation to replace competition and took a relatively optimistic view of the future prospects for art and ornament, to 'The Prospects of Architecture in Civilization' (1881), where such art is 'sick' and like to die:

the many millions of civilization, as labour is now organized, can scarce think seriously of anything but the means of earning their daily bread; they do not know of art, it does not touch their lives at all: the few thousands of cultivated people whom Fate, not always as kind to them as she looks, has placed above material necessity for this hard struggle, are nevertheless bound by it in spirit: the reflex of the grinding trouble of those who toil to live that they may live to toil weighs upon them also, and forbids them to look upon art as a matter of importance. ... it may be she [Art] will die, but it cannot be that she will live the slave of the rich, and the token of the enduring slavery of the poor (xxii.123).

Morris began to devote much of his time, energy and money to further-ing the cause of radical social and economic change in Britain. His aims as a socialist speaker and editor of *Commonweal,* journal of the Socialist League, grew out of the moral dilemmas posed by his work at the Firm. Ornament, Morris insisted, should not be just for the rich: 'I do not want art for a few, any more than education for a few, or freedom for a few' (xxii.26). In the better ordered world to which Morris's socialism looks forward, good ornamental art would be 'made by the people for the people as a joy for the maker and the user' (xxii.58). That is the prospect he held out to those who would join him:

> If I were asked to say what is at once the most important production of Art and the thing most to be longed for, I should answer, A beautiful House ... To enjoy good houses and good books in self-respect and decent comfort, seems to me to be the pleasurable end towards which all societies of human beings ought now to struggle. (Ideal Book, 1)

Ensuring that beautiful house for all was a political no less than an aes-thetic project.

Morris's lectures on art and society, the fruit of two decades of practi-cal experience at the Firm and his growing disillusion with its limitations, give us important insights into the particular genius of his designs. In the final section of this chapter, I focus on walls: the papers and textiles that Morris designed for what he saw as the defining structures of domestic liv-ing spaces. 'Whatever you have in your rooms', Morris taught, you must 'think first of the walls, for they are that which makes your house and home' (xxii.262). Successful design in the lesser arts of domestic deco-ration, Morris explained in his talks, should sustain a tension between arousing imaginative desire and satisfying a need for harmony and order. In his own pattern designs – as he elaborated in his 1881 lecture 'Some Hints on Pattern-Designing' – respecting 'eventfulness of form' meant creating what a recent critic has called a 'topography of sensuous surface'

for flat walls, using the curving, spiralling, interwoven forms of leaves and flowers, stylized and arranged in carefully structured repeating designs.[4] Morris insisted on a wall of order that would guard against vagueness by using balance, symmetry, and clearly defined lines and colours, yet would leave open a door for the imagination (xxii.179–81).

But what did that mean, in visual terms? Morris's first design for wallpaper, *Trellis* (drawn 1862, registered 1864), was inspired by the ordinary climbing roses in the trellised garden at Red House (see Figure 12.1). The squares of the trellis provide a firm structure for the weaving, wandering branches, which extend beyond the limits of the pattern repeat and mask its severe geometry. Philip Webb drew the small birds that dart in and out between flowers and trellis. The pattern was printed in different colourways, but always over a flat ground (beige or grey or a medium grey-blue; this version was a favourite of Morris and was used in his bedroom at Kelmscott House). By weaving birds and stems sometimes over and sometimes behind the bars of the trellis, the design suggests both thickness and motion but without attempting the radical three-dimensional illusionism popular at the time and condemned by design reformers (in one example in the collections of the V & A from c. 1850–60, a large bunch of elaborately realistic and brightly coloured flowers floats improbably in a sky of Mediterranean blue inside a *trompe l'oeil* rococo architectural frame). Morris first tried etching his design on zinc plates (a newer method, allowing the use of machine-driven rollers) and printing with oil colours, but was dissatisfied with the results and commissioned Jeffrey & Company, an established wallpaper manufacturer, to use an older technique of printing by hand from carved wooden blocks pressed into a pad saturated with distemper colours (chalk, pigment, water, and a binder usually of animalhide glue). Each colour required a separate block. Jeffrey continued to produce the Firm's wallpapers in this way well into the twentieth century. Together with the other two papers Morris designed in the 1860s – *Daisy* (inspired by the wall hangings depicted in an old manuscript found in the British Museum) and *Fruit* (also known as *Pomegranate*) – *Trellis* remained among the Firm's most popular papers. It exemplifies Morris's initial impulse to lighten and simplify while preserving a degree of visual intricacy. Moderately priced and pleasingly but sparingly coloured, it provided interest for the eye without calling undue attention to its colours and shapes.

By the mid-1870s, however, Morris was designing much more complex patterns for both paper and textiles. *Tulip and Willow,* for example, was designed in 1873 for printing on cotton – for curtains, wall hangings

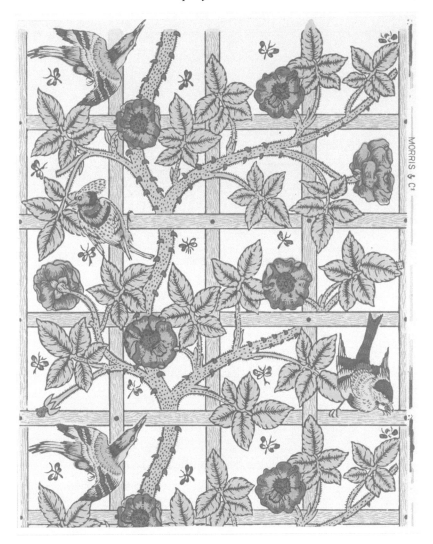

Figure 12.1 William Morris and Phillip Webb, *Trellis* (wallpaper), designed 1862, block-
printed in distemper colours on paper for Morris & Company by
Jeffrey & Co; reproduced courtesy of the Metropolitan Museum of Art, New York

and furniture covers – though not successfully produced until 1883
(see Figure 12.2).

A strong, undulating vertical stem in pale yellow with flower branches
curving off alternately to either side produces a balanced but not symmetrical

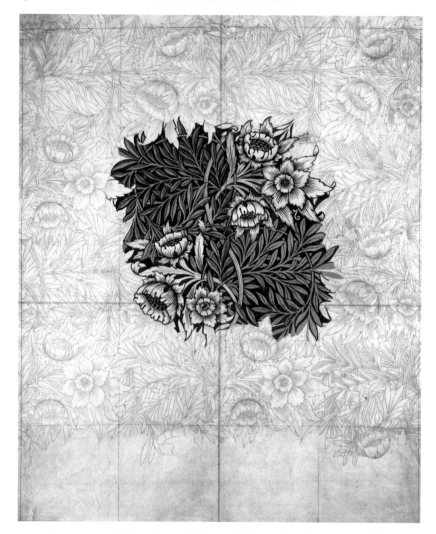

Figure 12.2 William Morris, *Tulip and Willow* (design for printed textile),
1873–5, pencil, watercolour, and bodycolour on paper; reproduced courtesy
of Birmingham Museums and Art Gallery

composition, whose multiple repeats, seen from a little distance, give an
impression of continuous vertical growth, as if Jack's magical beanstalk
were shooting up the walls. The design is further complicated by a second,
background pattern of swirling blue-green willow leaves. The design is
held firmly together both by the gradual shading of related colours and by

the vertically growing stems and the horizontal and diagonal rows of flowers that appear when the repeating design is seen across a larger surface. The largely flat layers of the design are, however, still clearly distinguished, its different natural forms crisply defined by contrasts of colour and tone, from the light yellow-white of the surface pattern to the medium blues and greens of the willow-leaves and the dark blue of the background. The effect is at once dense and surprisingly open, intricate but restful.

It took Morris nearly ten years to realize these effects, however. His first trials used a commercial firm, Thomas Clarkson's, whose Prussian Blue synthetic dye did not allow either the contrasts required or the integrated colour harmony intended. Commercial firms preferred synthetic dyes – a whole new range of aniline dyes derived from coal-tar were particularly popular – because they were cheaper and easier to handle. Moreover, they dried rapidly, allowing machine printing where many different colours are applied at once. They also yielded bright and novel shades to catch a consumer's eye. But these chemical dyes bled into one another around the edges; more significantly, over time they damaged the fabric and were not colour-fast, some colours taking on unpleasant new tones that destroyed any original colour balance. Morris determined to revive the older and more permanent natural plant dyes, especially a blue made from the indigo plant, and to use the old discharge or resist technique of printing the pattern with a resistant paste onto the fabric before dyeing, leaving some areas undyed. Depending on the desired intensity of blue in a given part of the pattern, the process can take up to four hours and nine or more successive dips into the dye vat. Lighter areas can then be printed from separate blocks with other colours. This technology, standard in Europe and Asia for centuries, had largely been replaced by the middle of the nineteenth century. Morris spent years experimenting to recover lost knowledge and perfect the resist block printing process, which he finally achieved when he acquired larger premises in 1881, at Merton Abbey outside London, where *Tulip and Willow* was printed. The results, however, were spectacular. Both the printed and the woven textiles (using yarns dyed with natural dyes before weaving) produced from the 1880s at Merton Abbey have kept their clarity and precision of structured form while remaining faithful to the hues imagined by their designer. The colours, even when softened by exposure to light over the intervening years, retain their intended harmonies.

Textiles were, in fact, always of the first importance to Morris in his designs for walls. He preferred cloth to paper as wall covering (though he was not able to convince many others): printed or woven patterned fabric loosely hung, or a fine Persian rug, a large embroidered hanging, or a woven

tapestry. From the embroidered hangings of medieval inspiration made for Red House grew a flourishing embroidery department under the direction of Morris's daughter, May; the complex printed and woven furnishing fabrics produced at Merton Abbey became the special focus of his attention; and to crown his efforts came the magnificent series of tapestries woven there, with figures by Edward Burne-Jones, animals by Philip Webb, and borders and backgrounds of vigorously twining leaves and flowers by Morris. Textiles satisfied the eye while they appealed to the sense of touch, creating indeed a 'sensuous topography' when used on the flat walls of domestic spaces. The large patterns Morris increasingly preferred, organized into layered structures (like *Tulip and Willow*) or mirror repeats (used in many of his woven designs) invited the imagination to wander along vertical, horizontal, and diagonal paths, losing the self in a complexity of interlacing forms and colours. When stirred into movement by a passing draft or with the entry of someone into a room, they conveyed a sense of aliveness, not only of growth but of motion, enhanced by the play of light and shadow caught in a hanging's folds – an effect especially noticeable under changeable English skies or in the partial, wavering light of candles, oil lamps, or gas sconces before the advent of uniform bright lighting with electricity.

Morris took risks with these later designs, however. So much complexity and motion may refuse its role as merely background for living. The risk is the greater given already damaged minds and senses – those which Morris, as we have seen, had most wished to reach. The unhappy woman in Charlotte Perkins Gilman's 1892 novella, *The Yellow Wallpaper*, sentenced by her doctor-husband to confinement and idleness as a cure for depression, fantasizes that her wallpaper is actively malevolent: that it conceals a faint figure of a woman, struggling to get out. The story brings out the latent cruelties of late nineteenth-century social conditions for women. But her account of the wallpaper's menacing complexities sounds very like a description of one of Morris's more complicated patterns (though its horrid yellow is its own):

> This wallpaper has a kind of sub-pattern in a different shade, a particularly irritating one, for you can only see it in certain lights, and not clearly then. But in the places where it isn't faded and where the sun is just so – I can see a strange, provoking, formless sort of figure, that seems to skulk about behind that silly and conspicuous front design.[5]

By the end of her six-weeks stay in a rented house, this woman has been completely absorbed into the disturbing world of her paper, and like the faint figure trapped in its depths, tears the wallpaper in strips in a desperate struggle to get out.

There are no recorded instances of Morris's patterned walls driving anyone mad. Yet his pursuit of his boyhood dream to realize for his own times those early magical impressions in Epping Forest took him far from the simplicity of the early paper patterns. Did he fulfil his hopes to create a socially therapeutic art available to all? In his own judgement, no. The woven hangings and tapestries were in one sense the culmination of his wishes, but they were never an art of and for the people. Costly and time-consuming to manufacture, they offered satisfaction only to the few workers the Firm employed or the wealthy who could buy them. Yet perhaps that is to misunderstand their role. They help to keep alive the desire for a future world where such an art will be possible. That was Morris's abiding hope.

Notes

1 *The Letters of Henry James*, ed. Leon Edel, 2 vols (Cambridge, MA: Harvard University Press, 1974), 2, 352.
2 J. M. W. Turner, *Rain, Steam, and Speed: The Great Western Railway*, 1844. Oil on canvas; National Gallery, London.
3 Elizabeth Gaskell, *North and South*, ed. Angus Easson (Oxford: Oxford University Press, 2008), 61.
4 Jonathan Hay, *Sensuous Surfaces: The Decorative Object in Early Modern China* (Honolulu: University of Hawai'i Press, 2010), 12.
5 Charlotte Perkins Gilman, *The Yellow Wallpaper* (Old Westbury, NY: The Feminist Press, 1973), 18.

Pattern
Textiles and Wallpaper

Caroline Arscott

In his 1881 lecture 'Some Hints on Pattern-Designing', William Morris discussed the relationship between decorative art and high art. As a thought experiment he imagines an environment where no ornament exists and interior spaces are populated exclusively by high art with its weighty repertoire of history, scripture, and mythology, wearying and eventually numbing, he says, when kept constantly in view. Decorative art works differently on the viewer, he suggests, operating in an aesthetic mode that gives respite from the concentration on terror and anguish so common in high art (xxii.176). This is not to position pattern-work as vapid or unintellectual. On the contrary, in all his comments on good ornament Morris maintains that it involves thought; sometimes this is expressed in terms of imagination or invention. On occasion Morris wrote about the way the craft-maker interacts with their equipment with 'thinking' hand (xxiii.87). When recommending the purchase of a sixteenth-century Persian carpet, the Ardabil carpet now in the Victoria & Albert Museum, he stressed the logic and beauty of the design, going on to speak of the design's 'beauty and intellectual qualities' (*CL*, iv.23).[1] His lecture 'Some Hints on Pattern-Designing' lists the crucial attributes of pattern: 'Ornamental pattern-work, to be raised above the contempt of reasonable men, must possess three qualities: beauty, imagination, and order' (xxii.179). Pattern draws on thought, furthermore it appeals to reason. In this chapter I will discuss these aspects of pattern as explored by Morris and will argue that, despite his comments about offering respite from high seriousness, he did locate themes of great significance in it. Rather than veering away from issues of life and death he sought, in his designs, to avoid a numbness with regard to such themes. Satisfying pattern might be pleasing and restful, but it was also mysterious and poignant, even passionate. This chapter will show how Morris theorized the linkages instanced in pattern. These linkages, alluded to in his own designs, were those of materials in fabrication, of symbiotic organisms in nature, of peoples across time and space, of elemental powers

invoked in myth, of communities, of kinship groups and, not least, of the passionate joining of lovers.

The unassuming word 'pattern' is most often used when repeat systems of ornamentation are meant and William Morris as a designer of patterns for manufactured goods uses the term with reference to pattern made, as he put it, by 'more-or-less mechanical appliances, such as the printing block or the loom' (xxii.102). Non-repeating ornament is possible as part of the fabrication and decoration of any object of use, but pattern-designing was the system of creating orderly and attractive systems of ornament that could be repeated, for instance, on rolls of wallpaper to decorate a room, or on lengths of fabric to be made up into curtains or sofa coverings. Pattern was found in the repeats around axes of symmetry adopted for carpet making and in the borders of woven tapestries. Pattern can be thought of in this context as the middle term between spontaneous creativity in decorating a handmade object for the sheer satisfaction of doing so (a scenario often evoked by Morris to explain the essential human joy in making and contemplating art) and the reproducible ornament necessary for a larger-scale decorative scheme or for the steady production of manufactured items in a commercial culture.[2] Pattern was fundamental to the goods produced by the company Morris, Marshall, Faulkner and Company from 1861, then by its successor Morris & Company from 1875. The original company and its successor are often referred to as 'the Firm'. They made goods that could be listed in catalogues, displayed as samples in the Firm's showrooms and shown off as manufactured items at international exhibitions. Morris was proprietor, director, and the chief designer at the Firm, closely attentive to all aspects of design, technique, and production whether production was outsourced or, when premises and equipment allowed, in-house. Design work was also undertaken by his collaborators – for instance, Edward Burne-Jones, Philip Webb, John Henry Dearle, and May Morris.

The peak of in-house production of items based on Morris's designs was the period from the launch of the Firm's operations at the Merton Abbey Works from 1883 until the late 1880s when he started to delegate a great deal both in terms of daily management and in terms of design. Continuity was ensured even beyond the death of Morris in 1896, as his manager Henry Dearle had already from 1888 taken on the greater part of the design work and was in a position to take over as art director in 1896. He maintained the Morris & Company production processes and created designs that were very close in style and sensibility to those made by William Morris. William Morris's younger daughter May Morris, as well

as contributing as a pattern-designer, was leader of the embroidery division of the works; unlike Dearle, she chose to work more independently after Morris's death.[3]

Pattern to be displayed on the article was the province of the designer, but fabrication processes had their pattern-creating aspects. The theorization of design in the mid-nineteenth century drew strongly on the ideas of the German architect and cultural theorist Gottfried Semper, and Semper's location of the origin of ornament in the fabrication systems developed in weaving and ceramics, where repeat criss-cross effects were intrinsic to basket-work, where edges had to be bound with special stiches or directional reed work, where ceramic handles had to be attached with distinct forms of indentation or encrustation, and so on. Semper drew attention to binding and linking elements as fundamental to pattern design and said, moreover, that the knot, technically intrinsic to textiles, was the root of ornament and was universally endowed with mystical or religious significance.[4] Morris was certainly familiar with Semper's theories, which had enormous influence on the design and architectural world across Europe.[5] When asked in 1892 about beauty in the fabrics and wallpapers produced by Morris & Company, Morris described pattern as being annexed to a more fundamental beauty. He acknowledged the underlying beauty that came from the fabrication and materials: paper, wool, cotton, silk, linen, mineral-based, and animal-size-based printing ink for papers and mainly vegetable dyestuffs for textiles. He referred to the 'primary beauty which belongs to naturally treated natural substances' (*WMM*, 63). In this primary aspect the natural fibres and dyes of printed textiles showed unmistakable characteristics and potential for beauty 'almost without the intervention of art' (*WMM*, 63). Vegetable dyes shone out in bold colours having been absorbed by the fibre. They faded to graceful, subdued hues under the action of sunlight. The fabrication of woven stuff – whether heavy weavings that would fall into soft folds for curtains, closely woven or knotted wool to lie flat for floor and wall coverings, or factory-produced undyed cotton cloth – produced a particular fabric with its own character which the designer could recognize and respect.

As a designer Morris was ready to intervene, adding beauty to beauty, in the patterns created: patterns that would be woven into or printed onto these articles. He favoured plant forms with foliate stems knotted or interwoven, further plant forms showing through in the gaps, and a profusion of flowers and sometimes paired birds or animals arranged around the axes of symmetry. Morris avoided shading, respecting the two-dimensional field of the design; nonetheless his designs summon up and attend to nature.

When designing for wallpaper and for textiles he combined elements of disparate size, sometimes sending tiny tendrils into a background zone while rendering giant vigorous stems and flower heads placed as it were on the surface of the design. In this case the visual effect was of close encounter and dizzying distances. At other times minor elements take their place in proximity to the viewer, tiny blossoms opening onto the surface as if pushing through the design responding to light in the space of the room.

Following Semper, Morris could not conceive of ornament or pattern as being alien to fabrication; indeed, it was derived from the processes of making and maintained an alliance with the rhythms and procedures of fabrication. In Morris's view the more basic the materials (paper and distemper, for instance, in printed wallpaper pasted flat onto a wall) the more the pattern should be elaborated to produce an effect of nature's fullness, compensating for the thinness of the artefact. This was to be done, he explained, by de-emphasizing the repeat and by spreading plant forms throughout to fill the visual field, while toning down the colours to achieve subtle variations. The eye would be drawn into the tangled growth that would produce a 'satisfying mystery' (xxii.191). In the case of richer materials such as woven wool, he thought an illusionistic evocation of the natural world was less appropriate. The geometrical basis of the pattern and the repeat should not be disguised; motifs taken from nature, whether plants or animals, could be more stylized. Lines could be sharper and forms more distinct in this mode. Leading lines in the pattern should be strongly marked. Stylization of the motif along with display of the fabrication method resulted in a horizontal colour-banding in Morris's *Peacock and Dragon,* designed in 1878 for weaving in wool (see Figure 13.1).

Fierce dragons are picked out in buff colour, twisting round to blow at the base of a flame-shape, which is edged in the same incandescent shade; the pinkish-buff colour illuminates all elements in that stratum of the fabric. In another band, peacocks are paired at the apex of a plant-form, throwing their heads back to call. This band is considerably darker, with all elements picked out in shades of olive and russet. These colours were set against the main hue: a dark or pale indigo or paler beige. The design emphasizes the movement of the weft threads running horizontally to make colour-coded bands.

For Morris stylization did not constitute a leaching out of significance in the pattern, for all the distance from a direct 'pictorial' encounter with nature that was established in this 'more dignified style of design' (xxii.193). In traditionally stylized motifs, as found in historic textiles that he studied in the South Kensington Museum, he discerned a lineage of reference both

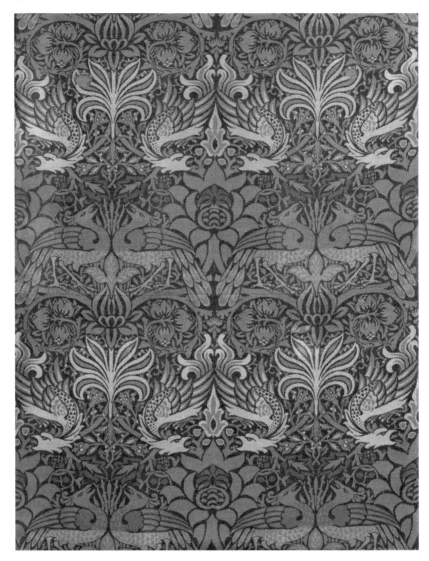

Figure 13.1 Morris & Company, *Peacock and Dragon*, woven woollen fabric, designed
by William Morris, 1878, private collection; photo by GraphicaArtis/Getty Images

to nature and to mythology. Like Semper he believed that there is a deep
history to ornament. Fundamentally he recognized an intrinsic human
joy in decorating (evident in 'primitive' tattooing as Semper noted), a joy
that can be retrieved in part, Morris thought, by giving art-making its due

place, combating alienated work processes and industrial systems of apply-ing ornament.[6] He believed that not only is there an emergence of pattern from the constitutive procedures of making necessities – items for cloth-ing, habitation, and storage of foodstuffs – but there is a long history of the inclusion of culturally significant motifs in ornament. References to sacred concepts linked to natural form, such as motifs of the tree of life, sacred fire, or the lotus, and to life-forms associated with deities or mythologi-cal beings were, Morris pointed out, from the earliest times, included in ornament. As time rolled on, and cultural transmission occurred, the sig-nificance in many instances was largely forgotten. According to Morris the deep associations were nonetheless tied into the design, surviving in some way and contributing to its significance. His examples are early-period silk textiles from Greece, Syria, and Byzantium and medieval figured silk textiles from the looms of Italy and Sicily (xxii.227).

When Morris wrote on the history of pattern designing, he imagined the historic movements of goods and peoples as interlacing vectors. His imag-ery shows that he was thinking of history as enacting the kinds of combina-tory procedures of fabrication familiar to him from textile production (weft meeting warp) and of the bringing together of lines within the patterns he designed. This goes two ways; he also conceives of pattern designing as referencing and harnessing the movements and encounters of history. A Morris & Company printed textile such as *Windrush* was vat-dyed and block-printed to complete the pattern (designed 1883, see Figure 13.2).

The lengths of cotton or linen-union furnishing fabric when sewn together in curtains, for instance, would produce marked horizontal rows: a line of huge shaggy tulip heads and then, above and below these, giant exotic floral forms, petals surrounding a teardrop or lotus-leaf heart whose centre is emblazoned with a trio of little flowers. In this case the ensem-ble constitutes a fanciful form referencing historic Indian, Turkish, and Persian designs.[7] Within Morris's pattern, the familiar botanical world of the modern day lines up in strata quite separate from the 'exotic' rows relating to geographically distant cultures cognizant of magic, reaching back to the mythic past. However, the greatest energy in the Morris design is in the overlapping vertical meanders; in the case of this design, these loop over one another to make a chain running up the fabric, bottom to top.[8] The chain is disturbed all the way up, and its regular geome-try obscured, by a right-branching stem bearing the exotic flower. This branching stem appears from behind the tulip bloom suggesting that it is annexed to a system belonging to the modern cultivated tulip: every tulip head sits firmly on the left bend of a meander, appropriating the meander.

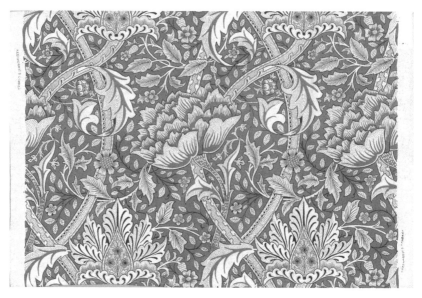

Figure 13.2 Morris & Company, *Windrush*, printed cotton, designed by William
Morris, 1883; photo by Heritage Art/Heritage Images via Getty Images

The stems themselves tell another story though, because the tulip is given
a dainty naturalistic flecked stem that twists behind a strong, tooth-edged
line of the meander, and is visible just as far as an overlapping leaf. This
annexes the tulip to a system belonging to the oriental plant associated
with past times, in which case the overlapping meanders belong to that
oriental plant too.

Depending on the colourway, tulip elements and exotic plant elements
can be differentiated with great emphasis or somewhat assimilated as in the
colourway illustrated in Figure 13.2. Importantly, whatever the colourway,
no system is entirely self-consistent or autonomous. The design grafts or
bastes together differently bordered stems into the main meanders, many
patterns contributing to the design's organizing structure with something
of the combinatory logic of plant culture along with a suggestion of nee-
dlework. The pattern includes a profusion of smaller flowers and their
foliage. Campions with swollen calyces are lined up on the vertical axis
between the tulip heads. A marigold-like bloom appears punctually, like
a series of buttons lined up on the vertical axis between the exotic flow-
ers. Other flowers stray into the gaps; buttercups or anemones show side-
on, each borne by a spiral stem, and generic five-petalled flowers push,

open-faced, onto the surface of the pattern. This pattern, May Morris recalls, was 'named in memory of pleasant summer journeys along the Windrush valley'.[9]

Movement through space and time is coded into the pattern, then, in multiple ways. The left-right variation of the meander speaks of a left turn to the present with its European naturalistic tendency, and a right turn delving deep into the past and the origins of ornament. Therefore, the meanders can be understood to indicate the flow of time itself which is not conceived of as unidirectional. The points of crossing signal the role of technical fabrication at the birth of decoration. The hybrid linkages of different plants speak of the history of world culture where cultural diversity and exchange at nodal points produced extraordinary developments in ideas and in the decorative arts. The lines of the meander allude to the flow of the Thames and its tributaries through verdant flower-filled river meadows.[10] The idea of river water connotes the washing of cloth to prepare it for printing, and the rinsing out of dyestuffs in the multi-stage printing process. Plant-based dyestuffs such as those favoured by Morris & Company are alluded to by the coloured plants of the design. The crossing and overlap of the meanders speak in terms of group identity, of a family history of multiple journeys lodged in fond memory, habitual river trips with dearest companions, passing forward and backward along the waterways.[11]

The heroic deeds and mystical settings of the Middle Ages as told by Froissart and Malory caught Morris's imagination, as did the Icelandic sagas mingling warlike deeds of historical record and magic. Middle Eastern myths and legends were also important to him. Edward Burne-Jones recalled, of Morris, 'He loved everything Persian, including the wild confusion of their chronology' (Mackail, ii.92). By the early 1880s Morris was working on a translation into English, from the French, of Ferdowski's retelling of Iranian myth and history – the Shahnameh (c. 1010 CE). The Shahnameh was listed by Morris in 1885 as one of the best books of all time (his list had 54 titles, xxii.xiii). This foray into pre-Islamic Persian myth, legend, and history took him to its world-making myths, the acts of a magical giant bird (the benign simorgh), interactions with magical horses, fearsome dragons, and demons as well as feats of strength on the battlefield in encounters stretching from the mythic past to the historical era. The segment that Morris translated focused on the world-making myths, where each legendary king, in reigns sometimes lasting hundreds of years, established certain foundational technologies.[12] Metalworking and the digging of irrigation channels were introduced in one reign; the control of fire and huge public celebrations of a mighty pillar of fire, the domestication of animals, and the fashioning of

garments from animal skins in another; and sheep shearing, spinning yarn for clothing, and the weaving of carpets in another.

Later still the text tells of the discovery of what Morris translates as 'the craft of writing', which enabled the accumulation of knowledge and allowed the exchange of vernacular languages from diverse lands – 'the words of Rome and Armenia, of Persia, of Turkland, of China and the ancient of Babylon; and all this writing set forth plainly in what wise the tongue should say it'.[13] The emergent crafts move on to arms manufacture and eventually to advanced textile working. Here, in Morris's rendition, the king 'wrought webs of linen and silk and wool, of hair and rich-wrought stuff: he taught men to throw and to spin, and interweave the warp with the weft, and when it was woven they set themselves to learn of him both how to cleanse it and to fashion it into garments'.[14] Reading Morris's translation we can appreciate the way in which pattern was bound up with technologized world-making for him. The conjunctions of pattern take us back through history to the birth of human society where the discovery of correlations between written languages, and the ability to join weft to warp, usher in aeons of wisdom and well-being.

As a member of the Committee of Art Referees from 1884 Morris was a consultant for the South Kensington Museum (now the Victoria and Albert Museum) advising on purchases of works coming from Icelandic, far-eastern, and middle-eastern cultures.[15] In his lecture 'The History of Pattern-Designing' (1882) and in a subsequent lecture, 'Textile Fabrics' (1884), he pondered on the symmetry and stylization of paired figures in historic textiles and architectural ornament. Simorghs rear up opposite one another on the silk fragment now known as the Sēnmurw Silk, which came into the South Kensington Museum collections in 1863 (see Figure 13.3a).

This circa eighth-century, probably Iranian, textile shows giant winged creatures: part-bird (with wings and thick peacock-like tails), part-mammal (with dog-like snouts and lion-like forelimbs bearing fearsome claws). Morris may not have known the exact date or the identity of the figured beasts, but his instinct was that paired beasts 'winged or otherwise' in roundels on early textile fragments 'carry us further back and hint at a time before the dawn of history' (xxii.276). In a movement forwards through time, the South Kensington Museum simorgh motif is recognizable as a historic predecessor of griffins shown in the medieval Italian woven silk fragment that entered the museum one year later in 1864, the pattern later clarified by the watercolour continuation of the pattern added by John Watkins in 1895 (see Figure 13.3b). There the creatures stand on lion-like back feet but have taloned forefeet, and distinct beaks and wings.

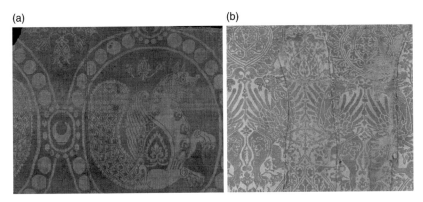

Figure 13.3 (a) The Sēnmurw Silk, woven silk fragment with large sēnmurw (simorgh) in roundel, Iran or Central Asia, eighth or ninth century, detail; © Victoria and Albert Museum, London and (b) Woven silk fragment, with griffins, Italian, Lucca, 1270–1329, watercolour continuation of pattern by John Watkins, 1895, detail; © Victoria and Albert Museum, London

In discussing patterns that arranged symmetrical figures around a central vertical motif Morris saw an ongoing reference back to the worship of fire in pre-Islamic cultures of the Middle East and to a (sometimes indistinguishable) tradition of the tree of life, or Holy Tree, attended by benign guardian figures. He describes these common motifs as 'far-travelling symbols' referencing the earliest civilizations and pondered as to whether two benign guardians were shown or whether, in accordance with dualistic Zoroastrian beliefs, they represented two opposed figures, one good and one evil (xxii.230, 276). He writes about the transmission of motifs from the Accadian peoples of the Middle East and ancient Babylon, tracing paths of transmission and alteration through cultures, showing up, for instance, as peacocks drinking from a central fountain in Byzantine art. Byzantium, he described as 'a kind of knot to the many thrums of the varied life of the first days of modern Europe', using 'thrum' (a thread in weaving) in a textile metaphor for the cultural intermingling that enlivens art (xxii.229).

Morris considered that the travelling symbols which had lost their explicit cult meanings retained a mysticism. This, allied with love of nature and inklings of political freedom, produced unrivalled beauty in ornament in the early medieval period. At that stage, he claimed, the heritage of ornament was still traceable in a clear line running through from its earliest days. Byzantine ornament retained an intellectual aspect, a quality of 'richness and mystery' that it passed on to Gothic ornament, an aspect coming from

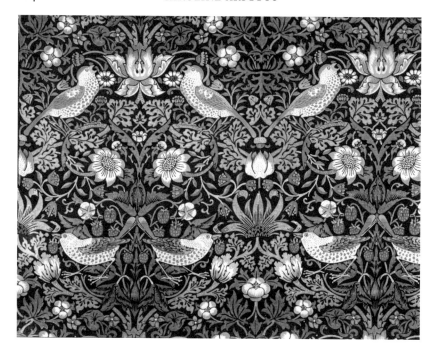

Figure 13.4 Morris & Company, *Strawberry Thief*, printed cotton, designed by William
Morris, 1883; photo by Historica Graphica Collection/Heritage Images/Getty Images

the remote past that it also transmitted to the Safavid Persia and China.
When summing up the legacy of these components of pattern, Morris's
phrasing picks up on qualities of thought, attitudes to worship and political
impulses, listing 'the influence of its [the East's] thought, its strange mysti-
cism that gave birth to such wild creeds, [and] its looking to equality amidst
all the tyranny of kings that crushed all men alike' (xxii.230).

Awareness of Morris's interest in the Middle Eastern mythological ori-
gins of guardian figures leads us to look again at some of his designs where
birds or other creatures flank a series of growing spines. The familiar gar-
den thrushes that populate his textile design *Strawberry Thief* channel the
magical presence of the winged simorghs. *Strawberry Thief* was designed
for indigo-discharge printing on cotton in 1883 (see Figure 13.4).

The birds lean back and sing joyously at either side of a large tulip bloom
rising up from a strawberry plant, a hybrid growth that can be said to stand
in for the tree of life. At ground level, purloined strawberries in their beaks,
thrushes approach each side of a half-bloom whose petals wave and rise like
the flames of the sacred fire. The birds in the design are divided, maybe with

Zoroastrian duality, into blameless singers and mischievous thieves. Within Morris's sequence of designs we might say they are domestications of the noble peacocks and the fire-generating dragons of *Peacock and Dragon* (see Figure 13.1). The themes of *Strawberry Thief* are not weighty and terrifying in numbing high-art mode. The variety of colour, the naturalism and profusion of flowers and foliage, and the vitality of flora and fauna make the pattern delightful and reminiscent of the beauties of nature, offering the unassuming presence of little violets, cultivated fruit, and dainty strawberry blossoms. Morris advised trainee designers in Birmingham in 1894 to open their eyes to the beauty of the cultivated, inhabited countryside, to take pleasure in what he called 'the embroidery of the general face of the country' where nature and human intervention coexist (xxii.428). His *Strawberry Thief* textile is as restful as a garden. Nonetheless it has its serious side: the very weaving together of elements in the design references the mighty movements of peoples, ideas, and goods throughout history and the pattern format brings with it sacred mysteries.

Pattern and its communication of love as the mainspring of human interchange and of sacred mystery was written about by Morris in relation to the architectural examples that he came back to, time and again. In the great gothic churches and cathedrals, he felt the legacy of the love of all men radiating from the craft workers and the love of life that is evident in their carvings. He described this at the outset of his career, in the essay 'The Churches of Northern France' (1856).[16] The façade of the cathedral, which in retrospect we might compare with the area of the pattern design made by Morris for textile or wallpaper production, is described as infused with life and breath. He refers to 'the uprising of the great cathedral front with its beating heart of the thoughts of men, wrought into the leaves and flowers of the fair earth', making an early claim for the intellectual stakes of ornament, its dependence on mind.[17] He speaks of his love for the original craftsmen, just as real, he claims, as the love that is exchanged between living men in the current world. In animistic terms the buildings themselves are said to be kind and loving. Love seems to be a force that pulls the past into the present, and the present into the past, as the meander does in the river-named printed patterns created by Morris roughly thirty years later in the 1880s. Love does a lot of work in the 1856 essay, bridging from romantic love and heartfelt esteem to love of nature's variety. The youthful Morris recognized the theological context and centred his analysis on love devoted to social justice seeing the angels as battling against wrong. His beliefs did not stay with the established church; by the end of his life, fully committed to a struggle for the revolutionary transformation of society, he

baldly professed not atheism but paganism: 'In religion I am a pagan' (xxii. xxxii). Simorghs rather than angels exercised his imagination.

William Morris used pattern to speak in the combinatory language of textile itself. The Shahnameh, repository of ancient myth, offered him many textile ideas, not least an image of the rapturous love that created a living fabric, when two lovers Zal and Rudabeh spend the night together, cleaving to one another like weft to warp.[18] In his patterns Morris consistently pursued the goals of cohesion, vitality, allusions to nature, emotional force, and intellectual power. He was committed to patterns that produced calm and contentment for the modern world and nonetheless evoked timeless mystery and passion.

Notes

1 See also R. Stead, *The Ardabil Carpets* (Malibu, CA: J. Paul Getty Museum, 1974), 82; C. Arscott, 'Morris Carpets', *RIHA Journal*, 0089 (2014), Special Issue *When Art History Meets Design History*, n.p.

2 For example, the decorative handle of the knife carved for pleasure in 'The Aims of Art' (xxiii, 87) and the ornate pipe that features in chapter 6 of Morris's *News from Nowhere* (1890; 1891).

3 Jan Marsh, *Jane and May Morris: A Biographical Story 1839–1938*, rev. ed. (Horsham: The Printed Word, 2000), 240–3.

4 Gottfried Semper, *Style in the Technical and Tectonic Arts; or, Practical Aesthetics*, intr. H. F. Mallgrave, trans. H. F. Mallgrave and M. Robinson (Los Angeles, CA: Getty Research Institute, 2004), 155.

5 Exploration of Semper's understanding of ornament and his influence on design and architectural theory in the second half of the nineteenth century is undertaken in A. Payne, *From Ornament to Object: Genealogies of Architectural Modernism* (New Haven and London: Yale University Press, 2012), 25–111.

6 Gottfried Semper, 'Über die formelle Gesetzmässigkeit des Schmuckes und dessen Bedeutung als Kunstsymbol' (1856), discussed in Payne, *From Ornament to Object*, 51 and fn. 131.

7 S. M. Leonard comments on the way the stylized leaf motif in *Windrush* references Turkish and Persian textiles and Iznik ceramics. Every Morris@ EveryMorris 13 June 2019 (1) Every Morris on Twitter: Pattern 62: 'Windrush', printed textile. William Morris, 1883. Printed; Merton Abbey Image, V&A https://t.co/LeAE5wXZMs / Twitter (consulted 22 June 2022).

8 For commentary on Morris's introduction of meanders into his designs see P. Floud, 'Dating William Morris Patterns', *Architectural Review* (July 1959), 14–20.

9 Quoted by Linda Parry, *William Morris Textiles* (London: V&A Publishing, 2013), 237.

10　The river associations of the late designs that emphasized the meander are discussed in C. Arscott, *Edward Burne-Jones and William Morris: Interlacings* (New Haven and London: Yale University Press, 2008), ch. 8. See also S. M. Leonard, 'Printed Ecologies: William Morris and the Rural Thames', *British Art Studies*, 22 (April 2022), n.p.

11　For the to-and-fro river journeys in Morris's late prose romances, discussed in terms of blue routes and red routes as an aspect of Morris's textile designs and printing processes, see C. Arscott, 'William Morris: The Poetics of Indigo Discharge Printing', *Nonsite #35* (9 May 2021), n.p.

12　William Morris, 'Part of the "Shah Namah" of Firdausi', trans. c. 1883, WILLIAM MORRIS LITERARY MANUSCRIPTS, Add MS 45317, vol. xxl (ff. i + 76), item (5), British library, Western Manuscripts.

13　Morris, 'Part of the "Shah Namah"', 59.

14　Ibid., 60–1.

15　On Morris's contribution to the South Kensington Museum's Persian collections, see Moya Carey, *Persian Art: Collecting the Arts of Iran for the V&A* (London: V&A Publishing, 2017).

16　William Morris, 'The Churches of Northern France', *Oxford and Cambridge Magazine*, 2 (February 1856), 100.

17　Ibid.

18　Zal was the prince who was reared in the simorgh's nest. 'So tightly they embraced, before Zal left, /Zal was the warp, and Rudabeh the weft/Of one cloth', Abolqasem Ferdowski, *Shahnameh: The Persian Book of Kings*, trans. Dick Davis (New York: Penguin, 2007), 79.

Technologies of the Book
Revisiting the Kelmscott Press

Marcus Waithe

The *Oxford English Dictionary* defines 'technology' as 'dealing with the transformation of raw materials into finished products in industry and manufacturing'. This meaning rose to prominence in the nineteenth century, and was preceded by a radically different sense based in the word's Greek etymology (τεχνολογία). Far from evoking mechanical solutions, it suggested matters of grammar and morphology, and by extension a path by which the forms of language might tally with the forms of things in the world. Despite the futuristic allusion to 'force barges' in *News from Nowhere* (1890; 1891) (xvi.162), readers have not tended to associate William Morris with technology. One might, however, imagine him engaging with this earlier and enlarged sense of the technical. A convergence between the literary arts and ideas of making, or *poesis*, is in fact strikingly Morrisian. Nevertheless, I want to persist here with the modern or industrial sense of the word, and in particular with Morris's improbable contribution to what the *Dictionary* calls that 'branch of knowledge dealing with the mechanical arts and applied sciences'. While this may seem a perverse manoeuvre, its advantage lies not only in offering something unfamiliar or unexpected. I hope also to demonstrate an overlooked quality of compromise and pragmatic adaptation that bears on Morris's approach to craftsmanship and to making more generally.

Our ability to recognize the 'technology' of a given era has to do with the assumptions of our historiography. Just as Victorian medievalists sought to recover the Middle Ages from perceptions of social and cultural barbarism, so recent historians have begun to understand them less as a set of unformed 'dark ages' than as a time of technological advance.[1] A student of robotics need only examine the prosthetic articulations of a German armoured gauntlet to find the origins of a quintessentially industrial technology in the 'pre-industrial' era. We can likewise recognize a source for modern turbines in medieval methods of harnessing the power of wind and water.[2] Or we might notice connections between modern principles

of integrated design and the fortifications built by medieval siege engineers.[3] For the most part, though, Morris's relationship with technology is striking less for its disclosure of an unrecognized continuity between the modern and the medieval than for its hybrid combination of differing elements. The first part of this chapter considers the broad principles, and unacknowledged complexity, of Morris's thinking on mechanization. The second part discusses the Kelmscott Press, the fine-printing venture that Morris set up at Hammersmith in 1891 with the help of his friend Emery Walker.

When thinking of the Press, most people picture the illustrious *Kelmscott Chaucer* (1896): a vast compendium set in a creatively revived Gothic type whose finest editions were bound in vellum. In this respect, the Press has become synonymous with medievalism in its fundamentalist form. It will be my business here to question and complicate such first impressions, and not only because many of the Press's books were plain, unornamented volumes printed in a Roman type inspired by early Venetian models. Although Morris wished to transport his readers into other realms, his means of doing so were not in every respect inspired by past models. In this regard, I will pay particular attention to his use of advanced photographic techniques alongside a broader gamut of lens-based media. Some of these methods can be traced back to seventeenth-century precedents. But their technological incarnation – as I will seek to show – implies a distinctly nineteenth-century cutting edge.

Technology

What Morris has to say about machines offers a helpful place to start. In this respect, he is often paired with his mentor John Ruskin, who banned steam-driven mechanisms from his utopian enterprise the Guild of St George, and opposed railways in the Lake District. It was easy for critics in the 1950s and 1960s to dismiss these positions as foibles, partly because they flew in the face of what Western society knew about the transformative power of engines, and partly because these positions were inconsistently held: Ruskin used the railways when it suited him (Ruskin, xxviii.247–8), and was dismissive of purism in shunning them (Ruskin, xxvii.xxviii). From an early twenty-first-century perspective, however, these issues look radically different. Ruskin's distinction between machines *per se* and those based on a polluting fossil fuel economy now seems logical and prescient.

The allusion to 'smoke-vomiting chimneys' (xvi.8) in *News from Nowhere* reveals Morris's comparable concern about the dirtiness of

modern production. Moreover, his nervousness about machines in general draws heavily on Ruskin's labour ethics, in as much as they enjoined employers to nurture the intelligence and imaginative capacities of their employees. Especially after he converted to socialism in 1883, Morris railed against what he described as 'wage-slavery' (xxiii.78), the implication being that employees were paid, but not to the extent of choosing how, when, or where, they might work. Morris is vague about which mechanized processes he has in view, but he worried that a reliance on them converted individual workers, endowed with unique imaginative capacities, into machine-minders. This rationale differs from a blind prejudice against machines, not least because it situates Morris historically: he lived, after all, in a period when machine-production was associated with cheap and inferior outcomes, and when handicraft would nearly always produce a superior product. Equally, he could not have anticipated the mechanized developments of the twentieth century: notably, the democratization of good design and the ways in which domestic machines would release people from mind-numbing tasks.

To be dispassionate, one should acknowledge that Morris was not always consistent in maintaining this distinction. Like Ruskin, he was at once capable of a more suspicious prejudice against machines – steam-driven, or otherwise – and of an equally suspicious awe in their favour. The first tendency draws on Thomas Carlyle's social analysis of a society turning from spiritual or organic values towards '[t]he huge demon of Mechanism'; but even this philosophical basis devolves quite readily into self-stymying suspicion.[4] The result is a level of productive inconsistency, sometimes prompted by the technical advantages of compromise, and sometimes by the conceptual difficulties of stubborn resistance.

An example of the last effect arises when Morris discusses weaving in his lecture on 'The Lesser Arts of Life' (1882). The art of weaving was close to Morris's heart, so much so that he set up a dedicated textile mill for Morris & Company at Merton Abbey in southwest London. Yet weaving also turns out to be a special case where machines are concerned. The loom, after all, is a contrivance that sits somewhere between handicraft and automation. As Morris grudgingly explains, weaving is 'not so much of an art as pottery and glass-making, because so much of it must be mechanical' (xxii.249). Even so, he counters, it 'produces beautiful things, which an artist cannot disregard' (xxii.250). This exception for woven goods is also unavoidably a concession, or at least a conceptual tremor in as much as Morris admits the possibility of a beauty generated by a (partially) mechanical method.[5]

This exception makes sense, he explains, because weaving compensates the operative with the spectacle of 'the web growing day by day almost magically' (xxii.250). Morris's reference to 'magic' also concedes something, however. Victorian machine-suspicion reflects a concern about infinitely repeatable execution, and an apparently demonic autonomy. Magic, on the other hand, possesses a more ambivalent connotation in Morris's lexicon, and is a force he recognizes and willingly admits into his vision of the medieval world. Importantly, its status as a first cause is entangled with the handiwork that Morris praised. Burne-Jones's illustration to *The House of Fame*, collected in *The Kelmscott Chaucer*, is a case in point. It shows a vast rotating wicker tower – a 'house' that Chaucer enters towards the close of that tale.[6] A sense of architectural impossibility or sorcery heightens our appreciation of the rhetorical trouble found inside: it proves a place of rumour and wagging tongues. And yet the inhuman scale also combines strangely with the lingering impression of a structure that has been wrought carefully and skilfully by nimble hands.

Far from keeping the hand separate from mechanized magic, this quality of mingling is apparent across a range of Morris's activity. There is, first of all, the quality of audacity that, from the very beginning of his career, accompanies his revivalist agenda: disinterring lost knowledge from early printed guides, and proceeding experimentally according to the motto painted on a window at Red House, '*si je puis*' ('if I can'). This sense of experimentalism never left Morris, and while it stops short of our modern understanding of 'innovation', the results remain something novel. May Morris recalls an 'experiment' (xv.25) from the period when her father and his associate Emery Walker were testing papers and inks for the Kelmscott Press. It resulted in a 'curiosity': a paper that was 'cockly, hard as a board and semi-transparent – rather like fish-glue, the queerest production' (xv.25). This anecdote, with its emphasis on the strange and indescribable, suggests something new coming into the world, an experimentalism whose revivalist premise has strayed into unforeseen effects.

The Kelmscott Press offers a particularly resonant example of the old and the new combined. While a cursory inspection suggests an antiquarian spirit at the level of woodcuts, early typefaces, and handmade paper, it is worth pausing on the strangeness of this proposition as applied to a printed book. Printing, after all, figures in many accounts as the epitome of incipient mechanical reproduction, the moment when the hand is supplanted by a less singular impress. All the more striking, then, that the enthusiasm for printing among members of the Arts and Crafts movement was premised on an entirely contrary view. Rather than seeing printing

as a challenge to manual production, they made a case for its status as a craft. Walker, for instance, argued that instead of implying a decisive break with the manuscript culture of the medieval past, 'the earliest punch cutters' – the artisans who sculpted the steel punches used to form the copper matrices from which lead type was cast – found a middle way, in copying 'the current handwriting of the country in which they lived' (Peterson, 325). That emphasis reached its apogee in 1924 with the publication of Henry Halliday Sparling's *The Kelmscott Press and William Morris Master-Craftsman*, a work that understands Morris's late bookmaking as the epitome of his commitment to an integrated art. Frederick Compton Avis's study of Edward Prince (1967), the Press's talented punchcutter, revives something of this late Arts and Crafts spirit on acknowledging the 'singular appropriateness in the collaboration of Prince, a great craftsman', as well as Morris's own estimation that Prince 'cut' not mechanically but 'with great intelligence and skill'.[7] It follows that Morris's lead type depended on a prior act of craftsmanship: the original sculpture that Prince lavished on his punches to form the matrices in which it was cast.

Apart from challenging a false opposition between print technology and craftsmanship, the example of Prince reveals the hybridity – one might even say, modernity – built into the core of Morris's new venture. It would be wrong, for related reasons, to suggest that Morris spurned industrial technology. He had experimented with manuscript work earlier in his life, and at the threshold of his new printing enterprise, confessed that 'I couldn't help lamenting the simplicity of the scribe and his desk, and his black ink and blue and red ink, and I almost felt ashamed of my press after all' (*CL*, iii.306). None of this stopped him, of course. The cast-iron Albion machine pressed into service at the Kelmscott Press may have been seventy years old, but it remained an example of industrial-era technology. Just as Morris embraced the greater pressure and span afforded by a metal rather than wooden handpress, he likewise accepted modern materials and methods where they promised better results. From these several examples emerges a responsive hybridity of method and execution, and an appreciation of complication. The rest of this chapter enlarges on that tendency.

Lens-Based Methods

In his influential essay on 'The Work of Art in the Age of Mechanical Reproduction' (1935) it is photography, not print, that Walter Benjamin identifies as a catalyst to the destruction of art's singular and sacred aura.[8] In this respect, too, the Press might not be so far from the 'mechanical'

as is often imagined, even if its primary impetus was to keep aura intact. At the level of type design, ornamentation, and illustration, it relied on an alliance between the older technology of print and the new invention of photography. William Peterson notes this much when he observes that 'some of Morris's professed disciples, in their unrelenting hostility toward the machine, failed to take into account how heavily Morris had depended upon … photography' (*Ideal Book*, xxxiv). This point is well made, but the question arises whether photography is necessarily 'mechanical', at least as understood in the pejorative sense inherited from Carlyle. Does a camera count as a machine?

Ruskin, for his part, was not sure how to categorize this invention when it came into his hands. He initially felt wonderment at its ability to contain 'under a lens, the Grand Canal or St. Mark's Place as if a magician had reduced the reality to be carried away into an enchanted land' (Ruskin, xxxv.373). Once again, a sense of spell legitimizes what might otherwise defeat the honest and patient application of artistic labour. Indeed it is easy to see how 'the mere action of Light upon sensitive paper' – what the early photographer William Henry Fox Talbot called 'the pencil of nature' – might present as a magically manual process.[9] Morris seems not to have been so enthusiastic about photography as a medium for art, though he posed for the usual portraits and group photographs. The Minute Book of Morris, Marshall, Faulkner & Company affords tantalizing glimpses of a more creative interaction with the medium: most notably, an entry from 28 January 1863 that reports a 'Design for binding and clasp of photographic album allotted to William Morris', and a 'Design for decoration of stereoscopic box' allotted partly to Morris.[10] Stereoscopy, or the practice of assigning to different eyes separate views of the same scene, was an invention of the previous decade that created the impression of a three-dimensional image. The ornamentation of an existing object does not sound much in keeping with Morrisian principles of deep structural integrity, but it sits better with the idea of decoration at the heart of the business, and possibly with the visual distortions embraced by the second generation of Pre-Raphaelite artists.

It was not until the 1890s, however, that Morris's relationship with photography deepened to the extent of being fundamental to artistic outcomes. In this respect, a chance meeting with Emery Walker – his neighbour, but soon a friend, collaborator, and fellow socialist – proved crucial. As a director of Walker and Boutall, a firm of Automatic and Photographic Engravers, Walker was not only an expert on printing, but possessed an advanced understanding of process engraving and the very

latest 'automatic' methods. While the partnership maintained offices at Clifford's Inn on Fleet Street, their printing operation was situated in Sussex House at Hammersmith – which directly adjoined the home of the Kelmscott Press at Sussex Cottage. Walker declined Morris's offer of formal partnership in their new printing venture, but he nevertheless lavished on it his expertise, his connections, and his technological know-how. In this respect, the Press shared its premises, as well as aspects of its premise, with the very latest methods.

The broader origins of the Press are often traced to the early nineteenth-century revival of 'old face' type styles, and its culmination in an exhibition at the South Kensington Museum (1877) to mark the birth of William Caxton (Peterson, 36). The after-effects are seen in the Kelmscott Press's republication of *The Recuyell of the Historyes of Troye*,[11] a copy of whose Caxton edition the Duke of Devonshire had lent for display at South Kensington.[12] Further interest in bookmaking was marked by the publication in 1887 of Talbot Baines's *History of the Old English Letter Foundries* (1887), a seminal work that couches its subject in a wider decline of 'that labour of head and hand which our fathers called Handicraft'.[13] Like Morris, Baines ran a business, and even cast the type for the Kelmscott Press at his Fann Street Foundry. The revival of early faces offered an intellectual justification, then, for Morris's later experiments. He was determined to supplant 'The sweltering hideousness of the Bodoni letter' (*Ideal Book*, 68–9), and the verticality of other typefaces derived from the eighteenth-century innovations of John Baskerville. His account of the Press's origin also reflects a more circumstantial impetus, arising amidst a futuristic and sensory scene of lens-based magic.

Walker's evening lecture on 'Letterpress Printing and Illustration', given in the New Gallery in connection with the first Arts and Crafts Exhibition Society (15 November 1888), was the first occasion for such magic. In as much as Walker used lantern slides to illustrate his typographic analysis, it proved for Morris a lightbulb moment in more than one sense. The projecting lantern was not new technology: the redirection and magnification of a slide via a light source began in the seventeenth century, and Morris would have witnessed various theatrical contexts for throwing an image. Equally, though, it was not usually employed as an instructive aid. As May Morris reports, 'a lecture with lantern-illustrations was not the common thing it is now' (xv.xv). It is perhaps revealing in this regard that both Oscar Wilde (Peterson, 329) – in his report on the same lecture – and Morris himself (xv.xx) refer meaningfully to the 'magic-lantern'. The phrase conjures a mode of demonstration that generates both light and

attention, and perhaps by virtue of some necromancy keeps intact the aura of the images its projects. Pursuing this thought further, Walker emerges as a shy conjurer. Though reportedly mumbling his lines, he avoids the pitfall of the Wizard of Oz because he projects substance rather than empty trickery. Moreover, there is something distinctive and compelling about Walker's use of slides as a basis for evidential and aesthetic claims, evoking as it does a coincidence of taste and analysis. Using examples from the books printed by Nicolas Jenson and Aldus at Venice (including the *Hypnerotomachia Poliphili*), and a Bible by Johann Schöffer, his benchmarks for perfection tallied with lessons Morris had derived from his own reading and collecting. In *News from Nowhere*, William Guest's vision of a utopian London includes the spectacle of a bridge he had 'dreamed of' but 'never seen … out of an illuminated manuscript' (xvi.8). In similar wise, the lecture's combination of light and clarified form takes us out of books and dreams in such a way that we step further into them, as if implementing them and socializing them. At the end of the book, Guest hopes to share what he has seen so that 'it may be called a vision rather than a dream' (iv.211). This linking of 'vision' and 'illumination' – whether understood as the projection of a coloured slide, or as the application of paint and gilding to vellum – seems highly significant. Both afford a glimpse into another world, whether assisted by technologies of the book or the lens. As May recalls, her father emerged from the lecture 'very much excited' (xv.xv).

It may be that this experience softened Morris's attitude toward photographic methods. Certainly, he would harness the same technology when speaking in public – in a letter responding to a speaking invitation, he notes 'You understand of course that it is a "lantern" lecture' (*CL*, iii.363). In what remains of this chapter, I will focus on two effects of this influence, the first relating to a principle of technological mediation, and the second to that of enlargement. The question of mediation mainly affects the illustrative component of the Press. However, it is also remarkable for the way it bears on, and defies, emerging Arts and Crafts principles. In the late 1860s, Burne-Jones produced an evocative sketch of Morris carving the woodblocks designed for their unrealized illustrated edition of *The Earthly Paradise*.[14] For the *Kelmscott Chaucer*, by contrast, neither Morris nor Burne-Jones fashioned the woodblocks. Burne-Jones supplied a drawing in pencil. This medium reflected his artistic methods and training, but its tendency towards shading and softness of line was ill-suited to the relief work of a wood block, so it was necessary for another hand to render the sketches in ink. May Morris explains that 'It was a difficult task enough … translating the freedom and breadth of the artist hand working swiftly in

an easy medium into the careful set line of the brush' (xv.xxvii). The idea of translation she evokes is striking: the conversion, that is, of incommensurables, as the visual language of one medium is expressed in another.[15] And though Burne-Jones 'looked them over', he was ultimately deputing his work: to the inked line, and in two further steps, to the automatic eye of the electrotyping process – 'they were then photographed on to the wood' (xv.xxvii) – and, finally, to the eye of 'wood-cutter'.

In fact, there were several more stages involved. The person charged with the inky 'translation' of Burne-Jones's drawings was Robert Catterson-Smith. His account of the process is worth quoting in full:

> Emery Walker made a very pale print of a photograph (a platino) from Sir E. B-J's pencil drawing – the exact size of the drawing – I then stuck the print down on stout cardboard …. Next I gave the print a thin even wash of Chinese white with a little size in it. The result was to get rid of everything but the essential lines. Next I went over the pale lines with a very sharp pencil, copying and translating from the B.-J. drawing which was in front of me. The lines of shading were put in in pencil. These shadow lines were very difficult as they had to be translations of very grey pencil tones, and they often took a long time to fit into their spaces. When the pencil drawing was finished all trace of the photograph had disappeared. Next came the inking over, which was done with a fine round sable brush and very black Chinese ink which I bought in bottles. … Finally E. Walker made a photograph on the wood block and Hooper cut it.[16]

The practice described here recalls that of nineteenth-century sculptors who would employ a studio hand to cut from the models they had already created. By the same token, it is at odds with the tendency towards 'direct carving' preferred (though not always practised) by those of an Arts and Crafts persuasion – where a union in one person is sought between the designer's mind and the executing hand. Photography, in this case, reassures that the artist's intentions are being carried through, thereby keeping the influence of alien hands to a minimum. However improbably, photographic mediation thus joins the projecting lantern in 'magically' evoking a referral from sources that avoids distortion or alienation.

A submerged Arts and Crafts tradition of the copyist supplements this effect. Derived from Ruskinian attempts to preserve 'memorial studies' of Venice, this philosophy applies an almost feudal conception of duty and fidelity in defending the integrity of representational outcomes. Not coincidentally, the first person charged with converting Burne-Jones's soft pencil lines into ink was Charles Fairfax Murray, himself one of Ruskin's loyal copyists. As Duncan Robinson pertinently observes, his patron described him as

'a heaven-born copyist', a man professing simply that 'I have no invention.'[17] In Robinson's lucid exposition, the second and most instrumental of the Press's copyists, Catterson-Smith, conflates fidelity and loyalty on recalling that 'Sir Edward was responsible for every dot and line in the eighty Chaucer drawings which I did under his guidance'.[18] The irony in all this hardly needs stating: that in the flight from the machine, a version of silent automation is accepted – whether photographic or uncomplainingly human – that eliminates personality without the vulgarity of steam. This is allowed, apparently, because it preserves the hand of the artist in the hand of the operative.

Turning from mediation to enlargement, Morris derives a new understanding of lens-based methods as affording access to something real that has previously been veiled by the passage of time and by the limits of our senses. May Morris understood her father's excitement at Walker's disquisition as produced by 'The sight of the finely-proportioned letters so enormously enlarged and gaining rather than losing by the process, the enlargement emphasizing all the qualities of the type' (xv.xv). We again approach an idea of translation redeemed: a dislocation that somehow enhances rather than diminishes. And because in her account Morris's first thought, on strolling home with Walker, was to say to him, 'Let's make a new fount of type' (xv.xv), we can be reasonably sure that the idea of the Kelmscott Press takes its origin not from dreams of handmade paper, or from old ink recipes, but from typographic ambition. Such ambition was prompted by the ways in which Walker's lantern lecture resolved printed forms into a light that reproduced 'mechanically', but also productively, through its distortion of marks on the page. In this manner, the process of enlargement proves at once transformative and heuristic. It may be compared as such to Walker's habit of applying a magnifying glass in scrutiny of his employees' work: a distortion, paradoxically, that reveals true form.[19] And after all this process is not at odds with the nature of type itself: the inky mark on the page is a secondary impression, formed by the lead type; and the lead type is itself an impression of the matrix in which molten lead was poured to achieve its cold form; and the matrix in turn is a struck impression of the original steel punch, a form of original sculpture by now at several removes from the ink on the page.

So reproduction was fundamental to the technology of the book already in play, and it is to Walker's credit that he helped Morris intuit the possibilities of harnessing that fact. Most importantly, Walker persuaded Morris to take the principle of projected samples a step further, by reconstructing – and then adapting – the early Venetian type of Nicolas Jenson. He did so by photographically blowing up examples preserved in Morris's

Figure 14.1 Emery Walker, portion of Pliny's *Historia naturale* (printed by Nicolas
Jenson, 1476) at five times magnification, photograph, early 1890s; St Bride Library,
London. Reproduced with permission

own library. The surviving prints, now held in London's St Bride Library,
testify to a design process inspired by a slide show, which in itself honours
the form of a letter materially alienated from its ultimate origin in the
punch (see Figure 14.1).

 The results of this reconstructive process were then founded in lead
through further impressions and controlled distortions. May Morris
observes a similar principle on recalling how her father and Walker

'criticised' and 'brooded' over their type designs (xv.xxii). Morris 'worked on them again on the large scale' and also 'on its own scale', before Prince cut a punch which formed the basis of 'a smoked proof' – where the punch is carbonized under a flame to produce a sooty impression – at which point 'it was again considered, and the letter sometimes recut' (xv.xxii). An idea of criticism and scrutiny at different levels of magnification is prominent here, just as in Walker's original lecture where Morris found 'telling contrasts between the good and the bad' (*CL*, ii.836). So, too, is the sense that we are not dealing with a fixed form, whether in considering the source or the end result. Walker notes of his typographic model, a copy of Pliny's *Natural History*, that it 'like nearly all of Jenson's was, judging by modern standards, over-inked and gave an imperfect view of the type'.[20] In this regard, the inky mark was no substitute for the punch, or indeed the ideal punch envisaged by the type designer. In a revealing phrase, he adds that 'The true shapes had to be extracted so to speak'.[21] This suggests a kind of Platonic divination applied in the process of creation. A past but imperfect form is mined for its ideality, but always in acceptance of its generative essence rather than of black letter finality.

As Mary Greensted and Sophia Wilson observe, 'Morris and Walker were probably the first to create new typefaces using the camera as a primary tool of design'.[22] This is a striking claim: first, because it illuminates what is at stake – the photograph less as an instrument of passive record-keeping than as a dynamic instrument that enlarges possibility – and second, because it crystallizes the initially improbable but ultimately compelling claim that the Press represents a technological contribution as much as a revivalist gesture. And this, crucially, is a contribution that resides in hybridity of method: finding a compromise, for instance between mediation and direct carving, or enlarging an imperfectly inked impression derived at second hand from an ancient punch. This technological vision is distinct from one that emphasizes the white heat and the cutting edge; and it differs from one that recruits aesthetic values to the futurology of 'force barges'. In that respect, it is harder to see. But when 'blown up' by a curious lens, its presence dawns, and we witness the intelligent strokes of a mind that takes opportunities and adapts to new circumstances.

Notes

1 See, for instance, E. R. Truitt, *Medieval Robots: Mechanism, Magic, Nature, and Art* (Philadelphia: University of Pennsylvania Press, 2015); and Patricia Clare Ingham, *The Medieval New: Ambivalence in an Age of Innovation* (Philadelphia: University of Pennsylvania Press, 2015).

2 See Adam Lucas, *Wind, Water, Work: Ancient and Medieval Milling Technology* (Leiden: Brill, 2006).

3 For a general discussion, see Peter Purton, *The Medieval Military Engineer: From the Roman Empire to the Sixteenth Century* (Woodbridge: Boydell, 2018).

4 Thomas Carlyle, '*Chartism*', in H. D. Traill (ed.), *The Works of Thomas Carlyle*, 30 vols (London: Chapman and Hall, 1896–1901), vi.141.

5 See Marcus Waithe, *The Work of Words: Literature, Craft, and the Labour of Mind in Britain, 1830–1940* (Edinburgh: Edinburgh University Press, 2023), 132–4.

6 Geoffrey Chaucer, 'The House of Fame', *The Works of Geoffrey Chaucer* (Hammersmith: Kelmscott Press, 1896), 466.

7 F. C. Avis, *Edward Prince: Type Punchcutter* (London: Glenview Press, 1967), 34, 36.

8 Walter Benjamin, 'The Work of Art in the Age of Mechanical Reproduction', in *Illuminations*, trans. Harry Zohn (New York: Houghton Mifflin Harcourt, 2019), 166–95.

9 H. Fox Talbot, 'Introductory Remarks', *The Pencil of Nature* (London: Longman, Brown, Green and Longmans, 1844), n.p.

10 Morris, Marshall, Faulkner and Company, Minute Book, 1862–74, Sanford L. Berger Papers, Huntington Library, San Marino.

11 *The Recuyell of the Historyes of Troye* (Hammersmith: Kelmscott Press, 1892).

12 'The Caxton Exhibition', *Morning Post*, 24 July 1877, 6.

13 Talbot Baines, *A History of the Old English Letter Foundries* (London: Elliot Stock, 1887), v.

14 Joseph R. Dunlap, *The Book that Never Was* (New York: Oriole Editions, 1971), 23.

15 For a recent discussion of this process, see Heather Bozant Witcher, *Collaborative Writing in the Long Nineteenth Century: Sympathetic Partnerships and Artistic Creation* (Cambridge: Cambridge University Press, 2022), 95–143.

16 Catterson-Smith, MA 8593, Morgan Library, New York: quoted in Duncan Robinson, *William Morris, Edward Burne-Jones, and the Kelmscott Chaucer* (London: Gordon Fraser, 1982), 33–4.

17 Robinson, *William Morris*, 34.

18 Ibid., 33.

19 John Dreyfus, *Emery Walker: 'The Master of the Art of the Book'* (Austin, TX: Carol Kent / Press at HRC, 1988), n.p.

20 Quoted in John Dreyfus, *Into Print: Selected Writings on Printing History* (London: British Library, 1994), 63.

21 Ibid.

22 Mary Greensted and Sophia Wilson, *Originality and Initiative: The Arts and Crafts Archives at Cheltenham* (Cheltenham: Cheltenham Art Gallery and Museum, 2010), 14.

Movements and Causes

Practical Socialism
Newspaper and Propaganda Work

Ingrid Hanson

The artist Walter Crane noted after William Morris's death that 'there is no greater mistake than to think of William Morris as a sentimentalist, who, having built himself a dream-house of art and poetry, sighs over the turmoil of the world, and calls himself a Socialist because factory chimneys obtrude themselves upon his view'.[1] Crane went on to challenge those who sidelined or dismissed Morris's politics in this way; among them, for instance, was Max Nordau, who suggested in his sensationalist cultural jeremiad of 1892, *Degeneration,* that Morris's 'emotional activity in recent years has made him an adherent of a vague socialism, consisting chiefly of love and pity for his fellow men'.[2] Crane has no time for this kind of minimizing of Morris's political commitment: 'it seems to have escaped those who have inclined to such an opinion that a man, in Emerson's phrase, "can only obey his own polarity."'[3] While contestation over Morris's precise political position in the ranks of socialists, Marxists, communists, and anarchists has continued into the twenty-first century, his active, wholehearted commitment to revolutionary socialism for the sake of social transformation, renewed human instinct and desire, and harmonious environmental conditions is evident in his writing, speaking, and lecturing schedule as well as public and private correspondence from 1883, the year of his final disillusionment with Liberal politics, onwards.[4]

Morris had great hope in the Liberals in the late 1870s, having joined the Eastern Question Association to oppose Benjamin Disraeli's support of the Ottoman Empire against Russia: 'I … feared that once we were amusing ourselves with an European war no one in this country would listen to anything of social questions', he wrote later in partial explanation of his motives (*CL*, ii.230); but by the early 1880s he had become thoroughly disillusioned with the Liberals, as unable to bring about radical change, and in 1883 he joined the Democratic Federation, 'the only active Socialist organization in England' (*CL*, ii.200), soon to become the Social Democratic Federation (SDF), led by Henry Mayers Hyndman.

Deploring the acceptance of capitalism that ran through radical ideas, Morris wrote to the sceptical C. E. Maurice in 1883, 'I so much desire to convert all disinterested people of good will to what I should call active and general Socialism' (*CL*, ii.199). Political freedom, he argued, was no use unless it became 'an instrument for leading reasonable and manlike lives' (*CL*, ii.200); after a further eleven years of active socialism, he again invokes what is reasonable, noting that 'it is the province of art to set the true ideal of a full and reasonable life' in front of people (xxiii.281). Crane claims this focus on the role of art as a strength of Morris's politics: 'The accident that he should have reached economics and politics through poetry and art, so far from disqualifying a man to be heard, only establishes his claim to bring a cultivated mind and imaginative force to bear upon the hard facts of nature and science'.[5] While Crane leaves unexamined the relationship between economics and politics and those two apparent monoliths, nature and science, Morris consistently links his claims about socialism and its effects to a relationship of equality not only among people but between humans, the rich variety of their environment, and their powers of invention. At the same time, his approach is characteristic of art: it is, in Ruth Levitas's terms, 'provisional and dialogical, rather than rigid and exhortatory'.[6]

Morris identified his own position as a socialist as a specific response to social conditions and their effects on human creativity. In 'How I Became a Socialist' (1894), writing about his early hero John Ruskin, he notes: 'it was through him that I learned to give form to my discontent, which … was not by any means vague. Apart from the desire to produce beautiful things, the leading passion of my life has been and is hatred of modern civilization' (xxiii.279). The forms of that hatred and the passions it generated – for Gothic architecture, for the medieval past, for equality and brotherhood, for the work of the hand rather than of the machine – changed little over the course of Morris's life, but he found first one way and then another of expressing it and acting on the hope of a better future. 'What shall I say of it now' he writes in 1894, of modern civilization, 'when the words are put into my mouth, my hope of its destruction – what shall I say of its supplanting by Socialism?' (xxiii.279). He goes on to note that before coming to socialism he understood, just as he did later, the joint 'mastery' and 'waste of mechanical power' that characterized civilization, 'its commonwealth so poor, its enemies of the commonwealth so rich' and 'its stupendous organization – for the misery of life!' (xxiii.279). Socialism, he argued, gave him both a clear account of the causes of this misery in the class inequalities of society and a means to attack them.

It was, however, the longings for art and beauty that had run through his life that brought him to the practicalities of socialism, he suggests: 'in my position of a well-to-do man … I might never have been drawn into the practical side of the question if an ideal had not forced me to seek towards it' (xxiii.278). Drawn into it he was, however, noting that he saw the inequalities between rich and poor as 'unendurable' and that 'feeling this, I am bound to act for the destruction of the system' (*CL*, ii.202). George Bernard Shaw wrote of him that 'he was fundamentally the most practical of all the Socialists'.[7] 'Practical', in the sense in which Shaw uses it here, and as Morris uses it in his account of coming to socialism, might equally be rendered *committed to action in everyday life*; Morris uses it this way in an 1884 letter, noting of Ruskin that 'he is not a socialist, that is not a *practical* one' (*CL*, ii.305). Elsewhere, however, 'practical' becomes a pejorative term to identify those 'practical' socialists, as he termed them, who focused tactically on the economics of socialism without recognizing its revolutionary implications for the whole organization of society and the individuals of whom it is composed; in Morris's thinking its effects would be as much on the physical, corporeal, and mental life of individuals, on 'people's ways of life and habits of thought' as on social structures.[8] In trying to appeal to those who might be put off by the revolutionary implications of socialism, he argued, the 'practical' socialist ensures that 'the wolf of socialism gets clad in the respectable sheeps-skin of a mild economic change'. This is, in the end, to no good effect, Morris suggests, as the 'respectables' always notice the 'glistening teeth and red jaws peeping out from under the soft woolly clothing of moderate progress'. He goes on to argue that such 'practical' socialists take this approach because of a failure to see beyond the present: 'it seems somewhat strange that they should have no vision of the future', he notes.[9] Morris, by contrast, devoted many lecture hours and many words on the page to creating images of a transformed, egalitarian, and harmonious future, but one which would inevitably come about through disruption and at a cost: 'to give hope to the many oppressed and fear to the few oppressors, that is our business; if we do the first and give hope to the many, the few *must* be frightened by their hope'. This is a by-product, he suggests, rather than an aim: 'otherwise we do not want to frighten them; it is not revenge we want for poor people, but happiness' (xxiii.3).

In pursuit of this end, Morris's socialism was certainly an everyday practice, if not a purely pragmatic one: it shaped his life, his work, and his relationships. The energy he brought to all of his projects he now brought to bear on the task of bringing about communism – which is, he argued

in an 1893 lecture, 'the completion of Socialism', once it 'ceases to be mili-
tant and becomes triumphant' (xxiii.271). In order to arrive at such a state
of communism, 'what we have to do first is to make Socialists', he sug-
gests in an 1894 essay on 'Why I am a Communist'.[10] Earlier, in 1885, he
had written to Georgiana Burne-Jones in explanation for his propaganda
work: 'The ideas which have taken hold of me will not let me rest. ... To
me society, which to many seems an orderly arrangement for allowing
decent people to get through their lives creditably and with some pleasure,
seems mere cannibalism' (*CL*, ii.480). The achievement of communism,
then, required wholesale change, brought about by propaganda work to
prepare people for the revolution, or 'the Change' as he terms it in *News
from Nowhere* (1890; 1891), which Morris saw as the only solution to the
enormous inequities and resulting ugliness – a key term in his political-
aesthetic vocabulary for describing and assessing wrongs, both moral and
physical – of the world (xvi.103). 'And thus I became a practical Socialist',
he notes (xxiii.281).

Morris makes a distinction in his 1894 essay between his own uses of
the concept of communism and its uses in earlier utopian experiments in
'Community-Building, which played so great a part in some of the phases
of Utopian Socialism', gesturing towards the various plans for commu-
nal living imagined and tried out by Charles Fourier and Henri de Saint-
Simon in France and by Robert Owen in England and America.[11] He goes
on to offer a definition that posits communism not as a temporary and
partial community, separate from mainstream society, but as a wholesale
transformation of it: 'real Communism is ... a state of Society the essence
of which is *Practical Equality of condition*'. By *practical equality*, he means
'equality as modified by the desires, and capacity for enjoyment of its var-
ious members'. This variant of Marx's 'from each according to his ability
to each according to his need', to which Morris refers explicitly later in the
essay, is 'its economical basis'.[12] Economics is explicitly shaped by desire,
then, for Morris, and therefore equality in his view is not uniform; and
if the 'capacity for enjoyment' seems even more difficult to measure than
desire, it is a capacity modified, in Morris's thinking, by habit.[13] The 'eth-
ical basis' of communism, the other strand of Morris's thinking about it,
draws on what Marx describes in *The German Ideology* as 'real, positive sci-
ence': that is, 'the representation of the practical activity, of the practical
process of development of men'; for Morris this means 'the *habitual* and
full recognition of man as a social being, so that it brings about the habit of
making no distinction between the common welfare and the welfare of the
individual'.[14] The logical conclusion of this emphasis on habit – a matter

of belief expressed in repeated practice which in turn brings about change in bodies, desires, and communities – can be seen in *News from Nowhere*, in which habit is repeatedly invoked: habitual ways of behaving are altered through the battles and struggles of the Change, and subsequently, Old Hammond tells Dick, 'a tradition or habit of life has been growing on us; … a habit of acting on the whole for the best', or, as Guest understands it, 'a habit of good fellowship' (xvi.80).

Morris's own habits changed with his conversion to socialism: he developed a pattern of life that involved regular and frequent lecturing and speaking on behalf of the cause. Between 1883 and his death in 1896, he gave more than 350 lectures and public talks in places as varied as Oxford and Cambridge colleges, working men's clubs in London and Manchester, civic and institutional halls in Sheffield, Edinburgh and Glasgow, Hamilton and Coatbridge, Bolton and Blackburn, the School of Art and Design in Birmingham and the Rotunda Theatre in Liverpool; he gave speeches at open air demonstrations in Norwich and Northumberland, as well as in numerous London halls, parks, squares, and clubs, and on street corners across the capital (*UL*, 291–322; *Socialist Diary*). Some lectures he gave repeatedly over several years in different places, while other talks were tailored to the occasion or the audience. Although he was not, as his daughter May points out, 'a born orator', it was characteristic of him, she notes, that when 'this public expression of his thoughts was demanded of him, he should doggedly teach himself to speak, somewhat against the grain' (xvi.xv).

He had begun to speak publicly on matters of art before his conversion to socialism but he delivered 'Art, Wealth and Riches', his first lecture as a socialist, in Manchester in 1883, noting that, 'my business … is to spread discontent' (xxiii.159). In the lecture he discusses the decline of art and craftsmanship in everyday life and traces a relationship between this decline, the working conditions of the labouring classes, 'competitive commerce', or capitalism, and the exploitation of the land. He concludes that workers should be properly paid for their work and the land, commensurately, treated not as 'here a cinder-heap, and there a game preserve, but as the fair green garden of Northern Europe' (xxiii.161). Having begun with a definition of *wealth*, as 'the means of living a decent life' that includes art and beauty, in contradistinction to *riches*, 'the means for exercising dominion over other people' (xxiii.143), he concludes, in words underpinned by Ruskin's dictum, 'there is no wealth but life' (Ruskin, xvii.105), with a gesture towards a transformed future. 'These are the foundations of my Utopia', he notes, 'a city in which riches and poverty will have been

conquered by wealth; and however crazy you may think my aspirations for it, one thing at least I am sure of, that henceforward it will be no use looking for popular art except in such an Utopia, or at least on the road thither' (xxiii.161). Seven years later, in *News from Nowhere*, the result of the people's revolution is that 'art or work-pleasure, as one ought to call it, … sprung up almost spontaneously, it seems, from a kind of instinct amongst people' (xvi.134). In this renewed world, equality of condition leads to changes in the very biology of human desire.

The Manchester lecture garnered much press attention and controversy, as E. P. Thompson has noted (*WMRR*, 308–9). The *Pall Mall Gazette* reported, without disapproval, that the lecture was 'an arraignment of modern civilization and its dominant force, "competitive commerce"'; but a letter, signed only 'Verax' in the *Manchester Weekly Times*, accused Morris of obfuscation and urged him to 'reconsider his ideal and have something less impracticable and less discouraging to say to us the next time', while a *London Evening Standard* editorial suggested that his vision of equality through the abolition of competitive commerce, which lay at the root of other 'fantastic and absurd' visions he laid out, relied on state control and state expansion.[15] This, the article argued, was 'at once the apotheosis and apocalypse of Socialism', adding that 'unfortunately before the scheme can be accomplished, human nature itself must be revolutionised'. This, of course, was precisely Morris's hope, as articulated in his emphasis on habit: the change of patterns of behaviour in a reinforcing circle with changes in human environment and desire. Following the media furore, he noted wryly in a letter to his daughter Jenny, 'you see one may yet arrive at the dignity of being hissed for a Socialist' (*CL*, ii.175).

Another of his early and explicitly socialist lectures, 'Art under Plutocracy', first delivered in November 1883 to the Russell Club at University College, Oxford, developed the connections he had begun to make in 'Art, Wealth and Riches'. 'Is it too much to ask civilization to be so far thoughtful of man's pleasure and rest', Morris asks, as to 'keep the air pure and the rivers clean, to take some pains to keep the meadows and tillage as pleasant as reasonable use will allow them to be; to allow peaceable citizens freedom to wander where they will, so they do no hurt to garden or cornfield …?' (xxiii.170). Morris is willing to countenance the cost of this; he embraces human activity in the natural world, falling back on the idea of 'reasonable' use to suggest self-regulation, while gesturing towards a limited forerunner of rewilding, asking if it might even be possible 'to leave here and there some piece of waste or mountain sacredly free from fence or tillage as a memory of man's ruder struggles with nature in

his earlier days?' This cannot be, he suggests, 'an unreasonable asking'. Yet 'not a whit of it shall we get under the present system of society' (xxiii.170). He goes on to link art, instinct, and beauty specifically with habits and conditions of work: 'all art, even the highest, is influenced by the conditions of labour of the mass of mankind'. To endure, then, art must be produced as part of the common everyday life of a people: 'any art which professes to be founded on the special education or refinement of a limited body or class must of necessity be unreal and short-lived. ART IS MAN'S EXPRESSION OF HIS JOY IN LABOUR' (xxiii.173). He acknowledges his debt to Ruskin, attributing these last words – or if not the very words, he notes, at least the sentiment – to him.

Morris urges his listeners: 'Art is long and life is short; let us at least do something before we die' (xxiii.191). His own forms of doing something included, from 1883 onwards, contributing articles and poems to socialist newspapers, initially to *Justice* and *To-day*, the two most prominent socialist papers of the early 1880s. At the very end of 1884, disillusioned with the SDF and its autocratic leadership by H. M. Hyndman, and having found, as was his habit, a group of comrades and fellow-visionaries, he left the SDF with them and launched a new 'party-organization' (*CL*, ii.357), the Socialist League. In a letter to J. L. Joynes outlining the events that led to the split, he writes, 'we are firmly resolved to check any personal ambition at once, and if at any time we have anything one against the other to bring it at once before the Council without letting it grow into intrigue and enmity' (*CL*, ii.257). Along with the new organization came a new paper: *Commonweal*. The Socialist League's manifesto in the opening issue of February 1885 claimed that it was a body that sought 'a change in the basis of Society – a change which would destroy the distinctions of classes and nationalities'.[16] This is an organization with internationalism and the seamless wholeness Morris so admired and longed for at the core of its agenda; he noted in a letter of 1884 that, given the chance to discuss 'peace & war' in a lecture, 'I wound up with a short oration on the wickedness of using the word "foreigner" and the impossibility of workers in different countries having any cause of quarrel' (*CL*, ii.316). Similarly, urging the necessity of working together in 'close fellowship', the manifesto notes, 'We are working *for* equality and brotherhood for all the world, and it is only *through* equality and brotherhood that we can make our work effective.'[17] This simple, neat, and surely Morrisian formulation – reflective of his constant concern with what Northrop Frye identified as 'the very neglected revolutionary element of fraternity'– highlights a matter of extraordinary difficulty in the ideals-driven, split-prone Left of the 1880s

and 1890s, but one that the Socialist League, from its earliest years, pursued energetically in its reportage and news coverage as well as its communal life and campaigning.[18] Among the twenty-three signatories to the manifesto were working-class, middle-class and upper-class men, and one woman, Eleanor Marx: journalist, translator, playwright, and youngest daughter of Karl Marx. She and her common-law husband Edward Aveling would go on to lead a further split from the Socialist League in 1888, but at its beginning, both played active roles, as sub-editor in Aveling's case and contributor of international stories, in the case of Marx.

While the newspaper was primarily concerned with Britain and Europe, it located that specific focus amid the interconnections of labour and oppression across the world. These connections are framed in terms of what Morris elsewhere called 'the World-Market' (xvi.93–5), as well as world politics, particularly the warmongering of empire with its 'rifle-and-bible' approach, and the working conditions, aspirations, and political organization of the international labouring classes.[19] Letters and articles from socialists, mainly Europeans visiting or working in Africa, Asia, or Latin America, highlighted the plight of indigenous people as well as immigrant labourers.[20] This international setting for its national focus was reflected to some extent in its readership: *Commonweal*, on sale on the street, at demonstrations and gatherings, was also sold by postal subscription in Britain, Europe, Canada, and the United States as well as in China, Hong Kong, India, South Africa, New Zealand, and Argentina, where mainly expatriate readerships took it, read it, and shared it. *Commonweal*'s editors, in return, solicited and received newspapers from 'Socialistic contemporaries throughout the world'.[21] Morris's own frames of reference are always predominantly British, yet he could translate from Icelandic, read Marx in French (*CL*, ii.393), and find reason to lament his limited smattering of German (*CL*, ii.235; 315–16; 516; 586). His thinking was shaped not only by his wide reading but also by his conversations with European socialist, anarchist, and nihilist exiles in particular: Sergius Stepniak, Johann Most, Andreas Scheu, and Peter Kropotkin, as well as Eleanor Marx and former Communard Louise Michel.

Many of these European radicals spoke alongside Morris at public events, in keeping with the motto of the Socialist League: 'Educate. Agitate. Organise.' As well as propaganda rallies in public, the Socialist League held regular guest lectures and discussions in the offshot hall at Morris's Hammersmith home, Kelmscott House, on Sunday evenings. H. G. Wells recalls drifting 'as most students in London in those days drifted sooner or later, to that little conventicle in the outhouse beside

Kelmscott House, at Hammersmith'.[22] These gatherings and others of the Socialist League were a meeting point, not only for members, curious visitors, and European comrades, but also for those committed to interlinked causes further afield. Sarah Gostling – economist, feminist, and proponent of socialism in India – spoke at League events and wrote articles for *Commonweal*, while her husband, the architect David Ebenezer Gostling, based in what was then Bombay, promoted *Commonweal* in India, wrote articles for it about Indian affairs, and contributed to newspaper and strike funds.[23] The years 1887 and 1888 saw lectures on India included in the regular Socialist League programme of talks, an indication of the 'anticolonial energies' and sense of 'interconnectedness' Leela Gandhi highlights, while on 10 November 1888, Lucy Parsons, wife of one of the executed Chicago anarchists, spoke – with 'great success', and introduced by Morris – at a London gathering of socialists and anarchists (*CL*, ii.837).[24] Three days later Morris gave a talk at an event in Clerkenwell Green commemorating 1887's 13 November Bloody Sunday demonstration (*CL*, ii.836), so called because of the swift and brutal police response to the event, which led to at least one death and many injuries. Speaking alongside him, representing the Finsbury Liberal and Radical Federation, was the Indian nationalist, and later Liberal MP for Finsbury, Dadabhai Naoroji (*CL*, ii.836), who continued to be involved with the London socialists across the 1890s before returning to India to work with the Indian National Congress.[25]

Also speaking at the Bloody Sunday memorial rally at Clerkenwell was Eleanor Marx, whose annual 'Christmas Trees' – parties set up in 1885 to provide some fun for the children of socialists and exiles in London – garnered funds from supporters in the form of money and toys, and drew in among others Louise Michel and Morris's daughter May. Morris himself underwrote many of the parties, social events and fundraisers of the Socialist League, contributed to strike funds and to living costs for the families of colleagues imprisoned for their political activities, and helped to finance the funerals of destitute comrades. Even as he continued to work for, write about and generate visions of a socialist revolution to do away with class inequality, he made use of his own economic security to offer practical financial support to the Socialist League's work and its workers.

Morris's vision of socialism, like that of his earlier ideal of brotherhood, was one of camaraderie, conviviality, and pleasure, and despite his occasionally dispirited and often comedically wry notes to his intimate friends and family on the work of 'mak[ing] socialists', he contributed energetically to the cultural and social life of the movement.[26] He took great pleasure from his earliest days in reading aloud, a pleasure shared not only

with his close friends and family, but also with wider socialist circles; in public he read Dickens and the African American Brer Rabbit stories popularized by white plantation journalist Joel Chandler Harris, as well as his own work – most often extracts from *A Dream of John Ball* – and other rousing or comic material (*WMAWS*, i.88). His protest songs, collected in 1885 as *Chants for Socialists* and expanded in subsequent editions, formed as common a part of socialist meetings and outings as the Marseillaise, the Carmagnole and the Red Flag.[27] Morris also wrote ephemeral poems, plays, sketches, and dialogues for performance at Socialist League events and for publication in *Commonweal*. He was not alone in this: Eleanor Marx, George Bernard Shaw, May Morris, and her husband of the 1890s, Henry Halliday Sparling, all wrote pieces and participated energetically in the plays, readings and performances that took place regularly in London across the years of the Socialist League and its successor the Hammersmith Socialist Society, to raise money for the cause. Morris himself took the role of the Archbishop of Canterbury in at least one performance of his slight, satirical play about a prejudiced judge propelled into a socialist future, *The Tables Turned; or Nupkins Awakened* (1887).

In a less playful vein, he read his short poem, 'Socialists at Play' to introduce an early Socialist League entertainment at South Place Institute in June 1885. In it the speaker urges his listeners:

> So be we gay; but yet amidst our mirth,
> Remember how the sorrow of the earth
> Has called upon us till we hear and know,
> And save as dastards, never back may go.[28]

Morris brings together, in this fifth stanza of his poem, the key preoccupations of his practice of socialism: the celebration of community and fellowship in the plural pronouns; the link between a past awakening and a future imperative to action in the temporary and incomplete moment of the present; and the patterned and rhythmic expression of political hope. At the same time he draws attention to the relationship between people and the environment: it is 'the sorrow of the earth' to which he wants his fellow-socialists to attend, a sorrow that the rest of the poem makes clear encompasses human and supra-human concerns, and links them in a call to his listeners to speak out, alert others to a better future, and at the same time wait with hope for the day when they can, he suggests, take effective, disruptive action, 'sword in hand', to bless the 'tortured land'. The liberation of the working class, then, is aligned with the liberation of the 'land' – signifying both the physical earth and the nations of Britain. Socialism

becomes, in Morris's thinking, the means to liberate deformed bodies, cramped minds and the earth itself from the distortions of oppression and injustice into the harmonies of equality, justice, and beauty. It was with this radical and revolutionary vision of complete transformation that Morris undertook the everyday work of practical socialism.

Notes

1 Walter Crane, *William Morris to Whistler* (London: G. Bell and Sons, 1911), 9.
2 Max Nordau, *Degeneration* (London: William Heinemann, 1898), 99.
3 Crane, *William Morris*, 9.
4 See, for instance, Meier, i. 53–55; Ruth Kinna, 'Anarchism, Individualism and Communism: William Morris's Critique of Anarcho-Communism', in A. Prichard, R. Kinna, S. Pinta, and D. Berry (eds), *Libertarian Socialism: Politics in Black and Red* (Basingstoke: Palgrave Macmillan, 2012), 35–56.
5 Crane, *William Morris*, 9.
6 Ruth Levitas, 'Morris, More, Utopia … and Us', *Journal of William Morris Studies*, 22 (2016), 4–17 (8).
7 George Bernard Shaw, 'Introduction to William Morris', *Communism* (London: Fabian Society, 1903), 4.
8 Morris, 'On Some "Practical" Socialists', *Commonweal*, 18 February 1888, 52.
9 Ibid.
10 Morris, 'Why I Am a Communist', *The Why I Ams* (London: James Tochatti, Liberty Press, 1894), 6.
11 Ibid., 2.
12 Ibid., 2, 5, 2.
13 For an influential account of Morris and desire, see E. P. Thompson's Postscript: 1976, *WMRR*, 763–810.
14 Karl Marx, *The German Ideology in Karl Marx, Selected Writings*, ed. Lawrence H. Simon (Indianapolis: Hackett, 1994), 112; Morris, 'Why I Am', 2.
15 'Mr W. Morris' Utopia and the Way Thither', *Pall Mall Gazette*, 8 March 1883, 11; 'Letter CCLXII: An Art Ideal', *Manchester Weekly Times*, 10 March 1883, 5; *London Evening Standard,* 14 March 1883, 5.
16 'The Manifesto of the Socialist League', *Commonweal*, February 1885, 3.
17 Ibid., 4.
18 Northrop Frye, 'The Meeting of Past and Future in William Morris', *Studies in Romanticism*, 21.3 (1982), 313.
19 *Commonweal*, 3 May 1890, 140.
20 See, for instance, *Commonweal*, 4 June 1887, 180.
21 *Commonweal*, 4 January 1890, 4; 8 January 1887, 12.
22 H. G. Wells, 'The Well at the World's End', *Saturday Review*, 17 October 1896, 413.
23 See 'Lecture Diary', *Commonweal*, 20 November 1886, 272; 24 December 1887, 416; 7 June 1888, 176.

24 'Lecture Diary', *Commonweal*, 2 April 1887, 112; 3 November 1888, 351; Leela
 Gandhi, *Affective Communities: Anticolonial Thought, Fin-de-Siècle Radicalism,
 and the Politics of Friendship* (Durham, NC: Duke University Press, 2006), 123.
25 See *Commonweal*, 1 March 1890, 71.
26 Morris, 'Why I Am', 6.
27 See, for instance, *Commonweal*, 28 August 1886, 175; 27 October 1887, 343; 14
 January 1888, 16.
28 *Commonweal*, July 1885, 56.

Morris and the Arts and Crafts Movement

Mary Greensted

William Morris is credited as a founder of the Arts and Crafts movement, one of the most influential art movements to develop in Britain. It took shape in the 1880s as the up-and-coming generation in their twenties and thirties absorbed the teachings of both John Ruskin and Morris. There were individuals, including Walter Crane, Sydney Cockerell, and Emery Walker, who were already closely involved with Morris's various projects before going on to play an active role within the movement. It was spearheaded primarily, however, by young architects, designers, and manufacturers born in the 1850s and 60s. A group of them set up the Art Workers' Guild in 1884 as a talking shop – almost a club – and its offshoot, the Arts and Crafts Exhibition Society in 1887 (see Figure 16.1).

The latter provided the movement with a public face and the first coining of the phrase 'arts and crafts' which has since become synonymous with all types of craft activity. An innovation introduced by the Society, never considered by Morris, was to credit makers as well as designers in its exhibition catalogues as a move towards raising the status of craftspeople.

Much of the philosophy of the movement came from Morris – joy in labour, the power of communal artistic endeavour, nature as the source of pattern and the inspiration of traditional or historic work. By the mid-1880s, however, Morris, then in his fifties, was beset by doubts as he witnessed industrial expansion reinforcing capitalism and a growing population seduced by consumerism. His early enthusiasms – for artistic projects, for his business and even for the Society for the Protection of Ancient Buildings – wavered as he became convinced that only violent revolution could bring about change. The younger generation who saw Morris as their inspiration must have been disheartened by his lack of interest in their activities. He initially declined to join the Art Workers' Guild and in 1887 his first reaction to the formation of the Arts and Crafts Exhibition Society was one of scepticism. He did stand for election to the Guild in 1888, although, according to C. R. Ashbee, one member actually voted

Figure 16.1 Walter Crane, masthead for the Arts and
Crafts Exhibition Society, 1888, print.

against him (the black ball – signifying rejection in a secret ballot – was
deftly removed).[1] Almost unable to resist a new challenge, however, Morris
was gradually subsumed into the new movement. He played an active role
on the committee of the first Arts and Crafts Exhibition. Both his own
designs and Morris & Company wares were prominently featured while
Morris himself wrote an essay on textiles for the catalogue.

Many future Arts and Crafts practitioners came to Morris through his
writings and the lectures he gave on gruelling tours throughout Britain in
the 1880s. The young T. J. Cobden-Sanderson was searching for a craft to
adopt when he wrote in his journal for 1882:

> I have been reading Morris's *Lectures on Art*. I read the first "On the Lesser
> Arts". It inspired me again with ardour, and made my own projected hand-
> icraft seem beautiful to me.[2]

It was a conversation with Jane Morris the following year that finally
led him to take up bookbinding. The Scottish architect Robert Lorimer
may have heard Morris talk about 'Gothic Architecture' in Glasgow in
1889. He subsequently purchased a copy of the lecture, describing it as
'one of my choicest possessions'.[3] In Leicester in 1884 the young Ernest
Gimson attended a lecture on 'Art and Socialism' where Morris recounted
his horror at the time and effort that went into making ugly and useless
things. His anti-consumerism message convinced Gimson and many of his
contemporaries that, by substituting art and craft for useless luxuries and
promoting useful and rewarding work instead of inhuman toil, they could
change people's lives.

The Society for the Protection of Ancient Buildings, founded by
Morris in 1877, became a magnet for young architects, providing oppor-
tunities for interesting work and training in traditional building tech-
niques under the guidance of Philip Webb and later William Weir.

Weekly meetings were followed by convivial and informative exchanges between the generations at Gatti's, a large Italian restaurant in London's Strand. Morris and Webb were usually in attendance together with Sydney Cockerell and Emery Walker and some of the younger architects including William Lethaby, Alfred Powell, Ernest Gimson, and Mervyn Macartney.

The business side of Morris's enterprise was much admired and the Morris & Company shop at 449 Oxford Street also provided a valuable point of contact. Its proximity, next door to the office of the architect John D. Sedding, created a particular link to the latter's pupils and assistants who included Henry Wilson, Ernest Barnsley, and John Paul Cooper. Cooper recalled Morris coming to the shop in his blue shirt with a bag slung over his shoulder and the cheers from socialist processions when they passed the shop on the way to or from meetings in Hyde Park.[4] Gimson, who joined Sedding's office as an 'improver' in 1886, was a regular visitor, describing it as 'a treasure house for anyone furnishing' and in 1890 wrote to his newly married brother suggesting the purchase of some Morris printed cotton chintz curtains at 3/- per yard.[5]

Communal Art

Morris's early experiences of communal artistic endeavour, working first on the Oxford Union murals and then on the decoration of Red House, had shaped his outlook. This practice took on almost a moral force with the Arts and Crafts generation, many of whom believed that working together, in designing and making useful and beautiful things, could improve the quality of people's lives. The term 'guild', with its evocation of a pre-industrial world and its emphasis on supportive group craftwork, was revived and became widely used. From the Century Guild founded in 1882 by A. H. Mackmurdo, Selwyn Image, and Herbert Horne to Eric Gill's Catholic community, the Guild of St Joseph and St Dominic, set up in 1921, the prospect of working closely with a group of like-minded individuals towards a common goal seemed very rewarding. This was the plan of Gimson and Sidney Barnsley when in 1893 they turned their backs on the prospect of traditional architectural careers for a life of craftwork in the Cotswolds. They persuaded Sidney's elder brother Ernest to join them and, although they soon moved into separate workshops, for some twenty or more years they designed and made furniture and metalwork, and turned chairs and plasterwork alongside their architectural projects (see Figure 16.2).

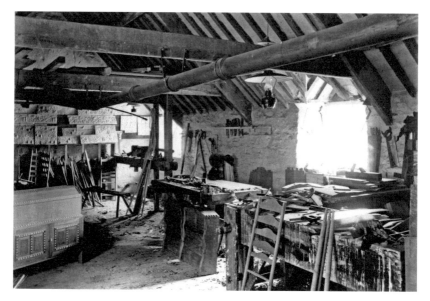

Figure 16.2 The workshop of Ernest Gimson, Ernest and Sidney Barnsley at
Pinbury, Gloucestershire, 1895, photograph; Cheltenham Borough Council
and the Cheltenham Trust. Reproduced with permission

Designers, artists, and manufacturers from the 1880s onwards also set
up workshops to provide training and worthwhile employment. Many of
them were influenced both by Morris's radical ideas about society and
the increasing evidence of the impact of industrialization on the urban
poor. From Henry Mayhew's survey *London Labour and the London Poor,*
published in the early 1860s to, some twenty years later, *Life and Labour of
the People in London* by Charles Booth, the evidence for the poverty and
ugliness suffered by the poorest in society was brought home to the com-
fortable middle classes and reinforced in novels by Charles Dickens and
George Gissing. Unlike Morris, however, few of the next generation had
strong political affiliations and most believed that social change was achiev-
able without direct involvement in politics and the upheaval of revolution.

C. R. Ashbee typically put his faith in the ability of small groups and
communities of like-minded individuals to effect improvement in soci-
ety. He started his working life as an architect living at Toynbee Hall, the
philanthropic university settlement set up in 1884 by the Revd Samuel
Barnett in London's East End. Inspired both by Ruskin's words and by the
example of Morris and his Pre-Raphaelite friends at the Oxford Union,

Ashbee's reading class took a practical form. In 1887 they painted the walls of Toynbee Hall's dining room freehand with a scheme of leaves and branches, now long disappeared, together with painted and gilded plaster medallions. Later that year, when Ashbee attempted to enlist his support for his proposed School and Guild of Handicraft, Morris poured cold water on the scheme. In his eyes it was too small an endeavour to make any impact on society, although Ashbee's timing, three weeks after the shattering events of Bloody Sunday, may have coloured his negative reaction. Ashbee returned to Toynbee Hall and produced a drawing of Morris as 'a great soul rushing through space with a halo of glory round him, but this consuming, tormenting and goading him on'[6] (see Figure 16.3). He was disappointed but not cast down by this encounter. The School and Guild of Handicraft was set up on a cooperative basis in 1888 and two years later moved to new premises at Essex House on the borders of Mile End and Bow.

The Mortuary Chapel at Compton, near Guildford in Surrey, is another remarkable example of communal artistic endeavour. In 1891 the artist G. F. Watts, who had painted Morris's portrait in 1870, and his second wife, Mary, a sculptor and illustrator, moved to the area. She set up a kiln and started evening classes for locals making terracotta tiles. The tiles were used to decorate the exterior of a chapel, designed by her and built using local materials and labour, while the interior was decorated with exuberant gesso-work designs of angels and tree of life motifs. The entire project was a communal effort: a surviving photograph shows Mary Watts with two other women – all three wearing artist smocks with brushes in hand – and an overalled man, surrounded by tables, stepladders, and craft equipment.[7] Following the chapel's completion, the pottery was developed into the Potters' Art Guild specializing in terracotta garden pots decorated with Celtic and Byzantine motifs, and a second short-lived enterprise, the Aldourie Pottery, was set up at Dores, near Inverness in Scotland. The Compton products were retailed through Liberty's, among others, and were bought for many Arts and Crafts gardens.

Unlike Morris & Company, many Arts and Crafts workshops encouraged the integration of the makers with the designers in a loose family-like relationship – in, for example, Christopher Whall's stained-glass workshop or among Ashbee's Guild. Detmar Blow worked for a while as a clerk of works and architect with his own team of stonemasons on projects such as Stoneywell, the house in Leicestershire designed by Gimson in 1898–9. Blow was so attached to his craftsmen that they were seated in a front pew in St Paul's Cathedral for his marriage to Winifred Tollemache in 1910.

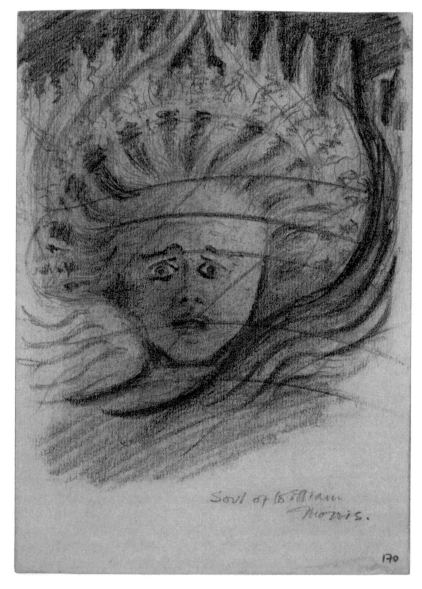

Figure 16.3 C. R. Ashbee, *The Soul of William Morris*, December 1887,
pencil drawing; Archive Centre, King's College, Cambridge.
Reproduced with permission

Learning by Doing

Founded in 1861, Morris, Marshall, Faulkner and Company described themselves not as designers but as 'Fine Art Workmen'. This encapsulated Morris's approach: he tried his hand at more or less every craft he designed for; he believed that understanding the process of making improved his design skills. Together with his wife Jane and Georgiana Burne-Jones, he studied and even unpicked historic pieces of needlework, stitched several hangings for Red House and learnt the basics of embroidery in the process. Many in the Arts and Crafts generation followed the same course.

When Ashbee set up the cooperative School and Guild of Handicraft in 1888, he worked alongside the local lads to design and make a range of pieces in wood, metal, and leather, learning as they went along (see Figure 16.4). As they became more adept, Ashbee introduced more techniques. The Guild revived the craft of lost wax casting by a process of trial and error, using for guidance the writings of Benvenuto Cellini translated by Ashbee

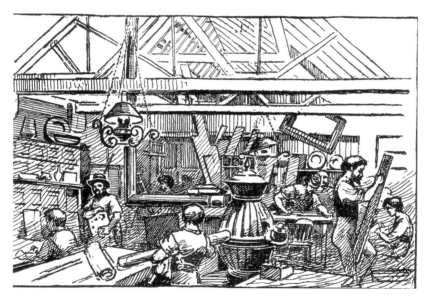

Figure 16.4 The workshop of the Guild of Handicraft at 34 Commercial Street, London, about 1889 (from C. R. Ashbee (ed.), *Transactions of the Guild & School of Handicraft*. Vol. 1); The Guild of Handicraft Trust and Court Barn Museum, Chipping Campden. Reproduced with permission

from the original Italian. It was subsequently the first book published by
the Essex House Press in 1898 with a dedication: 'To the metal workers of
the Guild of Handicraft, for whom I have set my hand to this work, and
to whom I look for the fruit it is to bear.'

A similar approach was taken by Christopher Whall who began work-
ing in stained glass in 1879. Initially he used a type of glass known as 'Early
English' developed by the architect Edward Prior in conjunction with the
firm of Brittain and Gilson. Its thick uneven slabs containing bubbles of
air were an attempt to reproduce the luminous qualities of medieval glass,
but Whall was disappointed with the end results. Instead, he taught him-
self the techniques of stained glass by studying medieval examples and the
writings of Viollet-le-Duc. Through the process of hands-on experimen-
tation he was able to produce much fine work, including the magnificent
windows for the Lady Chapel at Gloucester Cathedral, executed between
1898 and 1900.

The architect Heywood Sumner also revived a number of neglected
crafts. Having studied sixteenth-century Italian chests whose carved dec-
oration was filled with coloured wax in the South Kensington Museum,
he began experimenting and described his methods of wax inlay at a
meeting organized by the Royal Institute of British Architects (RIBA) in
1901.[8] Sumner also developed the technique of sgraffito as a wall decora-
tion. Originally a Roman process, it had been revived in the decoration
of the South Kensington Museum in the 1870s, but Sumner made it his
own. Examples of Sumner's sgraffito work can be seen at St Mary the
Virgin at Llanfair Kilgeddin in Monmouthshire (1887–8) and at All Saints,
Ennismore Gardens in Kensington, London (1897–1903). His essay 'Of
Sgraffito Work' was included in *Arts and Crafts Essays*, published in 1893,
and continued Morris's practice of writing about craftwork.[9] The first
three catalogues of the Arts and Crafts Exhibition Society in 1888, 1889 and
1890 had included essays on different crafts. This stopped in 1893, although
public lectures remained a feature of the shows, and *Arts and Crafts Essays*,
with a preface by Morris, brought together many of these as well as new
chapters such as Sumner's. Technical texts about the crafts continued to
be produced in journals such as *The Studio* and *Arts and Crafts*, the lat-
ter aimed at the amateur market, and books including the *Artistic Crafts
Series of Technical Handbooks* from 1901. Their editor, Lethaby, was also
appointed first joint director of the LCC Central School of Arts and Crafts
in 1896, one of a number of art schools, including Birmingham, Glasgow,
and Manchester as well as London, that helped to promote the movement
throughout Britain.

Pattern Design

Morris's pattern designs dominated the first two decades of the twentieth century and remain a recurrent source of inspiration and re-evaluation. His influence was so pervasive that as a young man C. F. A. Voysey would keep away from Morris's shop to avoid being influenced by his patterns. Although he produced his own version of Morris's 'Daisy' wallpaper as late as 1924, Voysey's designs have a stronger graphic quality, a greater lightness, and occasional fanciful or humorous elements. Morris's wallpapers were recommended by M. H. Baillie Scott in *Houses and Gardens* published in 1906, alongside those of his contemporaries, Walter Crane and Voysey.[10] Nature remained the main inspiration in the work of Arts and Crafts designers such as Lewis F. Day, William Butterfield, and Allan Vigers, but the impact of continental Art Nouveau brought an emphasis on grotesque forms of leaves and flowers with attenuated stems and tendrils.

In 1901 William Lethaby gave a lecture on 'Morris as Work-Master' to an audience at Birmingham Municipal School of Art where he chronicled Morris's life and work and emphasized the important relationship between art and nature in his designs. He subsequently recalled how, in the mid-1880s, the young Ernest Gimson would go on study trips round England, sketching buildings as part of his architectural training and travelling with 'large pieces of Morris chintz as an easy way of "having something to look at" in his sitting room'.[11] Gimson's own designs for plasterwork and embroidery share many of the same qualities as those of Morris, bringing suggestions of nature to each pattern without slavish copying or excessive detailing. One of his decorated plaster ceilings with a flowing Tudor rose design typically includes the occasional leaf extending over the frieze adding vitality and naturalism (see Figure 16.5).

The Tudor rose, used by Morris in his 'Trellis' wallpaper of 1864 and later in 1881 in 'St James's' woven silk damask, was taken up by a number of Arts and Crafts designers including Crane, Gimson, and Lethaby. An early textile by George Walton, 'Briar and Rose', which survives only in a photo of his refurbishment of the Argyle Street tea room in Glasgow in 1888, also shows the influence of Morris. The rose became a motif for Walton's firm with the 'Lily and Rose' block-printed wallpaper designed and executed by his assistant, Robert Graham, in 1890 and the branching rose with grapes and vine leaves in Walton's Luncheon Room frieze at Argyle Street in 1899. Despite the growing influence of Aubrey Beardsley and Charles Rennie Mackintosh on Walton's designs, the inspiration of Morris remained evident.

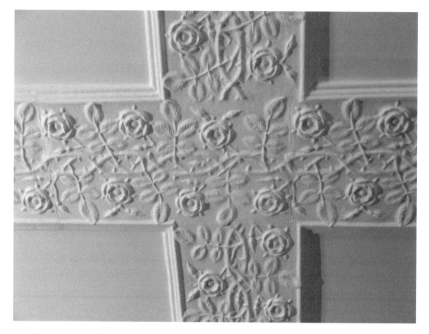

Figure 16.5 Mary Greensted, detail of a plaster ceiling by Ernest Gimson, 1903,
photograph. Reproduced with permission

Louise Lessore (later Powell) was in her early twenties and a callig-
raphy student at the Central School of Arts and Crafts when, in 1904,
she was invited to collaborate with Charles Fairfax Murray and Graily
Hewitt on the completion of William Morris's manuscript, Virgil's *The
Aeneid*. She designed and executed the elaborate floral and foliate border
patterns based on designs used for the Kelmscott *Chaucer*. This presti-
gious commission had an impact on her career and on her later work. At
the 1906 Arts and Crafts Exhibition she exhibited a Christmas card with
text in gold on an illuminated floral ground featuring the scrolling leaves
inspired by Morris's 'Acanthus' wallpaper of 1875 and other later designs.[12]
Her enthusiasm for Morris's work was such that 'Larkspur', a Morris &
Company woven silk damask of 1875, provided the ground for her altar-
cloth for Edward Prior's Arts and Crafts masterpiece, St Andrew's Church
at Roker, Sunderland. The altar-cloth was worked by her together with
Frances Channer in 1907, and the combination of Morris's fabric and her
floral design was much admired. With her husband Alfred, Louise Powell
was inspired by Morris's pattern designs and his enthusiasm for Turkish

and Persian work to create embroideries, calligraphic manuscripts, painted furniture, two-dimensional designs, and, most memorably, hand-painted pottery for the firm of Josiah Wedgwood and Sons through the first half of the twentieth century.

A Beautiful House

The overwhelmingly domestic nature of the Arts and Crafts movement derived directly from Morris, who stated that a beautiful house was 'the most important production of art and the thing most to be longed for' (*Ideal Book*, 1). Red House, Kelmscott Manor, and Kelmscott House in Hammersmith all played major parts in his own life. Many of Morris's lectures relate to domestic buildings and interiors while both *A Dream of John Ball* (1886–7; 1888) and *News from Nowhere* (1890) include descriptions of houses and interiors which influenced Arts and Crafts architects and designers. Lethaby and Gimson together defined architecture as 'building touched with emotion', emphasizing the importance of both craft skills and individuality inspired by local traditions.[13] Lethaby's Melsetter House, Orkney, 1898, for the Middlemore family and Gimson's Stoneywell in Leicestershire, 1898–9, are excellent examples of this approach. Developing an English architectural tradition was the aim of Voysey; his asymmetrical low-slung houses were lauded for their quality and adaptability. In *Homes and Gardens* Baillie Scott used a quote from *A Dream of John Ball* as the heading for the chapter on 'Halls'.[14] It describes Will Green's house, its large open ground floor with just a stair at one corner. Baillie Scott perfected the large communal hall with alcoves for different activities in houses such as Blackwell in the Lake District (see Figure 16.6).

A Beautiful Book

Morris believed that a beautiful book was secondary only to a beautiful house. On his deathbed he had a brief conversation with Sydney Cockerell about keeping the Kelmscott Press open. It was considered impossible and in 1898 Ashbee employed Morris's former compositor, Thomas Binning, and negotiated the purchase of two Albion presses from the Kelmscott Press for his own newly founded Essex House Press, moving them from Hammersmith to the East End with some style. Laurence Hodson, Morris's former client, had originally proposed the purchase to Ashbee and both men saw it as a great publicity coup – the Guild of Handicraft as the successor to William Morris (see Figure 16.7).

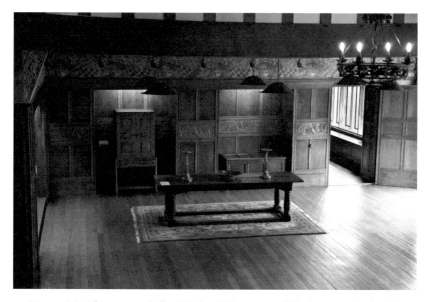

Figure 16.6 The entrance hall at Blackwell, Bowness on Windermere, Cumbria by
M. H. Baillie Scott; Neil McAllister / Alamy Stock Photo. Reproduced with permission

The worldwide private press revival in the twentieth century was a direct response to Morris and the Kelmscott Press. Advised by Walker and Cockerell, C. H. St John Hornby founded the Ashendene Press in 1894, while Walker himself joined forces with Cobden-Sanderson to establish the Doves Press in 1900. Outside Britain, Daniel Updike set up the Merrymount Press in Boston, USA in 1893 and his compatriot Bruce Rogers, a friend of Walker's, took over the Riverside Press in Cambridge, Massachusetts in 1896. Walker's support was also crucial for H. G. Kessler who founded the Cranach Press in 1913 in Weimar, Germany.

The Cotswolds

The Arts and Crafts movement spread from cities to many rural areas including the Lake District, Surrey, Devon, and Cornwall. Its link to the Cotswolds was particularly strong because of Morris's affinity for the area. He loved Kelmscott Manor, his 'jewel of a house' (xvi.205), for its proximity to the Thames, the surrounding countryside, and the austere beauty of traditional Cotswold buildings. He welcomed visitors and happily introduced them to his favourite places. The Birmingham artist, Charles M. Gere, visited in April 1892 to work on a drawing of the

AN ENDEAVOUR TOWARDS THE TEACH~
ING OF JOHN RUSKIN AND WILLIAM
MORRIS.

BEING A BRIEF ACCOUNT OF THE WORK,
THE AIMS, AND THE PRINCIPLES OF THE
GUILD OF HANDICRAFT IN EAST LON~
DON, WRITTEN BY C. R. ASHBEE, AND
DEDICATED BY HIM LESS IN THE WRIT~
ING, THAN IN THE WORK THE WRITING
SEEKS TO SET FORTH, TO THEIR MEM~
ORY. AN. DOM. MDCCCCI.

Figure 16.7 C. R. Ashbee, a page from *An Endeavour towards the teaching of John Ruskin and William Morris* (the illustration shows Essex House, the premises of the Guild of Handicraft on Mile End Road, East London), printed by the Essex House Press, 1901; The Guild of Handicraft Trust and Court Barn Museum, Chipping Campden. Reproduced with permission

front of the house for the illustrated edition of *News from Nowhere* in 1893. Morris took or directed him to Hailes Abbey near Winchcombe, St John's Church at Burford and St George's Inn at Lechlade. Gere was one of a number of Birmingham artists and craftspeople who subsequently moved to the Cotswolds. Morris's influence was certainly significant in opening up this previously neglected part of England as were the railways: stations were opened in Chipping Campden in 1853, Cirencester in 1883, and Lechlade in 1873.

The Guild of Handicraft's move in 1902 from London's East End to the small market town of Chipping Campden in the north Cotswolds was regarded by Ashbee and others as a bold gesture in the spirit of Morris. He described it as leaving 'Babylon to go home to the land', although neither he nor any of his Guildsmen had ever lived in the countryside.[15] Subsequently, Morris featured in the semi-biographical novel written about one of Ashbee's Guildsmen, the metalworker Arthur Cameron, by his son William. It is clear from Cameron's novel *The Day Is Coming* (the title comes from one of Morris's most popular poems written in 1883 and included in *Chants for Socialists*) that his father and his fellow Guildsmen had been imbued by the character of Morris and his ideals as central to the formation of the Guild of Handicraft.[16] The move took Morris's ideals a step further, creating a tight unit between the workforce and Ashbee and his wife that worked successfully most of the time. It also shaped the character of Chipping Campden, attracting designers, makers, and artists to the town through the twentieth century up to the present day.

The community of Gimson and the Barnsleys at Pinbury and Sapperton from 1894 had a similar impact on the south Cotswolds. Many of Gimson's workforce – woodworkers and metalworkers – continued working independently after his death in 1919, establishing a strong craft tradition which can be seen in many Cotswold buildings. Others came to live and work in the area, including Alfred and Louise Powell, the architects Norman Jewson and Detmar Blow, and the stained-glass artist Henry Payne. Then, after the end of the First World War, the woodcarver William Simmonds and his wife Eve, a skilled needlewoman, arrived, followed later by Phyllis Barron and Dorothy Larcher, who revived the tradition of hand block-printed textiles.

Leisure and Social Change

Morris's one attempt at writing a socialist entertainment, *The Tables Turned; or Nupkins Awakened* (1887), was never repeated despite numerous plaudits and performances, but drama and music flourished as part of

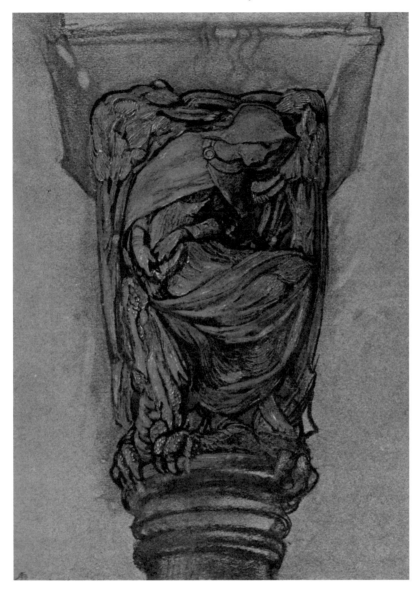

Figure 16.8 Henry Wilson, a design for a capital to one of the stage columns for *Beauty's Awakening*, 1899; reproduced in *The Studio*, summer number, 1899.

the Arts and Crafts movement. A masque, *Beauty's Awakening*, was staged in 1899 by members of the Art Workers' Guild, their family members and their friends at the London Guildhall (see Figure 16.8).

Despite the effort expended by over a hundred participants on what could be described as an ephemeral project, it was a major communal activity and developed a sense of fellowship among those involved. It was preserved for posterity by the publication of a special summer issue of *The Studio* which included the text, together with photographs, drawings and designs relating to the costumes, scenery, and props.[17]

Another strand of the Arts and Crafts movement was the charitable promotion of amateur craftwork, inspired partly by Morris's desire of art for all. It wasn't always welcomed. 'Dear Emily' was Ashbee's name for the women who learnt the basics of jewellery and metalwork at classes before trying to earn a living from their craft. Hampshire House in Hammersmith, London had been established as a non-denominational meeting place for working men but, with the outbreak of war in 1914 and the influx of refugees from Belgium, it opened craft workshops for both men and women under the direction of the architect and designer Charles Spooner. The Home Arts and Industries Association set up in 1884 was particularly strong in rural areas; craft classes for working people were set up, often by women, to provide useful leisure occupations and develop new skills. Maude King established the Haslemere Peasant Industries in Surrey in 1896 together with her sister and brother-in-law, Ethel and Godfrey Blount. Amateur craft activity flourished throughout Britain and in Ireland; there were regular exhibitions in London and elsewhere and retail outlets. As Tanya Harrod suggests, however, 'The powerful association of handwork with charity and philanthropy certainly operated against a serious assessment of other kinds of handmade objects in this period and is an odd by-product of Morris's dream of work made "as a joy to maker and user".'[18] Certainly by 1914 many felt that the term 'Arts and Crafts' had become debased.

The Legacy

Morris's importance to the development of the movement was acknowledged by W. B. Yeats in a review of the 1890 Arts and Crafts Exhibition for an American paper: 'But for these "arts and crafts" exhibitions of which this is the third year, the outer public would hardly be able to judge of the immense change that is going on in all kinds of decorative art and how completely it is dominated by one man of genius.'[19] The fifth exhibition was due to start on 3 October 1896, the day Morris died. When it finally opened a week later, a reviewer commented:

True that the personal sadness of each member of the society imparted a gloom to the event; yet looking at the beautiful objects which his enterprise had made possible, one felt that although the master had been taken, the principles he had established were so firmly rooted, that the legend of William Morris would be the creed of the new movement, and loyal adherence to his teaching would rank more than ever as its watchword.[20]

Morris's legacy was discussed by leading figures of the movement. May Morris was responsible for editing her father's writings, a task that taxed her to the utmost but kept these inspirational works in the public domain as well as providing a very intimate and insightful overview of his life and work in the introductory essays to the twenty-four volumes. In 1897 Robert Lorimer gave a lecture on the work and influence of Morris to the Edinburgh Architectural Society. He described Morris as a pioneer, 'the brave man who found all the arts sick unto death and yet was not discouraged but resolutely set to work to set things moving again, and it takes a big man to do this'.[21] Morris inspired designers, makers, and philanthropists to set up hundreds of workshops in Britain and elsewhere: in continental Europe, Russia, the USA, Canada, South Africa, Japan, Australia, and New Zealand.

Notes

1 C. R. Ashbee, unpublished *History of the Art Workers' Guild Masters,* Art Workers' Guild, London.

2 *The Journal of T. J. Cobden-Sanderson, 1879–1922,* 2 vols (London, 1926), i.97.

3 Robert Lorimer to Robin Dods, 22 December 1896 (Sir Robert Lorimer Papers, Coll-27, University of Edinburgh Main Library, MS.2484.1.).

4 Cooper Family archive, John Paul Cooper, Journal IV, 173.

5 Ernest Gimson to Sydney Gimson, 31 March 1886, The Wilson, Cheltenham 2006.5.5.

6 The Ashbee Journals, 4 December 1887, King's College Library, Cambridge.

7 The original image is held by the Watts Gallery Archive. It is illustrated in M. Greensted, *The Arts and Crafts Movement in Britain* (Oxford: Shire Publications, 2010), 8.

8 *Journal of the Royal Institute of British Architects*, vol. ix, 12 April 1902, 291–6.

9 P. Faulkner (ed.), *Arts and Crafts Essays by Members of the Arts and Crafts Exhibition Society* (London: Thoemmes Press, London, 1996), 161–71.

10 M. H. Baillie Scott, *Houses and Gardens* (London: G. Newnes, 1906), 71.

11 W. R. Lethaby, 'Ernest Gimson's London Days', in Lethaby, Powell and Griggs, *Ernest Gimson, His Life & Work* (Stratford-on-Avon: Shakespeare Head Press, 1924), 4.

12 V&A NAL MSL/1959/4396.

13 Lethaby, 'Ernest Gimson's London Days', in Lethaby, Powell and Griggs, *Ernest Gimson, His Life & Work*, 2.

14 M. H. Baillie Scott, *Houses and Gardens* (London: G. Newnes, 1906), 17.

15 The Ashbee Journals, 25 December 1901, King's College Library, Cambridge.

16 William Cameron, *The Day Is Coming* (New York: Macmillan, 1944), 19–21.

17 *Beauty's Awakening, A Masque of Winter and of Spring, The Studio* (summer, 1899).

18 Tanya Harrod, 'Paradise Postponed: William Morris in the Twentieth Century' in *William Morris Revisited: Questioning the Legacy* (London: Crafts Council, Whitworth Art Gallery, and Birmingham Museum & Art Gallery, 1996), 13–14.

19 Quoted by Peter Stansky, *Redesigning the World* (Princeton, NJ: Princeton University Press, 1985), 270.

20 'The Arts and Crafts: First Review', *The Studio*, ix (1896), 55.

21 R. Lorimer, copy of the text of his lecture given to the Edinburgh Architectural Society in March 1897. With thanks to Dr John Frew and Annette Carruthers.

Female Fellowship
Morris, Feminism, and the New Woman
Zoë Thomas

In 1894, the journalist Sarah A. Tooley, who was well known for inter-viewing famous figures in late-nineteenth-century society, journeyed to Hammersmith to talk to William Morris about 'A Living Wage for Women' for the *Woman's Signal*. Clutching his pipe and 'puffing vigor-ously as he paced backwards and forwards', Morris's answers to Tooley's questions offer revealing insights into his views on the 'woman ques-tion' two years before his 1896 death.[1] Unsurprisingly, Morris's socialist views permeated his responses. Like many involved in socialism at this time, Morris emphasized throughout the interview the need to first and foremost prioritize fighting for a socialist society. He argued this was the only way women could ever achieve a living wage, as it would put them on the same economic standing as men. Although his focus was a socialist future, Morris did support some of the major aims of the late-nineteenth-century women's movement. He believed that women should have the vote (on the lines of adult suffrage for all), felt it 'com-mon fairness' that women should be awarded university degrees, and encouraged women to join trade unions, feeling it the 'best remedy' to unfair pay.

Yet Morris did believe men and women had different roles to play in society, be this in 1894 or in the future. He accepted that occasionally women might pursue similar callings to their male peers, but told Tooley that 'when women, with their more nervous and less muscular structure, come to compete in the labour market with men, it is inevitable that they must take less pay if they are to be employed at all'. Continuing, he emphasized that 'I do not say, mind you, that woman is inferior to man, because she isn't; but she certainly is different, therefore her occupation, broadly speaking should be different.' Tooley queried this point, asking whether this difference was simply due to 'habit and training, rather than fundamental', and although Morris admitted it was hard to predict what women's capabilities could be within an improved society, he made much

of their supposed 'physiological differences'. He stressed the 'muscular strength' of the 'strong, burly fellows' who worked as weavers and tapestry makers at his business, whilst claiming that 'It is strength that makes their touch so delicate.' Morris was working during an era when there was suspicion that men working in the arts had concerning effeminate tendencies.[2] He, like other leading male designers of this era such as C. R. Ashbee, often foregrounded the supposed physical prowess and muscular masculinity, but also the curious, apparently inimitable, 'delicate' power of touch of the working-class men in their workshops.[3]

Morris told Tooley too of his disappointment that working-class married women were having to engage in physically rough work outside of the home. Then, moving his focus to fields more likely to be associated with middle- and upper-class women at this point, he flippantly declared there had been no great women artists, arguing women 'do not excel in the arts or in inventive power'. When Tooley proffered examples of celebrated painters such as Elizabeth Thompson and Rosa Bonheur, he dismissed them as 'Not up to the high-level'. Instead, he promoted the need for there to be greater respect for 'woman's special work' of 'housekeeping', continuing that 'Anybody can learn mathematics, but it takes a lot of skill to manage a house well. Don't let the modern woman neglect or despise housekeeping.' Morris placed considerable weight on this point, telling Tooley that it was 'one of the most difficult and important branches of study', and that women should 'cherish the art' of housekeeping 'as her own special domain'. He finished by asserting 'Men will never do any good at it.'

For Morris, like the vast majority of his generation, whether embedded in progressive circles or not, it was completely unimaginable that middle- and upper-class men would – in any society – ever regularly contribute towards domestic duties. Although his intention was to support women here (if we are to be generous), such overt focus on promoting the valuable contribution women were making to society through household labour further encouraged the already dominant belief that there were considerable binary differences between women and men. This was heightened by Morris's dismissal of the professional gains women were making in fields including mathematics and painting. Moreover, Morris repeatedly projected an ideal of domestic labour as joyful and fulfilling, part of a wider tendency of Arts and Crafts adherents to romanticize domestic cultures, which did little to reflect the exhausting realities of such daily drudgery or to offer tangible, structural suggestions as to how to improve women's domestic lives.

Reading Morris's varied responses in Tooley's interview it is clear why scholars have tended to draw from different elements of Morris's writings, letters, and interviews to explore the extent to which he can be claimed as a 'feminist'.[4] Morris evidently held a range of views about women's roles. His vision of the future included everyone having the vote and there being greater respect for domestic work. However, as we have seen, he held more regressive views about who should perform particular forms of labour, and when encouraged to speak in more detail about opportunities for women as a presumed mass group he reverted back to established stereotypes about innate differences and characteristics.

But attempting to position Morris's life in relation to the category of feminism can flatten understanding of the specific contexts to his views, which were shaped by the historical moment in which he lived, and his own circumstances and temperament. The term 'feminism' is largely anachronistic in relation to late-nineteenth-century discourse in Britain.[5] People instead tended to talk of 'the woman question', which encompassed a variety of topics, from education to women's suffrage to prostitution, and of the 'New Woman', a term intended to capture the behaviours and lifestyles of certain 'advanced' women at the *fin-de-siecle*.[6] Even later, in the 1920s, although some women invested in women-centred movements had started to use the term 'feminist' more regularly, others (including certain socialist women and writers) continued to avoid this framing because it was viewed as antagonistic towards men.[7] 'Feminism' then provides a useful, important shorthand to alert readers to the progressive aims of historical individuals, and to build a sense of a wider, shared feminist history. At the same time, it is crucial to foreground and contextualize the language historical figures such as Morris used, and to consider how these views sat in relation to others, if we are to understand how ideas about women and gender roles have circulated and been reformulated within British society.

For instance, Morris's view of the need to elevate women's 'special domain' of domesticity was prevalent within the women's movement and literary cultures in the 1890s.[8] Many women (although by no means all) argued via novels, articles, lectures, and interviews that their innate femininity meant they should be allowed greater opportunities to contribute to specific areas of public life which usually dealt with women, children, and domestic concerns. Women were likely influenced in their socially maternalistic approach here by a desperate need to assuage concern as they tried to navigate new roles in society. They took care to stress they would be able to effectively manage their houses as well as undertaking new working

lives. Indeed, in this very interview Tooley quipped to Morris that 'The advanced woman does not despise housekeeping, Mr Morris; she only brings brain to it.' Altogether, this created a climate which helped facilitate a growth of opportunities for women, yet at the same time also fed into the development of a modern model of womanhood which placed considerable expectations on women to simultaneously oversee and navigate domestic responsibilities alongside their work, whilst also maintaining a façade of 'femininity'. Such encompassing roles were not expected of men and foreshadowed issues which continue to be the focus of feminist agitation in the twenty-first century.

Morris's 1894 interview fed into the nexus of debates about women which rapidly circulated across Anglophone print cultures during this era, but what did his literary works have to say about gender and what sort of relationships did he have with women? This chapter now turns from Tooley's interview to consider how Morris articulated his views at other key moments, to gain a more cohesive understanding of the breadth and range of his perspectives about the 'woman question', as well as to consider how his relationships and circumstances shaped the development of his ideas. It also briefly examines these views in relation to the networks of fellowship which made up the socialist and women's movements, to situate and compare his views, and to best explore how Morris's writings and ideas contributed to public discourse about women and gender at the brink of the twentieth century.

In 1858, Morris published his first volume of poetry, *The Defence of Guenevere and Other Poems*. This included 'Sir Peter Harpdon's End', a poem which featured brave medieval Gascon Knight Sir Peter Harpdon and his 'darling' Lady Alice de la Barde who nervously waited for news of his adventures from her window seat at home. It is a quintessential example of his early work, which frequently focused on women in passionate and suffering contexts, often waiting to be 'rescued' from confinement by brave men. Such portrayals of romantic relationships were common for the mid-nineteenth century: the men tended to be courageous and chivalrous whilst the women were beautiful, young, and preoccupied with romantic yearnings. Florence Boos, who has worked extensively on Morris's writings, has convincingly argued that his characterizations of women did, however, encourage reflection on the harmful consequences of excessive restrictions on women's freedom: on their lives, on romantic relationships, and on social happiness more widely. In contrast to many other male poets, Morris slowly developed a more expansive range of emotions for the women in his work, encouraging awareness of 'the psychological intensity and depth of

female experience' as well as 'characteristic awareness that social injustice falls with greatest weight on those permitted the meagerest defense'.[9]

Morris's poetry and writings were noticeably shaped by his relationship with his wife Jane Morris (née Burden), whom he married in 1859, and in particular by her romantic relationship with painter and poet Dante Gabriel Rossetti. An unpublished poem from c. 1865–1974, with the telling title of 'Alone, Unhappy By the Fire I Sat', sees the author attempting to address the 'seed of hatred' after 'they both are gone'.[10] During the years of the affair, Morris shifted from portraying women largely as victims. *The Earthly Paradise*, his epic poem (completed and published between 1868 and 1870), instead offered readers alluring yet distant female characters who appear unaffected by the romantic needs of men. Alongside this, from the late 1860s, he created numerous women protagonists motivated by extreme jealousy and anger (see, for instance, Medea in the *Life and Death of Jason* (1867) and Brynhild and Gudrun in *The Story of Sigurd the Volsung* (1876)). Although the difficulties within his marriage had clearly made Morris deeply unhappy, he developed the perspective that sexual freedom, even when married, was crucial to human happiness. Sexual and emotional autonomy within relationships were to be prominent themes in his later work *News from Nowhere* (1890; 1891). The extent to which Morris sought to overcome his personal feelings of frustration, 'hatred', and melancholy in this regard is striking. His view of the need for women as well as men to have sexual freedom was unusual even when considered in relation to the progressive circles he interacted with, although it is important to note this was a world of sexual freedom framed around choice within heterosexual relationships alone.

Morris's employment of women provides another useful lens through which to explore his views and impact on the development of opportunities for women. Here, however, unlike his progressive ideas about heterosexual sexual freedom, he appears more conservative. This was especially the case in terms of the fields he encouraged women to work in. He employed several women as domestic servants to perform the hard physical labour which created the conditions where he could write his romances and socialist manifestos, but his business Morris, Marshall, Faulkner & Company (founded 1861) employed few women aside from within the embroidery section. As Anthea Callen has argued, Morris largely employed women to work in this segregated, traditionally 'feminine' craft, and although it is essential to account for the subversive potential and creative fulfilment embroidery offered some women, it still ultimately 'reinforced a sexual division of labor' that was replicated across other Arts and Crafts workshop

cultures with men as managers.[11] Irish embroiderer Lily Yeats, who worked for the embroidery section, wrote in her diaries of the difficulties of working there, with 'fear of [William] Morris's violent temper' and the coldness of May Morris, who managed this section, and 'did not allow time off for illness'.[12] William Morris also tended to encourage the women around him in his personal life to work on embroideries as the creative field of choice: alongside training May Morris from a young age, this included his other daughter Jenny Morris and wife Jane Morris; his housekeeper at Red Lion Square, Mary Nicholson; sister-in-law Elizabeth Burden; and female friends including Georgiana Burne-Jones.[13]

From the 1880s, Morris's immersion in socialist politics affected the ways he engaged with the 'woman question', which had similarly crystalized into a more clearly defined movement during this era (the first British women's suffrage societies had begun to be founded in the 1850s and 1860s). His political views led him, like German socialist Clara Zetkin and Eleanor Marx (who was one of the founders alongside Morris and others of the Socialist League in 1884), to become more disapproving of the prominent strand of the women's movement which foregrounded liberal and parliamentary aims. In 1880, Morris gave a speech at the Annual Meeting of the Women's Protective and Provident League, which promoted trade unions for women, where he argued for the need for better remuneration for women workers and that 'in all classes every woman should be brought up as if she might not marry and keep house; as if she might have to earn her own living'.[14] He also actively demonstrated his support for causes relating to women across the 1880s, including lecturing to a 'crowded and fashionable audience of ladies' at the Kensington Vestry Hall, London about the need for women to be allowed to 'exercise liberty of choice' in their choice of dress, and not have to wear clothing which, he felt, would 'degrade the human body'.[15] Morris's socialism appears to have influenced his attitude at his own business as well, at least to some extent; several press reports in 1892 announced that 'Mrs Jane Pyne', a compositor at Morris's Kelmscott Press, and the first female member of the London Society of Compositors trade union, was 'receiving the same weekly wages as the male employees of Mr Morris'.[16]

Yet in 1884, Morris had declined an invitation from the Liberal suffragist Jane Cobden to deliver a lecture for the National Society for Women's Suffrage, writing that 'To speak plainly my private view of the suffrage matter is that it is no use unless people are determined on Socialism' (*CL*, ii.255). This was a view which many women with socialist leanings held into the twentieth century. Women too could have other priorities at this

point, alongside (or instead of) getting 'votes for women'. May Morris, although agreeing with her father that women should be enfranchised, and engaging in certain suffrage activities such as designing banners, largely focused on issues of pressing importance to her, which, alongside ensuring her father's posthumous legacy, included working as an exceptionally talented art worker, writer, and speaker about jewellery and embroidery and the histories of these fields.[17] In contrast, Jane Morris held more conservative views than her husband or daughter (a useful reminder of the breadth of opinions about suffrage in one creative family alone), writing in a 1907 letter that 'of course it is absurd that I should not have a vote while many a drunken working man has one', but still 'I can't make up my mind … I object to these noisy women having any increased power because they only want to reverse things and spitefully trample on the men. I want both sexes to have equal rights when the women are better educated companions and housekeepers.'[18]

Despite the growing interest in women's emancipation, the ostensibly 'radical' political and artistic groups Morris participated in were profoundly masculine in their focus and were orientated around the repeated performance of middle- and upper-class bohemian male identities. This was deemed crucial in building the 'brotherly' solidarity which continued to underpin political, professional, and creative cultures. Such groups tended to formally and informally bar women's participation. Morris was 'Master' of the Art Worker's Guild in 1892, which positioned itself as the leading network for figures associated with the Arts and Crafts movement. Women were not allowed to join as members (formally known as 'Brothers') until the 1960s. In socialist circles too, even when women were allowed to participate, Karen Hunt and June Hannam's work has shown how women, whether involved in the Social Democratic Federation, the Independent Labour Party, the Fabian Party, or the Socialist League, often became frustrated with organizations, leaders, and individual branches which could be actively antagonistic towards women or dismissive of their concerns, and assumed women would undertake gender-specific roles.[19]

The close friendships men developed within these male-orientated networks and organizations could deeply influence their perspectives on gender. Morris co-authored *Socialism; Its Growth and Outcome* with Ernest Belfort Bax, a barrister whose own socialist beliefs were fuelled by his prominent anti-feminist stance. (Later, in 1913 Bax published *The Fraud of Feminism*, in which he argued women were privileged at the expense of men, especially through legal codes.) There is a curious lack of discussion of women in *Socialism: Its Growth and Outcome*; this contrasts

noticeably with Eleanor Marx and Edward Aveling's engagement with the contemporary women's movement in their 1886 *The Woman Question*.[20] Morris's friendship with Bax appears to have encouraged him to minimize discussions at the Socialist League on marriage and women's equality and on members' objections to Bax's horrific views about domestic violence towards women and children.[21] Indeed, in one 1886 letter Morris wrote:

> Again, as to the woman matter, it seems to me that there is more to be said on Bax's side than you suppose. For my part, being a male man, I naturally think more of the female man than I do of my own sex: but you must not forget that child-bearing makes women inferior to men, since a certain time of their lives they must be dependent on them. Of course, we must claim absolute equality of condition between women and men, as between other groups, but it would be poor economy setting women to do men's work (as unluckily they often do now) or vice versa.[22]

Such 'private' scribbled comments help flesh out Morris's views, in contrast to his more guarded comments in the press – or his complete avoidance of the topic, as in his published work with Bax. This perspective, that women should not be allowed to encroach on 'men's work' (although they 'unluckily', in Morris's opinion, often did), illuminates the difficulties women faced in a society where, on the face of it, men such as Morris were largely understood as supporting their efforts.

Moreover, certain other leading socialists during these decades moved away to a greater extent from the romanticized, socially maternalistic roles Morris often placed as of central importance for women and the future happiness of society. German socialist August Bebel, in *Die Frau und der Sozialismus* (first published in German in 1879), pushed back more forcibly against the idea of women's 'natural' role as being 'home and hearth' (the quotes here and below are from the 1892 edition).[23] Bebel's enthusiasm to encourage social change and to demonstrate women's capabilities likely influenced the inadequate attention he placed on addressing the full toll of pregnancy, working conditions, assault, violence, and poverty, amongst other issues.[24] Bebel's (and Friedrich Engels's) works also contain troubling views on topics such as sex work and non-heterosexual relations.[25] But unlike Morris, Bebel did write of the urgent need for there to be central laundries and kitchens which could help alleviate women's oppression in domestic roles, as well as noting that 'The general aversion of rich and wealthy women against kitchen work does not seem to signify that this occupation is a part of woman's "natural sphere."'[26]

Socialist ideologies influenced the very forms Morris's creative work took and fed into how he portrayed women and men characters. He viewed

the growing literary focus on interiority, which was threaded through the work of 'New Woman' writers, as a form of middle-class self-absorption. Owen Holland has offered a comparative analysis of Morris's writings on women in relation to debates in the women press, and in the fictional works of women writers and socialists. He has compellingly demonstrated that Morris's works 'frequently reinscribed patriarchal assumptions'.[27] 'New Woman' writers often explored social realist topics pertaining to individual struggles, including the plight of married women subjected to domestic violence, marital rape, enforced motherhood, and legal gender inequalities (for instance, within divorce laws). Morris, with his romantically inflected revolutionary ideals, instead routinely portrayed motherhood and domesticity as joyous experiences within a woman's life, although he was always vague on the practicalities or daily realities. He also used his works to 'experiment with the representation and consolidation of a collectivist structure of feeling', rather than to focus on interiority and personal struggle.[28]

News from Nowhere usefully reveals Morris's literary portrayal of gender in the final decade of his life. It tells of the adventure of 'William Guest' who has been transported to a utopian future where capitalist society has been overturned. As introduced earlier in this chapter, Morris provided an alternative to monogamy and repressive late-nineteenth-century models of expected marital conduct. His characters Clara and Dick are comrades and married lovers who pursue relationships outside the 'marriage contract'. Morris's views about innate gendered difference are, however, clear when he has Clara say: 'We do not deceive ourselves, indeed, or believe that we can get rid of all the troubles that besets the dealings between the sexes'. She continues: 'but we are not so mad as to pile up degradation on that unhappiness by engaging in sordid squabbles about livelihood and position, and the power of tyrannising over the children who have been the results of love or lust'. Such views would have stood out as decidedly controversial in comparison to wider late-nineteenth-century attitudes. At the same time, *News from Nowhere* offers no meaningful discussion as to who exactly would be responsible for the daily care of such children, and again assumes heterosexual relationships to be the only model of romantic relationships which would be being pursued in the future.

The novel even pre-empts Morris's discussions with Tooley four years later, where they would discuss in his Hammersmith home what women would *potentially* do in the future, as it seeks to answer this very question. The character 'Old Hammond', who offers the narrator William Guest an overview of life in this new world, tells him that the 'Emancipation of Women movement' is a 'dead controversy' because 'The men have no

longer any opportunity of tyrannising over the women, or the women over the men; both of which things took place in those old times. The women do what they can do best, and what they like best, and the men are neither jealous of it or injured by it.' For Morris, this meant portraying the majority of women as happily engaged in domestic roles. One of the most famous examples, much criticized by feminist scholars, is the Guest House scene where Hammond observes the 'comely' and 'merry' female servers who 'bustled about' waiting upon the men (xvi.59, 15). Through such scenes, the novel reinscribes a deeply gendered division of labour onto this imagined ideal society; Jan Marsh has argued that it is, 'undeniably and regrettably, a masculinist idea of paradise … deeply imbued with the feeling and language of male desire'.[29] Morris did add a chapter to the 1891 book form of *News from Nowhere* (it originally appeared in serial form in the *Commonweal*) titled 'The Obstinate Refusers', where a group of builders work under the stewardship of 'head carver' Philippa and her daughter.

Yet, the novel is evidence of Morris's ongoing habit of ignoring and even effacing the impact of female fellowship on processes of social change. Eileen Sypher has pointed out that any meaningful discussion of the women's movement was curiously absent from Old Hammond's account of 'How the Change Came'.[30] This is striking as his 1897 fantasy, *The Water of the Wondrous Isles,* published shortly after his death, addresses many 'New Woman' themes. The whole book orientates around a woman named Birdalone who, over the course of the novel, faces a range of sexually threatening situations, independently establishes a craft business, is physically strong and characterful, and has satisfying and beneficial relationships with women, rather than simply with men. However, even this refreshing adaption reiterates Morris's tendency to accept and endorse a world where a few exceptional, creative women may pursue similar paths to those of their male peers, whilst also promoting his wider view elsewhere that the vast majority of women had different interests and capabilities to men.[31]

The range of examples discussed in this chapter emphasize that Morris, in the press and within the hundreds of poems and works he composed over the course of his life, offered a particular framework for women. He clearly expanded on his views, and in several important ways contributed to the aims of the women's movement, be this through his expressed support for women's political emancipation or even through his repeated focus on women in his works. Morris also promoted the need for heterosexual sexual freedom and fulfilment for both women and men in society, which went far beyond what was advocated for by the vast majority of people involved in the women's movement.

At the same time, comparatively analysing Morris's ideas and writings helps to illuminate why such gendered views of women, framed around their supposedly heightened caring and domestic capabilities, remained dominant. Morris's persistent framing of women in this way appears at odds with his socialist rhetoric, which was framed around the need for change for all. This tension in his life and works was never fully resolved. Moreover, his support of Ernest Belfort Bax, amongst other activities, fed into the social conditions that made 'New Women' writers, women socialists, women art workers, and women more generally (of all classes) uncomfortable. Such antagonisms, and the wider masculine world of workshop cultures, clubs, and groups – which Morris participated in and enabled – increasingly encouraged women to funnel their energies into creating alternative networks of fellowship and solidarity by the dawn of the twentieth century. This included Arts and Crafts workshop businesses managed and run by women, women's informal socialist networks, artistic groups, and, perhaps most strikingly, the Women's Guild of Arts, co-founded and run by May Morris from 1907.[32]

Notes

1 S. A. Tooley, 'A Living Wage for Women', *Woman's Signal*, 19 April 1894, 260–1.

2 M. Danahay, *Gender at Work in Victorian Culture: Literature, Art and Masculinity* (Abingdon: Routledge, 2005).

3 Z. Thomas, 'Between Art and Commerce: Women, Business Ownership, and the Arts and Crafts Movement', *Past and Present*, 247.1 (2020), 151–96 (161).

4 Most recently, see F. S. Boos, 'Morris, Gender, and the Woman Question', in F. S. Boos (ed.), *The Routledge Companion to William Morris* (London: Routledge, 2020), 58–86 (58). Noted with thanks to Florence Boos for sending me a copy of this work.

5 B. Griffin, *The Politics of Gender in Victorian Britain: Masculinity, Political Culture and the Struggle for Women's Rights* (Cambridge: Cambridge University Press, 2012), 19–21.

6 K. Gleadle and Z. Thomas, 'Global Feminisms, *c.* 1870–1930: Vocabularies and Concepts—A Comparative Approach', *Women's History Review*, 27.7 (2018), 1209–24.

7 K. Hunt and J. Hannam, *Socialist Women: Britain, 1880s to 1920s* (London: Routledge, 2001), 9.

8 S. Ledger, 'The New Woman and Feminist Fictions', in G. Marshall (ed.), *The Cambridge Companion to the Fin de Siècle* (Cambridge: Cambridge University Press, 2007), 153–68.

9 F. S. Boos, 'Sexual Polarities in the Defence of Guenevere', *Browning Institute Studies*, 13 (1985), 181–200 (199).

10 William Morris Autograph Poems, British Library 45, 298A.

11 A. Callen, 'Sexual Division of Labor in the Arts and Crafts Movement', *Woman's Art Journal*, 5.2 (1985), 1–6 (4).

12 P. Faulkner, 'Dark Days in Hammersmith: Lily Yeats and the Morrises', *William Morris Society Journal*, 11.3 (1995), 22–5.

13 J. Marsh, *Jane and May Morris: A Biographical Story, 1839–1938* (London: Pandora, 1986).

14 Anon., 'Annual Meeting of the League', *The Women's Union Journal: The Organ of the Women's Protective and Provident League*, 5.54 (1880), 67–72 (69).

15 'The Author of "The Earthly Paradise" on Ladies Dress', *Glasgow Herald*, 3 April 1882, 3.

16 *Glasgow Evening Post*, 21 September 1892, 7.

17 Z. Thomas, *Women Art Workers and the Arts and Crafts Movement* (Manchester: Manchester University Press, 2020), 187.

18 J. Marsh and F. Sharp (eds), *The Collected Letters of Jane Morris* (Woodbridge: Boydell and Brewer, 2012), 401.

19 K. Hunt and J. Hannam, *Socialist Women: Britain, 1880s to 1920s* (London: Routledge, 2002), 5.

20 E. Marx and E. Aveling, *The Woman Question* (London: Swan Sonnenschein & Company, 1886).

21 F. S. Boos and W. Boos, 'News from Nowhere and Victorian Socialist-Feminism', *Nineteenth-Century Contexts*, 14.1 (1990), 3–32(4–5)

22 J. Bruce Glasier, *William Morris and the Early Days of the Socialist Movement* (London: Longmans, Green, and Company, 1921), 185.

23 A. Bebel, *Die Frau und der Sozialismus*, 11th ed. (Stuttgart: Dietz, 1892), 181.

24 F. Engels, *The Origin of the Family, Private Property, and the State*, trans. Ernest Untermann (Chicago: Charles H. Kerr, 1902).

25 Boos, 'Morris, Gender, and the Woman Question', 72–3.

26 Bebel, *Die Frau und der Sozialismus*, 178–9. With thanks to Simon Thomas Parsons for translating these quotations from the original German.

27 O. Holland, *William Morris's Utopianism: Propaganda, Politics and Prefiguration* (London: Palgrave, 2017), 54. Noted with thanks to Owen Holland for providing me with a copy of his book.

28 Ibid., 53.

29 J. Marsh, 'Concerning Love: *News from Nowhere* and Gender', in S. Coleman and P. O'Sullivan (eds), *William Morris & News from Nowhere: A Vision for Our Time* (Bideford: Green Books, 1990), 107–26 (121).

30 E. Sypher, *Wisps of Violence: Producing Public and Private Politics in the Turn-of-the-Century British Novel* (London: Verso, 1993), 102.

31 F. Boos, 'Gender-Division and Political Allegory in the Last Romances of William Morris', *Journal of Pre-Raphaelite Studies*, 1.2 (1992), 12–23.

32 Thomas, *Women Art Workers*.

Landscape and Environment

Elizabeth Carolyn Miller

William Morris was among the most prescient of ecological thinkers in Victorian arts and literature, and along with contemporaries such as Thomas Hardy and John Ruskin, his work offers a searing appraisal of Victorian industrialism from within the context of its epochal rise. During this time Britain and its Empire saw major transformations in the natural world and in human relations to the natural world, while at the same time new developments in evolutionary theory, geology, and physics were changing ideas and assumptions about nature and the human place within it. Shifts in the English language offer a snapshot of how profound these changes were. As Allen MacDuffie observes, the word 'environment', for example, was first used in its modern sense in 1828 to refer to 'not merely surroundings or context … but rather the vital, ongoing influence of those surroundings upon a person or thing'.[1] The word 'ecology', similarly, was coined in 1866 to capture a more dynamic and interrelational web of associations than the word 'nature' could convey.[2] Even an older word like 'landscape' shows a similar morphological drift in the Victorian period; the oldest English meaning, from the Early Modern period, is 'a picture representing natural inland scenery', a definition that would eventually expand to include 'a view or prospect of natural inland scenery'. But in the Victorian era, under the expanding influence of geological science, a new meaning would emerge: 'a tract of land with its distinguishing characteristics and features, esp. considered as a product of modifying or shaping processes and agents (usually natural)'. (John R. Stilgoe notes that 'landscape' comes 'from the old Frisian language' where it 'once meant shoveled land, land thrown up against the sea', but 'around 1600, literate Englishmen began writing the word as landskip or landskep to identify paintings representing views across water toward land'.[3]) From a vision of 'landscape' as mediated through human representation or the human eye, to a vision of a dynamic Earth subject to continual 'shaping processes and agents', the history of the word captures in miniature the burgeoning idea

of the independent life of the Earth, its vibrancy as well as its vulnerability to anthropogenic influence. Among artists and writers, Morris was one of the first to grasp this new vision and connect it, forebodingly, to the industrialization and capitalization of nature.

For if Victorian Britain was increasingly able to name and comprehend the independent life of the Earth and its sublime interconnectivity, it was at the same time developing a new social base that was profoundly disruptive to that independent life. Living in the context of the first fully fossil-fuel-powered society, Victorian writers and artists were also the first to observe the impacts of coal-fired industry and render them into art. The smoke that pervades Charles Dickens's London and the iconic fog of the Sherlock Holmes stories convey an atmosphere remade in the context of industrialized nature, but only a few authors, including Morris, channelled such observations into a full-throated critique of what was lost and diminished in the process of industrialization. As Morris argued in his 1884 lecture 'Useful Work versus Useless Toil', 'The misery and squalor which we people of civilization bear with so much complacency as a necessary part of the manufacturing system, is just as necessary to the community at large as a proportionate amount of filth would be in the house of a private rich man' (xxiii.114). He compares the wilful industrialization of Britain to a rich man allowing 'cinders to be raked all over his drawing-room, and a privy to be established in each corner of his dining-room' (xxiii.114). Modern industry and commerce, in sum, alienate us from the natural world: 'how rare a holiday it is for any of us to feel ourselves a part of Nature' (xxiii.108).

Morris's 1890 utopian novel *News from Nowhere* would imagine a new society where feelings of natural interconnection make up the texture of everyday experience rather than a short holiday from smoke and pollution. Speaking from the perspective of the postcapitalist future in which most of the novel is set, one character, Clara, describes the life of the nineteenth century as 'a life which was always looking upon everything, except mankind, animate and inanimate – "nature," as people used to call it – as one thing, and mankind as another' (xvi.179). In Nowhere, by contrast, human life is fully enmeshed with 'nature' and with the dynamic cycles of existence that thread through all dimensions of Earthly life. As one character, Dick, explains of his feelings for the rhythms of the seasons, 'I can't look upon [the course of the year] as if I were sitting in a theatre seeing the play going on before me, myself taking no part of it. ... I mean that I am part of it all, and feel the pain as well as the pleasure in my own person' (xvi.206–7).

Clara and Dick's structure of feeling as expressed in such passages could be said to return to a more ancient sentiment regarding the human place in the natural world, for in the longer history of art and literature, landscape and nature were not always conceived as mere backdrop to human drama. Mikhail Bakhtin has described the rise of 'biographical time' in older literatures as a new form that would exert a powerful influence over the development of the European novel. 'Biographical time' describes the individualization and personalization of narrative literature, a narrowing of narrative focus to the private individual, and as Bakhtin explains, the representation of nature transformed as literature adapted to biographical time:

> Even nature itself, drawn into this new private and drawing-room world, begins to change in an essential way. 'Landscape' is born, that is, nature conceived as horizon (what a man sees) and as the environment (the background, the setting) for a completely private, singular individual who does not interact with it. Nature of this kind differs sharply from nature as conceived in a pastoral idyll or georgic – to say nothing of nature in an epic or tragedy. Nature enters the drawing-room world of private individuals only as picturesque 'remnants,' while they are taking a walk, or relaxing or glancing randomly at the surrounding view. These picturesque remnants are woven together … but they [do] not come together to form a single, powerful, animating independent nature complex, such as we see in epic or in tragedy.[4]

Here Bakhtin describes the emergence of literary landscape as backdrop and horizon, as static picture rather than animate force. More recently, Amitav Ghosh has similarly discussed ancient epic as a literary mode capable of depicting animate nature, in sharp contrast to the modern novel with its static environments and carefully delimited horizons.[5] By the Victorian period this static horizon was a well-worn groove in literary form, but Morris's creations work against such formulations in part by reaching back to older artistic modes.

Bakhtin's concept of the 'folkloric chronotope' exemplifies the kind of older aesthetic modes that Morris was engaging, in environmental terms, in works like *News from Nowhere*, *A Dream of John Ball* (1886–7; 1888), and the late romances.[6] With the term 'chronotope' Bakhtin describes how temporal and spatial determinations work together in narrative to create the fictional world; the folkloric chronotope, more specifically, depicts a 'paradise, a Golden Age, a heroic age, an ancient truth', all of which, Bakhtin says, are actually an expression of historical inversion: 'To put [the folkloric chronotope] in somewhat simplified terms, we might say that a

thing that could and in fact must only be realized exclusively in the *future* is here portrayed as something out of the *past*.'[7] This is a helpful heuristic for thinking about the project of *News from Nowhere* in particular, since it is a novel ostensibly set in the post-capitalist future but that depicts characters dressed somewhere between 'the ancient classical costume and the simpler forms of the fourteenth century garments', who live in dwellings 'like mediæval houses of the same materials' (xvi.14, 23). In *News* Morris effectively takes the historic inversion of the folkloric chronotope and turns it inside out, so the future actually *is* set in the future rather than the past, but is still drawn imaginatively by means of the past.

This approach extends to the natural world in Nowhere, which has also gone forward in a way that looks like going back. Nowhere has undergone a process of what we might now call rewilding, returning to a pre-industrial baseline of indeterminate date. The country is full of forests and 'wastes' as well as 'pieces of wild nature' (xvi.74). Like the rewilding projects of today, Nowhere's wild nature is wild nature with a purpose, wild nature with a human end in view; it is a post-industrial wildness rather than mere hearkening back to a time before human mastery.[8] The character Old Hammond explains, 'England was once a country of clearings amongst the woods and wastes', using 'waste' to mean a place simply untouched by humans rather than purposively untouched; 'it then became a country of huge and foul workshops…. It is now a garden, where nothing is wasted and nothing is spoilt' (xvi.72). The oldest meaning of the noun 'waste' is 'uninhabited … country; a wild and desolate region, a desert, wilderness' or 'piece of land not cultivated or used for any purpose'. A bit later, waste also came to mean 'useless expenditure or consumption, squandering'.[9] These conflicting but overlapping meanings suggest an ethic of human use buried in the ideas of land and environment we have inherited from the past: to not use land at all is in some sense equivalent with profligate overuse. The challenge of rewilding projects in this epistemological context is in imagining the use value of non-use. *News* employs the word 'waste' frequently in both its senses, evoking just this question of what counts as use *versus* waste.

We see a similar engagement with the nature of 'waste' in Morris's late romances, which offer a vision of a more pristine Earth, but lightly touched by human industry and agriculture, intermixed with a desire for a more perfect human use of those pristine earthly resources. In *The Wood Beyond the World* (1894), for example, the protagonist, Walter, journeys to a 'Wood beyond the World', travelling through 'waste' to get there (xvii.24). In the chapter 'Walter wends the Waste', he sleeps on grass, drinks from springs,

and bathes in natural pools. After making his way through a landscape 'harsh and void, like the face of the desert itself', he passes over a mountain ridge into a 'lovely land of wooded hills, green plains, and little valleys' (xvii.25, 26). While in this 'wood beyond the world', he lives almost entirely from hunting and foraging – small deer and hare, wild fruits, and cherries abound in this forest of plenty. In the classic pattern of fantasy, a genre that Morris helped create with stories like this, the setting is a world apart, detached from our own reality – a place as yet uninjured by the hallmarks of modern land exploitation: industry, deforestation, enclosure. Yet at the end of the narrative, Walter's lady love gives the gift of agriculture to the uncivilized 'Bear men' who live on this side of the mountains. The Bear men have pastured animals, but not agriculture, until Walter's lady meets them, promises them 'the increase of the earth', and returns in the end to '[tell] them of the art of tillage, and bade them learn it' after which 'they throve and multiplied' (xvii.109, 129). A narrative such as this traffics at once in a fantasy of a premodern nature and an unmediated relation to the natural world, while still acknowledging the inevitability of human intermixing with the Earth and the transformative impacts of human labour. *The Wood Beyond the World* thus positions its fantasy environment in a trajectory of development that equates civilization with agriculture, but not necessarily with industrialism, which Morris saw as the primary threat to the nineteenth-century natural world.

Morris wrote *The Wood Beyond the World* specifically for his Kelmscott Press, and the first edition of this romance was a Kelmscott edition. In his discussion of the folkloric chronotope, Bakhtin is interested in narrative rather than the materials on which narrative is printed and distributed, but his ideas provide insight not only into Morris's fascination with medieval stories, settings, and tropes, but also into the means of production that Morris put into place in backward-looking craft projects like the Kelmscott Press. If we extend Bakhtin's analysis of the folkloric chronotope down to the level of the material, in other words, we can see the Kelmscott Press as an expression of historical inversion where the future is communicated from the materials of the past, and we can see Morris's environmentalism as a material project as well as a political and ideological one; for Morris's aesthetic vision for Kelmscott required the use of pre-industrial methods, handmade materials, and a resolutely materialist attention to the raw substances from which his books would be made.

Kelmscott was a revolt against the conditions of modern capitalist production under which the materials and labour that produce the value of an object had become increasingly obscured. Without mentioning

Morris directly, Amitav Ghosh in *The Great Derangement* identifies an environmental alienation at work in 'the evolution of the printed book', and his words speak to Kelmscott's project of recovery. In nineteenth-century print's 'slow but inexorable excision' of pictorial and design elements, he says, it is as though 'every doorway and window that might allow us to escape the confines of language had to be slammed shut, to make sure that humans had no company in their dwindling world but their own abstractions'.[10] With Kelmscott, Morris not only brought back illuminated borders and coloured inks but he brought back a forceful sense of the book as material rather than abstract, as rooted in environmental materiality. Morris searched diligently to find, for example, the perfect handmade paper to use at his press, settling ultimately on an antique laid, linen rag paper made by the firm Joseph Batchelor and Son, which used preindustrial production processes and no bleaching chemicals. With Emery Walker, Morris visited Batchelor's firm in Kent in October 1890 to scout out paper for the press, and while there, Morris asked to try his hand at papermaking too.[11] The anecdote suggests his keen curiosity about all handicrafts, but also his desire for familiarity with his materials all the way down the supply chain.

Morris's choice of Batchelor's paper dramatically opposed the drift and inclination of print culture in his day. Victorian papermaking had undergone a massive shift in the years leading up to Kelmscott, down to the level of its raw materials. Traditional papermaking used linen or cotton rags, while industrial papermaking as it developed in nineteenth-century Britain relied on esparto grass from North Africa and Spain or on wood pulp that originated mostly in Canadian and Scandinavian forests. These new globally sourced materials were produced and extracted in environmentally heedless ways, with little care for the forests and ecosystems that bore the brunt of the massive increase in the tons of paper produced in Britain from 1870 to 1900.[12] Morris's careful attention to the origins of Kelmscott's paper is thus particularly significant when we position it against the backdrop of this print revolution, a revolution that his press rejected so vociferously.

Kelmscott paper was laid paper rather than wove, which provided its characteristic texture and depth; laid lines, chain lines, and watermarks made the work of the paper's production shine through in artisanal fashion. As Richard Menke has argued in a recent article on the ecologies of Victorian paper, 'Paper is no *tabula rasa*: blank, neutral, ignorable. Rather, it is the industrial, material, and ecological *a priori* of the forms of culture and commerce [that were] built upon these thin layers of matted

cellulose fiber.'[13] Kelmscott's paper, too, is no *tabula rasa*; it tells a story we can only read by positioning it in the broader ecology of nineteenth-century papermaking and resource extraction. The story concerns an industry that had previously depended for its raw materials on recycled rags and old clothing, renewable materials, rather than appropriated land and deforestation; it is a story about what Jason Moore calls the 'cheap nature' of industrial capitalism, the drive to extract labour and material from the natural world at a global scale for maximum profit.[14]

Morris's concern for his raw materials also extended to Kelmscott's inks, which were similarly old-fashioned and free of modern chemical formulations, but a closer look at these inks suggests that Morris's commitment to using pre-industrial materials did not necessarily always lead to environmentally responsible choices.[15] He went through a few different suppliers for Kelmscott's black ink before finding one from Hanover that was, according to Kelmscott secretary Henry Halliday Sparling, 'made of the old-fashioned pure materials' that Morris sought. Morris found sourcing ink to be 'more troublesome than anything else', Sparling says, because 'the chemist had wrought infinite mischief' in ink-making (Sparling, 65). Sydney Cockerell, another Kelmscott secretary, recalls that Morris 'often spoke of making his own ink, in order to be certain of the ingredients, but his intention was never carried out'.[16] If Morris had undertaken to make his own ink and secure his own ingredients, it might have led him into some difficult questions about the use of traditional materials at the press, for, as the example of Kelmscott's red ink suggests, Morris was highly sensitive to the desecrations of coal-powered industrial capitalism but perhaps less alert to the forms of environmental harm that accompanied pre-industrial commodities rooted in older forms of exploitation.

Kelmscott's red ink was a vermillion made by a British firm, primarily used for titles and special effects. William H. Bowden, overseer of the Kelmscott printers, describes it as 'a beautiful, full-bodied red, and free of any impurities. It has none of the carroty appearance of the usual commercial ink.'[17] An 1871 article from a chemical trade magazine explains that vermillion can appear in 'different shades, from a deep red to an almost light orange', depending on 'the size of the crystals' in its chemical makeup. 'The larger the crystals, the deeper the color', and the redder the vermillion, the more valuable it was.[18] Kelmscott's vermillion, free of impurities and featuring a deep red hue, met Morris's aesthetic standards, but vermillion was not by virtue of such purity a responsible commodity. Vermillion is the pigment that comes from cinnabar, a mineral that is chemically known as mercuric sulphide. Cinnabar is highly toxic because

of its mercury component, and traditionally much of Europe's vermillion had originated in Spain's Almadén mine – a mine with a history of slave and convict labour because of the illness, madness, and death from mercury poisoning that plagued its mineworkers.[19]

In an article on Kelmscott's inks, William Peterson writes that the red ink was 'manufactured in a large, technologically advanced factory', which he considers an affront to Morris's 'arts-and-crafts purity', but to me the more interesting problem is that the ink relies for its colour on a traditional material basis – vermillion, or cinnabar – which had been mined in Europe at least since the Roman Empire but is toxic to human health and has a long history of violent and oppressive extraction.[20] To trace Kelmscott's red ink only as far as the British factory is to separate the ink from the commodity and supply chains that connect it, ultimately, back to the Earth and to the subterranean minerals that compromised the health of the workers who dug them up. Nineteenth-century cinnabar was primarily sourced from Spain, Eastern Europe, China, North Africa, and the Americas, but British firms participated in its global extraction and trade. A search through the archive of the London *Times* shows that specimens of cinnabar were often featured in the colonial exhibitions of Victorian London, and reports regularly appear in *The Times* concerning the potential profits for investors in cinnabar mining in such places as Peru, South Africa, British North Borneo, Australia, and the Guizhou province of China. In a discussion of cinnabar and other rich mineral resources in South Africa, for example, an 1892 article in *The Times* states, 'Never was there a country to which the saying of Job could be more suggestively applied: "…Iron is taken out of the earth, and brass is molten out of the stone."'[21] In 1892, when this article appeared, South Africa was undergoing a period of history known as the Mineral Revolution, a surge in industrial mining led by imperial Britain; meanwhile, Kelmscott had only just printed its first book using red ink, *Poems by the Way* (1891). As this suggests, for Morris's audience vermillion was a commodity rather than a mineral, and, indeed, in Morris's own letters the only reference to mercury pigments is in an 1876 letter to Thomas Wardle about textile dye (*CL*, 301–2).

As a political craftsman, Morris has been accused over the years of both uncompromising purism and pragmatic hypocrisy. His subsequent critics have held all his work's materials up to the light of history for ruthless ethical scrutiny, from motives that Morris himself surely would have approved. Kelmscott's red ink is in this sense merely another reminder that Morris swam in the waters of anthropogenic toxicity even while he

recognized and criticized its environmental effects; given the time in which he lived, it could hardly have been otherwise. Morris lived at the heyday of coal capitalism, when Britain's imperial resource frontiers extended to their most expansive reach. His philosophy of materials prioritized a return to premodern and pre-industrial materials where possible, in reaction against industrial capitalism, but as we see with Kelmscott's vermillion, this approach did not necessarily extricate him from the ethically compromised circuits of capital out of which the industrial era was born. Kelmscott can be viewed, nonetheless, as a print experiment based on the premise that the raw materials of production are as politically significant as the product – a key contribution to environmental thought.

News from Nowhere – as one of the great novels of eco-socialism – is also a key contribution to environmental thought, and it was part of Morris's original vision for the press to create a Kelmscott edition of the book. *News from Nowhere* had originally been serialized in the Socialist League newspaper *Commonweal* before being published shortly thereafter in a volume edition by Reeves and Turner, and one of the changes to the text that Morris made in his 1892 Kelmscott version was to place vermillion shoulder-notes at the top of each page, summarizing the action. One such red shoulder-note reads 'A man from another planet', seemingly locating this backward-looking agrarian utopia, printed on an archaic hand-press, in the futuristic realm of the planetary romance subgenre.[22] The note underscores a running planetary motif in the novel, for when protagonist William Guest arrives in Nowhere he tells Old Hammond to speak to him 'as if I were a being from another planet' (xvi.54). Hammond goes on to refer to Guest seven times as 'a man from another planet', and Guest himself reflects, 'I really was a being from another planet' (xvi.135). From gloomy Victorian London, Guest has come to a future imbued with 'the spirit of the new days', the essence of which, as one character explains, is 'delight in the life of the world; intense and overweening love of the very skin and surface of the earth on which man dwells, such as a lover has in the fair flesh of the woman he loves' (xvi.132).

Why would Morris include a touch of the planetary romance genre in a novel that seems so very earthly? The 'man from another planet' line is a sharp reminder of the planetary medium of this paradise and of the fundamental ecological dependency of any society, utopian or otherwise. All social organization is for naught if we cannot find a way to live in the context of our planetary home, and yet, as Dipesh Chakrabarty writes, 'to encounter the planet is to encounter something that is the condition of human existence and yet profoundly indifferent to that existence'.[23]

The characters in *News* seem to recognize, even celebrate, this condition of profound dependency, as we see in Ellen's climactic cry at the end of the novel: 'O me! O me! How I love the earth, and the seasons, and weather, and all things that deal with it, and all that grows out of it … The earth and the growth of it and the life of it! If I could but say or show how I love it!' (xvi.202). The declaration irritated an early reviewer, who objected to the idea that such 'a strong utterance' would be made merely about the 'luxuriant development of matter'. In this 1891 review, titled 'A Materialist's Paradise', Maurice Hewlett griped that Morris 'exaggerated the dependence of human nature upon its environment', and that he 'is convinced that the conditions of human welfare are physical'.[24] In its very obtuseness, the review clarifies the environmental stakes of Morris's work.[25]

Morris's environmentalism feels remarkably timely today, and as this review suggests, remarkably unusual for a man of his day. How did he develop such unusually keen insights into the problems of industrialized nature? A quick survey of his biography suggests several possible origin points. As a child, he grew up on the edge of Epping Forest and rambled in its paths. As a student, he inherited his family's lucrative shares in the Devon Great Consols copper mine, and though the dividends enabled him to devote his life to art and poetry, he would eventually divest himself of the shares.[26] In mid-life, he became increasingly dispirited with industrial capitalism's encroachments into England's natural environment and architectural heritage, and involved himself in such causes as historic preservation and the protection of the commons, which eventually developed into a more systematic anti-capitalist philosophy. Today we can position Morris in a trajectory of eco-socialist environmental thought that also includes more recent figures such as Rebecca Solnit and George Monbiot, and recognize that he was among the first within this tradition to articulate an anti-capitalist position by means of environmental critique.

Notes

1 Allen MacDuffie, 'Environment', *Victorian Literature and Culture*, 46.3/4 (2018), 681–4.

2 Elizabeth Carolyn Miller, 'Ecology', *Victorian Literature and Culture*, 46.3/4 (2018), 653–6.

3 J. R. Stilgoe, *What Is Landscape?* (Cambridge, MA: MIT Press, 2015), 2, 4.

4 M. M. Bakhtin, *The Dialogic Imagination: Four Essays*, ed. Michael Holquist, trans. Caryl Emerson and Michael Holquist (Austin: University of Texas Press, 1981), 143–4.

5 Amitav Ghosh, *The Great Derangement: Climate Change and the Unthinkable* (Chicago: University of Chicago Press, 2016).

6 On *News from Nowhere* and Bakhtin's idyllic chronotope, see Marcus Waithe, '*News from Nowhere*, Utopia and Bakhtin's Idyllic Chronotope', *Textual Practice*, 16.3 (2002), 459–72.

7 Bakhtin, *Dialogic Imagination*, 147.

8 On rewilding, see, for example, Isabella Tree, *Wilding: The Return of Nature to a British Farm* (London: Picador, 2018). For more on anthropogenic wilderness, see Jesse Oak Taylor, 'Wilderness after Nature: Conrad, Empire, and the Anthropocene', in Lissa Schneider-Rebozo, Jeffrey Mathes McCarthy, and John G. Peters (eds), *Conrad and Nature* (New York: Routledge, 2019), 21–42. On human control over natural systems in Nowhere, see Benjamin Morgan, 'How We Might Live: Utopian Ecology in William Morris and Samuel Butler', in Nathan K. Hensley and Philip Steer (eds), *Ecological Form: System and Aesthetics in the Age of Empire* (New York: Fordham University Press, 2019), 139–60.

9 'waste, n.' *Oxford English Dictionary* Online (June 2021). Oxford University Press. www.oed.com/view/Entry/226027?rskey=2Ac1Ep&result=1&isAdvanced=false (last accessed 23 July 2021).

10 Ghosh, *Great Derangement*, 84.

11 William Peterson, *A Bibliography of the Kelmscott Press* (Oxford: Clarendon, 1984).

12 On the rise of industrial papermaking and the shift in papermaking materials, see Richard L. Hills, *Papermaking in Britain, 1488–1988* (London: Athlone, 1988).

13 Richard Menke, '*New Grub Street*'s Ecologies of Paper', *Victorian Studies*, 61.1 (2018), 78.

14 Jason W. Moore, *Capitalism in the Web of Life: Ecology and the Accumulation of Capital* (London: Verso, 2015).

15 For more on ink's history, see C. H. Bloy, *A History of Printing Ink: Balls and Rollers, 1440–1850* (London: Wynkyn de Worde, 1967).

16 S. C. Cockerell, 'A Short History and Description of the Kelmscott Press' (rpt. in Sparling, 146).

17 Quoted in William S. Peterson, 'William Morris and the "Damned Chemists": The Search for an Ideal Ink at the Kelmscott Press', *Printing History*, 3.2 (1981), 7.

18 M. Alsberg, 'Observations on the Manufacture of Vermillion', *American Journal of Pharmacy* (April 1871), 162. Reprinted from London's *Chemical News* (17 February 1870).

19 David M. Gitlitz, *Living in Silverado: Secret Jews in the Silver Mining Towns of Colonial Mexico* (Albuquerque: University of New Mexico Press, 2019), 53–4.

20 Peterson, 'William Morris and the "Damned Chemists"', 8. On Morris's firm's use of arsenic in their green wallpapers, and possible connections here to his family's own economic dependence on arsenic mining, see my article 'William Morris, Extraction Capitalism, and the Aesthetics of Surface', *Victorian Studies*, 57.3 (2015), 395–404. See also the section on Morris and mining in my book, *Extraction Ecologies and the Literature of the Long Exhaustion* (Princeton University Press, 2021), 169–77.

21 'Letters from South Africa', *Times* (8 August 1892), 3.

22 William Morris, *News from Nowhere* (Hammersmith: Kelmscott, 1892), 77. (Other *News* citations refer to May Morris's *Collected Works of William Morris*.) Darko Suvin describes the planetary romance as a key subgenre of science fiction in which other planets serve as narrative settings or actors. Suvin, *Metamorphoses of Science Fiction: On the Poetics and History of a Literary Genre* (New Haven, CT: Yale University Press, 1979), 103. Six years after the Kelmscott edition of *News* appeared, H. G. Wells would release *War of the Worlds* (1898), one of the most iconic of planetary romance novels.

23 Dipesh Chakrabarty, 'The Planet: An Emergent Humanist Category', *Critical Inquiry*, 46.1 (Autumn 2019), 4.

24 Maurice Hewlett, 'A Materialist's Paradise', *National Review*, 102 (August 1891), 822, 819.

25 On Morris and aesthetic materialism, see Benjamin Morgan, *The Outward Mind: Materialist Aesthetics in Victorian Science and Literature* (Chicago: University of Chicago Press, 2017).

26 On this topic see my book, *Extraction Ecologies*, especially the section on Morris and *News from Nowhere* (169–77).

PART V

Influences and Legacies

Morris and John Ruskin

Stuart Eagles

'"Art is man's expression of his joy in labour." If those are not Professor Ruskin's words', Morris insisted in 1883, 'they embody at least his teaching on this subject' (xxiii.173). The concept of pleasure in work is at the heart of Ruskinian Gothic and pulses through Ruskin's life-long influence on Morris.[1] It derives from the medieval and aesthetic roots of their political thought and invigorates their criticism of capitalist society. As Morris acknowledged in 1892, 'the realization of pleasure in labour' was 'the key to the problem with which Ruskin was provided' (*WMAWS*, i.294): work, Ruskin taught, must please the worker and his God as well, uncorrupted by 'the "Goddess of Getting-on," or "Britannia of the Market"' (Ruskin, xviii.448). Moreover, both figures found their way to politics through art, and especially architecture. With this trajectory in mind, it is not surprising that each saw the political economy of art as indivisible from the art of political economy.

Yet Ruskin was a Tory with a deep, if conflicted, Christian faith which was the spiritual source of his moral vision. Morris, by contrast, came to believe that only socialist revolution could deliver the new society. It is all the more striking, then, that Morris's invocation of Ruskin's core message in 1883 a foundational element in his pivotal lecture in the hall of University College, Oxford, on 'Art under Plutocracy': this being the occasion on which Morris, the artist, poet, craftsman, designer, businessman, and disaffected Liberal, declared for socialism. Although Ruskin was present – indeed, it was one of the relatively few occasions on which the two men met – Morris's host was the Russell Club, a 'hitherto comparatively little known' group of Liberal undergraduates with Radical sympathies.[2] It was Liberalism, of course, that Morris was now leaving behind. Having joined H. M. Hyndman's Democratic Federation at the start of the year, he proudly described himself as 'a member of a Socialist propaganda' and begged his Oxford audience 'to renounce their class pretensions and cast in their lot with the working men' (xxiii.190). At the very

least they could donate money to further 'the cause' (xxiii.191). He wanted 'to foster [their] discontent' with the prevailing order (xxiii.181). Ruskin neither chaired the meeting nor definitely smoothed ruffled feathers as many scholars have claimed.[3] Far from voicing disapproval, though, he spoke to second the vote of thanks to Morris.

A new socialist spirit emerged in the 1880s alongside a growing movement to reform social conditions: Karl Marx had died in March 1883 and Morris had been reading *Capital* in French. In his lecture, Morris was clear that the 'continuous and unresting' war waged by commercial competition on the working class had to be ended (xxiii.187). (He used the word 'war' nine times.) His remedy was a 'reconstructive Socialism' that would bring about the 'new birth of society' (xxiii.189) and the 'new birth of art' (xxiii.173, 188). Morris thus folded Ruskin and Marx into a new blend. Art, Morris insisted, encompasses painting, sculpture, and architecture, as well as household objects, and what we would now call the built environment and the natural world. And he powerfully echoed Ruskin's Christian notion, expressed in *The Seven Lamps of Architecture* (1849), of 'the great entail', according to which 'God has lent us the earth for our life', but it 'belongs as much to those who are to come after us' (Ruskin viii.233). The beauties of the world do not 'belong to us', Morris likewise insisted, lamenting the careless destruction of Oxford, that 'most precious jewel': rather, we are 'trustees ... for all posterity' (xxiii.171). When Morris launched the Society for the Protection of Ancient Buildings in 1877 it was Ruskin's inspirational prose that gave authority and force to the campaign.

Referring to the Plutocracy lecture, the *Oxford Magazine* pointed out that Morris had 'always been the first to acknowledge that there is nothing in his lectures that is not an echo of Ruskin's teaching'.[4] That is an exaggeration, but the influence on Morris of Ruskin's reading of architecture, art, and society, especially in 'The Nature of Gothic', the central chapter of *The Stones of Venice* (1851–3), was vital and profound. To many who read it, Morris later wrote, 'it seemed to point out a new road on which the world should travel' (*WMAWS*, i.292). He read it aloud as a student, and it impelled him towards a career in architecture while his friend Edward Burne-Jones decided to become a painter. In 1892 the chapter became the fourth publication issued by Morris's Kelmscott Press. He wrote in his preface that it was 'one of the very few necessary and inevitable utterances of this century' (*WMAWS*, i.292).

In his Plutocracy lecture, and in many of the lectures he had given since 1877, especially those collected in *Hopes and Fears for Art* (1882), Morris followed Ruskin in arguing that the artistic achievements of the medieval

craftsmen who worked on the Gothic cathedrals were unsurpassed. They had been made possible by the joyful conditions in which the artisans worked. The mason was free to express his individuality in striking the stone, but he worked collaboratively to create beautiful art for the benefit of the community. Morris commended this as 'the harmonious co-operation of free intelligence' (xxiii.177). It contrasted sharply with the oppressive conditions demanded by the commercially competitive system of nineteenth-century industrial capitalism. Morris acknowledged the 'grievous material oppression' suffered in the Middle Ages, but considered differences of status to be 'arbitrary rather than real' (xxiii.175): it was 'a wall built by law' as Ruskin put it (Ruskin x.194). Craftsmen collaborating in a community simultaneously transcended class and avoided atomized individualism by means of their creative work.

Ruskin declared that though there had never been 'so much sympathy' between the upper and lower classes as there was in the mid-nineteenth century, the separation was 'a veritable difference in level of standing, a precipice between upper and lower grounds in the field of humanity, and', he warned, 'there is pestilential air at the bottom of it' (Ruskin x.194). Modern masons followed the architect's plan and had no creative freedom at all. The wage-slave felt no bond of affection for an unsympathetic and unimaginative so-called superior. Drawing on Carlyle's view of feudalism, Ruskin considered that the submission of honest workers to wise masters in the hierarchical order of the Middle Ages was 'not slavery' at all, but 'often the best kind of liberty – liberty from care' (Ruskin, x.194).

The 'machine system, the system of the Factory' (xxiii.178), on the other hand, was an inevitable demand for drudgery because, Morris said, 'the profit of the capitalist' (xxiii.180) became 'an end in itself' (xxiii.178). Art began its descent with the Renaissance: although glorified by the five pre-ceding centuries on which it was built, it spelt 'the death of art and not its birth' (xxiii.179). Individual self-expression within a creative community was replaced by selfish, atomized individualism. Instead of giving plea-sure, work demanded by the interests of commerce caused 'unhappiness', a word repeated by Morris three times in quick succession (xxiii.179), and 'nothing should be made which does not give pleasure to the maker and the user' (xxiii.186). When Morris had made much the same point in 1877, in the lecture later published as 'The Lesser Arts', he referred to his 'friend Professor John Ruskin', and modestly conceded that what he had to say could 'scarcely be more than an echo' of that chapter, "The Nature of Gothic"': 'the most eloquent words that can possibly be said on the sub-ject' (xxii.5). Repeating the point in 1881, in his lecture 'The Prospects of

Architecture in Civilization', he added, significantly, that for 'all Ruskin's fire and eloquence' the great truth he had told, 'a truth so fertile of consequences', had not yet been widely accepted (xxii.141). Morris speculated that perhaps this was because people feared that to heed Ruskin's warning 'would either compel them to act on it or confess themselves slothful and cowardly' (xxii.140). Ruskin's message was so important, Morris claimed, that the words 'should have been posted up in every school of art throughout the country; nay, in every association of English-speaking people which professes in any way to further the culture of mankind' (xxii.140). As a disciple of Ruskin, Morris was remarkable for embodying the medieval spirit of Ruskinian Gothic in the dizzying range of arts and crafts he mastered in the course of his extraordinarily energetic and varied life.

'It is not that men are ill fed', Ruskin wrote in 'The Nature of Gothic', 'but that they have no pleasure in the work by which they make their bread, and therefore look to wealth as the only means of pleasure' (Ruskin x.194). This was an argument Morris developed in his Plutocracy lecture. He stated that 'if pleasure in labour be generally possible, what a strange folly it must be for men to consent to labour without pleasure'; moreover, 'what a hideous injustice it must be for society to compel most men to labour without pleasure!' (xxiii.173) What made work so miserable in the mechanical world of the factory system was that instead of using 'the whole of a man for the production of a piece of goods', it used 'small portions of many men'; instead of developing 'the workman's whole intelligence according to his capacity', he was forced to concentrate 'his energy on one-sided dealing with a trifling piece of work': the 'hand and soul of the workman' had been sacrificed to 'the necessities of the competitive market' instead of being afforded 'freedom for due human development' (xxiii.176).

Morris, in this respect, was re-stating Ruskin's well-known attack on the factory system, in which he challenged the division of labour by directly confronting Adam Smith's example of pin manufacture:

> It is not, truly speaking, the labour that is divided; but the men;—Divided into mere segments of men—broken into small fragments and crumbs of life; so that all the little piece of intelligence that is left in a man is not enough to make a pin, or a nail, but exhausts itself in making the point of a pin or the head of a nail. (Ruskin x.196)

For both men, the only labour capable of producing happiness is creative work. It promotes order and unity by considering the whole workman as an organism in sympathy with nature. Specialized machine labour, which

is fragmentary and soulless, seeks profanely to improve nature –human and environmental – in a pretence of perfection. 'You must either make a tool of the creature, or a man of him', Ruskin warned. 'You cannot make both' (Ruskin, x.192). Morris also weighed mental and manual labour in his Plutocracy lecture. He shared Ruskin's regret that modern society destructively distinguished the gentleman from the operative. 'We want one man to be always thinking, and another to be always working', Ruskin argued, 'whereas the workman ought often to be thinking, and the thinker often to be working, and both should be gentlemen, in the best sense' (Ruskin x.201). In 'the times of art' as Morris called the Middle Ages, 'Intellectual' and 'Decorative Art' had existed in a vital bond (xxiii.168). In evidence, he cited St Mark's Basilica, Venice, the building so close to Ruskin's heart in that 'Paradise of cities' (Ruskin, xxxv.296), and central to the argument of *The Stones of Venice*.

As influential as 'The Nature of Gothic' was in Morris's thinking about art and craftsmanship, work and society, it reveals a crucial difference between Ruskin and Morris. The source of Ruskin's moral vision was the Bible. Brought up an Evangelical Protestant, the certainty of his religious faith was admittedly already under strain in 1851 when he decried the geologists' 'dreadful Hammers!' and explained that 'I can hear the chink of them at the end of every cadence of the Bible verses' (Ruskin xxxvi.115). Yet even after Ruskin abandoned his formal training in 1858, his broader Christian faith remained vitally important. Ruskin's evangelicalism was a crucial element in his conception of the nature of gothic. He believed in the Christian doctrine of original sin, which fostered an acceptance of imperfection as fundamental to the human condition. It is this acceptance that drives man's yearning for salvation which is at its most glorious when it energizes creative capacity, motivates the refinement of skill, and inspires the production of the greatest achievements of art. Ruskin insisted that only the imperfect work of the hand could be true to the material being worked, because only the sympathy of feeling thus facilitated could do justice to its inherent qualities. Efforts towards mechanical perfection were formulaic, repetitive, unthinking: not merely pretentious and unimaginative, but fraudulent, even blasphemous. Although the religious roots of such ideas were more remote for Morris, the effect of competitive commerce and capitalism was just as plain to him. This was so-called civilization, and he abhorred it.

In 1871 Ruskin told his Oxford students, 'The art of any country *is the exponent of its social and political virtues*' (Ruskin, xx.39). Contemporary art was worthless in a society imperilled by moral vacuity and manifest

injustice. This was most obvious in a nation's buildings, which should express the relationship between landscape and human need. Gothic craftsmen worked in the towns and cities of the Middle Ages in a shared spirit of admiration and reverence for the divine beauty of the natural world. Their imaginative communion with nature provided consolation for physical separation from the countryside. As a romantic anti-capitalist, Ruskin blamed the cash nexus for demeaning work and degrading the workman, and for displacing people by making them ever more remote from nature. Worse, mechanized industry was destroying the natural world by disfiguring the landscape, befouling the rivers and polluting the air. What Ruskin came to call the storm-cloud of the nineteenth century threatened to devastate the Earth.

For Ruskin, redemption lay in the restoration of creative freedom and a return to small communities based on the land. This would revive admiration of beauty and inspire moral regeneration. He attempted to demonstrate these principles by instigating a series of localized but exemplary experiments. In 1871 he founded a charitable society later called the Guild of St George. He established some agricultural settlements, encouraged the revival of some traditional handicrafts, and set up an educational museum in Sheffield to inspire its artisans with the beauty of nature by means of an exemplary art collection. Ruskin's quest was for a new Eden in which man and nature were in sympathy, and the good of the community was ensured by bonds of social affection. Morris's Arcadian vision in *News from Nowhere* (1890; 1891) differed little except in the revolutionary path that was pursued to reach his utopia.

Morris strove like Ruskin to reinvigorate the harmonies of the pre-industrial, pre-capitalist world. But, unlike Ruskin, Morris was convinced from 1883 that the answer lay in supporting the workers in the class struggle. It was 'the only lever for bringing about the change', he wrote in 1885, in a letter in which he regretted that Ruskin did 'not understand this matter of classes' (*CL*, ii.462). Morris believed that the commonweal could only be recuperated by means of a socialist revolution. A socialist society would revitalize the true spirit of fellowship.

It is notable that Morris invoked Ruskin in his Plutocracy lecture shortly after he proclaimed his socialism. Whilst it is surely true, as Tony Pinkney points out, that Morris thereby 'shrewdly folded back into a more familiar tradition', Morris was also, to some extent and perhaps unconsciously, implicating Ruskin in his revolutionary socialist solution.[5] This was despite fully understanding that Ruskin was not a socialist – at any rate, in his judgement, certainly not a 'practical' one (*CL*, ii.305). Ruskin had refused

Morris's invitation to join the Democratic Federation in April 1883. But at his most radical, at the time of the Paris Commune, Ruskin wrote that the truly 'guilty Thieves of Europe' were 'the Capitalists': 'people who live by percentages on the labour of others; instead of by fair wages for their own': the '*Real* war in Europe, of which this fighting in Paris is the Inauguration, is between these and the workman, such as these have made him' (Ruskin, xxvii.127). However, he was not after all recruited to the class struggle. The aesthetic trumped the economic, and he quickly retreated in fear of the destructive potential of a violent working class when he heard of the burning of the Louvre. Yet Ruskin came closer here, in July 1871, to the later Morris than he would ever be again.

The growing political distance between the Tory Ruskin and the socialist Morris did not dilute their mutual affection. Morris continued keenly to credit Ruskin with laying the foundations from which he launched into socialism: 'how deadly dull the world would have been twenty years ago but for Ruskin!' he wrote in 'How I Became a Socialist' (1894). 'It was through him that I learned to give form to my discontent, which I must say was not by any means vague' (xxiii.279). In 1886, in an editorial note for *The Commonweal*, he recognized Ruskin's weaknesses but emphasized his strengths: 'I think that whatever damage Ruskin may have done to his influence by strange bursts of fantastic perversity, he has shown much insight even into economical matters, and am sure he has made many Socialists; his feeling against Commercialism is absolutely genuine, and his expression of it most valuable.'[6]

Morris's absorption of Ruskin's philosophy of beauty made him a uniquely Ruskinian Marxist. Yet he surely detected affinities between Ruskin and Marx. Ruskin was a different type of materialist who saw God in the stones of Venice, but he was grieved that the multitude had been made into wage-slaves forced 'to feed the factory smoke' (Ruskin, x.193). Capitalists greedily pursued profit at the expense of Life itself. Independently of Marx, and long before Marx's theories were available in English, Ruskin recognized that when a man was robbed of the value of his labour the result was alienation. As E. P. Thompson pointed out, Marx, like Ruskin, wrote that the means of production under capitalism deprived men of their pleasure in labour, and the similarity of ideas and imagery is striking: 'they mutilate the labourer into a fragment of a man', Marx wrote,

> degrade him to the level of an appendage of a machine, destroy every rem-
> nant of charm in his work, and turn it into a hated toil; they estrange from
> him the intellectual potentialities of the labour-process in the same propor-
> tion as science is incorporated in it as an independent power; they distort the

conditions under which he works, subject him during the labour-process to a despotism the more hateful for its meanness; they transform his life-time into working-time, and drag his wife and child beneath the wheels of the Juggernaut of capital.[7]

Both Ruskin and Morris went on a political journey. Morris first became actively engaged in politics in 1876 as the treasurer of the Eastern Question Association, but it was another seven years before he publicly announced his arrival as a socialist campaigner. Ruskin's ideas had also evolved over time. Morris pointed out in 1892 that 'The Nature of Gothic' initiated Ruskin into 'ethical and political considerations' which since then had 'never been absent from his criticism of art', and the project was 'brought to its culmination in the great book *Unto this Last*' (*WMAWS*, i.295). It was in *Unto this Last* (1860; 1862) that Ruskin stated the timeless moral of his political philosophy, emphasizing it in block capitals: 'THERE IS NO WEALTH BUT LIFE' (Ruskin, xvii.105). For Ruskin and for Morris, 'Life' was the touchstone of true value. Ruskin's concept of 'Life' included 'all its powers of love, of joy, and of admiration', and a truly rich country 'nourishes the greatest number of noble and happy human beings' (Ruskin, xvii.105).

Ruskin was reportedly met with 'immense enthusiasm' when he rose after Morris's Plutocracy lecture and praised him as 'the great conceiver and doer, the man at once a poet, an artist, and a workman, and his old and dear friend' (Ruskin, xxxiii.390n1). According to Sir Sydney Cockerell, Ruskin later described Morris as 'beaten gold' and later still as 'the ablest man of his time' (Mackail, vi). To that extent, Ruskin's reply is not surprising, but coming after Morris's first explicit socialist appeal, in which Ruskin's own analysis of art and labour had been explicitly invoked, his 'warmly-appreciative speech', as the *Christian Socialist* characterized it, certainly constituted no kind of violent Tory reaction.[8] Nevertheless, the *Oxford Magazine* commented that, though Morris's Ruskinian analysis was fair enough, 'to tack on to the new gospel the programme of the *Democratic Federation* is only to discredit the gospel itself'.[9] Ruskin went on in his response to Morris to commend neighbourly love, and to quote the Bible and Milton. He 'agreed with' Morris, he said, in 'imploring the young men who were being educated here, and their wives, to seek, in true unity and love for one another, the best direction for the great forces which, like an evil aurora, were lighting the world, and thus to bring about the peace which passeth all understanding' (Ruskin xxxiii.390n1). Ruskin thus re-emphasized the Christian source of his own moral objection to capitalist society, the aspect of his thinking that most clearly distinguished

Morris from him. The local press did not quote Ruskin directly but gave a stronger sense of how far Ruskin was from being a revolutionary: 'Professor Ruskin agreed with all that Mr Morris had said, *but* urged that whatever the outcome of things might be let all be actuated by feelings of love, and strive to bring about universal peace.'[10] The *Oxford Magazine* was surely right to describe the occasion as '[a]n interesting little piece of history' when Ruskin 'pronounced a sort of benediction over his pupil'.[11]

Ruskin extended his response three days later in his lecture 'The Hill-Side' on the modern English landscape school. The *Pall Mall Gazette* speculated that Morris's lecture had 'made a deep impression on Mr Ruskin' such that part of the lecture was 'apparently rewritten in order to bring in a reference to Mr Morris'.[12] Ruskin advanced a familiar argument: landscape art was impossible in a country with 'towns twenty miles wide' connected by underground railways (Ruskin, xxxiii.371), in which artists represented nature with 'whitewash and a pot of gas-tar' (Ruskin, xxxiii.381). Following Morris in looking at how Oxford had been defaced by commercialism, he endorsed the central thrust of Morris's lecture. Art was not about 'saleability' and no-one should make his artistic skill 'a source of income', not because the labourer is unworthy 'of his hire', but because his heart must not be 'the heart of an hireling' (Ruskin, xxxiii.391): it violated the command in Proverbs 23.23, 'Buy the Truth, and sell it not' (Ruskin, xxxiii.391).

Taking the examples of George Robson and Copley Fielding, Ruskin argued that nowhere could you 'see enforced with any sweeter emphasis the truth on which Mr Morris dwelt so earnestly in his recent address to you – that the excellence of the work is, *cæteris paribus*, in proportion to the joy of the workman' (Ruskin, xxxiii.386). Criticizing the commercial spirit of contemporary art, Ruskin remarked on the 'significant change' Morris had made to his lecture title by substituting 'Plutocracy' for 'Democracy'.[13] Once again emphasizing the Christian foundation of his moral vision, he said that the change

> strikes at the root of the whole matter; and with wider sweep of blow than [Morris] permitted himself to give his words. The changes which he so deeply deplored, and so grandly resented, in this once loveliest city, are due wholly to the deadly fact that her power is now dependent on the Plutocracy of Knowledge, instead of its Divinity. (Ruskin xxxiii.390)

If, in his Plutocracy lecture, Morris was in some sense passing on to the students of Oxford the baton he had taken from Ruskin, then it is notable that, however indebted to Ruskin and Morris those students and

subsequent generations would feel, most of them would look to a reform-
ist agenda for the solution to Britain's social and political problems, and
would invest hope in the parliamentary palaver and liberal platitudes that
Ruskin and Morris deplored. In their view, capitalism should not be pal-
liated by reform. However numerous were the 'men who may hope to
become small masters', they would always leave a working class behind
them (xxiii.188).

 With this analysis in view, it is striking that Ruskin first got to know
Morris personally when he agreed to teach the drawing class at the
London Working Men's College. He did not subscribe to the Christian
Socialist aims of its founders but nevertheless consented to their request
to re-print 'The Nature of Gothic' in cheap pamphlet form as a type of
manifesto. Ruskin made it clear that his aim was 'directed not to making
a carpenter an artist, but to making him happier as a carpenter' (Ruskin,
xiii.553). This meant restoring to the artisan the freedom of thought and
imagination characteristic of the Middle Ages but lost under capital-
ism. Arthur Quiller-Couch would lampoon such a programme when
he quipped that for 'some weeks' after Morris's Plutocracy lecture, 'a
few enthusiasts tried to persuade their comrades that the social prob-
lem could be solved by importing another Black Death and enrolling
the survivors in Guilds'.[14] By contrast, the principal proponents of guild
socialism, especially G. D. H. Cole, took the ideas of Morris and Ruskin
seriously. They wanted workers to be given collective control of their
industries and placed in a relationship with the public that would restore
the pre-capitalist sense of agency and community. However, although
guild socialism gained popularity in the early twentieth century, its
influence was short-lived.

 Notwithstanding the considerable sympathy between Ruskin and
Morris, it must be admitted that they took little interest in each other's
practical efforts. Aside from stained glass, Ruskin scarcely noticed Morris's
mastery of so many arts and handicrafts, nor his work as a designer, nor
the products of the Firm. For his part, Morris seldom referred to Ruskin's
'letters to the workmen and labourers of Great Britain', *Fors Clavigera*
(1871–84). He virtually ignored Ruskin's Guild, though in 1889, under
his editorship, *The Commonweal* did publish some valuable if unflatter-
ing accounts of the failure of a farming colony Ruskin founded at Totley.
Scholars have neglected the fact that Morris visited Ruskin's museum
when he was in Sheffield to promote the Socialist League at the end of
February 1886 (easily missed, because the only evidence of it is his signa-
ture in the visitors' book).[15]

The Kelmscott Edition of *The Nature of Gothic*, the result of an act of devotion, embodies Morris's values and Ruskin's aesthetic, political, and moral influence upon him. This finely crafted book, beautifully bound and printed in Morris's Golden Type on handmade paper, contained Ruskin's vital lesson: 'that art is the expression of man's pleasure in labour; that it is possible for man to rejoice in his work' (*WMAWS*, i.292). Morris's Plutocracy lecture urged 'the new birth of society'. It is a phrase that resounds in the final words of his preface to *The Nature of Gothic*:

> John Ruskin the teacher of morals and politics (I do not use this word in the newspaper sense), has done serious and solid work towards the new-birth of Society, without which genuine art, the expression of man's pleasure in his handiwork, must inevitably cease altogether, and with it the hopes of the happiness of mankind. (*WMAWS*, i.295)

In Ruskin, Morris discovered the aesthetic objection to industrial capitalism that informed his understanding of the social ethics of work. Workers, he believed, must be free to express themselves creatively and collaboratively. He did not, however, fully share in the deeply moral vision of Ruskin's Christian faith. Enduringly conscious of Ruskin's influence, he nevertheless blended it with the insights of Karl Marx. He developed a political consciousness dedicated to the class struggle and revolutionary socialism, but his vision was firmly rooted in the Middle Ages, and the Ruskinian sense of the nature of Gothic.

Notes

1 For a recent collection of essays which explores many aspects of the relationship between Morris and Ruskin, see John Blewitt (ed.), *William Morris and John Ruskin: A New Road on Which the World Should Travel* (Exeter: University of Exeter Press, 2019).

2 *Oxford Magazine* [hereafter *OM*] (24 October 1883), 319.

3 For a comprehensive and fully contextualized examination of Morris's Plutocracy lecture, see the exemplary study by Tony Pinkney, *William Morris in Oxford* (Grosmont: illuminati, 2007), 46–79.

4 *OM* (21 November 1883), 384.

5 Pinkney, *Morris in Oxford*, 61.

6 *The Commonweal*, ii.18 (15 May 1886), 50.

7 Karl Marx, *Capital: Critique of Political Economy* (1867), i.2 (quoted in *WMRR*, 38–9).

8 *The Christian Socialist* (December 1883), 109.

9 *OM* (21 November 1883), 384 (original emphasis).

10 *Oxford Times* (17 November 1883), 8; and *Oxfordshire Weekly News* (21 November 1883), 2 (my emphasis).

11 *OM* (21 November 1883), 384.

12 *Pall Mall Gazette* (19 November 1883), 2.

13 The lecture had been advertised as 'Democracy and Art' and then as 'Art and Democracy'. Morris explained his change of emphasis when he spoke and the lecture was published in two parts as 'Art Under Plutocracy' in the socialist journal, *To-Day*, i.2 (February 1884), 79–90, and 3 (March 1884), 159–76.

14 Quoted in Peter Faulkner (ed.), *William Morris: The Critical Heritage* (London: Routledge & Kegan Paul, 1973), 396.

15 Sheffield Museums Trust (Collection of the Guild of St George): St George's Museum, Visitors' Book #5 (July 1885–July 1887).

CHAPTER 20

Morris and Marxism

Ruth Levitas

When I first visited Kelmscott Manor in 1976 the resident curator who showed me around told me that when Morris was an old man he went a bit peculiar and thought he was a socialist. Morris was in his later years indubitably a socialist, not merely joining explicitly socialist groups but playing a leading role in them. But was Morris a Marxist? There is no straightforward answer to this apparently simple question. There have been many attempts to claim Morris for Marxism, for example by Robin Page Arnot in the centenary year of Morris's birth, 1934, and later in 1964 (Arnot); by Edward Thompson in his detailed account of Morris's politics and their context, in 1955 and again in 1976 (*WMRR*); and by Paul Meier in the 1970s (Meier). But the versions of Marxism to which Morris is compared or assimilated in these works differ considerably. Equally, there have been persistent attempts to distance Morris from Marxism, and even from socialism. At the glorious Victoria and Albert Museum exhibition in 1996, the centenary of Morris's death, there was one small display case relating to his politics, placed behind and to the right of the path to the exit: easily missed, to the rage of some Marxist Morrisians at the time; the V&A representation of Morris has never fully acknowledged the integration of Morris's pioneering design work with his views on the production of art, the labour process, and social organization itself. Even those who have acknowledged Morris's socialism have often argued he was an 'ethical' rather than 'economic' socialist – that is, not a Marxist – although this is a spurious distinction, since all socialism is at root ethical. Others have claimed, largely on the basis of *News from Nowhere* (1890; 1891), that Morris's views were closer to those of the anarchist Peter Kropotkin than to those of Marx. Unpicking Morris's relationship to Marxism and the possible influence of Marxism on Morris's social and political thought requires us to consider three distinct but overlapping areas: Morris's political activities in the 1880s and 1890s; what it might mean to call someone a Marxist at that time and later; and Morris's actual political beliefs in this period and their origins.

Morris never met Marx, who died on 14 March 1883 and was buried in Highgate Cemetery three days later. Morris had joined the Democratic Federation (renamed the Social Democratic Federation (SDF) in August 1884) a mere two months earlier at the age of forty-eight. He had been moving towards socialism for some time. In 1881 he wrote to Georgiana Burne-Jones that 'I have long known, or felt, say, that society, in spite of its modern smoothness was founded on injustice and kept together by cowardice and tyranny: but the hope in me has been that matters would mend gradually, till the last struggle, which must needs be mingled with violence and madness, would be so short as scarcely to count. But I must say matters ... shake one's faith in gradual progress' (*CL*, ii.51). In 1894 in 'How I Became a Socialist', published in *Justice*, he said that by the summer of 1882 he was ready to join any body that distinctly called itself socialist. He set out what he meant by socialism:

> [A] condition of society in which there should be neither rich nor poor, neither master, nor master's man, neither idle nor overworked, neither brain-sick brain workers, nor heart-sick hand-workers, in a word, in which all men would be living in equality of condition, and would manage their affairs unwastefully, and with the full consciousness that harm to one would mean harm to all (xxiii.277).

At this stage, he said, he had not even heard of Marx.

The (S)DF, however, was not only a socialist but an explicitly Marxist organization. It was led by Henry Mayers Hyndman, whose 1880 book *England for All* sought to popularize Marx's views for an English audience. Both Marx and Engels disliked Hyndman, partly because *England for All* gave insufficient credit to Marx himself. Shortly after Morris joined he set out to read Marx's *Das Kapital* – or *Le Capital* in French, because it was not translated into English until 1887. He enjoyed the historical elements but struggled with the economics – interestingly remarking that he came to understand these as much from conversations with others in the movement as from reading Marx himself. But his was no cursory reading; in 1884 he gave his well-thumbed copy of *Le Capital* to Thomas Cobden-Sanderson to be rebound. And despite his own professed difficulties, over the next decade whenever people asked him what they should read he pointed them to Marx's *Capital*, initially in German or French, and after 1887 in English, or to Lawrence Gronlund's *Cooperative Commonwealth*. By May 1883, Morris was Treasurer of the Democratic Federation. He co-wrote statements of principles with Hyndman. He had not attended Marx's funeral, but on 16 March 1884 he did join a demonstration to commemorate both Marx's death and the Paris Commune, wearing a red

ribbon in his buttonhole and singing the international communist anthem *The Internationale*. Throughout 1884 he subsidized the movement's journal *Justice*, launched initially with a £300 donation from Edward Carpenter.

Morris's involvement with the SDF was, however, short-lived. In January 1885, a mere two years after he joined, and after long discussion with Engels, the organization split and Morris, together with others including Marx's daughter Eleanor Marx, her partner Edward Aveling, and Ernest Belfort Bax, formed the Socialist League. The reasons for the split were both political and personal. There were arguments over the editorial control of *Justice*. Moreover Hyndman and others in the SDF were inclined to parliamentary action; Morris and his comrades were not. Morris also had a much more internationalist outlook than Hyndman. But the occasion of the dispute was Hyndman's attempts to eject from the Party those who challenged his authority. It was amid these conflicts that Morris, speaking in Scotland, allegedly made a statement that has been repeatedly cited to claim that he was not really a Marxist. Morris, it is said, was challenged with the question 'Does Comrade Morris accept Marx's theory of value?', to which Morris replied 'I am asked if I believe in Marx's theory of value. To speak quite frankly, I do not know what Marx's theory of value is, and I'm damned if I want to know … I have tried to understand Marx's theory, but political economy is not in my line, and much of it appears to me to be dreary rubbish'. He continued:

> It is enough political economy for me to know that the idle class is rich and the working class is poor, and that the rich are rich because they rob the poor … And it does not matter a rap … whether the robbery is accomplished by what is termed surplus value, or by means of serfage or open brigandage. The whole system is monstrous and intolerable.[1]

But this purportedly verbatim account was written in 1920, thirty-five years after the events in question, by John Bruce Glasier, a member of the Independent Labour Party (ILP) and himself strongly anti-Marxist. Glasier clearly had a vested interest in his claim that Morris's repudiation of Marx had 'passed into the movement as one of his best-remembered sayings'.[2] As Thompson has argued, had Morris claimed not to understand Marx's theory of surplus value, it would have been untrue, since there is ample evidence both from his published writing and his letters that he did. But notwithstanding Thompson's detailed and careful refutation the story remains in circulation (*WMRR* 356–7, 741–62). I was misled by it myself as a young undergraduate in 1970. It is repeated without qualification in Tristram Hunt's 2009 biography of Engels, so the mischaracterization of

Morris's position persists: citing the quotation from Glasier, Hunt claims, wholly erroneously, that '[t]he aethereal, ethical, Arts and Crafts Morris rarely disguised his lack of interest in the rational, technical precepts of scientific socialism'.[3] In 2017 Hunt was appointed Director of the Victoria and Albert Museum, reproducing that institution's reluctance to admit Morris's revolutionary and Marxist beliefs.

Morris remained in the Socialist League for six years, from January 1885 to December 1890, and these were the years of his most intense political engagement and activity. His comrades in the formation of the League were undoubtedly Marxist. So too was the League's Manifesto, signed by Morris and the League's Provisional Council and published in its new journal, *Commonweal*, in February 1885. Like *Justice*, *Commonweal* was heavily subsidized by Morris. The Manifesto sets out the relationship between classes in capitalist society. One class owns the means of production. The other, the bulk of the population, can live only by the sale of their labour power for a price less than the value that is produced. Thus profit, or surplus value, is extracted: 'As the civilised world is at present constituted, there are two classes of Society – the one possessing wealth and the instruments of production, the other producing wealth by means of those instruments but only by the leave and for the use of the possessing classes. These two classes are necessarily in antagonism to one another' (*Journalism*, 3–8). He refers to Labour as 'subject to the fleecing of surplus value'. And the solution? Socialism – the common ownership of the means of production: 'the land, the capital, the machinery, factories, workshops, stores, means of transit, mines, banking, all means of production and distribution of wealth, must be declared and treated as the common property of all. Every man will then receive the full value of his labour, without deduction for the profit of a master'. The Manifesto also distances the League from State Socialism, Co-operation, and the popular cause of land nationalization promoted by Henry George.[4] Besides a gruelling schedule of lecturing, much of Morris's finest political writing was produced during this period, including *A Dream of John Ball* (1886–7; 1888) and *News from Nowhere* (xvi), both of which were originally published as serials in *Commonweal*. So too was a series of articles co-authored with Bax, 'Socialism from the Root Up', later revised and published in book form in 1893 (*Socialism*). These cover the historical development of social formations and the emergence (and potential supersession) of capitalism. Attempts to argue away the Marxism of *Socialism* by attributing it principally to Bax are unconvincing, especially as Morris's *Socialist Diary* covering much of 1887 records days spent by the two of them in drafting these pieces.

The League, like the SDF, was riven by disagreements which were to lead, eventually, to its disintegration. Although these might be seen to have a theoretical underpinning, they were principally disputes about political strategy, most crucially about (non)participation in parliamentary elections. The 1884 Reform Act extended the franchise so that about 60 per cent of men aged over twenty-one could vote, and this perhaps added to the case for standing candidates. (Universal male suffrage was not achieved until 1918, when the franchise was also extended to women over thirty meeting a property qualification. It was not until 1928 that all adults over twenty-one were enfranchised.) But electoral participation had been an issue in the split between the League and the SDF in the first place, and within a few years it was to split the League itself. Morris was staunchly committed to an anti-parliamentary position. In *News from Nowhere*, of course, the Houses of Parliament are used as a dung-store, accompanied by the comment that 'dung is not the worst kind of corruption' (xvi.75). But Morris's fear was that the quest for electoral representation would lead at best to the amelioration of the condition of the working classes, rather than the real change in the basis of society that was needed. Just over two years after the League was founded, at its Third Annual Conference in May 1887, there was a dispute over standing parliamentary candidates. The resolution to do so was defeated, but those in favour, including Bax, Aveling, and Eleanor Marx-Aveling, resigned from the League's governing Council. The effect of this was to make way for those of an expressly anarchist persuasion. A few months later, Morris wrote 'I admit, and always have admitted, that at some future period it may be necessary to use parliament mechanically: what I object to is *depending* on parliamentary agitation', but '[t]here *must* be … a great organization outside parliament actively engaged in reconstructing society' (*CL*, ii.693). This, for Morris, was the role and purpose of the League. Three years later, at the League's Sixth Annual Conference, the anarchists took over the Council completely, and Morris was removed as editor of *Commonweal*. In November the Hammersmith branch seceded from the League and was reconstituted as the Hammersmith Socialist Society (HSS), remaining active with socialist discussions at Kelmscott House until after Morris's death. The Sunday evening programme of speakers in the Coach House (besides Morris) ranged widely, including Fabians such as George Bernard Shaw, the feminist Charlotte Perkins Gilman, the Christian Socialist Stuart Headlam, anarchists, Keir Hardie and Hyndman himself. They attracted audiences of up to seventy. William Butler Yeats and H. G. Wells were among those who attended.

There were divisions about political strategy across Europe as well as in Britain. In July 1889 Morris was a delegate to the International Socialist Congress in Paris, held on the centenary of the storming of the Bastille, and intended to establish an international federation of socialist and workers' associations. Divisions in French politics meant that there were two parallel conferences, dubbed the Marxists and the Possibilists. Hyndman and the SDF attended the Possibilist conference. The 'Marxist' conference was more international, importantly including all the large and influential German delegation. Morris was firmly in the 'Marxist' camp, along with Eleanor Marx-Aveling and Keir Hardie. Morris was chosen by the international committee to report on the situation in England, testifying to his standing in the international movement. Despite his own anti-Parliamentary position, he insisted that Hardie also be allowed to speak for the pro-Parliamentary wing. Morris reported on the Congress in *Commonweal*, concluding that 'the impression made on me by attendance at this International Congress is that such gatherings are not favourable for the dispatch of business, and that their real use is as demonstrations, and that it would be better to organize them as such'.[5] Morris's alignment with the 'Marxist' conference in Paris underlines his commitment to an international socialist movement, much, but not all, of which was Marxist. But Thompson argues that it was in 1889, and partly due to the Paris Congress, that Morris started to define himself not just as a socialist, but a communist: 'He meant, in the first place, to identify himself with the recognised Communist tradition: the *Communist Manifesto* of 1848; the Communists of the Paris Commune; and the revolutionary theory of Marx and Engels' (*WMRR*, 533–4). In so doing, he distanced himself from anarchism, which had taken over the Socialist League, and from Fabianism, asserting the centrality of class struggle, revolution, and the collective ownership of the means of production.

After 1891 Morris continued to speak locally at outdoor meetings. He radically reduced his political activity, partly because he was in poor health. He concentrated on writing and on his newly established Kelmscott Press. Nevertheless, he insisted that he had not changed his mind about socialism. In 1893 he was engaged in an attempt to bring together the disparate socialist groups of the HSS, the SDF, and the Fabians. A joint committee delegated Morris, Shaw, and Hyndman to produce a joint *Manifesto of English Socialists*. This commits to an international federation of workers 'upon a common basis of the collective ownership of the great means and instruments of the creation and distribution of wealth'. Morris had changed his position. He not only healed his breach with Hyndman but

also conceded that the capture of the state might be a necessary staging post in achieving socialism. It was, however, only a staging post. The 1893 *Manifesto* asserts that '[o]n this point all Socialists agree. Our aim, one and all, is to obtain for the whole community *complete ownership and control of the means of transport, the means of manufacture, the mines, and the land*. Thus we look to put to an end for ever to the wage-system, to sweep away all distinctions of class, and eventually to establish national and international communism' (*WMRR* 607). In October 1894 Morris wrote to Robert Blatchford (editor of the radical journal *The Clarion*) of the need for a united Socialist Party with 'an explicitly declared agreement with the aim of the nationalization of the means of production and exchange and the abolition of privilege', and the pursuit of a 'society of equality'.

Notwithstanding Thompson's insistence on Morris's identification with Marx, it is quite difficult to separate 'Marxist' from 'non-Marxist' socialists in 1890. The question of electoral strategy always straddled this divide. Moreover, later decades would see the Communist Party of Great Britain (CPGB), formed in 1920, standing candidates in elections from the outset. Between 1922 and 1945 four Communist MPs were elected, two in Scotland and two in London. In 1945, substantial numbers of Communist local councillors were elected, including a group of ten in the East London borough of Stepney (among whom was my uncle Max Levitas). A few years later, in 1951, the CPGB published *The British Road to Socialism*, adopting precisely the wholly parliamentary strategy Morris feared. Conversely, in the early twentieth century some Marxist terminology was current among socialists who were wholly committed to the form of state socialism Morris abhorred. Thus in 1918 the Labour Party adopted a commitment to 'the common ownership of the means of production, distribution and exchange'. This 'Clause IV' was written by the Fabian Sidney Webb and was removed (against widespread protest) only in 1995. The Paris conferences were important, however, in inaugurating the Second International, the international socialist federation which continued until 1914, holding meetings every two or three years. It was during the period of the Second International that a Marxist orthodoxy emerged against which Morris must be seen not as non-Marxist or inadequately Marxist, but as more than Marxist, insisting on the need for a vision of an alternative society to inspire the movement for change.

In 1893, the Second International appointed Engels its Honorary President, underlining the fact that after Marx died Engels was regarded as the key bearer of Marx's legacy. Engels did not have a high opinion

of Morris as a political strategist, and later writers including Edward Thompson have also been critical, especially of Morris's anti-parliamentary stance. But it is perhaps Morris's 'utopianism', as well as the debate about the importance of surplus value, that has cast doubt on his Marxist credentials. In 1880 Engels had published his short work *Socialism: Utopian and Scientific* (in fact a reprint of three chapters of a longer 1878 work, *Anti-Dühring*, itself a sharp intervention in debates within German Marxism and socialism). Initially appearing in French translation at the behest of Marx's son-in-law Paul Lafargue, *Socialism: Utopian and Scientific* was followed in 1883 by an edition in the original German and at least five other languages before being issued in English in 1892. It was enormously influential, probably more widely read than *The Communist Manifesto* of 1848, and certainly (because shorter and simpler) more so than *Das Kapital*. Engels criticizes the so-called utopian socialists – Henri de Saint-Simon, Charles Fourier, and Robert Owen – for devising intellectual schemes for reforming society: 'These new social systems were foredoomed as Utopian; the more completely they were worked out in detail, the more they could not avoid drifting off into pure phantasies'.[6] In fact Engels does recognize the insights and strengths of the utopian socialists, particularly their insightful early critiques of capitalism, but argues that social change stems from changes in the modes of production and exchange – that is, from economic relations, not from philosophy. It is an argument for a materialist rather than idealist view of historical change. During the period of the Second International these arguments hardened into a rejection of all 'utopianism' in the sense of speculation about the nature of a future society. It is arguable that this is a distortion of both Marx's and Engels's intentions.[7] However, the 'orthodox' Marxism that emerged from this period consisted of only what the German Marxist and Utopian Ernst Bloch later described as the 'cold stream' of analysis. It was a position that lapsed sometimes into economic determinism, the belief that the structural conflict between the owning class or bourgeoisie and the working class or proletariat would somehow by itself deliver the new society. Bloch attempted to endorse the 'warm stream' of passion, imagination, and vision in Marxism – a warm stream that is so palpably present in Morris's work.[8] For although Morris refers to 'the inevitable advance of the Society of Equality' (*Communism*, xxiii.267–8), he also insisted on the importance of agency in any potential transition: 'Intelligence enough to conceive, courage enough to will, power enough to compel. If our ideas of a new Society are anything more than a dream, these three qualities must animate the due effective majority of the working-people' (xxiii.266). This suspicion of utopianism persists

among contemporary Marxists. The Communist daily paper in Britain, the *Morning Star* (previously the *Daily Worker*), ran an article in 2020 under the by-line of the Marx Memorial Library: 'Do Marxists believe in utopias?' It argued that 'Idealistic visions should not obstruct our understanding of social reality as it exists and our efforts to bring about change'. Contrasting Edward Bellamy and Morris and profoundly critical of both, it grudgingly conceded that fictional utopias 'can provide food for thought as well as some relaxation from work and struggle'.[9] This significantly underplays the potential role of utopian imagination, especially from a thinker as profound as Morris.

It is principally *News from Nowhere* that generally identifies Morris as 'utopian'. In 1889 Morris reviewed Edward Bellamy's utopian novel *Looking Backward* in *Commonweal*. Bellamy imagines a centralized, state socialist society – something Morris had repeatedly argued against. His concern about its effects was two-fold. Some would like it and 'accept it with all its necessary errors and fallacies (which such a book must abound in)' thus 'warp[ing] their efforts into futile directions'; others, also potentially 'accepting its speculations as facts' will reject it, and socialism with it (*PW*, 420); for 'incomplete systems impossible to be carried out but plausible on the surface are always attractive to people ripe for change but not knowing clearly what their aim is' (*PW*, 425). Morris accepted the Marxist position that 'human nature' is historically variable, and that it is therefore impossible to predict the wants and needs of people in a post-revolutionary society: 'it is impossible to build a scheme for the future, for no man can really think himself out of his own days' (*Socialism*, 17–18). So a utopia is a speculation, not a blueprint, and '[t]he only safe way of reading a utopia is to consider it as an expression of the temperament of the author' (*PW*, 420). On the other hand, said Morris, it was 'essential that the ideal of the new society should always be kept before the eyes of the working classes, lest the continuity of the demands of the people should be broken, or lest they should be misdirected' (*Socialism*, 278). It is quite clear from these comments that Morris did not regard *News from Nowhere* as a prediction of the future, but rather as a vision of a world qualitatively different from both capitalist society and the kind of centralized state socialism set out by Bellamy and pursued by the Fabians.

Much has been written about the interpretation of *News from Nowhere*. Those who have read it literally have variously seen it as backward-looking and medievalist, or in the case of Meier, a fictional version of an orthodox Marxist account of revolution, followed first by

seizure of the state and the dictatorship of the proletariat, and then by the withering away of the state and the emergence of full communism. Others have argued that this is entirely the wrong way to read *News from Nowhere* or any other fictional account of the future. The imaginative space opened up by this form of literature does more than describe an alternative social structure based on a different set of acknowledged needs and available satisfactions. It offers the reader the possibility of experiencing or exploring what it would feel like to want and need differently. Miguel Abensour sees this 'education of desire' as the primary function of utopian literature, and of Morris's writing in particular.[10] This is confirmed by Morris's own recognition a mere two years before his death, when he wrote in 'How I Became a Socialist' that '[c]ivilization has reduced the workman to such a skinny and pitiful existence, that he hardly knows how to frame a desire for any life much better than that which he now endures perforce' (xxiii.281).

Utopia, however, ranges more widely than a literary genre. It is, in the modern era, best understood not as a prescription or a blueprint but as a method: a projection of a possible (or indeed impossible) alternative society that is always provisional, for we know the actual future will be different; reflexive, in that the author(s) are aware of that, and of the specificity and limitations of their own social and historical location; and dialogic, in that it must be developed in the context of debates and movements taking place in the real world.[11] Morris understood all this. It then becomes possible to see that Morris's *method* is essentially utopian in his political as well as his fictional writing. So many of his lectures offer a critique of the present and the outline of an alternative: 'Work in A Factory as it Might Be', published in *Justice* (1884, *PW*, 32–5, 39–46); 'How we Live and How we Might Live' (1884, xxiii, 3–26) and 'Useful Work versus Useless Toil' (1884, xxiii, 98–120), both of which were delivered repeatedly to a range of audiences in the 1880s; 'True and False Society' (1886, xxiii, 215–37); 'What Socialists Want', delivered at least seven times between 1887 and 1889 (1887, *UL*, 217–33); 'How shall we live then?' (1889) delivered at least five times in 1889–90.[12] Morris's method in these political lectures is essentially utopian.

So, was Morris a Marxist? He was certainly a revolutionary socialist, or in his own words, a communist. In anticipating revolution he was not advocating violence, but predicting that those monopolizing wealth and property and the institutions of the state set up to maintain law and property relations would wreak violence on those attempting fundamental change. His political engagement was with explicitly

Marxist organizations and individuals, but there were many disagreements among these, and Morris also engaged with non-Marxist socialists, again disagreeing on many fundamental points. If asked, he would probably have said he was a Marxist – but the meaning of that had not yet crystallized into an orthodoxy. In terms of an analysis of the history and nature of capitalism, Morris's views certainly had close parallels with those of Marx: Owen Holland calls this an 'elective affinity', while Max Beer long ago said that Morris was 'stimulated' rather than 'influenced' by Marx.[13] But Morris did not come to socialism through Marx. His understanding of alienation and the labour process had earlier roots in his reading of John Ruskin, especially the chapter 'On the Nature of the Gothic' originally published in 1853 and republished by the Kelmscott Press in 1892. Moreover, Morris insisted that 'socialism does not rest on the Marxian theory … and many complete socialists do not agree with him on this point' (*CL*, ii.729). But Morris's mode of thought, his method, is fundamentally different from that of Marx, Engels, or what came to characterize orthodox Marxism in the years after Engels's and Morris's deaths. He sought above all to demonstrate that it does not have to be like this. It could be otherwise. The insistence that we use our analysis of how contemporary society works as a basis for imagining the possibility of living otherwise is as relevant now as it was when Morris died 125 years ago. Keeping the ideal of a new society before the eyes of the people is a central part of Morris's enduring legacy.

Notes

1 John Bruce Glasier, *William Morris and the Early Days of the Socialist Movement* (London: Longmans Green and Company, 1921), 32.
2 Ibid.
3 Tristram Hunt, *The Frock-Coated Communist: The Life and Times of the Original Champagne Socialism* (London: Penguin, 2010), 327.
4 Henry George, *Progress and Poverty* (New York: D. Appleton and Company, 1879).
5 Morris, 'Impressions of the Paris Congress II', *Commonweal*, 5.186 (3 August 1889), 242.
6 Frederick Engels, *Socialism: Utopian and Scientific*, in Karl Marx and Frederick Engels (eds), *Selected Works* (London: Lawrence and Wishart, 1968), 403.
7 See Ruth Levitas, 'Castles in the Air: Marx, Engels and Utopian Socialism', in *The Concept of Utopia* (Hemel Hempstead: Philip Allan, 1990).
8 Ernst Bloch, *The Principle of Hope* (Oxford: Basil Blackwell, 1986), 209.
9 *Morning Star* (online edition), 9 August 2020. www.morningstaronline.co.uk
10 Miguel Abensour, 'William Morris: The Politics of Romance', in Max Blechman (ed.), *Revolutionary Romanticism* (San Francisco: City Lights Books, 1999).

11 Ruth Levitas, *Utopia as Method: The Imaginary Reconstitution of Society* (London: Palgrave Macmillan, 2013).

12 www.marxists.org/archive/morris/works/1889/how.htm

13 Owen Holland, 'Morris and Marxist Theory', in Florence S. Boos (ed.), *The Routledge Companion to William Morris* (London: Routledge, 2021), 465–86; Max Beer, *A History of British Socialism* (London: National Council of Labour Colleges, 1940 [1919]), 230.

William Morris's 'Medieval Modern' Afterlives

Michael T. Saler

For much of his life William Morris looked to the past for inspiration; following his conversion to socialism in 1883, he emphasized the future as well. His progressive 'medieval modernism' flourished after his death in 1896 in multiple domains, including the crafts, literature, politics, and environmentalism.[1] Arguably his most important legacy has been in the fields of modern design and fantasy, where he has been acclaimed not merely as an influence but as an originator. In 1936, the art historian Nikolaus Pevsner identified Morris as a 'pioneer' of modern design, and in 1961 the writer Lin Carter proclaimed Morris as the progenitor of the 'imaginary world' subgenre of modern fantasy.

Morris's seminal influence on designers of worlds real and imagined is often taken for granted today, although Pevsner and Carter's initial arguments were not self-evident. In fact, they appear counter-intuitive: how could a thinker who venerated handicrafts and criticized industrial capitalism be the foundational figure for modern industrial design? How could a writer, whose late prose romances were little known for much of the twentieth century, be the inspiration for a vital branch of modern fantasy? As we shall see, Morris's surprising afterlives are beholden as much to the contingencies of history as the merits of the claims establishing them. Had Pevsner and Carter not promulgated their arguments so zealously – at times hyperbolically – over the course of decades, Morris would still be lionized as a major Victorian figure, but his association with 'modernity' as much as 'medievalism' might have been less apparent.

In what follows, I will discuss Morris's medieval-modern afterlives within the fields of modern design and fantasy, while assessing Pevsner and Carter's at times tendentious interpretations. Pevsner incorrectly asserted that, while Morris crucially affected the modern design movement on the continent and North America, he had negligible influence in England: 'England's activity in the preparation of the Modern Movement came to an end immediately after Morris's death.'[2] Between 1915 and 1939, however,

an informal network of English medieval modernists actualized Morris's dream of effacing the distinction between 'fine art' and 'craft' (or 'industrial art') at the level of public rhetoric, while embodying his vision in public projects such as the London Underground transport system.

For his part, Carter missed the social, political, and utopian undercurrents of Morris's late prose romances, focusing instead on the nitty-gritty of world-building and plots. However, by highlighting the importance of 'story' to Morris and modern fantasy in general, Carter inadvertently touched on Morris's own preoccupation with fiction's potential to provide secular guidance in a modern age.

From Romantic Medievalism to Medieval Modernism

In 1936, the German art historian Nikolaus Pevsner linked two seemingly incongruous figures: William Morris, partisan of medieval handicrafts, and Walter Gropius, champion of modern industrial design. Yet Pevsner's *Pioneers of the Modern Movement: From William Morris to Walter Gropius* (later retitled *Pioneers of Modern Design*) established Morris as a figure who belongs to twentieth-century modernism no less than nineteenth-century medievalism. While it has been criticized for its generalizations and teleological argument, Pevsner's history remains influential: a new edition was issued in 2005, and in 2009 the architectural critic Colin Amery observed that the book's 'continued significance … is not in doubt: it remains on the syllabus and is widely read over six decades since it first appeared'.[3]

Pevsner established empirical links between Morris and the English Arts and Crafts movement on the one hand, and design reformers in North America and the Continent on the other, culminating in the work of Gropius and the Bauhaus starting in 1919. He had met Gropius in 1922 and was enthusiastic about the Bauhaus mission of fostering an organically unified society through modern art, architecture, and design. Gropius acknowledged that Morris influenced his own influential briefs for the unity of the arts, a functionalist international style, and the social role of the artist. (He christened the Bauhaus after *bauhütten*, the lodges of medieval craftsmen.) Pevsner saw these features as integral to the 'modern movement', and his history was partly a polemic on its triumph in Germany.[4]

In his account, Morris was instrumental in restoring the medieval conception of the artist as craftsman, a figure integral to the community who created objects of utility as well as beauty. Further, while Morris was inspired by nature for many of his designs, he often rendered them

abstractly so that they cohered with the object's purpose and the nature of its materials. His focus on form as an expression of an object's function, rather than as mere decoration, embodied the functionalist ideal that was to become a hallmark of the modern movement.[5]

Yet the modern movement in England was still born in Pevsner's view. The anti-industrial outlook of Morris and the Arts and Crafts movement, as well as England's entrenched class system, restricted the market for well-designed goods to the elites who could afford custom-designed handicrafts. The movement instead developed in the USA, France, and Germany, which rejected divisions 'between the privileged classes and those in the suburbs and the slums'.[6] Pevsner concluded:

> Morris had started the movement by reviving handicraft as an art worthy of the best men's efforts, the pioneers about 1900 had gone further by discovering the immense, untried possibilities of machine art. The synthesis, in creation as well as theory, is the work of Walter Gropius.[7]

Pevsner had developed this teleological argument prior to emigrating from Nazi Germany to England in 1933, where he was hired to investigate the condition of industrial art in Birmingham. His assumption about England's rejection of modern design seemed to be confirmed by his researches there, undertaken while he was completing his broader history of the 'modern movement'.[8] This helps explain why the lively discussions in interwar England concerning Morris's continued relevance to modern art and industry went virtually unmentioned in Pevsner's 1936 account. He had not been directly privy to them until after 1933, and had already settled on a whiggish narrative celebrating Gropius and Germany. The complex story of Morris's significant impact on the reception of modernism in England has been recounted elsewhere; here we will revisit certain facets of that story as both a complement and corrective to Pevsner's work.[9]

During the interwar period, a loose network of Morris's more progressive followers sought to reconcile his aesthetic and political ideals with the new conditions of modern art and modern industry. A shared 'medieval modern' discourse about the unity of art and life was promulgated by government officials at the Boards of Trade and Education, critics, educators, artists, businessmen, and media organizations. This network emerged to address two concurrent controversies. The first had to do with the introduction of 'Post-Impressionist' art between 1910 and 1912. The unfamiliar styles from the Continent shocked many in England, but equally incendiary was the formalist aesthetic used to justify the new aesthetic approaches, which insisted that art was autonomous from utility and morality.

The second controversy involved Germany's success at integrating modern art with industry during the same period, challenging English goods on the export markets. The question of how to improve English industrial design had been unresolved during the nineteenth century; with the outbreak of war with Germany in 1914 it assumed a new urgency. By 1915, English medieval modernists proposed solutions to both controversies by combining the new formalist aesthetic with Morris's utilitarian aesthetic. Modern industrial design would combine formalism with functionalism.

In terms of the first controversy, the art critic Roger Fry had organized two exhibitions of what he termed 'Post-Impressionist' art in 1910 and 1912, which introduced many of the new styles of continental art to the English public. He and his fellow critic Clive Bell maintained that diverse works by *fin de siècle* artists such as Édouard Manet, Vincent van Gogh, and Paul Cézanne were united in rejecting realist representation, focusing instead on the emotional effects produced in the viewer by the arrangement of forms and colours in space. The Post-Impressionists revealed that design, rather than representation, was the essence of art. Fry and Bell's aesthetic of 'significant form' rejected the hierarchical distinction between fine art and craft that emerged during the Renaissance; all well-designed objects, from pots to paintings, were art. Their views cohered with those of Morris concerning the unity of the arts. However, Fry and Bell rejected the moral and utilitarian understanding of art upheld by the Victorians, including Morris.

This emphasis on art's autonomy proved as unsettling to the public as the new styles themselves. During the First World War, though, many of Morris's medieval modern adherents formulated a discourse about modern art reconciling formalism with functionalism. They accepted that significant form elicited 'aesthetic emotions', while retaining Morris's utilitarian standard of 'fitness for purpose', a classical and medieval conception of art that had been revived by English design reformers in the nineteenth century. According to this precept, the design of an object expresses and facilitates its function. In the discourse of medieval modernism, Post-Impressionism was fit for the purpose of industrial design, its flat, geometric shapes and pure colours ideally suited for mechanical reproduction. The discourse reassuringly restored a social function to art and secured a new direction for English industrial design.

Morris seemed to have anticipated this combination of formalism and functionalism in his own simplified, rhythmic designs for wallpapers and textiles. His emphasis on simplicity, truth to materials, and fitness for purpose influenced the English Arts and Crafts movement at the turn

of the century. As Pevsner showed, while the English movement focused on handicrafts, their functional, attractive designs inspired the creation of the Deutscher Werkbund in 1907, dedicated to industrial design. The Werkbund was a state-sponsored association of artists, designers, and industrialists seeking to make German exports more competitive by integrating art with industry, leading to the innovations of the Bauhaus.

English industries remained complacent about the issue of design as sales factor, partly because they had an assured market within the empire. The war, however, made the future of English exports less certain, especially given Germany's growing reputation for well-designed mass commodities. Frustrated by the Arts and Crafts refusal to engage with industry, medieval modernists founded the Design and Industry Association (DIA) in 1915 to lobby for the integration of art with industry, commerce, and education. As one of its founders stated, 'Morris & Ruskin each in their own way laid the foundation, and the Arts and Crafts people failed to join it up with everyday conditions. Our job is to do that.'[10]

The DIA combined 'significant form' with 'fitness for purpose', which became the association's motto. While small numerically, the DIA's membership was prominent socially, and the association's ideas concerning the social function of modern art were widely disseminated as well as appropriated by artists, teachers, government officials, and the media during the interwar period. Members included Frank Pick, Chief Executive of London Transport and Chair of the government's Council for Art and Industry during the 1930s; Herbert Read, a prominent art critic and author of *Art and Industry* (1934); and Charles Holden, an architect whose functionalist buildings for the Underground during the interwar period helped introduce the International Style to England.

Like the Bauhaus, English medieval modernists adapted Morris's views to the conditions of modern art, industry, and commerce. While Morris believed that only a political revolution could generate the social conditions for a new, 'living art', medieval modernists contended that art itself would foment an organic and spiritual community. Many welcomed modern art as the catalyst for a better world. They posited that Post-Impressionism met Ruskin and Morris's criterion that art be 'true to nature': its abstract forms and 'rhythmic' compositions captured the Platonic forms and invisible energies undergirding material existence that seemed to be implied by contemporary physics. Ideally, such forms and rhythms would resonate with their viewers' unconscious, restoring an atomistic populace to the primordial unity of the cosmos. To the potential objection that Morris revered external nature, not the abstractions of modern physics, Read had

a ready response: '... though the Morris of 1850 would have little sympathy for the art of to-day, Morris to-day would be by the side of Le Corbusier in architecture, Picasso in painting and probably Stalin in politics. The spirit of the man was fundamentally revolutionary.'[11]

Medieval modernists also redefined Morris's concept of 'common art', the creations of ordinary people expressing their joy in labour. His progressive followers considered that industrial commodities would constitute much of the common art of the future, provided that they were designed by artists following the principal of 'fitness for purpose'. The artist's elevated conception would imbue mechanically produced commodities with the human qualities that Morris associated with handiwork.[12] Medieval modernists also allowed that the public would contribute to the creation of this new common art through their roles as informed consumers. Once they were educated to evaluate commodities in terms of their fitness for purpose – how an object's 'significant form' cohered with its function – they would demand better-designed goods from manufacturers, leading to a decorous as well as harmonious society.

However, medieval modernists faced greater challenges when it came to the division of labour in factories, which seemed to preclude the 'joy in labour' that had been fundamental to Morris's outlook. They settled for a series of compromises. They noted that reduction of working hours gave people more time to pursue creative activities. Further, modern workers could experience 'joy in service' if not 'joy in labor': pride in creation could be extended to all phases of production, not simply that of individual creation.[13]

Medieval modernists also reconceived modern capitalism – Morris's *bête noire* – in moral terms. Rather than emphasize the maximization of profit, capitalism could be pursued for the services and innovations it provided to the community. The economist Alfred Marshall, an admirer of Morris, proposed this notion of 'economic chivalry' in 1907.[14] Frank Pick exemplified Marshall's ideal of altruistic entrepreneurship while directing the London Underground during the interwar period. He acted upon his stated belief that profits were the necessary means toward the higher goal of providing service to the community. 'I seek behind commerce, art and I know that behind art there must be good custom. Morality, we call it.'[15]

Indeed, the London Underground under Pick's direction became the culminating project of the Arts and Crafts movement, a glorious *Gesamtkunstwerk* intended to be a joy to both makers and users. Pick was deeply influenced by Morris, quoting him in speeches and citing him in his diaries and commonplace books. When he became a high-ranking

executive of the Underground starting in 1909, he used the system to realize, in microcosm, Morris's ideal of an Earthly Paradise. The Underground would be a model of aesthetic integration and communal service, a catalyst for a harmonious London of the future.

Pick began by providing the Underground with a cohesive visual identity, commissioning the Arts and Crafts calligrapher Edward Johnston in 1913 to design a typeface to be used throughout the system. He also hired modern artists to design posters starting in 1915, with the advertiser's aim of attracting attention – but also to introduce the public to the latest styles in art. (The Underground soon became known as 'the "people's picture gallery"'.)[16] During the interwar period, Pick took advantage of the system's vast expansion to embody the utopian aims of the DIA. He hired Holden to design new stations in the modern, functionalist style, writing to a colleague in 1925, 'We are going to represent the D. I. A. gone mad.'[17] Holden adhered to the medieval conception of the architect as master craftsman who designed all facets of a building. In addition to creating many of the system's fixtures, from spare benches to bronze wastebins, he commissioned modern sculptors like Henry Moore and Jacob Epstein to carve their works directly onto the new Underground headquarters, according to the medieval method of embellishment.

Thanks to the medieval modernists, Morris's inclusive and utilitarian understanding of art became widely disseminated by the 1930s. Paraphrasing Morris, a writer for the BBC magazine *The Listener* argued that 'art' no longer was synonymous with the fine arts: 'Art really means anything that can be designed by man to be beautiful as well as useful.'[18] Such rapprochements between the 'arts' and 'crafts' continued at the highest levels. To take but one instance, in 1937 the Board of Education revised their national circular 'Suggestions for Teachers' by combining the separate chapters devoted to 'Art' and 'Craft' into a single chapter. Many other examples could be cited, amply justifying Morris's biographer J. W. Mackail's claim in 1934: 'Morris and his works are thus alive now.'[19]

But although Morris's views were more prevalent in interwar England than they had been during his lifetime, artists were not integrated into industry to the extent they were in Germany. English industrialists remained largely indifferent to design issues; the decentralized English art schools lacked a common curriculum for designers, unlike the state supervised schools in Germany. Training for 'industrial artists' in England remained largely craft-based.

Pevsner accurately identified the Bauhaus as the practical fulfilment of Morris's design innovations in terms of modern mass-production.

His teleological argument favouring Germany persuasively established Morris as a design pioneer, but inaccurately held that he was no longer a prophet in his own nation. In actuality, Morris's medieval modernism was critical to the reception and legitimation of modern art in interwar England.

Morris's Late Prose Romances and Modern Fantasy

In addition to inspiring designers of the real world, William Morris spurred architects of invented environs: he has been acclaimed as the originator of the 'imaginary world' strand of modern fantasy. This subgenre presents heroic adventures within a cohesive, realistically detailed world that is autonomous from known reality, usually pseudo-medieval or pre-industrial in sensibility, magical in operation. J. R. R. Tolkien's *The Lord of the Rings* (1954–5) is the archetypal example of this form of heroic fantasy (he called such invented milieux 'secondary worlds'), but Morris is widely credited with establishing the prototype in five of the prose romances he wrote in the 1890s: *The Story of the Glittering Plain* (1891); *The Wood Beyond the World* (1894); *The Well at the World's End* (1896); *The Water of the Wondrous Isles* (1897); and *The Sundering Flood* (1897). They were different from earlier Victorian fantasy novels representing entirely imaginary worlds, such as Sara Coleridge's *Phantasmion* (1837) and George MacDonald's *Phantastes* (1865). The latter were dreamlike, allegorical fairy tales, whereas Morris's invented worlds were represented realistically, while retaining the enchantments of make-believe. As Henry Wessells notes, *The Sundering Flood*, published posthumously, is 'the first modern work of fantasy with a map', distinguishing it from other works containing maps of invented locales within known reality, such as Robert Louis Stevenson's *Treasure Island* (1883) and H. Rider Haggard's *King Solomon's Mines* (1885) (see Figure 21.1).[20] Maps have become a staple of secondary world fantasy ever since.

Works devoted to such imaginary worlds expanded gradually during the twentieth century and surged in popularity during the 1960s, partly driven by the vogue for *The Lord of the Rings* within the counterculture. Lin Carter's breezy *Imaginary Worlds* appeared in 1973, the first history of fantasy as a distinct genre; it asserted that, 'William Morris invented the imaginary-world novel, and the central tradition derives from his pioneering romances.'[21] Scholarly attention to fantasy as a distinct mode or genre also commenced in earnest in the 1970s, with numerous studies echoing Carter's claims for Morris's centrality.[22] This emerging consensus

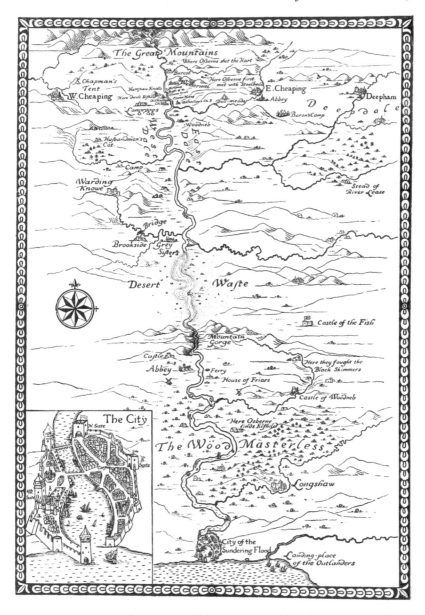

Figure 21.1 Map, in William Morris, *The Sundering Flood* (London: Longmans, Green, and Company, 1897) via Bill Ives / Alamy Stock Photo

affected Morris studies as well, which had largely ignored his late prose romances. Morris's seminal contribution to the genre had come full circle by 1998, when readers of *The Journal of the William Morris Society* were informed that Morris 'was the greatest and crucial inventor of secondary-world fantasy'.[23]

Yet this seemingly smooth trajectory is misleading: Morris's contribution to modern fantasy was a contested, contingent process. His late prose romances received mixed reviews from contemporaries; many perceived them as escapist works by an author disappointed in politics and exhausted by age. The titles soon went out of print following the First World War, when modernist irony replaced romantic heroics, and were not reprinted until the late 1960s.[24] Keyword searches of online databases of science fiction and fantasy magazines and fanzines between the 1920s and 1950s yield few references to Morris – and nearly all of those concerned his utopian novel, *News from Nowhere*. C. S. Lewis was one of the few academics to openly champion Morris's imaginary worlds until the 1970s.

The late prose romances were also occluded in public memory by the imaginary worlds created in the early decades of the twentieth century by Lord Dunsany, James Branch Cabell, and E. R. Eddison, among others. These authors deployed self-reflexive irony in their works, apparently distinguishing their modern fantasy from Victorian forebears like Morris. (However, once Morris was identified as a progenitor of the subgenre, scholars established direct and indirect influences between his works and those of these 'modernists', as well as direct influences on Tolkien and Lewis; Morris's own self-reflexive techniques have also been analysed.)[25] Many of the influential authors of imaginary-world fantasy who published in pulp fiction magazines between the 1920s and the early 1960s – including Robert E. Howard, C. L. Moore, Henry Kuttner, and Fritz Leiber – cited one or more of the modernists as influences, but Morris was notable by his absence.

Prior to the 1950s, though, few were concerned with the genealogy of modern fantasy as a distinct genre or literary mode. That decade represented a turning point, owing in part to the publication of landmark works, including Poul Anderson's *The Broken Sword* (1954), Tolkien's *The Lord of the Rings* (1954–55), and T. H. White's omnibus collection, *The Once and Future King* (1958). Among afficionados, fantasy had been discussed within the broad tent of science fiction fandom between the 1930s and 1950s. While that continued, a subset of fandom devoted exclusively to fantasy emerged in the mid-1950s, dedicated to defining its nature as an independent genre.

'The Hyborian Legion', a North American organization founded in 1955, actively explored this issue. Affiliates included prominent authors, such as L. Sprague de Camp, Anderson, and Leiber, enhancing the import of the Legion's discussions among Anglo-American fans. Michael Moorcock, a young English writer, published an essay in the May 1961 issue of the Legion's fanzine *Amra*, advocating 'epic fantasy' as the preferred nomenclature for

> the sub-genre of books which deal with Middle Earths [sic] and lands and worlds based on this planet, worlds which exist only in some author's vivid imagination. In this sub-genre I would classify books like [Eddison's] "The Worm Ouroboros", [Cabell's] "Jurgen", "The Lord of the Rings", "The Once and Future King", [Leiber's] the Grey Mouser/Fafhrd series, the Conan series, "The Broken Sword", [Fletcher Pratt's] "Well of the Unicorn", etc.[26]

A year earlier, Moorcock had published a story in an issue of an English fanzine that included an essay by its editor, Peter Mansfield, proposing a similar genealogy. Mansfield extolled Lord Dunsany as the founder of the modern fantasy tradition: 'the Irish bard who, in this field, was undoubtedly *the* formative influence of this century'.[27] The lineage advanced by Mansfield and Moorcock would become incorporated into the fantasy canon by the early 1970s – although Moorcock's 'epic fantasy' label was challenged by Leiber, who preferred 'sword-and-sorcery'.[28]

Leiber's term became affixed to the subgenre when de Camp edited the first anthology of stories devoted to *Swords and Sorcery* (1963). Yet Moorcock's term resonated in the title of de Camp's introduction to this influential mass-market paperback: 'Heroic Fantasy'. De Camp explained, '"Heroic Fantasy" is the name of a class of stories laid, not in the world as it is or was or will be, but as it *ought* to have been to make a good story.'[29] *Swords and Sorcery* thus codified the deliberations of a small circle of knowledgeable fantasy fans for the general public. It and two succeeding volumes edited by de Camp established 'heroic fantasy' or 'sword-and-sorcery' as a significant subgenre within modern fantasy.

At this juncture, Morris the eminent Victorian was saved from being branded a sword-and-sorcery author simply because his contributions were all but forgotten. Such anonymity was not to last, however. Fantasy author and critic Lin Carter revered Morris. Without his intervention into this nascent canon formation, it is possible that Dunsany would have been anointed as the fount of modern imaginary-world fantasy – with Morris being relegated to the ranks of romantic medievalists like Tennyson.

In a detailed essay published in the October 1961 issue of *Amra*, de Camp echoed Mansfield by proclaiming Dunsany as originator: 'Among [Dunsany's] stories are many from which stem the entire present-day sub-genre of heroic fantasy.'[30] He acknowledged that Dunsany 'had predecessors, including the many exploiters of Arthurian legend and the lost Atlantis theme'. Nevertheless, 'Dunsany was, as far as I know, the first to fully exploit the possibilities of heroic fantasy – adventurous fantasy laid in imaginary lands with a vaguely pre-industrial setting, with gods, witches and magic, like children's fairy tales but on a sophisticated adult level.'[31]

A month later, Carter introduced Morris as the more appropriate candidate in a lengthy essay published in the influential North American fanzine *Xero*. Citing other instances of imaginary worlds, including the nineteenth-century 'dream' narratives of MacDonald and Carroll, Carter insisted that, 'It remained for … William Morris to virtually single-handedly restore this species of literature to the position and plane of serious art … He brought a new dignity, epic resonance and heroic flavor back into the field.'[32] Carter's argument persuaded de Camp, who retracted his endorsement of Dunsany in the January 1963 issue of *Amra*: 'If we mean, who started the outburst of heroic fantasies that, after a long period of neglect of the genre, has flowered in the last century, Lin Carter is probably right in putting the finger on William Morris, with his pseudo-medieval romances'.[33] De Camp subsequently publicized this new finding in his influential Introduction to *Swords and Sorceries*: 'Let us give credit to Morris for reviving the genre.'[34] The Introduction incorporated the literary genealogy established by Mansfield, Moorcock, and others, now headed by Morris.

Between 1969 and 1974, Carter served as editorial director for the Ballantine 'Adult Fantasy' series of paperbacks, effectively institutionalizing this canon by reprinting many of its authors and titles. The series was intended to provide a historical overview of the subgenre, as well as rescue fantasy from its traditional association with children's literature – hence the 'Adult' label. Carter provided contextual introductions for the titles, drawing on his own extensive knowledge as well as the pioneering research of his fellow fantasy fans.

He was an enthusiastic, bombastic, self-promoting, and at times fallacious writer. Nevertheless, his version of modern fantasy's historical evolution, repeated in many of the nearly seventy volumes of the series, as well as his pioneering 1973 historical overview, were crucial to establishing fantasy as a distinct genre and Morris as its modern avatar. The opening lines of Carter's introduction to the first Morris title he reprinted, *The Wood Beyond the World* (1969), is characteristic: 'The book you hold in

your hands is the first great fantasy novel ever written: the first of them all; all the others, Dunsany, Eddison, Pratt, Tolkien, Peake, Howard, *et al.*, are successors to this great original.'[35]

Like Pevsner, Carter positioned Morris as a medieval modernist rather than romantic medievalist. Characteristically – but not inaccurately – he ballyhooed his own instrumental role in salvaging Morris for modernity in his Introduction to *The Water of the Wondrous Isles* (1971):

> One of the writers I was eager to revive was William Morris. Only through reading his great fantasy romances can one understand the origin of modern works such as *The Lord of the Rings* …. But without a familiarity with Morris one cannot realize this fact, and Morris was long out of print. Whenever de Camp or I would refer to these pioneering fantasy epics, we drew a blank response from our readers, few of whom knew Morris at all, and then only as a Socialist or Victorian designer. (In fact, now that I think of it, I was the one who originally drew L. Sprague de Camp's attention to the significance of the novels of William Morris in the history of the imaginary-world fantasy.)[36]

Carter also commended the William Morris Society to his readers, providing them with a brief history and mailing address.

Since the 1970s, academic scholarship concerning the late prose romances has advanced well beyond Carter's narrow focus on Morris's realist world-building and entertaining narratives. Yet Carter was right to emphasize these elemental pleasures. Morris himself made 'story' integral to his worldview, having interrogated the promises and pitfalls of escapism since his undergraduate years. He alighted upon realistic imaginary worlds that modern adults could 'inhabit' for prolonged periods partly because he lived in the imagination throughout his life. In some ways he anticipated the 'cosplay' (costume play) of contemporary fantasy fans: as a child and adolescent he donned knight's garb; as an adult he surrounded himself with an idealized medieval environment of his own construction.

Morris was modern in his medievalism, consciously scripting a preferred yet provisional story for himself and others. Like Friedrich Nietzsche and Georges Sorel, he believed that heroic narratives could be sources of meaning and spurs to action in a secularizing age. As he observed about the sagas in 1881, 'in the best art all those solemn and awful things … impress the beholder so deeply that he … lives among them for a time; so raising his life above the daily tangle of small things that wearies him to the level of heroism which they represent' (xxii.176). This insight applied to many of his own literary and pictorial representations. Those in turn inspired modern designers of environments real and imagined, as Pevsner and Carter maintained with heroic conviction.

Notes

1 Fiona MacCarthy, *Anarchy & Beauty* (New Haven, CT: Yale University Press, 2015); Bradley J. Macdonald, 'William Morris and the Vision of Ecosocialism', *Contemporary Justice Review*, 7.3 (2004), 287–304; John Plotz, 'Windy, Tangible, Resonant Worlds', in Florence S. Boos (ed.), *The Routledge Companion to William Morris* (New York: Routledge, 2020), 368–84.

2 Nikolaus Pevsner, *Pioneers of Modern Design* (New York: Penguin Books, 1977), 27.

3 Colin Amery, 'Nikolaus Pevsner's "Pioneers of the Modern Movement"', *The Burlington Magazine* 151.1278 (September 2009), 618.

4 Ute Engel, '"Fit for Its Purpose": Nikolaus Pevsner Argues for the Modern Movement', *Journal of Design History* 28.1 (April 2014), 15–17; 27–8.

5 Pevsner, *Pioneers of Modern Design*, 49; 53.

6 Ibid., 27.

7 Ibid., 38.

8 Engel, '"Fit for Its Purpose"', 17–19.

9 Michael T. Saler, *The Avant-Garde in Interwar England* (New York: Oxford University Press, 1999).

10 Ibid., 73.

11 Ibid., 88.

12 Ibid., 79.

13 Ibid., 80.

14 Alfred Marshall, 'The Social Possibilities of Economic Chivalry', *The Economic Journal*, 17.65 (March, 1907), 7–29.

15 Saler, *Avant-Garde in Interwar England*, 95.

16 Ibid., 101.

17 Ibid., 103.

18 Ibid., 132.

19 Ibid., 88.

20 Henry Wessells, *A Conversation Larger than the Universe* (New York: The Grolier Club, 2022), 70.

21 Lin Carter, *Imaginary Worlds* (New York: Ballantine Books, 1973).

22 Roger C. Schlobin, 'Preface', in Roger C. Schlobin (ed.), *The Aesthetics of Fantasy Literature and Art* (Indiana: Notre Dame University Press, 1982), ix–x; George P. Landow, 'And the World Became Strange: Realms of Literary Fantasy', *The Georgia Review,* 33.1 (Spring 1979), 33.

23 Norman Talbot, 'The First Modern "Secondary World" Fantasy', *Journal of William Morris Studies*, 13.2 (Spring 1999), 3.

24 Jamie Williamson, *The Evolution of Modern Fantasy* (New York: Palgrave Macmillan, 2015), 121.

25 Anna Vaninskaya, *Fantasies of Time and Death* (London: Palgrave Macmillan, 2020), 19, n.6.

26 Michael Moorcock, 'Putting a Tag on It', *Amra* 2.15 (May 1961), 15.

27 Peter Mansfield, 'Middengeard', *Eldritch Dream Quest*, 1.1 (November 1960), 3.

28 Fritz Leiber, Letter, *Ancalagon* 2 (April 1961), 6.
29 L. Sprague de Camp, 'Introduction: Heroic Fantasy', in L. Sprague de Camp (ed.), *Swords and Sorcery* (New York: Pyramid, 1963), 7.
30 L. Sprague de Camp, 'Conan's Great Grandfather', *Amra* 2.17 (October 1961), 3.
31 Ibid., 5.
32 Lin Carter, 'Notes on Tolkien', *Xero* 7 (November 1961), 21–2.
33 L. Sprague de Camp, Letter, *Amra* 2.23 (January 1963), 23.
34 De Camp, *Swords and Sorcery*, 8.
35 Lin Carter, 'The Fresh, Scrubbed Morning World of William Morris', in William Morris (ed.), *The Wood Beyond the World* (New York: Ballantine Books, 1969), ix.
36 Lin Carter, 'Birdalone', in William Morris (ed.), *The Water of the Wondrous Isles* (New York: Ballantine Books, 1971), x.

Morris in the Twenty-First Century

Sara Atwood

Viewed in light of modern debates and recent events, William Morris may seem an unlikely source of inspiration for our age: a privileged white male writer, designer, and business owner, whose firm produced finely crafted furnishings and books purchased by customers of the same demographic.[1] The face that looks out at us from photographs is the image of a comfortably well-off Victorian sage, bearded, buttoned-up, frozen in monochrome respectability. What could such a figure have to say to us today? Yet Morris was of course a great deal more complex and nuanced than these bare facts would suggest. A successful and talented businessman, he rejected capitalism and consumer culture, becoming an active and committed socialist. A craftsman enamoured of the past, he cultivated a medieval aesthetic yet was deeply immersed in the struggles and issues of his time. A protean Renaissance man, he deplored the Renaissance celebration of individual genius.[2] In a phrase that expresses his apparently paradoxical nature, biographer Fiona MacCarthy describes Morris as a 'conservative radical'[3] (although Ruth Levitas, reviewing MacCarthy's book, reads this as 'a way to distance Morris from Marxism, while incorporating the reader to a supposedly consensual position'[4] – a way of blunting Morris's revolutionary Socialism that Robin Page Arnot was already decrying in 1934).[5] Morris was both dreamer and doer, equally able to imagine an ideal past and work towards a progressive future.

Take a closer look at those photographs, remembering that while we see him in static black and white, Morris *lived* in colour, throwing himself into life with formidable energy and enthusiasm. He was a large man and an outsized presence, his mop of hair (for which he was nicknamed Topsy) always tousled, his conversation animated, his mind bursting with ideas, many of them remarkably forward-looking. Today, it's the fashion to call figures like Morris 'modern' or 'ahead of their time', an immodest way of aligning them with our superior selves and the supposedly 'continual forward movement of history of which we currently represent the

highest point'.[6] Relevance has become the ultimate litmus test. But as Francis O'Gorman has pointed out, this emphasis on relevance often hides the assumption 'that the thinker from the past needs to speak to the present *in the present's own terms* in order to be "relevant" or even merely readable. "Relevance" here means, usually, that the *present* has set the agenda and is asking its own questions of history.'[7]

Yet in every age modern is always *now*, the most innovative ideas and practices of the present moment. We don't have to justify Morris by assigning him twenty-first-century credentials; Morris was modern in his own day. He wasn't thinking or acting outside his time, but at the leading edge of it, pointing the way.[8] Relevance, as defined by critics and academics, too often means likeness: is Morris *like* us in some way? Can we see ourselves in him? Yet we often stand to learn more from strangeness than similarity. It strikes me that the better question to ask is not whether Morris's ideas are familiar, or self-reflective, but whether they are meaningful: does Morris challenge us? In what ways might his thinking productively inform our own?

Morris anticipated a number of our present concerns (many of them not especially modern but instead rooted in the nineteenth century) about the economy, the environment, and labour; defended the value of handmade, quality products against the growing proliferation of cheap, factory-made products; envisioned a peaceful, communal society that would value beauty, practise useful and stimulating work, and achieve equality of condition; and believed in the possibility of creating a better world by rejecting corrupt institutions and ideologies. Today, as civility, social justice, and ecological integrity erode under the pressure of divisive politics, short-sighted policy, war, nationalism, outbreaks of disease, and social unrest, Morris's ideas and practice are especially suggestive, both about where we might go and where we have gone wrong.

Unusually for a nineteenth-century figure, Morris has popular appeal: unlike, say, John Ruskin, who despite his influence on Morris is little known amongst the general public, Morris tends to be recognized, his reputation as a designer and one of the founders of the Arts and Crafts movement having sprung him from the Ivory Tower. A Google search of Morris's name returns nearly one billion results, a good number of them linked to terms such as pattern, design, wallpaper, fabric, tapestry, textiles, and stained glass, with a secondary emphasis on poetry and biographical information.

Even those who have never read a word of his writing and know nothing about his socialist activism are likely to recognize a Morris pattern.

His wallpapers and fabrics have a significant online presence at sites like Pinterest – which bills itself as 'a visual discovery engine for finding ideas like recipes, home and style inspiration, and more' – and Etsy, the online marketplace for makers. There is a surfeit of items featuring Morris designs for sale online, both handmade and mass-produced: fine art prints, pillow covers, jewellery, coasters, buttons, tea towels, smartphone cases, note-cards and pens, mugs, scarves, espadrilles. One can even purchase William Morris lounge pants. The online merchant Zazzle offers a pair of women's William Morris Strawberry Thief-printed spandex leggings. One thieving thrush (accident or tasteless design?) dangles a strawberry between the wearer's legs. A small number of these items – the fine art prints, some of the jewellery and fabrics – have clearly been produced in homage to Morris and with attention to his principles, motivated by his oft-quoted declaration to 'Have nothing in your houses that you do not know to be useful or believe to be beautiful'. Yet a great deal of these things (including twee placards and posters bearing that very declaration in jaunty fonts) are just the sort of poorly made, useless objects that Morris decried, cheapened further by an effort to capitalize on his aesthetic cachet and produced by a system antithetical to his ideals and practice. They are everything Morris hated, branded with his name and designs but emptied of his values. Sandra Alfoldy notes that the same sort of factory-produced items make up the bulk of purchases at the William Morris Gallery giftshop in Walthamstow.[9] Morris described goods like these as 'makeshift', writing in an essay of the same name that:

> As other ages are called, *e.g.*, the ages of learning, of chivalry, of faith and so forth, so ours I think may be called the Age of makeshift. In other times of the world's history if a thing was not to be had, people did without it, and there was an end. Nay, most often they were not conscious of the lack. But to-day we are so rich in information, that we know of many and many things which we ought to have and cannot, and not liking to sit down under the lack pure and simple, we get a makeshift instead of it; and once more it is just this insistence on makeshifts, and I fear content with them, which is the essence of what we call civilization. (*WMAWS*, ii.469–83)

The modern incarnation of Morris & Company (now owned by Sanderson Design Group), continues to produce high-end fabrics and wallpapers inspired by Morris's original designs, partnering with a number of artists and designers. Yet the Morris that emerges from the 'content' posted at the company's website might never have been a poet, socialist, or activist, so effectively has he been distilled down to the essence of craftsman (what would Morris the writer think of the company's ungrammatical

motto, 'Live Beautiful'?) There's nothing inherently wrong with Morris & Company's approach; the company of today offers not only goods but a heritage 'lifestyle', and its marketing centres the Morris best-suited to its brand. Yet there is something strange about a Morris & Company seemingly disconnected from its founder's radical convictions about art and labour. Morris's Firm was of course not simply a business venture, but an attempt to revive art and change 'the basis of society'[10] by restoring the 'attractiveness of labour' and the dignity of the workers, who were condemned under the existing system to wage-slavery, long hours, noisy, dirty factories and repetitive, mind-numbing tasks.[11] As Peter Stansky observes, Morris 'saw a necessary, inevitable linkage between the problems of politics and artistic endeavour'.[12] For Morris, art and design were bound up with social and political questions about beauty, labour, economics, education, and the environment. He saw that social cohesion depended on the workers' patience in bearing 'their intolerable burden', and that once that patience ran out, society would collapse.[13] As G. M. Young noted seventy years ago, Morris's socialism 'was the final synthesis of all his purposes; and without it his character would have been unfinished, his life incomplete'.[14] But there is no trace in today's Morris & Company of the Morris who declared that 'the price which commercialism will have to pay for depriving the worker of his share of art will be its own death',[15] and who accepted that armed revolution might be the only way to achieve

> a condition of society in which there should be neither rich nor poor, neither master nor master's man, neither idle nor overworked, neither brain-sick brain workers, nor heart-sick hand workers, in a word, in which all men would be living in equality of condition, and would manage their affairs unwastefully, and with the full consciousness that harm to one would mean harm to all – the realization at last of the meaning of the word COMMONWEALTH. (xxiii.277)

What the present Morris & Company does reflect, however, is the same dilemma that bedevilled Morris throughout his career: the difficulty of producing well-made, beautiful things at an accessible price. Despite his best efforts and intentions, Morris never succeeded in unpicking the knot of competitive production; given the nature of the market, the Firm's goods were simply out of reach for the vast majority of consumers. When shrewd manufacturers, capitalizing on the Firm's growing popular appeal, began producing cheap, affordable knockoffs, Morris 'warned patrons against his imitators, urging them to pay attention to the ideals behind the quality of production found at Morris & Company, thereby legitimizing the higher

prices of the products' (and raising fraught, age-old questions about orig-
inality and imitation).[16] Morris railed against a system that left him, as he
memorably put it, 'ministering to the swinish luxury of the rich'.[17] Today's
Morris & Company seems to have sidestepped Morris's dilemma by leav-
ing politics behind and embracing its role as purveyor of nostalgia and fine
goods to the wealthy. It is no easier now than it was in Morris's day to rec-
oncile the ideal and the real. Beautiful, well-made things still cost more to
produce and are thus usually purchased by those with a generous measure
of wealth and privilege. Making a living as a craftsman also remains diffi-
cult given the cost of material and time, factors which in turn contribute
to the high price of handmade and finely crafted goods (and often prevent
the craftsman from owning the sort of goods he makes). As Robert W.
Winter observes, and as Morris learned from experience, 'The problem is
that the craftsman always runs into the superior forces of capitalism: the
profit motive and the factory system.'[18]

There is a greater demand today for craftsmanship, driven not only
by nostalgia, but by increased social and political awareness about issues
Morris would recognize and approve, such as fair trade, working condi-
tions, environmental impact, and local sustainability. This growing desire
amongst consumers (of certain means) for high-quality goods produced
under just conditions has created a burgeoning market for handcraft and
spawned the Maker Movement, which advocates 'a renewed focus on
community and local resources and a desire for more authentic and qual-
ity things, along with a renewed interest in how to make things'.[19] Hand
work is central to the movement (although like Morris, makers do not
reject the thoughtful use of machinery and technology) and making is
broadly defined to include activities such as cooking, gardening, and 3D
printing. 'Being creative, the act of making and creating', writes Mark
Hatch in *The Maker Movement Manifesto*, 'is actually fundamental to what
it means to be human'.[20] In 2006 the movement's founders launched the
first Maker Faire (note the faux-medieval spelling), a gathering of creatives
that combines, in an unintentionally Morrisian spirit, a longing for the
past with the determination to transform the present. Today, Faires (and
mini-Faires) are held across the USA and abroad.[21] Makerspaces provide
places equipped with materials, resources, and support, where people can
gather to make and collaborate.

Maker Faires and Makerspaces facilitate equitable access to creative
community and resources (tickets to Faires are free and classes are rea-
sonably priced), yet this popular movement is aimed at non-professional
makers. In the commercial market, well-crafted goods remain costly and

inaccessible for the majority of consumers. Consider a representative example. At the big-box American chain Target, a twelve-piece dinnerware set (four place settings) mass produced in China on the commercial principles of use, replicability and affordability, costs less than thirty dollars. At Heath Ceramics, a California pottery studio founded in 1948, a five-piece dinnerware set (one place setting) made from the local Sausalito clay in 'a human-scale factory, blending hand and machine', with a focus on 'process, material, and the people and places behind the products we make' sells for seven and a half times as much.[22] You'd have to spend thirty-three times more money at Heath to come away with four place settings. Unlike the modern Morris & Company, Heath foregrounds the link between art and politics in a 'Vision & Values' statement that echoes Morris's principles:

> Design and make. Show and tell. Be resourceful. Honest. Responsible. Go direct. Use your hands. Mix old and new. Start small. Be human. Grow slowly. Provide jobs. Feed the environment. The community. Preserve craft. Honor the hand. Celebrate process and materials. Allow them to drive the making of simple, beautiful objects.[23]

Heath offers an alternative to the makeshift and looks towards a better world. The company's ceramics are both useful and beautiful, intimately connected to people, place and purpose. Yet beauty and ideals are no less 'article[s] of the market' now than in Morris's day,[24] with the result that Heath's goods are prohibitively expensive – a fact that gives new meaning to what Heath calls in another context 'the complexity of simplicity'.[25] (Might this phrase itself be a comment on Morris's claim that 'Simplicity ... is of all matters most necessary for the birth of the new and better art we crave' (xxii.24)?)

The high cost of local, sustainable, well-made goods extends to products such as food and drink as well: organic food is more expensive than conventional, while 'artisan' bread loaves, 'craft' beer, and other small-batch foodstuffs are often double (or more) the price of their supermarket counterparts. Quality ingredients, time, and limited production elevate cost. Echoing nineteenth-century debates, many commentators criticize what they see as niche products for the affluent, while others argue that present high prices are a necessary stage in creating the kind of meaningful change that will enable small producers to offer higher wages and employee benefits. It seems unlikely that this change will ever be fully achieved within the capitalist system, where progressive ideals struggle against 'the corrosive tendencies of markets'.[26] Even as reform-minded

producers urge alternative values and practices, canny marketers appropriate their language, leading to a proliferation of items that are 'artisan', 'sustainable', and 'craft' in name only, the food and drink equivalents of Morris tea towels and smartphone cases. 'Do we not shun the street version of a fine melody?—' declares the narrator of *Middlemarch*, 'or shrink from the news that the rarity ... is really not an uncommon thing, and may be obtained as an everyday possession?'[27] Not all the time, it turns out, especially if the market has habituated us to makeshifts and imitations – and put the real thing far beyond 'our' reach (the attitude Eliot's narrator describes presupposes a certain level of satisfied comfort). C. R. Ashbee's 1910 description of Morris's dilemma as a conflict between antithetical forces holds true today. The method and principles of production, Ashbee argued, are 'either commercial or cultural, and the two are not compatible'.[28]

The artist and activist Jeremy Deller has invoked Morris to underscore this very opposition. Deller has named Morris as one of his heroes, citing his socialist activism and his commitment to accessible art. In 2007, Deller joined local residents in protesting the cost cutting and imminent closure of the William Morris Gallery, Walthamstow. The campaign resulted in major reinvestment and refurbishment by the town council, an acclaimed reopening in 2012, and the museum's renewed reputation and impact. Deller's 2010 poster for the arts-funding programme 'Save the Arts' featured a William Morris quote: 'I do not want art for a few, any more than education for a few, or freedom for a few' (xxii.26). In 2013, Deller made Morris the centerpiece of his exhibition 'English Magic' at the Venice Biennale. In a huge mural painted by Sam Stuart Hughes and titled 'We Sit Starving Amidst Our Gold', Morris stands like a colossus in dark suit and tie, in the act of pitching Roman Abramovich's 377-foot yacht into the Lagoon. The mural was not only a criticism of thoughtless wealth and power (the Russian oligarch had moored the yacht beside the Giardini in 2011) but a commentary on the predatory nature of capitalism: yachts like Abramovich's and their even larger counterparts, cruise ships, endanger both the city's fragile structures and foundations and the environment. Deller imagined Morris 'as an avenging force, returning from the dead to punish the oligarch's selfishness' and to condemn, more broadly, the capitalist system that created and enables this sort of careless privilege.[29] Copies of Morris's socialist writings were displayed next to the mural, along with privatization certificates issued at the collapse of the Soviet Union, which contributed to the oligarchs' accumulation of wealth.[30] There was a further resonance in Deller's invocation of Morris

in this Venetian context given Morris's campaign, as founder and honorary secretary of the Society for the Protection of Ancient Buildings (what Morris called 'anti-Scrape'), to restore the west front of St Mark's and in his conviction that ancient structures, in Venice and elsewhere, should be protected from 'careless and wanton destruction' (*WMAWS*, i.146–7). Morris's great love of nature and his defence of the natural world against despoliation by industry and greed were also pertinent. 'Is money to be gathered?', Morris demands, 'cut down the pleasant trees among the houses … blacken rivers, hide the sun and poison the air with smoke and worse, and it's nobody's business to see it or mend it: that is all that modern commerce, the counting-house forgetful of the workshop, will do for us herein' (xxii.24). One can easily imagine Morris joining the ranks of No Grandi Navi, the modern Venetian protest against cruise ships and overtourism in Venice.

In the 2014 Modern Art Oxford exhibition 'Love Is Enough', Deller paired Morris with Andy Warhol, asking audiences 'to suspend their disbelief momentarily and make connections about art across two centuries'.[31] Though these connections were sometimes strained, Deller's show drew intriguing parallels, such as both artists' determination to democratize art, their commitment to collaboration (Morris at the Firm, Warhol at the Factory), their methods of production and their radical tendencies. Citing Warhol's late interest in subjects such as nuclear missiles, the Soviet Union and endangered species, and works such as his 1971 'Electric Chair II.82' screen prints, his 1985 painting of the Soviet Union ('Map of Eastern U.S.S.R. Missile Bases'), and 'American Race Riot' (1964), Deller aimed to show 'that Warhol – contrary to some perceptions of him as celebrity-crazed – also had a social and political conscience'.[32] The exhibition juxtaposed Morris's socialist writings with Warhol's 1973 'Mao' silkscreens. Drawing a line between Morris's fascination with medieval figures and legends and Warhol's admiration of Hollywood stars, Deller hung the Morris tapestry 'The Attainment: The Vision of the Holy Grail to Sir Galahad, Sir Bors and Sir Percival' (1895–6) opposite Warhol's 'Marilyn Tapestry' (1968). An entire room documented Morris's and Warhol's love of floral designs and motifs (Morris's wallpapers, Warhol's screenprints and flower drawings). Surprisingly, Deller did not connect Warhol's famous screenprints of Campbell's soup cans or his Brillo boxes, which raise questions about art and commerce, imitation and originality, with Morris's ideas about these subjects; doing so might yet yield meaningful insights.

Kehinde Wiley, the first African American artist to paint the official presidential portrait (Barack Obama, 2018) engages with Morris's legacy

even more directly, incorporating Morris's floral patterns into the back-grounds of his portraits of young Black men and women. Wiley is known for paintings that reimagine famous works of Western art by making Black subjects the focus, engaging with questions of power, colonialism, and slavery and emphasizing the lack of Black figures in Western art, where they are usually depicted only as slaves.

Wiley's interest in William Morris began during his childhood in Los Angeles, where he was exposed to Morris's floral patterns – authentic and imitation – in his mother's second-hand store.[33] Wiley has said that the backdrop in his portrait of President Obama, with its lush green leaves interspersed with flowers, could not have been painted 'without an inter-est in the William Morris style of block printing'.[34] Wiley has used actual Morris designs in his paintings (often altering the colour scheme) as well as his own Morris-inspired patterns. 'I began to take the DNA of Morris', Wiley says, 'and build upon it to create hybrids of my own, these kind of all-over patterns that feel random and chaotic as opposed to that very rational order you see in traditional Morris prints'.[35] Wiley uses Morris's patterns and his own hybrids to explore 'the relationship between the human body and the decorative', placing his subjects in a dynamic rela-tionship with the intricate backgrounds.[36] Often, he chooses his subjects by street-casting, approaching strangers to explain his work and inviting them to pose.

In 2020, the William Morris Gallery commissioned Wiley to paint six new portraits. He chose to paint six Black women street-cast in East London. Inspired by Charlotte Perkins Gilman's 'The Yellow Wallpaper', with its themes of marginalization and oppression, Wiley was interested in 'the correlations … between the sense of powerlessness and the sense of invention that happens in a person who's not seen, who's not respected and whose sense of autonomy is in question'.[37] Wiley set out to depict his sitters' strength 'within a society of complicated social networks … [and] to use the language of the decorative to reconcile Blackness, gender, and a beautiful and terrible past'.[38] His Morris-influenced backgrounds were another way of engaging with Gilman's text. The wallpaper in the story is the antithesis of Morris's designs – busy, flamboyant, and hideously coloured, it is an artistic failure. Wiley's backgrounds are aesthetically appealing, but it isn't always clear whether their intricate patterns frame or confine the sitter. A further, though more tentative, connection between Morris and Wiley's female portraits might be found in Morris's encourage-ment of women's craftsmanship and his close partnership with his daughter

May, artist, designer, socialist, and editor, who in 1907 co-founded the Women's Guild of Arts (and who knew Charlotte Perkins Gilman).

Although Wiley doesn't comment on the subject of Morris and race, and Morris did not write or speak in any detail about the subject himself, it is nonetheless interesting to consider if and how Morris's ideas about fellowship and equality of condition might intersect with modern debates about systemic racism and its connection to capitalism. Bluntly stating that capitalist society is based on 'a state of perpetual war' (xxiii.5), Morris acknowledged the damage it has done to other peoples and races. 'I only want to show you what commercial war comes to when it has to do with foreign nations', Morris declared in 1884, 'and that even the dullest can see how mere waste must go with it. That is how we live now with foreign nations, prepared to ruin them without war if possible, with it if necessary, let alone meantime the disgraceful exploiting of savage tribes and barbarous peoples on whom we force at once our shoddy wares and our hypocrisy at the cannon's mouth' (xxiii.7). Although Morris's adjectives are freighted with nineteenth-century Western assumptions of superiority that we now rightly reject and that demand further scrutiny, his distaste in this passage is directed not at 'the other' but at his own kind. As Eddy Kent argues, Morris 'suggests that [individual] difference is essential':

> What might change, Morris suggests, is our collective attitude toward that difference. He explains that various European nineteenth-century nationalisms are really just a reflection of commercial competition.[39]

It would be wrong to describe Morris as an anti-racist in the modern sense, but the time seems right for a careful consideration of his ideas in relation to present thinking about race and society.

Morris did not solve the problems that troubled him (no one person could) and we seem no closer to doing so. Today, many of the most critical challenges we face – accelerating climate change, social and economic inequity, political division, the ever-widening reach of the market into our lives – are outgrowths of nineteenth-century issues. Yet Morris's attempts – his experiment with Morris & Company, his socialist activism, his forward-looking essays and lectures, his tireless commitment to the work of reform, even the street-corner speeches that so embarrassed his friends –set an example of active, principled effort from which, if we determine not to 'turn our faces to the wall, or sit deedless because our hope seems somewhat dim' (xxii.12), we might yet learn.[40]

Notes

1 Clive Wilmer notes that Morris was in fact 'a very rich man'. See Clive Wilmer, 'Introduction', in *News from Nowhere and Other Writings* (London: Penguin, 2004), x.

2 Peter Stansky, *Redesigning the World: William Morris, the 1880s, and the Arts and Crafts* (Palo Alto: The Society for the Promotion of Science and Scholarship, 1996), 6.

3 Fiona MacCarthy, *William Morris: A Life for Our Times* (New York: Knopf, 1995), 605.

4 Ruth Levitas, review of *Representations of William Morris*, (review no. 3a) www.reviews.history.ac.uk/review/3a

5 Robin Page Arnot, *William Morris: A Vindication* (London: Lawrence, 1934), www.marxists.org/archive/arnot-page/1934/03/morrisvindicated.htm

6 Francis O'Gorman, '"Influence" in the Contemporary Study of the Humanities: The Problem of Ruskin', *Carlyle Studies Annual*, 28 (2012), 5–30 (9).

7 Ibid., 6.

8 On whether Morris can be called a *modernist*, see MacCarthy, *William Morris*, 605.

9 Sandra Alfoldy, 'The Commodification of William Morris: Emotive Links in a Mass-Produced World', *RACAR: revue d'art canadienne / Canadian Art Review*, 27.1/2 (2000), 102–10 (102).

10 Lawrence Goldman, 'From Art to Politics: William Morris and John Ruskin', in John Blewitt (ed.), *William Morris & John Ruskin: A New Road on Which the World Should Travel* (Exeter: University of Exeter Press, 2019), 123–42 (128).

11 Morris, 'Unattractive Labour', *Commonweal*, 1.4 (May, 1885), 37.

12 Stansky, *Redesigning the World*, 6.

13 Morris, 'Unattractive Labour', 37.

14 G. M. Young, 'Topsy', in *Daylight and Champaign* (London: Hart-Davis, 1948), 66.

15 Morris, 'Unattractive Labour', 37.

16 Alfoldy, 'The Commodification of William Morris', 104.

17 Reported by Sir Lowthian Bell to Alfred Powell, 1877; W. R. Lethaby, *Philip Webb* (London: Oxford University Press, 1935), 94–5.

18 Robert W. Winter, 'The Arts and Crafts as a Social Movement', *Record of the Art Museum, Princeton University*, 34.2 (1975), 36–40 (38).

19 Mark Hatch, *The Maker Movement Manifesto: Rules for Innovation in the New World of Crafters, Hackers, and Tinkerers* (New York: McGraw Hill, 2015), 6.

20 Ibid., 11–12.

21 The Maker Movement's founders do not invoke Morris. In his book about the movement, Mark Hatch cites Hegel, Jung, and Maslow who, he writes 'all came to the conclusion that creative acts are fundamental' (*Manifesto*, 12).

22 www.heathceramics.com/pages/about

23 Ibid.

24 Morris, 'Unattractive Labour', 37.

25 Amos Klausner, *Heath Ceramics: The Complexity of Simplicity* (San Francisco: Chronicle Books, 2005).

26 Michael Sandel, *What Money Can't Buy: The Moral Limits of Markets* (New York: Farrar, Straus and Giroux, 2012), 9.

27 George Eliot, *Middlemarch* (London: Penguin, 2003), 469.

28 C. R. Ashbee, 'Man and the Machine: The Pre-Raphaelites and Their Influence upon Life', *The House Beautiful*, XXVII.4 (March 1910), 102.

29 Martin Oldham, 'Political Arts', *Apollo*, 25 (January 2014) www.apollo-magazine.com/political-arts/

30 Ibid.

31 Farah Nayeri, 'Andy Warhol and William Morris in a Joint Exhibition', *The New York Times*, 15 December 2014, www.nytimes.com/2014/12/16/arts/international/andy-warhol-and-william-morris-in-a-joint-exhibition.html

32 Ibid.

33 'Interview: Kehinde Wiley', *The Guardian*, 25 January 2020, www.theguardian.com/artanddesign/2020/jan/25/kehinde-wiley-william-morris-exhibition-interview

34 Ibid.

35 Ibid.

36 Kehinde Wiley, *William Morris Gallery* (Gallery Notes), 2020, 3.

37 Ibid., 7.

38 Ibid., 7.

39 Eddy Kent, 'Morris's Green Cosmopolitanism', *Journal of William Morris Studies* (Winter 2011), 64–78. (70).

40 Thank you to Stuart Eagles for reading early drafts of this chapter.

Guide to Further Reading

This selective guide to William Morris scholarship provides avenues for exploring the contributions collected in this volume.

Works

The Collected Works of William Morris, ed. May Morris, 24 vols (London: Longmans Green & Company, 1910–15)

The Earthly Paradise by William Morris, ed. Florence S. Boos, 2 vols (London: Routledge, 2002)

The Ideal Book: Essays and Lectures on the Arts of the Book, ed. William Peterson (Berkeley: University of California Press, 1982)

Journalism: Contributions to Commonweal 1885–1890, ed. Nicholas Salmon (Bristol: Thoemmes Press, 1996)

Morris, William, and E. Belfort Bax, *Socialism: Its Growth and Outcome* (London: Swan Sonnenschein, 1893)

Morris, William, and Eiríkr Magnússon (eds), *The Saga Library*, 6 vols (London: Bernard Quaritch, 1891–1905)

News from Nowhere and Other Writings, ed. Clive Wilmer (Harmondsworth: Penguin Books, 1993)

The Novel on Blue Paper by William Morris, ed. Penelope Fitzgerald (New York: Journeyman Press, 1982)

The Odes of Horace: A Facsimile, intro. Clive Wilmer, trans. William Gladstone (Oxford: Bodleian Library Publications, 2016)

Political Writings: Contributions to Justice and Commonweal, ed. Nicholas Salmon (Bristol: Thoemmes Press, 1994)

The Unpublished Lectures of William Morris, ed. Eugene D. LeMire (Detroit: Wayne State University Press, 1969)

Wiens, Pamela Bracken (ed.), *The Tables Turned* (Athens: Ohio University Press, 1994)

William Morris Archive, ed. Florence S. Boos http://morrisarchive.lib.uiowa.edu/

William Morris: Artist, Writer, Socialist, eds May Morris and Bernard Shaw, 2 vols (Oxford: Basil Blackwell, 1936)

William Morris: Selected Poems, ed. Peter Faulkner (Manchester: Carcanet Press, 1997)

William Morris: Selected Writings, ed. Ingrid Hanson (Oxford: Oxford University Press, 2024)

Letters, Diaries and Interviews

The Collected Letters of William Morris, ed. Norman Kelvin, 4 vols (Princeton: Princeton University Press, 1984–96)

Pinkney, Pinkney (ed.), *We Met Morris: Interviews with William Morris, 1885–1996* (Reading: Spire Books, 2005)

William Morris's Socialist Diary, ed. Florence S. Boos (Iowa City, IA: The Windhover Press, 1981)

Biography

Arnot, Robin Page, *William Morris: The Man and the Myth* (London: Lawrence and Wishart, 1964)

Henderson, Philip, *William Morris: His Life, Work and Friends* (London: Thames & Hudson, 1967)

Lindsay, Jack, *William Morris: His Life and Work* (London: Constable, 1975)

MacCarthy, Fiona, *William Morris: A Life for Our Time* (London: Faber and Faber, 1994)

Mackail, J. W., *The Life of William Morris*, 2 vols (London: Longmans, Green, & Company, 1899)

Salmon, Nicholas, *The William Morris Chronology* (Bristol: Thoemmes Press, 1996)

Thompson, E. P., *William Morris: Romantic to Revolutionary*, rev. ed. (London: Merlin Press, 1976)

Thompson, Paul, *The Work of William Morris* (London: Heinemann, 1967)

Vallance, Aymer, *William Morris: His Art, His Writings and His Public Life* (London: George Bell & Sons, 1897)

Bibliography

Coupe, Robert L. M., *Illustrated Editions of the Works of William Morris in English: A Descriptive Bibliography* (New Castle, DE: Oak Knoll Press, 2002)

Latham, David, *An Annotated Critical Bibliography of William Morris* (London: Harvester Wheatsheaf Press, 1991)

Latham, David and Sheila Latham, 'William Morris: An Annotated Bibliography', *Journal of William Morris Society/Journal of William Morris Studies* (biennial feature, running 1978–)

LeMire, Eugene D., *A Bibliography of William Morris* (London: British Library, 2006)

Peterson, William S., *A Bibliography of the Kelmscott Press* (Oxford: Oxford University Press, 1984)

Criticism: (i) Journals

The Journal of William Morris Studies (formerly, *The Journal of the William Morris Society*) (Winter 1961–Present)
The Journal of Pre-Raphaelite Studies (1977–Present)

Criticism: (ii) Edited Volumes

Banham, Joanna and Jennifer Harris (eds), *William Morris and the Middle Ages* (Manchester: Manchester University Press, 1984)
Bennett, Phillipa and Rosie Miles (eds), *William Morris in the Twenty-First Century* (Bern: Peter Lang, 2010)
Blewitt, John (ed.), *William Morris & John Ruskin: A New Road on Which the World Should Travel* (Exeter: University of Exeter Press, 2019)
Boos, Florence S. (ed), *The Routledge Companion to William Morris* (Oxford: Routledge, 2021)
Coleman, Stephen and Paddy O'Sullivan (eds), *William Morris & News from Nowhere: A Vision for Our Time* (Hartland: Green Books, 1990)
Faulkner, Peter and Peter Preston (eds), *William Morris: Centenary Essays* (Exeter: University of Exeter Press, 1999)
Latham, David (ed), *Writing on the Image: Reading William Morris* (Toronto: Toronto University Press, 2007)
Martinek, Jason D. and Elizabeth Carolyn Miller (eds), *Teaching William Morris* (Vancouver: Fairleigh Dickinson University Press, 2019)
Miele, Chris (ed.), *From William Morris: Building Conservation and the Arts and Crafts Cult of Authenticity, 1877–1939* (London: Yale University Press, 2005)
Parry, Linda (ed.), *William Morris* (London: Philip Wilson / Victoria and Albert Museum, 1996) (revised and reissued by Anna Mason (ed.) for Thames & Hudson, 2021)
Weinroth, Michelle and Paul Leduc Browne (eds), *To Build a Shadowy Isle of Bliss: William Morris's Radicalism and the Embodiment of Dreams* (Montreal & Kingston: McGill-Queen's University Press, 2015)

Criticism: (iii) Books, Chapters and Articles

Allison, Mark A., *Imagining Socialism: Aesthetics, Anti-politics, and Literature in Britain, 1817–1918* (New York: Oxford University Press, 2021)
 'Building a Bridge to Nowhere: Morris, the Education of Desire, and the Party of Utopia', *Utopian Studies*, 29.1 (2018), 44–66
Arnot, Robin Page, *William Morris: A Vindication* (London: Lawrence, 1934)
Arscott, Caroline, *William Morris and Edward Burne-Jones: Interlacings* (New Haven, CT: Yale University Press, 2008)
Beaumont, Matthew, *The Spectre of Utopia: Utopian and Science Fictions at the Fin de Siécle* (Bern: Peter Lang, 2012)

Boos, Florence S., 'Where Have All the Autographs Gone? Morris's Autographs in Diaspora', *Journal of William Morris Studies*, 22.4 (Summer 2018), 4–14

 History and Poetics in the Early Writings of William Morris, 1855–1870 (Columbus: Ohio University Press, 2015)

 Socialist Aesthetics and 'The Shadow of Amiens' (London: William Morris Society, 2011)

 The Design of William Morris's 'Earthly Paradise' (Lewiston, NY: Edwin Mellen Press, 1991)

 'Morris' German Romances as Socialist History', *Victorian Studies*, 27.3 (Spring 1984), 321–342

Burman, Peter, 'Defining a Body of Tradition: Philip Webb', in *From William Morris: Building Conservation and the Arts and Crafts Cult of Authenticity, 1877–1939*, ed. Chris Miele (London: Yale University Press, 2005), 67–100

Colebrook, Frank, *William Morris: Master-Printer*, ed. William Peterson (Council Bluffs, IA: Yellow Barn Press, 1990)

Faulkner, Peter (ed.), *William Morris: The Critical Heritage* (London: Routledge, 1995)

 Against the Age: An Introduction to William Morris (London: Allen and Unwin, 1980)

Felce, Ian, *William Morris and the Icelandic Sagas* (Woodbridge: D. S. Brewer, 2018)

Greenlaw, Lavinia, *Questions of Travel: William Morris and Iceland* (Kendal: Notting Hill Editions, 2016)

Greensted, Mary, *The Arts and Crafts Movement in Britain* (London: Shire, 2010)

Grimble, Simon, *Landscape Writing and 'The Condition of England', 1878–1917* (London: Edwin Mellen Press, 2004)

Hanson, Ingrid, *William Morris and the Uses of Violence, 1856–1890* (London: Anthem Press, 2013)

 'Morris's Late Style and the Irreconcilabilities of Desire', *Journal of William Morris Studies*, 19.4 (2012), 78–84

 'Bring me that Kiss': Incarnation and Truth in William Morris's The Defence of Guenevere, and Other Poems', *English*, 59.227 (August 2010), 349–374

Hanson, Ingrid, Jane Thomas and Marcus Waithe, 'William Morris', in *In Our Time: Celebrating Twenty Years of Essential Conversation*, eds Melvyn Bragg and Simon Tilloston (London: Simon & Schuster, 2018), 425–432

Harvey, Charles and Jon Press, *Art, Enterprise, and Ethics: The Life and Work of William Morris* (London: Frank Cass, 1996)

 William Morris: Design and Enterprise in Victorian Britain (Manchester: Manchester University Press, 1991)

Haslam, Kathy and Peter Faulkner, *William Morris: A Sense of Place* (Bowness-on-Windermere: Blackwell, the Arts and Crafts House, 2010)

Helsinger, Elizabeth, *Poetry and the Thought of Song in Nineteenth-Century Britain* (Charlottesville, VA: University of Virginia Press, 2015)

 Poetry and the Pre-Raphaelite Arts: William Morris and Dante Gabriel Rossetti (New Haven, CT: Yale University Press, 2008)

Hodgson, Amanda, *The Romances of William Morris* (Cambridge: Cambridge University Press, 1987)

Holland, Owen, *William Morris's Utopianism: Propaganda, Politics and Prefiguration* (London: Palgrave, 2017)

Kinna, Ruth, *William Morris: The Art of Socialism* (Cardiff: University of Wales Press, 2000)

Kirchoff, Frederick, *William Morris: The Construction of a Male Self, 1856–72* (Athens: Ohio University Press, 1990)

Levitas, Ruth, *Utopia as Method: The Imaginary Reconstitution of Society* (London: Palgrave Macmillan, 2013)

The Concept of Utopia (Hemel Hempstead: Philip Allan, 1990)

'Marxism, Romanticism and Utopia: Ernst Bloch and William Morris', *Radical Philosophy*, 51 (1989), 27–36

MacCarthy, Fiona, *Anarchy & Beauty: William Morris and his Legacy, 1860–1960* (London: National Portrait Gallery, 2014)

Marsh, Jan, *William Morris & Red House* (n.p.: National Trust Books, 2005)

Jane and May Morris: A Biographical Story, 1839–1938 (London: Pandora, 1986)

Marshall, Roderick, *William Morris and his Earthly Paradises* (New York: George Braziller, 1981)

Meier, Paul, *William Morris: The Marxist Dreamer*, trans. Frank Gubb, 2 vols (Hassocks: Sussex Harvester Press, 1978)

Miller, Elizabeth Carolyn, *Extraction Ecologies and the Literature of the Long Exhaustion* (Princeton, NJ: Princeton University Press, 2021)

'William Morris, Extraction Capitalism, and the Aesthetics of Surface', *Victorian Studies*, 57.3 (Spring 2015), 395–404

Slow Print: Literary Radicalism in Late Victorian Print Culture (Palo Alton, CA: Stanford University Press, 2013)

O'Donoghue, Heather, 'The Great Story of the North: William Morris's Sigurd the Volsung as National Epic', in *Mythology and Nation Building: N. F. S. Grundtvig and His Contemporaries*, eds Pierre-Brice Stahl and Sophie Bønding (Aarhus: Aarhus University Press, 2021), 305–322

'Re-presenting Icelandic Saga Narrative for Victorian Readers', in *The Oxford Handbook of Medievalism*, eds Joanna Parker and Corinna Wagner (Oxford: Oxford University Press, 2020), 616–631

Parry, Linda, *William Morris Textiles* (London: Weidenfeld and Nicolson, 1983)

Peterson, William S., *Morris & Company: Essays on Fine Printing* (New Castle, DE: Oak Knoll Press, 2020)

The Kelmscott Press: A History of William Morris's Typographical Adventure (Berkeley, CA: University of California Press, 1991)

Peterson, William S., and Sylvia Holton Peterson (eds), *The Kelmscott Chaucer: A Census* (New Castle, DE: Oak Knoll Press, 2011)

Pevsner, Nikolaus, *Pioneers of the Modern Movement: From William Morris to Walter Gropius* (London: Faber and Faber, 1936)

Pinkney, Tony, 'Problems of Utopia from the Thames Valley to the Pacific Edge', in *Utopias & Dystopias in the Fiction of H. G. Wells and William Morris: Landscape and Space*, ed. Emelyne Godfrey (London: Palgrave Macmillan, 2016), 91–105

'Ruskin, Morris and Terraforming Mars', in *Persistent Ruskin: Studies in Influence, Assimilation and Effect*, eds Keith Hanley and Brian Maidment (Farnham: Ashgate, 2013), 171–178

William Morris in Oxford: The Campaigning Years, 1879–1895 (Glyndŵr, Grosmont: Illuminati Press, 2007)

'Kinetic Utopias: H. G. Wells's A Modern Utopia and William Morris's News from Nowhere', *Journal of the William Morris Society*, 16.2 (2005), 49–55

Robinson, Duncan, *William Morris, Edward Burne-Jones and the Kelmscott Chaucer* (London: Gordon Fraser, 1982)

Robinson, Duncan, and Stephen Wildman, *Morris & Company in Cambridge* (Cambridge: Cambridge University Press, 1980)

Saler, Michael, *The Avant-Garde in Interwar England: Medieval Modernism and the London Underground*, rev. ed. (New York: Oxford University Press, 2001)

Sewter, Albert Charles, *The Stained Glass of William Morris and His Circle* (New Haven, CT: Yale University Press, 1977)

Skoblow, Jeffrey, *Paradise Dislocated: Morris, Politics, Art* (Charlottesville, VA: University Press of Virginia, 1993)

Sparling, H. Halliday, *The Kelmscott Press and William Morris Master-Craftsman* (London: Macmillan, 1924)

Stansky, Peter, *From William Morris to Sergeant Pepper: Studies in the Radical Domestic* (Palo Alto, CA: Society for the Promotion of Science and Scholarship, 1999)

Redesigning the World: William Morris, the 1880s, and the Arts and Crafts (Princeton, NJ: University Press, 1985)

William Morris (Oxford: Oxford University Press, 1983)

Swannell, John N., *William Morris & Old Norse Literature* (Hammersmith: William Morris Society, 1961)

Thomas, Zoë, *Women Art Workers and the Arts and Crafts Movement* (Manchester: Manchester University Press, 2020)

Tomkins, Joyce Marjorie Sanxter, *William Morris: An Approach to the Poetry* (London: Cecil Woolf, 1988)

Tucker, Herbert, *Epic: Britain's Heroic Muse, 1790–1910* (Oxford: Oxford University Press, 2008)

Vaninskaya, Anna, 'Cheers and Jeers: Lecturer-Audience Interaction in the Socialist Movement', *Journal of William Morris Studies*, 23 (February 2020), 36–52

William Morris and the Idea of Community: Romance, History and Propaganda, 1880–1914 (Edinburgh: Edinburgh University Press, 2010)

Waithe, Marcus, *The Work of Words: Literature, Craft, and the Labour of Mind in Britain, 1830–1940* (Edinburgh: Edinburgh University Press, 2023)

'Poetry in Dilution: Pater, Morris, and the Future of English', in *Walter Pater and the Beginnings of English Studies*, eds Charles Martindale, Elizabeth Prettejohn, Lene Østermark Johansen (Cambridge: Cambridge University Press, 2023), 255–269

'Building Utopia: The Structural Medievalism of William Morris's News from Nowhere', in *The Oxford Handbook of Victorian Medievalism*, eds Joanne Parker and Corinna Wagner (Oxford: Oxford University Press, 2020), 583–596

'Uncanny Romance: William Morris and David Jones', in *Timely Voices: Romance Writing in English Literature*, ed. Goran Stanivukovic (Montreal and Kingston: McGill-Queen's University Press, 2017), 199–217

'From Folklore to Folk Law: William Morris and the Popular Sources of Legal Authority', in *The Voice of the People: Writing the European Folk Revival, 1760–1914*, eds Matthew Campbell and Michael Perraudin (London: Anthem Press, 2012), 157–169

'The Laws of Hospitality: Liberty, Generosity, and the Limits of Dissent in William Morris's *The Tables Turned* and *News from Nowhere*', *The Yearbook of English Studies*, 36.2 (2006), 212–229

William Morris's Utopia of Strangers: Victorian Medievalism and the Ideal of Hospitality (Cambridge: D. S. Brewer, 2006)

'The Stranger at the Gate: Privacy, Property, and the Structures of Welcome at William Morris's Red House', *Victorian Studies*, 46.4 (2004), 567–595

'*News from Nowhere*, Utopia and Bakhtin's Idyllic Chronotope', *Textual Practice*, 16.3 (2002), 459–472

Watkinson, Ray, *William Morris as Designer* (London: Studio Vista, 1967)

Wild, Tessa, *William Morris & His Palace of Art* (London: Philip Wilson Publishers, 2018)

Wilmer, Clive, 'Dreaming of Reality: The Poetry of William Morris', in *The Oxford Handbook of Victorian Poetry*, ed. Matthew Bevis (Oxford: Oxford University Press, 2013), 475–491

'Maundering Medievalism: Dante Gabriel Rossetti and William Morris's Poetry', *P.N Review*, 29.3 (January–February 2003), 69–73

'The Names of the Roses: Modernity and Archaism in William Morris's *The Earthly Paradise*', *Times Literary Supplement*, 6 June 2003, 69–73

Index

Cambridge Companions To ...

AUTHORS

TOPICS

Made in the USA
Columbia, SC
15 August 2024

40509070R00201